Exposed
The Victorian Nude

Edited by Alison Smith

With contributions by Robert Upstone, Michael Hatt,
Martin Myrone, Virginia Dodier, Tim Batchelor

Tate Publishing

Sponsored by
TATE MEMBERS

Front cover:
Frederic Leighton
*The Bath of Psyche c.*1889–90 (no.36, detail)

Frontispiece:
Theodore Roussel
The Reading Girl 1886–7 (no. 162, detail)

Published by order of the Tate Trustees 2001 on the
occasion of the exhibition at Tate Britain, London,
1 November 2001 – 27 January 2002
and touring to
Haus der Kunst, Munich, Germany:
1 March – 2 June 2002
Brooklyn Museum of Art, New York, USA:
6 September 2002 – 5 January 2003
Kobe City Museum, Kobe, Japan: February – May 2003
Geidai Museum (The University Art Museum), Tokyo,
Japan: June – August 2003

ISBN 1 85437 372 2

A catalogue record for this publication is available
from the British Library

Published by Tate Publishing, a division of
Tate Enterprises Ltd, Millbank, London SW1P 4RG

Catalogue design by Atelier Works
Printed and bound by Arti Grafiche Amilcare Pizzi
S.p.A., Milan

Contents

Handwritten annotations:
- *= Atelier*
- ** Life class - victorian*
- *- like what I did*

Sponsor's Foreword

Tate Members are proud to support *Exposed: The Victorian Nude*, the first major exhibition in the Linbury Galleries, and are delighted to be so closely involved with the launch of the stunning new Tate Britain Centenary Development.

Exposed is a stimulating and provocative exhibition that challenges conventional ideas about Victorian prudery and hypocrisy and sheds new light on issues of morality, sexuality and desire – all of which are as relevant today as they were in Victorian times. We have chosen to support this exhibition because of its fresh and challenging approach to an historic subject.

Tate Britain now offers increased gallery space, the very best viewing conditions for British art, and improved access for the disabled; I hope that as many Members as possible will be able to visit the new galleries and see *Exposed*. Through this major donation, Tate Members are able to play an important part in the Centenary Development and a key role in contributing to the exciting range of Tate activities.

Tate Membership was formed in 1958 and over the years we have grown in number and in the level of our contribution to Tate. In the Millennium year our numbers increased by 50 per cent, to over 40,000. Members are central to the success of all four Tate galleries, providing an invaluable source of income for the purchase of new works of art for the Collection and funding educational and interpretive projects. We are very grateful for the support we receive and hope that many of you who view the exhibition and read this catalogue will be encouraged to join us, to enjoy the many benefits of membership and develop a special relationship with Tate.

Sue Woodford Hollick
Chair, Tate Members

Foreword

Despite the absence from the history of British art before 1800 of many celebrated depictions of the naked human form – an absence notable by its contrast with wider patterns of European art – the nude was to become one of the most prolifically produced, exhibited and collected categories of art in nineteenth-century Britain. Indeed the casual but still popular association of the Victorian era with narrow social propriety and rigid prudery has never been very thoroughly supported by historical evidence. But this remains for many a powerful preconception, informing that sense of surprise, even discomfort, which marks responses today to the revelation of a culture often less constrained, less morally certain, than our own. Many of the works of art in *Exposed: The Victorian Nude*, the first exhibition to explore the subject in depth, are arresting through their quality and beauty as judged by the taste and codes of our own time; others shock through their apparent appropriation of the dress of art to cloak an intent to titillate, sometimes crossing the boundaries of what might today be considered appropriate or even morally safe. In so doing they raise questions too about the definition of lines between the decent and the indecent, and the relationship of public and private as arenas for the consumption of art. Through such means, and others, the exhibition creates a live dialogue between the worlds of nineteenth- and twenty-first-century Britain.

The famous prejudices against Victorian art that prevailed at least until the last third of the twentieth century – creating a critical orthodoxy dismissive of much of it as sentimental social documentation devoid of aesthetic merit or art-historical significance – no doubt helped to discourage the staging of a searching exhibition of this kind in the past. But the vast advances that have been made in recent years across the field of Victorian visual studies, and the increasing currency of debate about the body, gender and their historical perspectives, have argued strongly in favour of mounting a project of this kind now, one which will, I hope, prove a worthy successor to Tate's distinguished series of nineteenth-century theme shows, notably *The Pre-Raphaelites* (1984) and *Symbolism* (1997). More generally, *Exposed* exemplifies the commitment of Tate Britain since its launch in March 2000 to offer a fresh and often challenging presentation of both accepted and neglected areas of British visual culture, from time to time cutting across conventional categories of high and low, and introducing a broad range of artistic production, including, for example, photography and film.

Exposed began as a proposal from Elizabeth Prettejohn, senior associate lecturer in the history of art at the University of Plymouth, and Alison Smith, author of *The Victorian Nude* (Manchester, 1996). We are grateful to them both for initiating the idea, and to Alison for subsequently taking it forward and transforming it into a real exhibition, going so far as to join the Tate staff, as a senior curator, along the way. Her enthusiasm, scholarship, and strong sense of intellectual adventure underpin the exhibition in all respects, and she has led the project with great authority, supported in Tate Britain's Exhibition and Display department both by Tim Batchelor, assistant curator, and by its former head, Sheena Wagstaff. Curators Martin Myrone and Robert Upstone also contributed crucially to the conception and making of the show: to them, to fellow catalogue contributors Virginia Dodier and Michael Hatt, and to Sarah Hyde as author of the accompanying exhibition guide, we offer many thanks. Alison Smith's acknowledgements on p.9 express the much wider extent of our debt to many further people within and beyond Tate. Meanwhile I would like to stress our particular gratitude to all those who have so generously lent works of art to the exhibition. As kind supporters one and all I hope they will forgive me for mentioning the exceptional assistance of Donato Esposito of the British Museum, Jane Farrington and Tessa Sidey from Birmingham Museums and Art Gallery, Mark Bills from the Russell-Cotes Art Gallery, and Reena Suleman and Daniel Robbins from Leighton House.

The exhibition is the first to grace the Linbury Galleries, the magnificent gift of Lord and Lady Sainsbury of Preston Candover to Tate Britain and a major component of Millbank's Centenary Development, which opens in tandem. The architects of the Development were John Miller + Partners and they were the natural choice to design the installation of the inaugural exhibition. To John, Su Rogers and Deborah Denner, and to exhibition graphic designers

Quentin Newark and David Hawkins of Atelier Works
(also designers of the catalogue and guide) our thanks
for taking this on with such evident pleasure as well
as precision. I am also pleased to record our close
collaboration with many staff at the venues of the
exhibition's international tour following its showing at
Tate Britain, especially Arnold Lehman, Barbara Gallati,
Ken Moser and Peter Trippi of the Brooklyn Museum;
Christoph Vitali and Bernhart Schwenk of the Haus
der Kunst, Munich; Dr Yasumasa Oka of Kobe City
Museum; and Reiko Onodera and Prof Masato Satsuma
of the Gedai Museum, Tokyo. For facilitating the
Japanese tour we pay tribute to Kenichiro Nakajima
and Keiji Emori of Mainichi Newspapers, and also to
Laura Gascoigne.

Finally, we are extremely grateful to the Tate Members
for making a substantial donation to support the staging
of the show in London.

Stephen Deuchar
Director, Tate Britain

Acknowledgements

Many people have been involved in the realisation of this exhibition. In addition to the comments made in the Director's foreword, I would like to acknowledge the invaluable assistance of a number of institutions and individuals who have helped make this project possible.

Within Tate Britain I would like to thank Stephen Deuchar, Sheena Wagstaff and her successor Judith Nesbitt for guiding the project through the various stages of its development. Although he has already been mentioned, Tim Batchelor should be acknowledged for the skill with which he has handled the complex logistics of the show. *Exposed* includes a large number of paintings and sculptures in the Tate collection, many of which have not been exhibited for a long time, so I am very much indebted to Jacqueline Ridge, John Anderson, Jackie Heuman, Piers Townshend and Helen Brett for the time they expended in treating works for display. Nicola Bion deserves a special thanks for her expertise in overseeing the production of the catalogue, as well as Fran Matheson for being such a dedicated picture researcher. Gillian Buttimer has co-ordinated transportation for the exhibition and tour venues with great care and professionalism. I am also grateful to the following members of staff for their important contributions to the making of *Exposed*: Joanna Banham, Alex Beard, Rosemary Bennett, John Bracken, Sarah Briggs, Celia Clear, Dave Dance, the Development department, Sionaigh Durrant, Mark Edwards, Melaine Greenwood, Sophie Harrows, Lorna Healy, Richard Humphreys, Tim Holton, David Fraser Jenkins, Carolyn Kerr, Sophie Lawrence, Ben Luke, Anne Lyles, Tara McKinney, Lyndsey Morgan, Sarah Munday, Anna Nesbitt, the Photography department, Katherine Rose, Judith Severne, Andy Shiel, the Special Events Department, Clarrie Wallis, Piers Warner, Terry Warren, Simon Wilson and Andrew Wilton.

I would also like to extend my gratitude to the following individuals and institutions for kindly agreeing to lend works and for their help over several years: Caroline Bacon, Claire Bertrand, the British Museum, David Brady, Peter Brown, Simon Brown, Ann Bukantas, Robert Coale, Jon Catleugh, Ron Clarke, Tina Craig, Judith Crouch, Tamsin Daniel, William Darby, Janey Dolan, Oliver Fairclough, Tina and Graham Fettes Thornton, Liz Forster, Penny Fussell, Melanie Gardner, Richard Green, Judith Guston, Richard Halonen, Julian Hartnoll, Mark Haworth-Booth, Robin Hildyard, Christine Hopper, Jenns Howoldt, Richard Jefferies, Joanna Jones, Louise Karlsen, Raymond Keaveney, Susan Lintott, The London Library, Andy Loukes, Olivier Meslay, Jonathan Minns, Peter and Renate Nahum, Charles Newton, Terence Pepper, Horst Rechelbacher, Sarah Richardson, Pam Roberts, Alex Robertson, Thierry Roland, Anne Rose, The Royal Collection, Marie-Pierre Sale, William Schupbach, Joseph Sharples, Helen Smailes, Kathleen Soriano, Paul Spencer-Longhurst, Sheena Stoddard, Virginia Tandy, Tate Library and Archive, Louis van Tilborgh, John Tonkin, Julian Treuherz, Catherine Wallace, Janet Wass, John Waters, Caroline Worthington, as well as those lenders who wish to remain anonymous.

Among the many others who have shared their expertise and offered advice, I would like to thank Barry Anthony, Victor Arwas, Roger Brown, Gill Burdett, John Christian, Ian Christie, Nicola Christie, Sarah Farley, Jane Fletcher, Clare Freestone, David Getsy, Charles Greig, Ken Howard, Mary Huston, Alison Inglis, Margaret Macdonald, Jane Mayes, Kathy Mclaughlin, Ben McPherson, Lynda Nead, Shirley Nicholson, Rictor Norton, Pamela Gerrish Nunn, Terence Pepper, Simon Popple, Martin Postle, Pru Porretta, Celia Quartermain, Emily Rawlinson, Simon Reynolds, Guy Roussel, Malcolm Shifrin, Hannah Spooner, Michael J. Shaw, Simon Toll, Nicholas Tromans, Diane Waggoner, Philip Ward-Jackson, William Vaughan, Rebecca Virag, Tim Wilcox and Joanna White.

Alison Smith

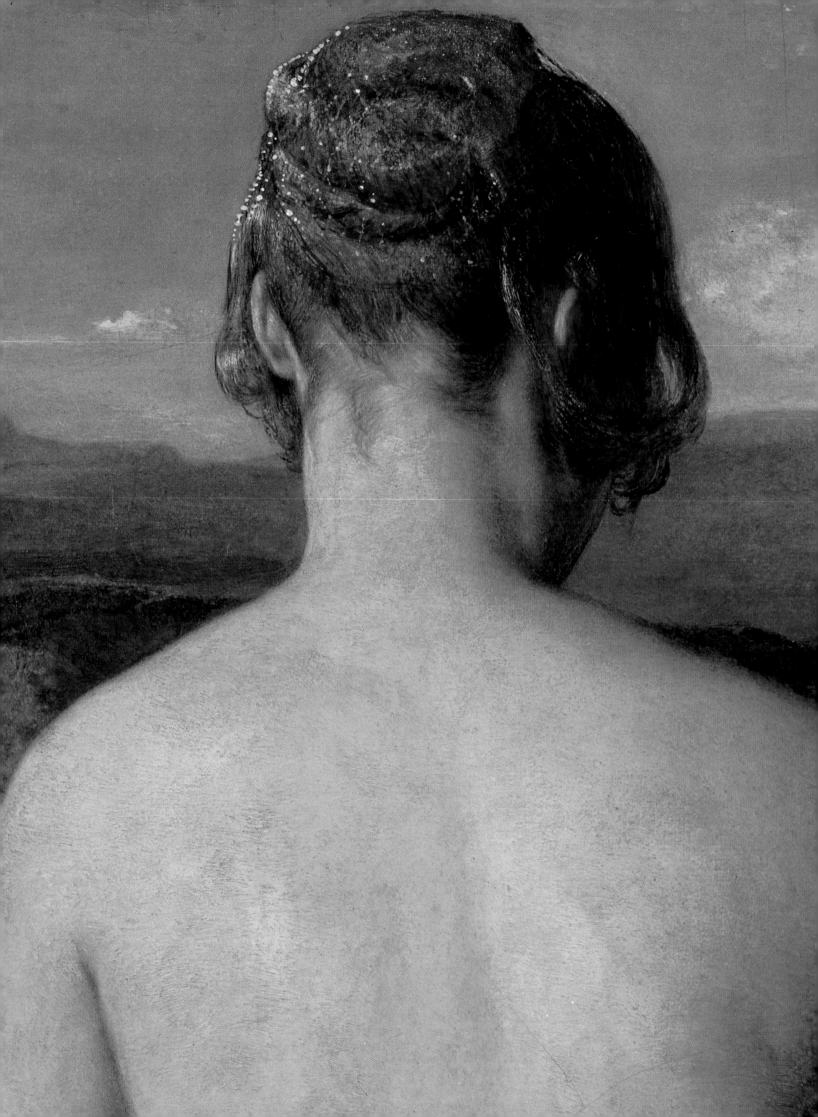

The Nude in Nineteenth-Century Britain: 'The English Nude'
Alison Smith

That the 'Victorian Nude' should seem an inherently contradictory notion owes much to the negative equation between the Victorian and moral restriction that emerged in the Edwardian era and which became entrenched during the twentieth century. Kenneth Clark effectively dismissed the Victorians from his influential survey *The Nude* of 1956 with a sweeping reference to 'the great frost of Victorian prudery', and even today the Victorian nude is still regarded as something of an embarrassment, oscillating between what Linda Nochlin has recently ridiculed as the 'consummate silliness' of classicists such as Alma-Tadema, and a 'customary English revulsion from nakedness'.[1] Such limiting views have served to obscure what was in fact a tradition as varied and as fraught with controversy as representations of the body are in our own post-modern culture: while the nude upheld the prestige of classical art and an academic system of art training, it also supported a number of competing perspectives on the way the human figure was represented in art and society, attitudes informed by religious and social morality as well as by aesthetic and libertarian values.

The focus of these debates was typically referred to as 'the English Nude', that national epithet (though ostensibly a synonym for 'British') functioning to contain a complex set of cultural and historical associations within an exclusive concept centred on London and the South. Indeed, the uncontested acceptance of 'English' as the normative term for describing the national school was reinforced by the many commentaries on British art published during the century, Richard and Samuel Redgrave's *A Century of Painters of the English School* (1866) and Ruskin's *The Art of England* (1883–4) being just two notable examples. However, 'English' was as problematic an appellation as 'Victorian' is for present-day scholarship in that it argued as much against a particular identity as it did for a distinct form of representation. The idea of the English Nude was first articulated in the 1850s at a time when British artists and critics were conscious of the lack of a tradition of representing the subject, and of the inadequacy of those nude works that did exist in serving the future interests of the national school. The absence and failure of the British nude was brought home by both official investigations into pedagogic practices and the aspersions cast by French commentators on the standard of life-drawing and figurative art displayed by British artists. Art education became the arena for a long-drawn-out battle over the advantages of adopting a 'Continental' idealising approach to life study, against the importance of defending local methods based on the principle of candidly empirical observation and resistance to the idea of British artists losing their individuality in pursuing a cosmopolitan manner.[2] The identification of the 'English Nude' therefore stemmed from a broader debate concerning the identity and evolution of the national school and the extent to which it should absorb or disavow European conventions in competing for cultural hegemony. Thus French criticisms, voiced at international exhibitions over the English incapacity for high art, were met with the rebuff that English artists abided by a different set of values. In 1862 the *Art Journal* defined Englishness in art in terms of decorum, sobriety and empathy with the subject-matter, and in 1867 commended British painters for their circumspection:

> a deeply-rooted sense of propriety has not a little to do with the paucity of naked women on the walls of English Exhibitions. The French do not even pretend to delicacy. Our notions, fortunately for the morals of our people, and certainly for the good manners of society, happen to be different, and so English pictures are for the most part decently draped.[3]

The 'English' designation also functioned to incorporate the nude into a north-European tradition of representing the body, fuelling a widespread perception that the subject did not come naturally to the pragmatic Anglo-Saxon mind and that whereas it had triumphed under the Greek and Latin races, and later under Catholicism, the climate, geography, history and religion of the northern Protestant nations opposed its development, as the American James Jackson Jarves explained in an essay of 1874: 'In the more southern climates the best traditions and examples of high Art have come from the nude ... To the average Protestant mind, trained for generations to receive contrary impressions, this phase of the beautiful is absolutely a "stumbling block of offence".'[4]

Evangelicism with its negative view of the flesh and suspicion of idolatry was often held responsible for uninformed northern prejudices against the subject. Although most denominations could tolerate the nude under the supervision of specialists within the private studio or dissecting room, they opposed its presence in public. Such objections intensified during the mid-nineteenth century when the state adopted a more interventionist approach in matters of social welfare and culture, advocating the widespread promotion of art via education and museums as a means of transferring social values through a non-political consensus of shared pleasures. The vociferous vigilante organisations which developed throughout Britain to protect public morals from what they considered to be the licence permitted by the processes of bourgeois democracy predicated their cause on the harm the nude presented to inartistic minds, drawing no distinction between 'fine' art and what they took to be 'pornographic' representation. In the mid-1880s a national furore developed over the issue of child prostitution, and in areas where the problem was considered to be rife, such as London, Liverpool and Glasgow, images of the nude were condemned by purity groups as a demoralising influence. The 'British Matron' controversy of 1885 (see p. 122) and the uproar surrounding Thomas Stirling Lee's relief *Joy follows the growth of Justice led by Conscience directed by Wisdom* (1882–5, fig.1) at St George's Hall, Liverpool, were two major instances of how the nude became politicised in the late Victorian period. Lee's panel was installed precisely at a time when vigilante groups were demanding greater protection for women and children, and his conception of Justice as a gauche naked girl was consequently interpreted as an indecent image that encouraged the abuse of vulnerable sections of society.[5]

In seeking to counter the challenge presented by moralists, defenders of the nude promoted the unclothed body as a pure ideal, both sides competing for the moral high-ground. In 1889 the Committee of the National Association for the Advancement of Art and its Application to Industry forwarded a statement to the Mayor and Corporation of Liverpool deploring the 'stupid and ignorant abuse' of Lee's panels by 'people who have too little idealism to understand their

meaning'.[6] The idea that the nude represented prelapsarian innocence was backed by the numerous epithets wielded against purists: 'To the pure in mind all things are pure' and 'Honi soit qui mal y pense' (Shamed be he who evil thinks: the motto of the chivalric Order of the Garter) were the two most popular phrases.[7] The accession of Queen Victoria in 1837 was significant in the development of a national mythology of the nude: her custom of giving Albert nudes as birthday gifts was regarded as a pure gesture that also fostered high art. By the late 1840s the royal couple had assembled an impressive collection of nude works that collectively communicated a message of national supremacy by exemplifying the idea of rustic harmony and female virtue. Victoria's appropriation of Godiva as a model for chaste leadership, along with Spenser's *Faerie Queene* as a prototype for the new Gloriana, stimulated the production of numerous nude works based on themes from national history and literature, all of which promoted chivalric duty and a pure gaze.

Indeed for much of the century issues of style were subsumed in a broader debate about the social character of the nude, with most writers on the subject adopting a sociological rather than a purely aesthetic perspective in both their defence and criticism of the subject. Differences in the ways artists approached the male and female nude can be explained in part by the prescriptive codes of social conduct set out for men and women in bourgeois society. The normative standard for the male nude was one of virile, purposive manhood, an ideal sustained by recreational and competitive sports. It was inevitable, therefore, that artists should use pugilists as models, for such types were not only seen to match the physical perfection of the Antique but also abided by a code of fair play. Both the visual images and mass spectacles involving prize-fighters supported an ideology of a nation forever on the defensive. Images like Millais's *Ancient Britons Wrestling* of the 1840s (fig.2) were probably inspired by popular entertainments, such as the Grand Aquatic Tournament staged on the Thames in June 1848 which included the attractions of gladiatorial wrestling and a tableau of *Britanniarum* or *Neptune and his Tributaries*, the latter also the subject of a large fresco Victoria and Albert had commissioned from William Dyce the previous year for the main stairwell at Osborne

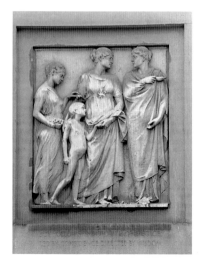

Fig.1
Thomas Stirling Lee
Joy follows the growth of Justice led by Conscience directed by Wisdom 1882–5
Stone relief panel
St George's Hall, Liverpool

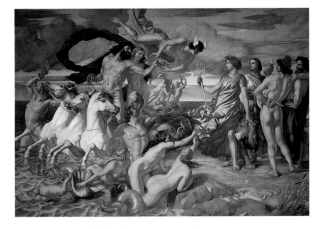

Fig.3
William Dyce
*Neptune resigning
the Empire of the Seas
to Britannia* 1847
Fresco
Osborne House

House as a symbol of Britain's maritime supremacy (fig.3).[8] During the mid-nineteenth century a patriotic athletic ideal was urged upon middle-class men seen to be at risk from sedentary occupations. For example, in an 'Address given to the middle-classes upon the subject of Gymnastic Exercises' in 1848, Lord Dalmeny criticised the bourgeoisie for being morally active but physically supine, and went so far as to argue that the efficiency of the constabulary in controlling the Chartist demonstrations of 10 April that year would have been doubled had each individual 'been inured to vigorous exercise ... on that day, I saw many forms cast by Nature in an athletic mould, but wasted or bloated by luxury or inaction'.[9]

Such complaints served to fuel a demand for recreational sports. The pre-eminence of the English as swimmers in the nineteenth century was attributed to a mixture of Nordic and Roman strains in the national constitution. 'Tubbing' or bathing was held up as a virtue that distinguished the English from the French who according to a writer in the *Saturday Review* did not bathe.[10] Swimming was seen to nurture independence and heroism, and feats such as Captain Matthew Webb's legendary first cross-Channel swim on 24 August 1875 inspired a nationwide passion for the sport, as the *New York Times* reported: 'The London baths are crowded, each village pond and running stream contains youthful worshippers at the shrine of Webb, and even along the banks of the river, regardless of the terrors of the Thames police, swarms of naked urchins ply their limbs.'[11] According to the historian of swimming Charles Sprawson, everyone swam naked until the popularity of bathing gathered momentum in the mid-Victorian period, by which time men could only bathe undraped off certain parts of beaches and at set times.[12] Male resistance to the imposition of drawers was a demonstration of the belief that bathing naked in nature offered a rare opportunity for men to experience a pure animalistic pleasure in their bodies away from the strictures of urban morality, a view illustrated in the diaries of the Revd Francis Kilvert, a stalwart naturist and swimmer who was constantly bemoaning the 'detestable' custom of bathing in drawers. In June 1874 he recorded an incident at Shanklin on the Isle of Wight:

Today I had a pair of drawers given me which I could not keep on. The rough waves stripped them off and tore them round my ankles. While thus fettered I was seized and flung down by a heavy sea which retreating

Fig.2
John Everett Millais
*Ancient Britons
Wrestling* c.1840–1
Watercolour on paper
Tate

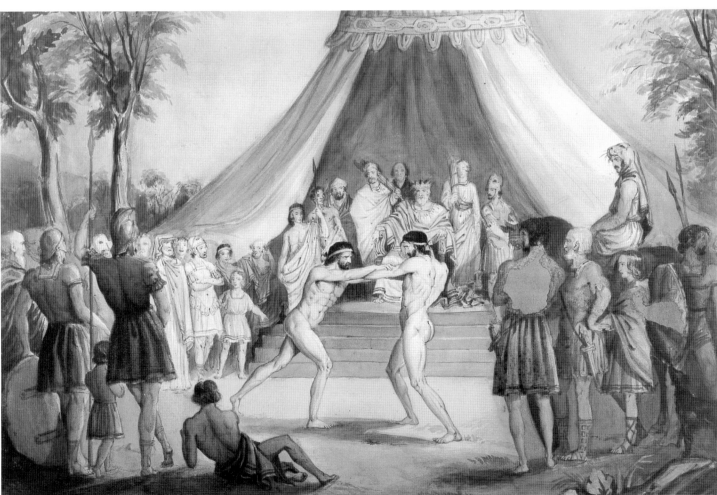

suddenly left me lying naked on the sharp shingle from which I rose streaming with blood. After this I took the wretched and dangerous rag off and of course there were some ladies looking on as I came out of the water.[13]

The physical and moral benefits of bathing were popularised in Charles Kingsley's novel *The Water-Babies* of 1863, a cautionary tale in which water acts as a metaphor for moral cleanliness and the simple innocence of childhood. The book influenced Frederick Walker's painting *Bathers* of 1867 (no.176), which, despite initial criticisms of its 'coarseness' and 'vulgarity', later came to epitomise one strain of Englishness among nude subjects on account of its nostalgic evocation of boyhood liberty and cameraderie. 'No painter in England has ever produced a picture more worthy of immortality' declared one critic on viewing the work at the Deschamps Gallery in 1876, and, discussing the painting with G.F. Watts, Hamo Thornycroft wished that he might see another picture 'as good and national'.[14] With this iconic image Walker was seen to imbue an ordinary rural scene with the spirit of Greek sculpture, imagining a male utopia that surreptitiously admitted a homoerotic chivalric gaze, while at the same time honouring a popular pastime.

In representing the female nude artists could not depend on the social body as a referent in the same way as they did in the case of the male nude because, according to the strictures of evangelical morality, the contexts in which the unclothed female body appeared in modern society were immoral. The women who performed in theatrical entertainments or who posed naked in life-classes were associated with prostitutes and were deemed meretricious and a corrupting influence. Etty was constantly under attack for demoting high art to the level of the burlesque and for placing actresses or habituées of the fashionable milliners of Hanover Street in his ideal compositions.[15] Therefore in presenting the female nude it was vital that artists should transcend the urban sexualised body by placing the figure in a pastoral setting so it could be appreciated as a symbolic embodiment of a place or natural formation. Maclise's *The Origin of the Harp* of 1842 (fig.4), based on Thomas Moore's popular *Irish Melodies* first published

in 1807, is one such subject in which the nude, a Celtic siren, is shown metamorphosing into the mythical harp of Erin. Although the demand for a generic allegorical treatment of the nude ran counter to the dominant tendency in British art of the mid-Victorian era – the naturalistic Protestant tradition seen to originate with the Dutch and Hogarth and which promoted truth above style – it did co-exist with the ideas advanced by Reynolds in his Academy *Discourses* (first collected 1797) which promoted the theory of Ideal Beauty based on elevated Old Master traditions. Both these approaches had advocates and both were subject to charges of impurity: the former for being too realistic and insular, the latter for being artful and conventionalised. Naturalism was a safeguard of Englishness with connotations of rural unselfconsciousness, and yet because any suggestion of nakedness was considered immoral, an infusion of classicism or of the Old Masters was accepted as a purifying agent so long as this did not disturb the essential 'English' character of the nude.

Stylistic Appropriations: The Anglo-Venetian Nude

The tensions inherent in representations of the female nude were partly negotiated through a process of appropriation in which stylistic models from the past were tested and adapted to meet contemporary aspirations. In the early and mid-nineteenth century an Anglo-Venetian aesthetic was in the ascendant, an essentially romantic approach to the figure which flourished in the aftermath of the French Revolution in reaction to what was denigrated as the 'frigid artificiality' and radical extremism of David and his followers.[16] For many painters the classical themes which formed the staple of the nude invited a hard-edged sculpted treatment which they found incompatible with the poetic subjects they wished to paint. The model for the romantic nude was Titian, whose great *Diana and Actaeon* and *Diana and Callisto* (fig.5) had astonished audiences when placed on quasi-public view at Stafford House in the early nineteenth century, offering a chromatic alternative to French classicism and rationalism and a more temperate treatment of flesh than that presented by Rubens, another informative influence on the nude in Britain. The quest to discover

Fig.4
Daniel Maclise
The Origin of the Harp
c.1842
Oil on canvas
Manchester City Art
Galleries

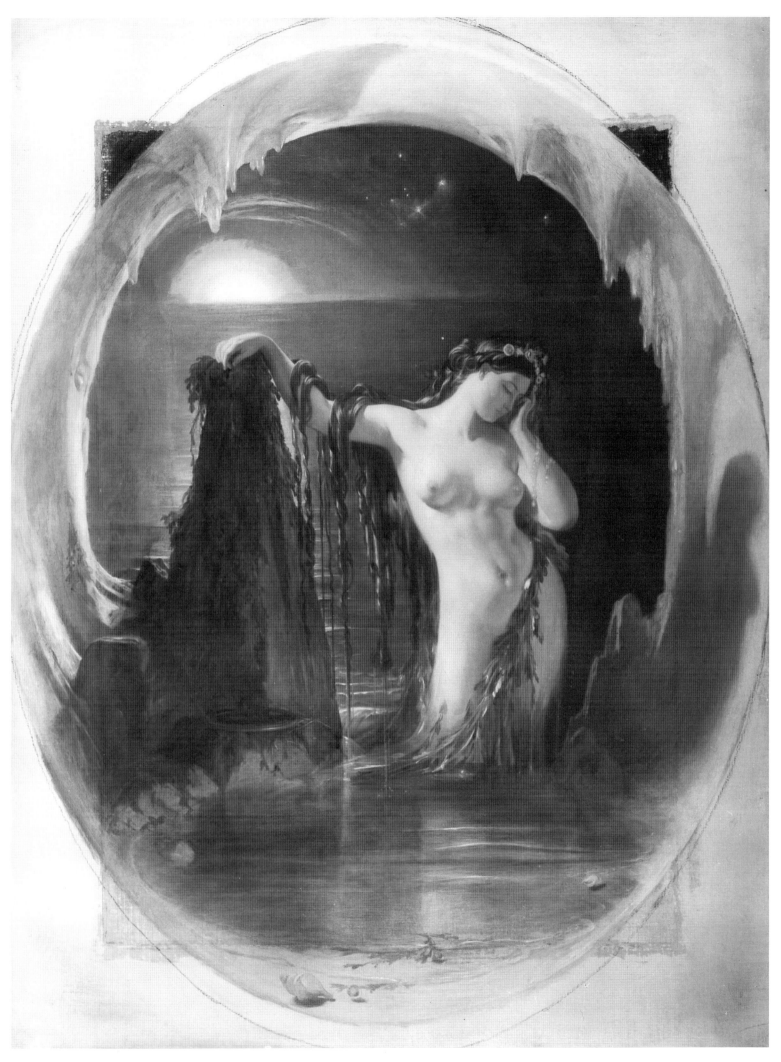

the technical 'secrets' of the Venetian painters developed into an obsession during the nineteenth century, encouraging a proliferation of painting manuals each seeking to divulge Old Master methods.[17] The link between Venetianism and Englishness was to intensify as the century progressed: Watts later compared the radiant beauty of the Venetian body with the Lorelei and fairies of the North, and in *Modern Painters* Ruskin extolled the sensuous Venetian nude as a 'Divine Fact'.[18] Although such an appraisal was at odds with the association between Venetianism and luxuriousness made by Reynolds in his fourth *Discourse*, the contradiction did not become an issue while Venetian paintings remained in private hands: after all, Titian's Ovidian romps had been intended for the private delectation of European monarchs and aristocrats.[19] It was only when such Old Master paintings entered public collections that the British experienced difficulties in reconciling a distaste for certain subjects with the appeal of formal properties such as colour. The National Gallery thus rejected an opportunity to acquire Titian's *Rape of Lucretia* in 1847, although it had purchased his *Bacchus and Ariadne* from the jeweller Thomas Hamlet in 1826, a painting which was received with both admiration and contempt, the *News of Literature and Fashion* describing the figure of Ariadne as 'a misshapen little hussey'.[20]

The painters who harboured ambitions with the nude thus set about the challenge of domesticating Titian, tempering his subject-matter to satisfy the sensibilities of a broad, popular audience. Etty made copies from Titian to ascertain his method, the allure of which he relayed in both private works and public statements where colouristic sensuousness was not intended to detract from the moral purpose of representing virtuous womanhood or chivalric endeavour.[21] Nevertheless for many observers this type of nude was more suitable for private viewing than public display: Etty's figures were often accused of exposing 'too much of that voluptuousness which his favourite Titian indulged in', and it was probably because of this sort of response that Mulready was reticent about exhibiting the subject in public.[22] By the 1850s the Anglo-Venetian nude was being widely criticised for appearing parochial, unconvincing as high art and orientated towards

prurient minds. The International Exhibitions of 1855, 1862 and 1867 were significant in publicising the differences between the English Nude and the classical ideal upheld by the French academies. The former was seen to possess a physiognomy that was specifically English in contrast to the typical beauty of both the Old Masters and the French nude. Those French critics who favoured formal idealisation noted that when it came to history painting the English disregarded universal standards of draughtsmanship and composition in taking literary themes as their guide. For instance, evaluating Paton's *Quarrel of Oberon and Titania*, exhibited at the Exposition Universelle in 1855 (see no.8), Étienne Delécluze thought the mimetic treatment of the painting led Paton to relax classical laws of proportion, an aberration he described as 'a national characteristic' typical of British writers such as Milton.[23] Even Baudelaire's rapt enthusiasm for Paton's phantasmagoria encouraged a general perception that English artists were constrained by an essentially Gothic imagination and thus erred in deviating from academic standards of representation.[24]

The Anglo-Classical Nude

The shift towards a more international style of figure painting in Britain grew out of the complex debates concerning the teaching of life-study in the wake of state-appointed investigations into the administration of art schools which took place in France and Britain in 1863.[25] Because the Royal Academy did not encourage a uniform school style, a number of aspirants to high art opted to pursue their studies in alternative centres such as the Slade, which opened in 1871, or abroad, mainly in the studios of Paris where they came under the influence of the pupils and followers of Ingres. British literature ceased to serve as a justification for the nude now that classical texts were taken up as more appropriate themes for the subject. It was during the 1860s that the Anglo-Venetian nude was assimilated into a more cosmopolitan classical ideal as artists set about reconstructing antique sculptural prototypes as models for emulation. Although the Parisian ateliers played a formative role in nurturing classicism, the French nude was still considered alien to the English predilection for naturalism and sensuous colour, and thus few British

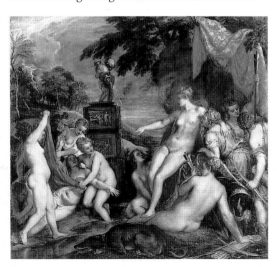

Fig.5
Titian (Tiziano Vecellio)
Diana and Callisto
c.1556–9
Oil on canvas
Duke of Sutherland
Collection on Loan to
the National Gallery
of Scotland

Joseph Noël Paton
*The Reconciliation of
Oberon and Titania*
1847
(no.8, detail)

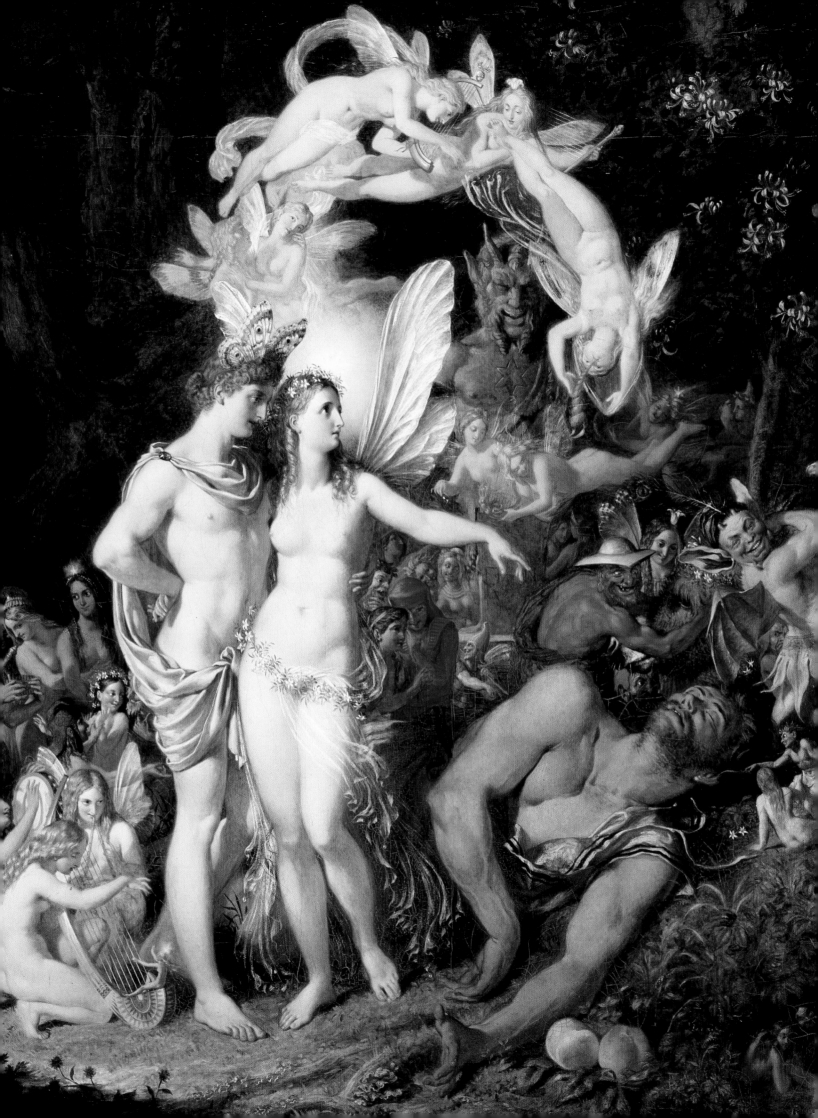

painters were inclined to abandon naturalism for what was considered the mannered style of the French, rather Venetianism was reinterpreted as a pure and natural corollary to the 'chaste' example of Greek sculpture.

It was out of the stylistic experimentation of the 1860s that a distinct Anglo-Classical type emerged that extended beyond the art world into the wider realm of science and medicine. For many artists and writers the ideal bodies of the Greeks elicited a pure perception in contrast to Roman lasciviousness and Oriental nations who in the words of W.C. Perry considered it shameful 'even for a man to be seen nude'.[26] It was thus considered the responsibility of the leading industrialised nations of the north to preserve the southern tradition of the nude, itself threatened by 'the materialistic pressures of northern ideas and example'.[27] Many English artists thought it a national duty to protect this standard by exhibiting classical nude works and, assessing the paintings of Alma-Tadema and Poynter, the German art historian Richard Muther felt moved to proclaim: 'the figures moving in them are Englishwomen. Among all the beautiful things in the world there are few so beautiful as English girls. Those tall, slender, vigorous figures that one sees up on the beach in Brighton are really like Greek women.'[28] Men were similarly assessed according to classical canons of beauty; the sculptor Charles Lawes, for one, was reputed to be so physically perfect as a young man at Eton and Cambridge 'that his father ... got an artist to model his son's figure in silver, in the attitude of the Apollo Belvedere'.[29] Both Kingsley and Watts accorded the classical body a missionary role in modern art and society, urging the ruling classes to develop a Grecian physique and set a model for general edification, for despite the prevalence of the Anglo-Classical ideal, the leading proponents of classicism accepted that the conditions of modern life were not really conducive to the development of the body beautiful. Dress reformers often blamed the upper classes for the spread of artificial sartorial habits, many alighting on the corset or the 'English Cross' together with the 'English bathing-gown' as modern forms of atavism.[30] In his essay *The Present Conditions of Art* of 1880 Watts expressed his concern that the potential leader of the future, 'the Eton boy', was setting an example of 'bad form' through his dress, in particular his tall hat which Watts thought destroyed any classical sense of proportion.[31] Poynter and Collier thought contemporary models were of an inferior type when compared to the splendid figures from whom the Greeks carved their statues, the latter complaining that most female models of the present day were apt to be stumpy in the leg, especially from the knee downwards.[32] While the classical nude can thus be viewed as implicitly anti-modern, a nostalgic retreat from the problems of urban existence, it was also projected as the antidote to modernity, an ideal by which the English could measure and set a universal, even classless standard for national attainment.

The English Nude

Given the pervasiveness of the argument concerning the civilising purpose of the classical nude and the importance of establishing an international standard of beauty, it was also suspected that the English Nude was losing its essential moral character in succumbing to the allure of Hellenism. In a paper given to the Maccabean Society in 1901, the painter Solomon J. Solomon warned:

> The Englishman is crawling out of his protective shell of Puritanism, and is getting restless and dissatisfied with the old order of things, since he knows something more attractive to his senses. He is no doubt a little less dull and stolid, but he is in danger of losing his rugged strength of character. The source of this evil I think we can trace back partly at least to the Hellenic Southerners, who above most things have pandered to their love of luxury and enjoyment.[33]

Despite the re-emergence of themes from British literature and history in the late nineteenth century, the nude was by now widely perceived as an official category that transcended boundaries of race and nationality, and many observers blamed the European academies for upholding what they felt had become a vacuous convention. A narrowing focus of the concept of Englishness at this time was paralleled by a reassertion of an earlier discourse claiming that English art was essentially naturalistic and insular yet progressive, a view propagated around the establishment of the National Gallery of British Art in 1897. This idea was informed

by the theories concerning English singularity and lack of conformity put forward by a number of French writers, notably the painter Paul Albert Besnard and the critics Ernest Chesneau and Robert de la Sizeranne, whose *The English School of Painting* and *English Contemporary Art* were often quoted by British writers following the publication of these texts in English translation in 1885 and 1898 respectively.[34] Besnard's caution that the predominance of a conventional style of nude painting at the Academy and New Gallery would frustrate the evolution of the English School, unless artists set about recovering the fantastic qualities of earlier artists such as Etty, were substantiated by the appearance of Camille Mauclair's *The Great French Painters* in 1903, a work further influential in transmitting the ideology of 'a pure autochthonal tradition'.[35] Mauclair's case that Italian culture had exerted a detrimental influence on French art, as evinced by the sterile nudes of the Salon, led him to propose an alternative indigenous tradition stretching from Watteau to Renoir which he characterised in terms of naturalism and continuity. Mauclair's essentially conservative misgivings regarding international tendencies in art found a sympathetic audience in Britain, not just with advocates of English School individualists such as Etty, but also among opponents of the Academy, several of whom had experimented with modern nude subjects along the lines of the French Realists and Impressionists, subjects which had been absent from British art for the greater part of the century.[36] Although the New English Art Club circle were influenced in this by painters such as Manet and Degas, they saw themselves as engaged on a more ambitious project of redefining the nude as an authentic English tradition, to which end they began to look beyond international 'classical' conventions, associated by a number of reactionary critics with cosmopolitan 'effeminate' and 'pessimistic' aesthetic influences, in favour of valorising earlier styles and frameworks for viewing the male and female figure. Thus Tuke's adolescent bathers represented a revival of Walker's earlier idyll of boys bathing and were further significant in reclaiming the natural realm as a pure space for homosocial activity in contrast to mythological settings associated with female seductiveness and duplicity.[37]

At the same time the female nude was assigned to the confined urban context of the studio or bedroom which had so disturbed critics earlier in the century. Designed to illuminate a seamy side of the female nude, such works succeeded in disturbing the idea of the artistic or unified body through a process of fragmentation. While artists such as Orpen, Sickert and Steer could be seen as responding to social anxieties regarding the sexualised female body, they may have been attempting to naturalise such concerns by adopting a strategy similar to that put forward by Mauclair in relation to the French school - namely of establishing a direct link between the modern body and what they considered a more honest and unaffected way of painting the figure extending back to Hogarth, Gainsborough and Etty. As William Vaughan has argued, the 'naturalistic-progressive' view of English art reached a high point with the publication in English of Muther's *The History of Modern Painting* in 1896.[38] This was significant in elevating Hogarth as the founder of vanguard tendencies in modern art on the basis of an approach that was essentially 'robust, crude, Anglo-Saxon, strongly and broadly painted ... sketches in the best sense of the word'.[39]

It is worth speculating as to whether Orpen had read Muther when he set about painting *The English Nude* during the summer of 1900. This confrontational work, with its 'unselective' observation of a nude contrived to appear frank, awkward and naked, projects as a virtue what many artists and theorists had condemned as the 'brutal' and 'vulgar' northern tradition of the nude.[40] *The English Nude* stands apart in the Victorian era and maybe was conceived as an anomaly: painted by an Irishman who self-consciously adopted England as his home, it was the sole Victorian nude to be thus titled and straddles two centuries without resting comfortably in either, being neither explicitly modern nor purely nostalgic. Moreover, the painting was received as strikingly 'un-English', its brushwork and tonality suggestive of Rembrandt, and the physiognomy of the model Emily Scobel reminiscent of the Dutch painter's mistress Hendrickje Stoffels.[41] By honouring a painter who had elevated the earthy naked body above idealised Italianate conventions, Orpen could have been championing the 'grotesque' northern body as a more relevant model for the English Nude, arguing

for a limited approach to the subject as an antidote to European conformity. The painting also tacitly acknowledges that the character of the nude as it developed in nineteenth-century Britain depended upon a tension between the naked social body and appropriated traditions from the past, and that, in a country which lacked a long tradition of the nude, it was incumbent upon artists to invent a tradition relevant to their culture. The 'English' appellation of what was understood to be a Dutch subject thus also casts an intriguing perspective on the nude as it was formulated in Victorian Britain, perhaps inadvertently suggesting that the paradox of the English Nude was that it had always been an imported tradition.

1 On the Edwardian invention of Victorian prudery see Mason 1994, pp.2–10; Clark 1980, p.150; for the Nochlin quotes see *Tate: The Art Magazine*, no.21, 2000, p.66, 70.

2 For a more detailed discussion on these issues see Smith 1996, pp.102–4.

3 'The International Exhibition 1862: Pictures of the British School', *Art Journal*, June 1862, p.150; 'The Paris International Exhibition: English Pictures', *Art Journal*, Oct. 1867, p.247.

4 Jarves 1874, pp.65–6.

5 See Beattie 1987, pp.44–5; Morris 1997, pp.51–2.

6 Quoted from Beattie 1987, p.44.

7 Davies 1999, p.417.

8 *Illustrated London News*, 17 June 1848, p.388; Forbes 1975, pp.40, 148.

9 *Athenaeum*, 5 Aug. 1848, p.768.

10 'Mind and Muscle', *Saturday Review*, 21 April 1860, p.493.

11 Quoted from Sprawson 1993, p.39.

12 Ibid, p.24.

13 Diary entry for 12 June 1874, Kilvert 1973, p.249.

14 Marks 1896, p.74, p.103; Manning 1982, p.101.

15 Whitley 1930, pp.146, 234.

16 'David's Pictures, Saville House, Leicester Square', *Spectator*, 1835, p.518.

17 For a more detailed discussion of the 'Venetian Secret' see Gage 1995, pp.213–14.

18 Watts 1912, III, p.251; Ruskin, 'The Wings of the Lion', *Complete Works*, VII, pp.296–7.

19 Reynolds 1981, Discourse IV, pp.63–7.

20 *Art Union*, 1847, p.73. In 1918 the painting entered the collection of the Fitzwilliam Museum, Cambridge; Whitley 1930, p.105.

21 Etty's copy of the *Venus of Urbino* was bought by the Royal Scottish Academy.

22 Whitley 1930, p.148.

23 *Les Beaux-arts dans les deux mondes en 1855*, Paris 1856, pp.90, 88.

24 'Salon de 1859', *Revue française*, vol.17, 10 June 1859, p.258.

25 In 1863 the French Academy abandoned its system of appointing instructors to teach in monthly rotation in favour of a permanent master, a reform which was seen to instil uniformity into style and group discipline. At the Royal Academy Commission, appointed by the government to investigate teaching at the institution, a similiar proposal was advocated but rejected in favour of maintaining the existing Visitor system which was seen to nurture individuality.

26 Perry 1882, p.7.

27 Jarves 1874, p.66.

28 Muther 1907 (originally published Munich 1893).

29 Obituary, *The Times*, 7 Oct. 1911.

30 Leighton (Limner) 1870, p.49; 'Vanities', *Vanity Fair*, 30 Aug. 1884, p.157.

31 Watts 1912, III, pp.154–5.

32 Poynter 1879, Lecture 3, p.42; Collier 1903, p.44.

33 Lecture reproduced in Phillips 1933, p.71.

34 These were originally published in Paris in 1882 and 1895 respectively.

35 Mauclair 1903, pp.xxi–xxiii.

36 Malcolm C. Salaman, 'Etty's Pictures in Lord Leverhulme's Collection', *Studio*, vol.85, 1923, p.9.

37 See e.g. 'The English and French Impressionists', *The Times*, 18 June 1889.

38 *Oxford Art Journal*, vol.13, no.2, 1990, pp.21–2.

39 Muther 1907, I, p.19.

40 Jarves 1874, p.65.

41 Arnold 1981, p.9; Konody and Dark 1932, p.158.

William Orpen
The English Nude 1900
(no.166, detail)

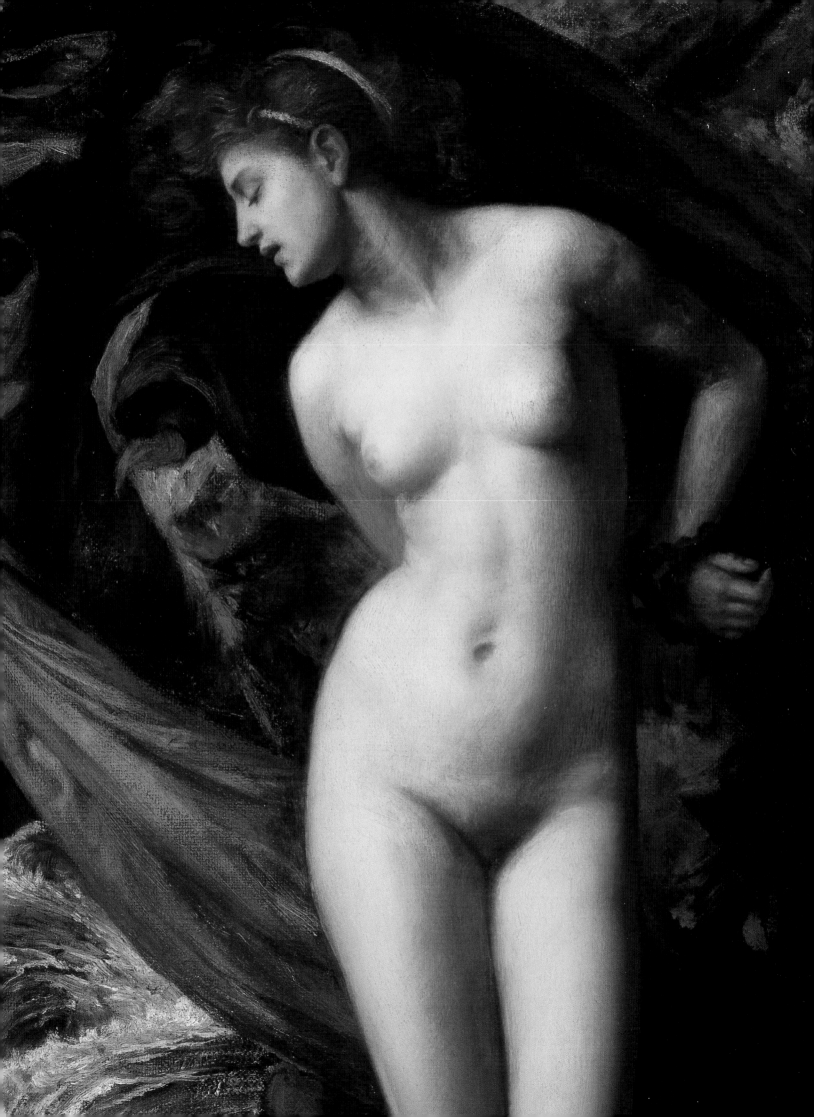

Prudery, Pornography and the Victorian Nude (Or, what do we think the butler saw?)

Martin Myrone

'The real masturbation of Englishmen began only in the nineteenth century.' D.H. Lawrence[1]

In the August–September 1993 issue of the British adult comic *Viz*, its regular character 'Victorian Dad' violently coerces his wife and two young children into paying a visit to the seaside at Lyme Regis. Having procured a 'bathing machine' so each of the family members can change into 'stout hessian bathing dresses that combine excessive modesty with striking discomfort' without exposing themselves, even to each other, and after ordering his family to 'stand starchily and uncomfortably in a formal group and adopt a miserable expression' for a photograph, Victorian Dad settles into a deckchair to read a paper. But on discovering that the children have been allowed to visit the amusement arcades unescorted, Victorian Dad sets out to find them, concerned that they will be drawn into a 'life of ruination and vice'. On the way he spots a mutoscope, prominently labelled for the interests of the reader 'What the Butler Saw'. He initially turns away, damning such 'filth', but soon succumbs to temptation and begins to operate the machine. Protesting against the 'wicked and pornographic degradation of the human form' he sees within, Victorian Dad proceeds to masturbate himself senseless, his rapid cranking of the mutoscope rhyming with his vigorous self-manipulation (fig.6).

The Victorians and Sex: Chalk and Cheese?

Although the creators of *Viz* have always denied any specifically political agenda behind their comic, it is hard to avoid seeing the character of Victorian Dad as anything but a response to the proposed revival of 'Victorian Values' during the previous decade. This familiar term was not invented by Margaret Thatcher (it was, apparently, presented to her during an interview in 1983), but it was seized upon by her Tory party in the 1980s as a catch-phrase defining their moral project.[1] For its proponents, Victorian Values stood for cleanliness, hard work, strict self-discipline and economy, and a code of morality centred on 'normal' heterosexual family life – all values supposedly paramount during the Victorian era, but demolished by the sexual permissiveness and general liberalism that took hold in the post-war era. For its opponents, Victorian Values stood instead for

social and sexual oppression, exploitation and abuse, and belonged to a different era, an era best left behind.

Much of the comedy in the Victorian Dad strip derives from the incongruity of this figure in its modern world setting, where his concern about public nudity or the immoral effects of amusement arcades appears wholly anachronistic. With his big moustache, upright posture, proclivity to punitive physical violence and combination of extreme prudery with potentially explosive prurience, this figure embodies the stereotype of a culture where sexuality could only be approached in circuitous, anxious and above all hypocritical ways. In particular, the Victorian Dad strip plays on the cliché of Victorian attitudes to the representation of the nude. The mutoscope the character uses was a late Victorian invention, in which the conventions of the artistic nude were reworked for titillating effect (see fig.30, p.179). Like photography before, and photo-mechanical forms of art reproduction, the mutoscope further opened up to question the distinction between 'legitimate' culture (or culture which could effectively be legitimated) and pornography, between the nude as an art object, and the nude as the object of erotic arousal (leading to 'lewdness, first in mind, then in action', as a correspondent to the *Magazine of Art* put it in 1894). The instability of the nude as a category of artistic production in the nineteenth century derives very largely from its place within the new physical, social and imaginative territories forged by the technologies of reproduction and representation at the opening of the modern era. The masturbating Victorian man, so damned by Lawrence, epitomises a soulless, shifty, selfish sexuality created by modernity and hidden by hypocrisy.

Victorian culture, we are commonly told, was a culture that saw John Ruskin reeling in horror on his wedding night at the sight of Effie Gray's pubic hair, the reality of a woman's body shocking a sensibility conditioned by the hairless ideal of classical sculpture, that referred to 'limbs' rather than 'legs', and disguised piano 'limbs' with little skirts so even the most faintly anthropomorphic intimation of nudity was hidden from sight, that saw fig-leaves applied to every statue for the sake of modesty. Whether interpreted as the over-zealous application of the moral code encompassed by essentially healthy Victorian Values, or as manifestations of a sick

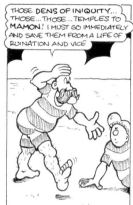
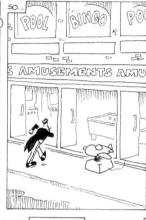
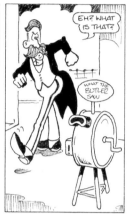
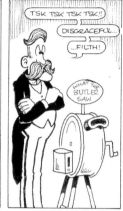
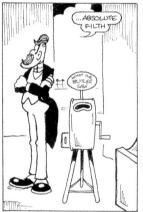
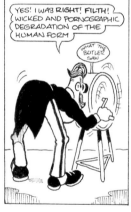
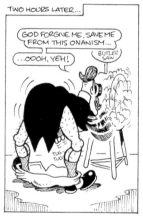
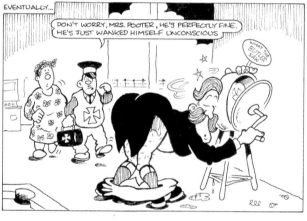

Fig.6
'Victorian Dad'
Viz August/September
1993

24

repressiveness, these images of prudery remain powerful mediating factors in our perception of nineteenth-century British culture, recycled, renewed and more rarely interrogated in film, television and fiction. A belief in, and tacit understanding of, Victorian prudery underpins a whole range of fictionalisations, from John Fowles' *The French Lieutenant's Woman* (1969) and the successful film based on it (set, as the creator of Victorian Dad may be acknowledging, in Lyme Regis), and Jane Campion's subtle and critical account of Victorian sexual silence *The Piano* (1993), to Miles Gibson's novel *Kingdom Swann* (1990) made into a television comedy, *Gentleman's Relish*, broadcast at the beginning of 2001. Within popular literature, Victorian historical references may provide a certain guarantee of 'erotic' rather than crassly 'pornographic' content, as demonstrated by novels in Virgin Publishing's hugely successful Black Lace series ('Erotic fiction written by women for women') such as *Silken Chains* (1997) the tale of Abbie, 'a blonde and beautiful, but sexually innocent young Victorian woman', the cover adorned by a suitably dishabille model whose averted gaze recalls a prevalent convention of the nineteenth-century nude (fig.7).[2] Victoriana of this sort provides what might be dismissed as a decorative, antiquating frill: 'erotica is to porn what a crocheted cover is to a toilet roll.'[3]

The identification of 'Victorian' as a by-word for hypocritical prudery has a long history. Although the *Oxford English Dictionary* records the use of the term to designate an historical era as early as 1839, by the 1930s the word was established as signifying 'prudish, strict;

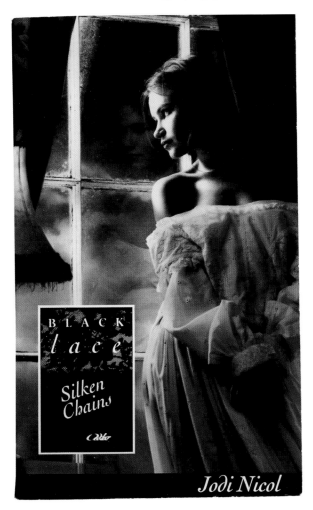

Fig.7
Silken Chains
Book cover
Cover photograph:
David Penprase
Cover design: Slatter-Anderson
Black Lace, 1997

old-fashioned, out-dated'. It was given that status in no small part by the Edwardian and Georgian writers and artists, the self-consciously forward-looking cultural commentators of the early twentieth century, who reduced the whole of Victorian society to a point of reference against which they could demonstrate their own modernity and liberalism. The 'otherness' of the Victorians and their supposed moral values was further bolstered by a series of celebrated legal cases in the 1950s and 1960s which pitched modern morals against Victorian Values (most famously the trial of Lawrence's *Lady Chatterley's Lover* in 1960). Looking back over a century of legal hypocrisy, Giles Playfair could announce in 1969 that 'the foundations of the Victorian order have finally crumbled'.[4]

In a very real sense, the writers and artists and lawyers of the earlier twentieth century who raised the battle-cry against their version of Victorian Values were fighting a real and present enemy. In his 1944 study *The Nude*, F. Gordon Roe could relate the memories of an 'older man' who thought that the public exposure of William Etty's nudes was morally dangerous. Quite aside from hearsay, the laws regulating obscenity in the visual and literary arts were Victorian creations.[5] Although the first legal moves against obscenity date from the reign of George III, it was the nineteenth century that saw the successive clarification and specialisation of the legal regulations. The Vagrancy Act of 1824, although not concerned exclusively or even primarily with obscenity, provided for the trial of any person exhibiting obscene materials in public. An amendment of 1837 extended this stipulation to the display of materials in shop windows. Subsequent, localised laws gave police powers to raid and seize the property of persons proffering obscene materials. But the key act was the Obscene Publications Act of 1857, proposed by Lord Campbell and generally known under his name. This was the first law to deal specifically with pictorial and literary pornography. Together with the Customs Consolidation Act of 1876, directed against the importation of obscene materials, and the Indecent Advertisements Act of 1889, Lord Campbell's Act remained as the law against obscenity all the way through to the late 1950s. These laws were not, in fact, readily enforced by government, but they were mobilised by the Society for the

Suppression of Vice to bring pornographers to justice. The Society, founded in its original form in 1802, was the primary, self-elected Evangelical agency enforcing the law against pornographers and it remained in action in one form or another well into the twentieth century.[6]

Despite some dissent, the dominant idea promulgated within academia through to the 1960s was of the Victorian era as being defined by hypocritical prudery, whether the motivation was theological, economic or psychological.[7] But while what was viewed as the inheritance of Victorian prudery was being repeatedly challenged in the courts, an alternative view of the Victorians was emerging. Cyril Pearl's *Girl with the Swansdown Seat* of 1955 unveiled in lurid detail the hypocrisy of the Victorians. The key work, and a text that deserves to be considered seminal, was Steven Marcus's *The Other Victorians* of 1966. Marcus proclaimed the discovery of a seething underworld of sexual activity of every variety, hidden only by a thin and fragile veneer of hypocrisy. Marcus figured the Victorian age as divided, exemplified on the one hand by the 'official' view of the sex doctor William Acton, who proposed the absolute necessity to repress sexuality, and denied completely the presence of sexual feelings in the normal, healthy woman, and on the other by the anonymous author of a massive pornographic autobiography, *My Secret Life*, which detailed a hugely diverse, experimental and abusive sexual life. Following Marcus a series of studies of Victorian sexuality appeared in the 1970s, each testifying to a vicious underworld of pornography and exploitation that was only ever hidden, never in fact suppressed, by official attitudes (as even the titles suggest): Ronald Pearsall's *The Worm in the Bud* (1969), Milton Rugoff's *Prudery & Passion* (1972), Eric Trudgill's *Madonnas and Magdalens* (1976) and Fraser Harrison's *The Dark Angel* (1977). These publications helped to establish a sexualised image of the Victorians that is still with us.

In retrospect, the work of Marcus and the other writers on the 'underworld' of Victorian sex only reinforced further the notion of Victorian hypocrisy that had always been part of the stereotype. Marcus has been much criticised for his stark division of Victorian values, not least by over-estimating the significance and typicality of the writings of William Acton, and the literalness of the evidence presented by the author of *My Secret Life*.[8] Moreover, while the intentions of all these writers were doubtless noble, the packaging and marketing of such publications are tainted with the prurience that is so much a concern of the texts inside. The lurid cover of a paperback edition of Marcus, showing a distinctly 1970s-looking model raising her heavy Victorian skirts to reveal her bare leg, may be evidence enough of that (fig.8).

In 1967 a reviewer of Marcus's book could ask 'why is research on Victorian sexuality so scanty?' Ten years later, it appeared that current notions of Victorian sexuality were 'in a promising state of uncertainty'. More than two decades further on, it can be said that 'The Victorians and sex have been exhaustingly, if not exhaustively, written about'.[9] The interested reader can now consult volumes on every aspect of Victorian sexuality, ranging from marriage and prostitution to male and female homosexuality, pornography, sex education, flagellation and paedophilia. Sexuality has been introduced as an important interpretative factor in studies of empire, sport, advertising and education. Arguably, the key figure behind this expansion was the French philosopher and historian Michel Foucault. The introductory volume of his projected *History of Sexuality* (first published in English in 1978) proposed that what appeared to be Victorian repression was, paradoxically, productive of sexuality. Far from being a natural 'fact', sexuality according to Foucault needs to be considered as a 'discourse' actually generated by the images, words

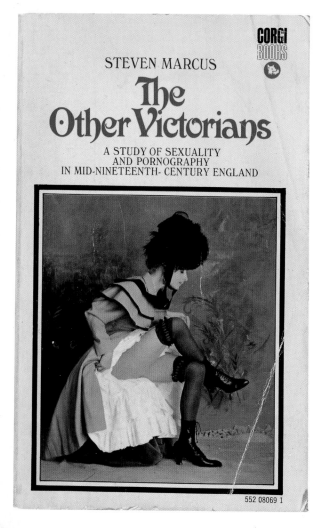

Fig.8
The Other Victorians
Book cover
Transworld
Publications Ltd

John Watson
Academic Study 1855
(no.90, detail)

and ethical and legal structures that seem to observe or describe it. The Victorians, in being so actively concerned to describe, analyse and repress sexuality were in truth, then, involved in a massive acceleration of sexual discourse, the creation of sexuality as a central component of human existence that could and should be subjected to reasoned examination. From the perspective of the history of the nude, these claims may have a particular significance, and might help us toward an understanding of the seeming paradox that exists in the fact that while there was undoubtedly a great deal of anxiety about nudity and sexuality in the Victorian era, it was also a period of vast acceleration in the production of images of the nude.

Foucault's account has been repeatedly challenged and revised. His blindness to the unequal differentiation between the sexes over history has been attacked, as has his inattention to the specificities of the various texts he deployed as evidence, while his insistent use of an emphatically expressed theoretical framework is often viewed with suspicion. Foucault's work has, though, been important in helping to overturn the conventional history of sexuality that would cast the whole of the modern era as a progression from repression to present-day liberation, and in presenting as paradoxical and historically problematic the very opposition between 'repression' and 'freedom'. Whether deploying the particular theoretical apparatus of Foucault or not, these are questions explored by historians in order to recover a much fuller, more complex view of nineteenth-century attitudes to sexuality. Major studies by Françoise Barret-Ducrocq, Peter Gay and Michael Mason have revealed that 'Victorian' attitudes can be traced much earlier than 1837, are hardly consistent through the period of Victoria's reign or across different social groupings, and that prudery, far from being simply typical, is only one element in the richly textured private lives of nineteenth-century men and women.

Sexing (up) the Nude

Until quite recently, the cliché of Victorian prudery determined what interpretation there was of the nude in nineteenth-century British art. This was a view confirmed and given the greatest authority in Kenneth Clark's 1956 study, *The Nude*. Clark's book established a highly influential framework for discussing the nude in art, which proposed a distinction between the 'nude', where the human body is aestheticised and idealised, and the 'naked', the term he applied to the raw, perhaps awkward, reality of the unclothed body. For Clark, the 'nude' may be erotically charged, but would always be bounded and ordered by the sense of the aesthetic: real art simply could not be obscene. The works he discussed to articulate this framework were drawn almost exclusively from ancient art and the art of the European Renaissance, with the addition of nineteenth-century French art. British art appeared only in passing, and was rudely disparaged. The only form of the nude that survived 'the great frost of Victorian prudery' in Britain was a kind of dumb academicism, the prevalent mood against the depiction of the nude stemming from an 'easily ridiculed' and to Clark clearly distasteful combination of 'anti-popery, chauvinism and bourgeois democracy'.[10]

Clark's prejudice can in part be explained by reference to the fact that Victorian art as a whole was very little understood or investigated at that time. Even when serious art historical studies appeared in the late 1960s, the myths about the Victorian prejudice against 'limbs' were taken as fact, and Clark's thesis of the 'icy blasts of prudery' and the English as 'the inheritors of Cromwellian Puritanism' accepted.[11] Rarer were the critical voices that called into question whether 'prudery' was a specifically British and specifically Victorian quality after all, and recognised that if there was such a thing as Victorian prudery then it also emerged during the era of the most prolific production of the nude.[12] Frederick Mentone's 1944 study of *The Human Form in Art* was exceptional in illustrating and commenting favourably on a number of major Victorian works (including Millais's *The Knight Errant*, Merritt's *Love Locked Out* and Etty's *Musidora*; nos.12, 146, 3) without bowing to the prevalent idea of stifling prudery. The fact that it was published by *The Naturist* and concluded its pictorial survey of the nude with a full-page advert for 'The Male Body ... An Unusual & Dynamic Book for Your Library Shelf' (a photographic exposition of 'muscular and perfectly developed manhood') rather draws attention to its atypical character.

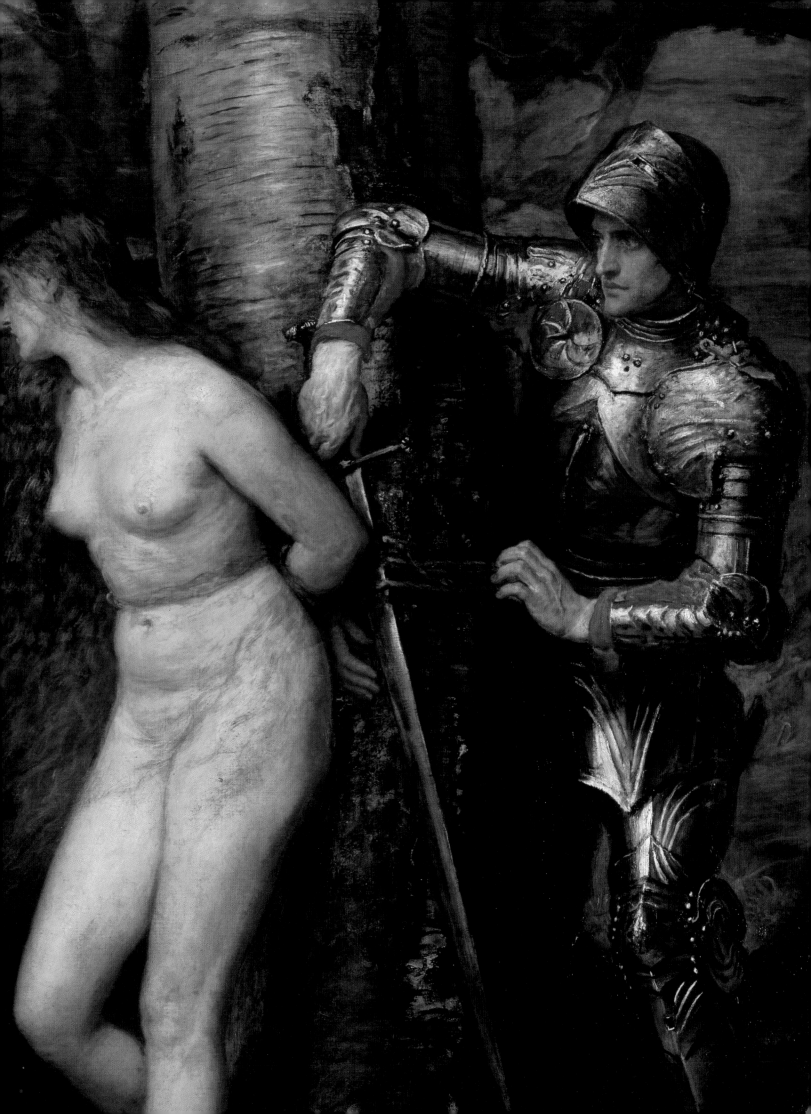

With the idea of the 'other Victorians', the Victorian nude emerged as a subject of new interest. In particular, a number of commentators perceived in the Victorian nude a form whose conventions permitted the indulgence of otherwise proscribed forms of carnal knowledge.[13] For feminists critical of the dominant conventions of traditional art, and critics more celebratory of the nineteenth-century nude, the device of classical subject-matter was merely a premise for the depiction of naked flesh. It has been claimed that Victorian artists established the prototypes for twentieth-century soft pornography, with close parallels being drawn between the tightly trussed maidens in Millais's *The Knight Errant* or Poynter's *Andromeda* (no.32) and modern bondage imagery, the evasive gaze of so many female nudes of the nineteenth century and the typical poses of men's magazines (fig.9).[14] Using Foucault's paradox, we might observe that far from providing a 'cover' for titillation, the academic nude was rather actively productive of a soft-core pornographic aesthetic; rather than fulfilling pre-existent (and timeless) male desires, the academic nude generates this desire, in the context of an imagery that through its very surfaces plays out an aesthetic of frozen possession. Revealingly, this is an aesthetic that still struggles to find a market. Although prices for Victorian academic nudes have risen, they still reportedly find most favour with the niche market of Middle Eastern art collectors whose moral outlook is perceived as coinciding with those of the Victorians.[15]

The loosening of the legislation around the production of sexually explicit books in the 1970s permitted the creation of a whole raft of fully illustrated

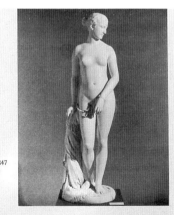

141 Hiram Powers,
The Greek Slave, 1847

and flesh-coloured (for which there were many Greek precedents) and the impression created by the girl clutching a sheet with one hand and an apple with the other as she gazes upwards with her mouth slightly open is highly suggestive. The implications of Powers's work seem distinctly Freudian to the modern spectator: the girl averting her face as she covers her vulva with one manacled hand and pats an extremely phallic post with the other bears close comparison with any number of today's pin-up photographs of a sado-masochistic variety (see illustration 142).

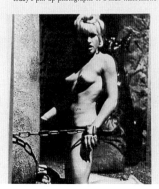

142 *Pin-up photograph*,
Playboy magazine,
New York, 1969

publications dedicated to 'erotic art'. Many of these were produced in the spirit of utopian libertarianism, positing cohesive traditions of 'erotic art' that spanned from Antiquity to the present day, taking long and appreciative detours into the subject of supposedly enlightened non-western traditions and exposing the hypocrisy prevalent in the Victorian era.[16] Perversely, this attitude was shared by the authors of the anti-pornographic Longford Report (published 1972), which proposed that there has always been pornography, using a definition which by encompassing everything from 'the most beautiful erotic art to public rape' becomes virtually meaningless. More critical perspectives emerged with the feminist art histories of the 1970s and 1980s, where nineteenth-century art formed a focus of the critique of male power.[17] The academic nude, with the female proffering herself as an object for a consuming masculine gaze, was claimed as embodying visually the structure of modern patriarchy. Instead of being a self-referential category of art, as proposed by Clark, the nude in these accounts was emphatically gendered: images of women are important because they embody and so, through critical reading, can reveal, socially constructed ideas of femininity (women as objects) and masculinity (men as empowered producers and consumers). The earlier feminist critique of the representation of women is now familiar, and has been interrogated and further complicated. The rather monolithic idea of masculine power it expresses has been opened up to alternative views provided by consideration of the varieties of masculine desire, the question of the male nude, and closer attention to the issues of race and class.[18]

The feminist critique has been one of the perspectives that have led to a more discontinuous view of the erotic in art. Rather than being a constantly present category of art and literature, finding different forms of expression but always evident, pornography is now seen as, quite precisely, a nineteenth-century invention.[19] This is true, in the simplest way, at the level of language; the earliest use of the term appears to date from the first decade of the nineteenth century, and the term entered English usage in 1857. 'Erotica' as a term also dates from the nineteenth century, emerging as a term employed by booksellers and bibliophiles. Linda Williams has traced the origins of hard-core pornography very precisely to

Fig.9
Peter Webb
The Erotic Arts
Peter Webb/Collection of
the Newark Museum;
Gift of Franklin Murphy,
Jr. 1926

the experiments with locomotive photography in the late nineteenth century, finding an exact technical and aesthetic origin where other commentators have laid claim for a single thread of 'erotic art' that can be followed from antiquity into modern times, and Lynda Nead has established the category of obscenity as something generated out of the mass production of images and spatial-moral anxieties of Victorian London. Where earlier obscene literature and art had some sort of critical social, religious or political content, pornography as a form of sexual entertainment for its own sake emerged in the early nineteenth century; Lord Campbell's Act of 1857 did not simply represent a tightening of the laws regarding obscenity, but a crucial turning-point in which sexuality is isolated as a cause of social disorder, rather than as something to be treated as part of a wider public order issue. Reviewed from these angles, the question to ask of the Victorian era is not how it was 'more' or 'less' repressive than other eras, according to a single scale of judgement, but how pornography and obscenity came into being as categories in relation to other forms of visual and literary production.

A Question of Taste

In most contexts, the distinction between 'art' and 'pornography', legitimate expression and abusive exploitation is now maintained by the most informal means. Repeatedly, writers have distinguished between 'erotica' and 'pornography' by reference to aesthetic quality: erotic art is realistic, concerned with love, of supreme technical excellence; pornography is crude (in its means of expression), unreal, brutal, ugly.[20] Underlying this is a question of propriety, as revealed in the casual comments of the editor of today's most successful erotic literary magazine: 'There's this funny dividing line between art and pornography. We are pretty sure where it rests. We take stuff only from proper artists and proper writers.'[21]

If Clark provided a legislatory intellectual structure for the aesthetic appreciation of the nude, and if we seem largely certain that there is legitimate 'erotica', these matters remained unsettled through the nineteenth century. Even the term 'nude' was open to question. The writer Edward Dowden was advised to change the

'indecent' word 'nude' in his essay on 'French Aesthetics' to 'unclothed', while another critic could refer to the term 'nude' as only 'slang'.[22] William Etty was haunted by accusations of salaciousness throughout his career and repeatedly defended himself against them, and we can trace a series of moral crises where the nude became the focus of public discourse. The exhibition of nude sculptures at the Crystal Palace in 1854 caused a notable storm of controversy, with the result that plaster fig-leaves were manufactured for the statues, the reporter for *The Times* (9 May 1854) noting drolly that 'it still remains somewhat doubtful whether the requisite quantity of plaster foliage can be obtained before the opening'. The exhibition of Millais's *The Knight Errant* in 1870 caused a huge furore, and the prolonged 'British Matron' arguments in the press about nudity in art in 1885 formed a high point of both moral outrage and artistic defensiveness. In fact, every expression of what we would expect to see as Victorian prudery was answered by a counter-argument or dismissal. The anxiety about nude sculpture which is threaded through Nathaniel Hawthorne's novel about Anglo-American artists in Rome, *The Marble Faun* (1860) may seem to conform to our greatest expectations about Victorian prudery (' "Not a nude figure, I hope!" observed Miriam … "An artist … cannot sculpture nudity with a pure heart, if only because he is compelled to steal guilty glimpses at hired models" '). But Hawthorne's prudery was immediately condemned as 'silly' and expressive of 'provincial narrowness'.[23] The last comment is particularly telling, as we frequently find Victorian Britons claiming that prudery originated in 'provincial' America. It was an 'unwritten law … more rigidly enforced in America' that 'for a picture to be sufficiently conventional for the taste of buyers, the Nude must be very sparsely introduced' (*Studio*, 1893, p.104). The oft-repeated story about Victorian ladies dressing their piano legs with little skirts so as to hide them seems to have originated with Frederick Marryat's *A Diary in America* (1839). The author, a particularly snooty English Tory, may have been presenting details like this as evidence of the lack of cultivation that would inevitably appear in a fully democratic state. And when a Glasgow printseller was prosecuted for exhibiting prints of nudes after major British artists, the *Magazine of Art* reported that 'we are

used to this sort of thing from the Pharisees of some Western State of America' (May 1894, p.xxix). Similarly, prudery was often cast onto the English middle class rather than the culture as a whole, an idea that persists in writing on the nineteenth-century nude: 'The nude will always affront the sense of right of the homely middle and lower classes.'[24]

The recurring debates about the morality of the nude in art reveal a range of contests, about class, about the definition of a legitimate national culture, about the role of fine art in society, that are central to Victorian culture. But these debates only rarely reached the law courts, despite the range of laws that were available and despite the best efforts of the Society for the Suppression of Vice. Where they did is revealing, demonstrating again the importance of new technology and new audiences for visual culture in destabilising the boundaries between mainstream and marginal culture. Sellers of photographic nudes were, from the very outset, subject to prosecution under the Obscene Publications Act, the defendants having recourse to the defence that they were 'art studies' and therefore legitimate.[25] As a mechanical means of producing an image, the photograph arguably lacked the presence of a 'proper artist' that could provide a stamp of legitimacy. The subject was of great concern in the pages of the new photographic magazines, and on at least one occasion became the motivation for a more practical effort. When Charles Caslake was arrested in 1882 for selling obscene photographs he objected that they were ' "art studies" for the benefit of art students who could not afford living models', but he was nonetheless sent down for twelve months' hard labour (*The Times*, 6 Jan. 1882). The reporting of this incident drew a response from the solicitors representing a new committee formed with the purpose of establishing the legality of photographic art studies, of the sort issued under the sanction of the academies of Paris and Vienna (*The Times*, 11 Jan. 1882). They were at pains to point out that in this case 'much more than the mere sale of photographs of undraped figures artistically posed' had been proven by the prosecution (although what more they did not specify). The committee, formed under the chairmanship of the successful publisher and avid art collector Henry George Bohn, does not seem to have become a real force. Bohn became infirm and retired from active life in the early part of 1882, and with his death two years later the committee became dormant.

Photographic art studies were singularly testing of the law's treatment of the representation of the nude. Reproductive prints in more traditional media formed the basis of the vast majority of obscenity cases in the nineteenth century, revealing, on the whole, the petty and sordid character of the defendants, commonly unemployed or small-time traders (and the scale of the industry: the Society for the Suppression of Vice reportedly seized 385,000 obscene prints and photographs between 1834 and 1880). So we find one Philip Johnson, of 'no occupation' found guilty of 'distributing filthy prints' and 'insulting' servant girls, and sent down for six months' hard labour (*The Times*, 12 Nov. 1878), or William Smith, 'a licensed hawker' accused of 'exposing for sale a number of indecent books and prints' in a tavern in Waterloo Road, fined forty shillings under the Police Act although the defendant protested that the books were not obscene, but were widely available, identifying among them a copy of 'Aristotle' (ie. *Aristotle's Masterpiece*, the most widely distributed example of sex education literature of the nineteenth century) (*The Times*, 23 Dec. 1873). A few cases from the last part of the nineteenth century, when the anti-vice movement was particularly active, drew into question prints of a more certain 'artistic' quality. In July 1891, when Ernest Jefferies was summoned to court by the National Vigilance Society for allegedly selling obscene prints and photographs (*The Times*, 15 and 16 July 1891), the defence lawyer protested that 'the photographs were simply those of the works of eminent French artists which had been exhibited at the Paris Salon'. Regardless, the judge ordered 'some portion' of the pictures be destroyed. Reporting the case, the *Photographic News* (24 July 1891) damned the actions of the Society and disapprovingly quoted its Secretary, W.A. Coote, as claiming 'that the photograph of a picture may be objectionable, though the picture itself may not be'. In 1894, when a print-seller in Glasgow was ordered to remove nude pictures from his shop-window by the Chief Constable, it emerged that the images in question were reproductions of works by leading artists, including *The Bath of Psyche* by Leighton (no.36), *A Visit to Aesculapius* by Poynter and Arthur Hacker's *Syrinx*

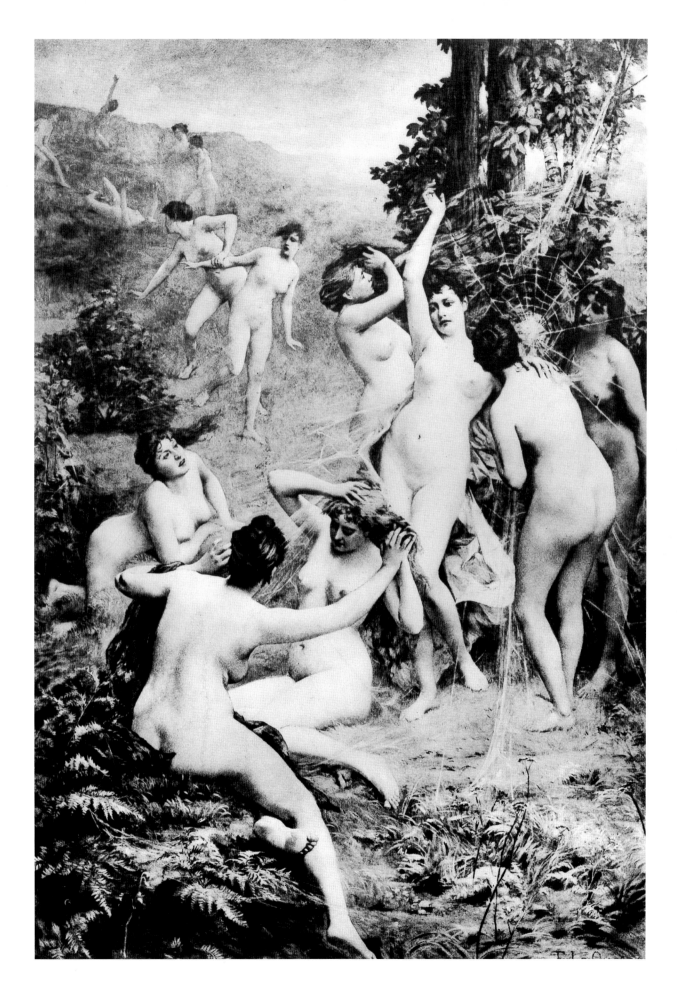

Fig.10
Lequesne
'The Disarranged Toilet'
Illustration in C.
Lansing *The Nude in Art*
By permission of
The British Library

(Manchester City Art Gallery) (*Art Journal*, June 1894). Although some ascribed it to a specifically Scottish kind of prudery, the *Art Journal* reported that the same kind of incident had taken place ten years earlier in London. Even so, the *Journal* was not entirely supportive of the print-seller, noting that 'Had there been one single print, or even a couple, no objection would probably have been made, but a window filled with nude figures, and nude figures alone, points to another attraction besides an artistic one, and is too apt to be so understood by the unreflecting multitude', a point further emphasised by the representative of the Glasgow Art Club, who insisted that account must be taken of 'the ordinary man of normal virtue [who] looks upon these pictures with very different eyes to the artist' (Charles Blatherwick, letter to the editor, *Art Journal*, July 1894). The cause was taken up more forcefully by the *Magazine of Art* who damned the prosecutors as only 'misguided tradesmen and one policeman' and claimed that the whole nation was being upheld for ridicule 'for our false prudery and hypocritical cant' (June 1894, p.xxxiii). When a self-righteous correspondent attacked the liberalism of the *Magazine*, he was ridiculed:

> It is possible that our correspondent is perfectly sincere; but without bringing any of the usual charges of cant or hypocrisy, we must confess that when he forwards us a batch of subjects from the nude, torn from illustrated catalogues which he says 'I should be ashamed to harbour', and when we find that he has certainly 'harboured' them since 1886 onwards, we feel considerable doubt as to the reality of his sentiments or the depth of his convictions. (July 1894, p.xxxvii)

Reproduction made possible the re-ordering of the aesthetic structures that prevailed in officialdom: nudes could be extracted from their 'art' context, and re-packaged (even quite literally, and commercially) according to the desires of the consumer (fig.10). What proved unsettling in this case was the capacity of the new technologies to defy the strictures of the art world, strictures that were meant to ensure propriety.

An exceptional case was brought to court in 1892 when the Belgian-born painter Rudolf Blind was accused by E.J. Cox, an unemployed solicitor's clerk, of exhibiting a picture alleged to be 'obscene, lewd, wicked, filthy, and indecent' (*The Times*, 7, 28 April 1892). The picture, titled 'The World's Desire', was put on display by the artist and advertised through handbills that described the picture as 'naked and not ashamed'. Significantly, the prosecution did not call into doubt whether 'the picture was beautiful, as there could be no question whatever about that', nor even whether it was 'a work of art', but only whether 'it was not an indecent picture which was being exhibited for the purpose of gain'. The defence contended that Lord Campbell's Act was not 'directed against the exhibition of single pictures which were works of art, but against the trading in pictures of an indecent nature', and that Cox had not been able to prove that his morals had 'in any way been shocked by what he had seen'. Unwilling to pass judgement in a question of art, the judge called a procession of expert witnesses, including Royal Academicians and art critics, who each determined that the picture was not obscene. The case was thrown out, a decision 'received with great applause'. Blind protested that the case should lead to the resuscitation of Henry Bohn's committee and a revision of Lord Campbell's Act for the sake 'of all those to whom liberty of artistic expression is justly valuable' (letter to the editor, *The Times*, 16 May 1892).

It was almost seventy years before the revision of Lord Campbell's Act took place, with the Obscene Publications Act of 1959, which took account of this question of 'artistic expression'. The Blind case has a familiar ring to it: the artist defending his freedom of expression and so the principle of free expression itself. Blind's motivations are harder to distinguish; he was a far from prominent or successful figure (indeed, he was announced bankrupt in 1893), and his promotional handbill, if recorded correctly, has a decidedly salacious tone. But whatever the truth of the case, in court he was able to protect himself under the legitimating banner of 'Art'. It is in the 1880s and 1890s that the argument for 'art for art's sake' and the legitimacy of all artistic expression came to prominence, laying the foundations for a modernist aesthetic of autonomy that is still with us. The ideas of aesthetic value and 'erotic realism' provide tools for us to negotiate the Victorian nude, determining perhaps whether we feel more comfortable

with the fleshy naturalism of Etty and Frost, the haughty academicism of Leighton and Poynter, the counter-cultural erotics of Rossetti and Burne-Jones, or the sickly, raw, damaged image of the body provided by Sickert and Gwen John. But our taste, and our art histories, are only further stages in the recycling of a culture that remains central to our self-definition. The liberal-minded writers of the *Magazine of Art* and *Art Journal* in the 1890s may well have looked on an exhibition dedicated exclusively to the nude with greater suspicion than we, and not because of straightforward prudery. They recognised more readily that the nude was not a stable or unified category of art. Perhaps in their debates, the Victorians were better able to see that the nude encompasses questions that art history per se can open up, but only begin to answer.

1 *Pornography and Obscenity*, London 1929, p.21; quoted Walvin 1987; Weeks 1989, pp.292–300.

2 In a recent interview, the Black Lace publisher Kerri Sharp has indicated that 'pirates and Victorians' will be disappearing from the series, in favour of 'the post-feminist paradoxes that exist within experimental sex, gender play, office politics and club culture'. See Jessica Berens, 'She's Gotta Have It', *Observer* Magazine, 10 Sept. 2000, pp.20–5, p.25.

3 Julie Burchill, 'Mediation is the Opposite of Justice ...', *Guardian* Weekend, 8 April 2000, p.3.

4 Craig 1962, pp.117–22 and, quoted, Playfair 1969.

5 Thomas 1969; Roberts 1984–5.

6 Bristow 1977; Roberts 1984.

7 The classic statement of this is Houghton 1957, pp.394–430.

8 See Porter and Hall 1995, pp.141–2.

9 Quoted: Harrison 1966–7, p.239; Smith 1977, p.182; Porter and Hall 1995, p.132.

10 Clark 1980, pp.150, 343, 379.

11 Maas 1988, p.164.

12 Grigson 1953, p.22; Stead 1966; Gaunt 1968.

13 Pearsall 1971, pp.141–50; also Gay 1984, pp.379–402.

14 Webb 1975, pp.186–202; Brooks 1989, p.9; Finch 1992.

15 See John Windsor, 'Bare Facts Behind those Naked Ladies', *Independent* Weekend Arts, 29 Oct. 1994, p.29.

16 Kronhausen and Kronhausen 1971; Lucie-Smith 1972; Webb 1975.

17 Notably: Nochlin 1989; Pointon 1990; Nead 1992.

18 See e.g. Dyer 1997 and Mackinnon 1997.

19 Williams 1989, pp.34–48; Hunt 1993; Nead 2000, p.192.

20 The classic statement of this view is Kronhausen and Kronhausen 1959.

21 Rowan Pelling, interview with Damien Whitworth, *The Times*, 2 March 1998, p.17.

22 Edward Dowden to John Dowden, 2 Feb. 1866, in Dowden 1914, p.30. Hippolyte Taine's Greek youths consequently appeared 'unclothed' rather than nude in the article by Dowden, 'French Aesthetics', *Contemporary Review*, vol.1, 1866, pp.279–310, p.307; H.H. Stratham, 'Reflections at the Royal Academy', *Fortnightly Review*, vol.26, 1876, pp.60–73, p.63.

23 *National Review*, vol.11, 1860, and *Westminster Review*, vol.73, 1860, quoted in Hawthorne 1968, p..xxxv.

24 'The Objects of Art', *Fraser's Magazine*, new series, vol.1, Jan.–June 1870, pp.675–6, p.675.

25 See Nead 2000, pp.199–200, referring to reports of February 1858. For the discussion following the prosecution of Henry Evans for selling what was vigorously argued to be legitimate art studies see *Photographic News*, 1870, pp.130, 501, and *British Journal of Photography*, 1870, p.171. These references have been kindly provided by Simon Popple. For a similar case in 1873 see Nead 2000, p.160.

Thoughts and Things:
Sculpture and the Victorian Nude
Michael Hatt

It is 1896 and, as the nineteenth century draws towards its close, people across London are busy looking. In a suburban bedroom a boy is exercising, swinging dumb-bells, working hard to build up his muscles. As he does so, he casts sidelong glances at the model on his nightstand, a statuette of his hero, physical culture guru Eugen Sandow. The boy dreams of possessing a body like Sandow's, muscular, defined; a living statue, as his physical culture magazine calls him. Downstairs his mother looks proudly at her mantelpiece, and shifts a piece of Parian ware an inch to the left. The small white object is, to her eyes, very artistic; while some might think these rather old-fashioned, she sees John Bell's *Una and the Lion* as timeless, her most precious recent purchase. In a wealthier part of town, a lady leafs through *Art Journal*, and notes that at Collie's in Bond Street one can now purchase statuettes in bronze of Mr Thornycroft's *Mower*. It would be a fine addition for the drawing-room – so much more appropriate than that vulgar Parian ware. Outside in the streets, too, people are busy looking. Some boys loiter by Alfred Gilbert's Shaftesbury Fountain, topped by the mercurial figure of Anteros, or Eros as he has already become in popular vision, transformed from selfless to worldly love, not least because of the prostitutes who congregate in Piccadilly Circus. An office clerk hurries to work in Oxford Street, past the Kinetoscope parlour. Perhaps he will go in later and see the wonderful moving images of wrestlers and of Madame Bertholdi, the daringly clad contortionist. People walk, purposeful or purposeless, and those who wander past the Colonial Office in Whitehall or past the National Provincial Bank in Billingsgate do not look up to see the unclothed figures in spandrels and friezes across the buildings' façades.

Throughout London, throughout Britain, there are Victorian sculptural nudes wherever one looks, be they plaster, marble, bronze or stone. This may seem surprising; popular myths about the Victorians continue to circulate, branding them as the very epitome of prudishness. Moreover, when we think of Victorian art, sculpture tends to be forgotten. While paintings spring to mind readily, it is harder to think of famous sculptors

and statues. These are objects that have somehow become invisible to us, unnoticed a century on in our own visual landscape. Painting was undoubtedly the more discussed and more practised art in the Victorian era, yet sculpture was considered by many artists and critics to be the greatest of the arts, the most elevated, moral and beautiful. The Victorians clearly wanted to see sculpture flourish. In 1863 a new but short-lived magazine, the *Sculptors' Journal*, declared its aims as diffusing 'a more general love of sculpture through all the circles of the community', to improve taste and extend patronage.[1] Over thirty years later, in 1896, another journal, the *Sculptor*, voiced the same concern. The requirement that modern Britain create a truly great school of sculpture was not simply an aesthetic issue; it was symptomatic of much more, for sculpture was perceived by many, as William Michael Rossetti put it, 'essentially a national art', the medium which best expressed national character and status.[2]

Sculpture's pre-eminence stems largely from its classical provenance, and at once one can see why the nude was so much in evidence. Greek art was still widely viewed as the greatest that had ever been produced, and the classical nude constituted the apotheosis of the body; rather than an embarrassment or an abomination, the sculptural nude was the very model of perfection. There was seen to be a necessary connection between the perfect culture and society of the Greeks and their bodily practices and representations; the visibility of the nude was integral to national greatness, as both a literal and moral exemplar. It is this philhellene notion which consciously or unconsciously directed our Londoners as they viewed or ignored modern nudes. Building up boys' bodies to prevent them turning into milksops meant showing them Sandow and other muscular heroes; teaching the petite bourgeoisie true aesthetic and moral values meant encouraging them to place Parian-ware copies of ideal figures in their homes; making public space virtuous meant raising monuments to great men or decorating grand public buildings, complete with allegorical nudes. Imitating the Greek model in such a way was a path to a better society. Although toward the end of the century classical scholars and writers were beginning to challenge the rather sanitised and idealised view of Greece, alerting their readers to what Nietzsche

Alfred Gilbert
Perseus Arming 1882
(no.49, detail)

called the Dionysian, the violence and irrationality in Greek culture, the art world maintained the more conventional image of Greece as utterly rational and morally perfect. Hence, there were insistent demands that such bodies, or their modern equivalents, should be created in contemporary Britain in order to emulate this most perfect of societies.

Of course, there were objections to nude statues. We would be wrong to overlook Victorian prudery entirely. There certainly were those who saw the display of these undraped bodies as bringing London or Birmingham or Liverpool one step nearer to Sodom. Religious convictions brought complaints from various quarters; for example, a pamphlet by William Peters appealed to the fathers of England to protect their children and womenfolk from such appalling spectacles as the displays of statuary like Powers' *The Greek Slave* (no.46) at the Great Exhibition of 1851.[3] Nonetheless, the sculptural nude is far less contentious than nudity in other media such as painting, and the presence of sculptural nudes in so many sites, public and private, corporate and domestic, makes it clear that the nude, if correctly shaped and posed, was decent, normative and the very model of decorum.

There is, however, one fundamental issue that underpins sculptural theory and criticism in Victorian Britain; one problem associated with the sculptural nude that haunts sculptors and viewers alike. In a guide to the sculpture halls of the 1851 Great Exhibition, Anna Jameson begins by defining sculpture, pithily asserting: 'Sculpture is a thought and a thing. Painting is not what it seems: sculpture is a reality.'[4] On the one hand, sculpture is the most abstract of the arts; it is defined, at mid-century at least, as pure form, as the body transformed into an allegory of virtue or morality. On the other hand, though, it is the most concrete; its three-dimensionality means that it shares the viewer's space. Unlike the illusory window of the painting with its own space, its own world, the statue is here with us, as substantial as – if not more so than – those who view it, and while this presence is one of the elements that elevates sculpture, it also threatens its status, for this materiality can threaten sculpture's purity. The moral idea can turn into an object; it can be reified, turned to a lump of inert stuff rather than the immaterial ethical

ideal it represents. While Powers' *The Greek Slave* was defended on the grounds that her nudity was a sign of her purity and chastity, we have already seen that some viewers could read this body as impure. Similarly, when critic F.G. Stephens declared of Thomas Woolner's *Lady Godiva* (no.17) that 'her very nakedness is her armour', it is clear that such a comment is defending nudity, pre-empting a potential attack.[5] Caught between the real and the ideal, the sculptural nude leads to both Olympus and oblivion.

Ideal sculpture transforms the body, disavowing all the messy interiority of the human form, an interior both physiological and metaphorical; such nudes attempt to remove the body from the flesh and to present it as free from internal processes. This is evident in the absence of body hair or of genitals on female nudes, or in the extraordinary legibility and conventionalised anatomy of the male nude, where the morphology of the body signifies a stable state of perfection. The removal of bodily process is matched by the absence of psychic processes, such as sexual desire, carnal appetites or violent emotion; this is exemplified by the pure surface of the marble nude. The skin is often seen as the site of subjectivity; that is, we see the skin as betraying the body's history with marks and wrinkles and scars and stretch marks, signs of a life lived. The ideal nude has a skin wiped clean. Like a cosmetic surgeon, the sculptor removes traces of experience, placing the body outside history, outside a corporeal engagement with the world. The nude contains the flesh, presenting the body as transcendent form where corporeal matter signifies reason.

In the middle of the century this ideal was held up to scrutiny in a long and vociferous debate. The topic of the debate was not form or pose or gesture, though, but colour. From early in the nineteenth century scholars across Europe debated the question of whether the Greeks painted their sculptures. Archaeological evidence, supported by the re-examination of certain writers such as Pliny, seemed to prove that, unlike the purely formal white bodies so worshipped by the moderns, Greek sculpture was polychromed. By the middle of the century this was the most urgent issue in sculptural aesthetics in Britain, and it was fuelled by two experiments which provided a focus for the

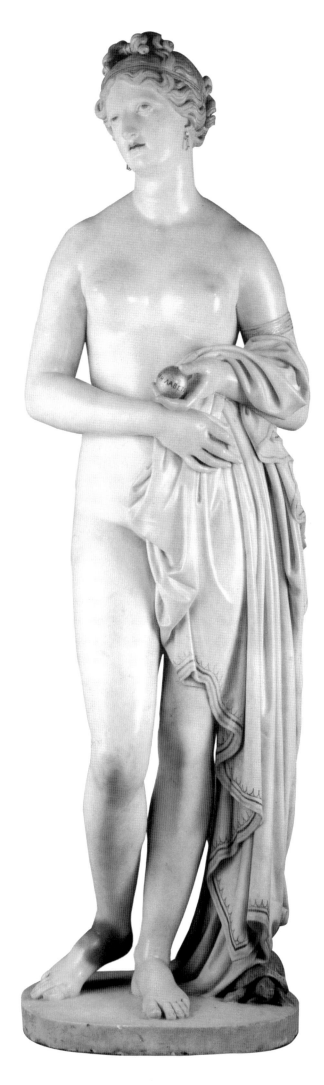

Fig.11
John Gibson
Tinted Venus c. 1851–6
Tinted marble
Walker Art Gallery,
Liverpool

debate, artistically and morally. The first of these experiments was Owen Jones's Greek Court at the 1851 Great Exhibition. Jones had created a model of the Parthenon and had painted it in bold, bright colours according to a certain archaeological wisdom. This, the *Athenaeum* declared in 1854, was a complete failure, since sculpture is an abstract art and its ideality lay in the absence of anything as superficial and distracting as colour; in other words, it turned the thought into a thing.[6] Even more important was the work of John Gibson, the most celebrated British sculptor of his day. Gibson became famous – or infamous – for tinting his statues; the best-known example is his *Tinted Venus* which caused a great stir at the International Exposition of 1862 (fig.11). Critics were kinder to Gibson than they had been to Jones; even those who disapproved of polychrome often made an exception in Gibson's case, in part because they did not wish to tarnish the name of the nation's greatest sculptor, and in part because they could point to the delicacy and restraint with which Gibson pursued this practice, thus gaining further ammunition against those archaeologists who insisted on the brightness of Greek polychromy. Nonetheless, most of those in the art world were unconvinced and in 1849 the *Art Journal*, in an otherwise laudatory piece about Gibson, asserted that the colouring of sculpture was potentially 'fatal' to sculpture.[7]

So what were the objections? Why such a furore over a practice that so few sculptors actually followed? First, there is a very clear objection on sexual grounds, a fear that colouring sculpture would debase the ideal body. Henry Weekes, when lecturing as Professor of Sculpture at the Royal Academy, remarked to his students that colour destroyed the purity of the nude, adding: 'The absence of colour in a statue is ... one of the peculiarities that remove it from common Nature, that the most vulgarly constituted mind may contemplate it without its causing any feeling of a sensuous kind.'[8] So, the purity of whiteness prevents the nude being viewed as a sexual or sensual body, while the addition of colour enables it to be seen in such a debased way. Supporters of Gibson evaded this issue by reading *Tinted Venus* as matronly, Venus as a goddess of marital love and fidelity rather than anything more contentious. This interpretive strategy, emphasising a moral disposition rather than physical

pleasure or erotic attachment, was clearly deployed as a means of refuting any charges of indecency.

This threat of immoral sensuality pertained not only to female bodies but male ones too. Richard Westmacott, Jr., son of the more famous sculptor, asserted like Weekes that the colouring of nymphs and Venuses would render the bodies too sensual, and rather than purifying the female body with its many dangers would promote the viewing of the nude as a site of unrestrained pleasure. Yet the colouring of the male nude was potentially even more horrific, and to apply colour to the 'manly and developed form' of a Theseus or an Achilles would be intolerable. Westmacott asks his reader with a rhetorical gesture, 'Would any father willingly take the females of his family into a gallery so peopled?'[9] The key point here is that it is not the male nude per se that invokes the figure of the distraught mother or daughter; it is a nude whose pure and perfected form is dragged from the airy realms of thought-like abstraction down to the squalid realms of physical fact. The muscle that signifies courage or virtue or manliness when dematerialised in whiteness is just brute muscle when coloured and reified.

The question of colouring the nude clearly has ramifications for ideas about gender. The coloured female nude is problematic because it turns the nude into a sign of sexual desire, of base physicality; exactly what the ideal is designed to expunge. Here decorous femininity turns into deviance: the matron is in danger of prostituting herself. The coloured male nude evidently works rather differently. For colour in Westmacott's reading does not replace a normative and decent masculinity with an indecent one; rather, it turns the masculine into the feminine. The idealising tradition differentiates male and female very clearly. On the one hand, there are bodies like Bell's *Andromeda*, with formally composed breasts, continuous unified anatomies, nipped in waists and flaring hips; on the other, there are heroic men like Lough's *Milo*, heavily muscled and powerful. There are also ephebic figures, of course, such as Gibson's *Narcissus* (no.45) or Foley's *Youth at a Stream*, which represent incipient masculinity; softer, less brawny, these are images of youth and their Apollonian beauty is no less masculine than Herculean brawn. In much art theory of the nineteenth century there is a conventional characterisation of form as masculine and colour as feminine; it is this kind of theory which underpins Westmacott's horrified image of a father having to walk past a coloured male nude with his daughters. While the form of the ideal contains the potential waywardness of the female body, colour brings feminine excess to the most muscly, manly male. When Hercules and Apollo have painted faces, dragged up like courtesans or painted Jezebels, their virile muscles are dissolved by the feminine surface. Colour disrupts these gendered bodies, introducing an element of deviant sexuality.

Colour also disrupts what one might call the ontology of sculpture; that is, what sculpture essentially is. Sculpture is defined as form; colour is outside its domain. The addition of colour blurs the boundary between painting and sculpture, between the formal and the chromatic, the abstract and the imitative. A reference that is used with wearisome regularity in the debate is that of the waxworks. Time after time, commentators remark that coloured sculpture is no more valuable than a waxwork, a worthless and hollow attempt to fool the viewer rather than engaging the spectatorial imagination and allowing the viewer to see something higher, a thought, through the medium of the sculpture, the thing. The sculptural nude, then, is seen as a representation of a body, but one which does not seek to imitate; rather to perfect and to transcend the flesh.

The prototypical coloured statue is Pygmalion's Galatea. The famous story of the sculptor Pygmalion relates that he could find no woman worthy of his love, so he sculpted a figure so beautiful he fell in love with her. The goddess Venus, taking pity on Pygmalion, breathed life into the statue of Galatea, transforming her from white lifelessness to blushing humanity. The Pygmalion story was enormously popular in the later Victorian period as witnessed by the numerous retellings in theatre, poetry and visual images: for example, Burne-Jones's cycle of paintings, the long poem by sculptor Thomas Woolner, or W.S. Gilbert's comedy *Pygmalion and Galatea* of 1871. The story is of particular relevance here because it is in many respects the most potent instance of the thought–thing

dichotomy. Moreover, the Pygmalion myth introduces a variation on Anna Jameson's theme: the distinction between the body as an object and the body as the vehicle of experience, outwardly beautiful thing and inwardly active subject.

The myth is fundamentally about the inadequacy of the body, both in its sculptural and corporeal manifestations. The flesh is seen to fail because no real body can ever equal the ideal loveliness of the marble Galatea; as a thing it can never fully embody the thought as the nude can. Yet the ideal statue is also shown to be wanting, for as long as the statue is marble Pygmalion's desire can never be satisfied. The abstract sculpture is insufficiently concrete or real. There is a happy ending, of course, in the transformation of marble into flesh which creates a hybrid body, at once blessed with ideality and yet animated into responsive life. Burne-Jones's cycle of paintings *Pygmalion and the Image* (nos.130–133) illustrates this well. The notion of the nude as ideal, as thought, is implicit in the first panel where the sculptor stands, deep in thought. No drawing, no model, no block of marble is before him; he merely looks inward to seek perfect bodily form in the imagination. Note too, the reflection of the Three Graces behind him in the tiles of the floor. It is as if we are being shown the realisation of this process; the immaterial, reflected idea of the sculpture mirrored by the actual group itself, thought made thing. In the second painting of the set, Pygmalion carves the ideal nude who is given life in the third image, and we end at the fourth panel with the sculptor kneeling before his creation. While Burne-Jones's *Galatea* has colour in the third and fourth panels, while we have seen her thaw into life, she is painted in such a way as to emphasise her hybridity: she is coloured, but the outline, the tonal modelling, the empty unfocused stare, and the rather dry, unyielding surface of the body all remind us of her marmoreal origins. While the Venus in the third panel is intended to suggest flesh dissolving into ethereal intangibility, suggesting a boundary between flesh and air, Galatea marks the boundary between flesh and stone. The whole cycle plays with thought and thing, object and subject, the tangible and the intangible. Although painted, Burne-Jones's works offer an acute example of fundamental sculptural concerns; indeed, it is only the medium of painting that allows Burne-Jones

to represent what the classicising tradition of the marble nude can never achieve. As we have seen, it was essential to the sculptural ideal that it not be coloured. White marble stands for both a presence and an absence. As a presence it signifies purity or chasteness; it alludes to the uncoloured Greek statues that one could see in the British Museum and elsewhere. But the whiteness also signified the absence of colour, pure form. The very absence of colour predisposed the viewer to read the statue as an instance of abstraction, as a moral thought rather than a carnal thing.

Another common argument against the colouring of sculpture was that coloured statuary belonged to non-white peoples and races. While whites, the heirs to ancient Greece, were able to appreciate the abstract quality of uncoloured sculpture, lesser civilisations demanded bright colours; they could only understand things as things, not as symbolic representations of thoughts. This is symptomatic of a broader connection between sculpture and race; a connection that positioned ideal sculpture as proof of racial superiority. It need hardly be said that racial divisions and hierarchies were fundamental to the Victorian world view. Whether informed by biblical views, where blackness is God's curse, the mark of Cain or of Ham, or by scientific views as in the racist misreading of Darwin that was consolidated as Social Darwinism, the crude notion of the survival of the fittest, the Victorians took it for granted that whites were superior to non-white peoples. The Empire which wrapped the globe in its pink blanket was the ostensible testament to that. How, then, is this related to the nude in sculpture?

Culture was a crucial tool for colonialism. In both assuming power and administering colonies, cultural institutions played not simply an important role, but a central role. Education and the teaching of English, or religion and efforts to convert native populations to Christianity, were ostensibly gifts bestowed yet were clearly means of gaining and consolidating imperial power. Sculpture also had its part to play, particularly in the legitimation of empire. When a large statue was placed in a colonial centre such as Calcutta or Melbourne, it could serve as a physical reminder of who was in charge, of the ideals and values that the apparently civilised West had brought to this corner

of the globe, of the colonial adventure as a tale of bravery and daring rather than appropriation and exploitation. These statues disseminated more specific ideas, though, and it is here that the nude is of absolute importance. As we shall see, the sculptural nude functioned as both a support for the colonisers' image of themselves, and as a means of presenting native peoples with a certain image of their own identity. We know that the ideal nude was seen as the most elevated type of humanity; the Greek model represented for the Victorian viewer the acme of human nobility. This has very clear racial implications. Aesthetics itself rested on the unquestioned assumption that whiteness was a higher state than any other, that the white Aryan body was simply greater, morally, aesthetically and intellectually, and so western notions of bodily beauty did not simply carry aesthetic notions to other parts of the globe, but were coded ways of disseminating the racial hierarchy. Watts's monumental *Cecil Rhodes Memorial*, with its nude hero celebrating what for Watts was the triumph of Aryanism in the dark continent, is a particularly clear instance of this. (While the statue was not erected until after Victoria's death in 1902, Watts had been working on it for many years; another version known as *Physical Energy* (fig.12) was placed in Kensington Gardens in London four years later.) The rough-hewn and vigorous figure astride his horse – an emblematic Englishman, according to Watts[10] – is a clear sign of white power and virility and its presence in Cape Town not only commemorates the act of colonisation and the recent events of the Boer War, but also purports to explain these phenomena. The nude declares that it is white destiny to take control of the lower races, and white bodily form is proof of this. Race and ideal sculpture are inseparably wedded to each other.

Inevitably, many colonial monuments represent the act of colonisation more literally, whether this be the quelling of the savage as on the relief panels beneath Thornycroft's *General Gordon* in Melbourne, or the conversion of the compliant native in Weekes's monument to Daniel Corrie, the Bishop of Madras. In these objects, the white man is clothed and the native unclothed; for in these unclassical contexts the uncovered figure is a primitive, savage body. The coloniser has to keep his clothes on since costume signifies civilisation in these images of imperialism in action. Dress also has a more specific function, in that the identity and achievement of the specific hero is instantly connoted by his dress, be it uniform or liturgical vestments. By the time Victoria came to the throne, the practice of depicting heroes nude had fallen away. Westmacott père's monument to Nelson in Liverpool, unveiled in 1813, shows the dying hero as an idealised nude, but it would have seemed quite inappropriate to show contemporary men naked to the Victorians. Watts asserted that for an individual to be represented nude was indecent since it implied the removal of clothing.[11] Nevertheless, allegorical nudes remained a familiar addition to public monuments, abstract counterweights to the literal hero in modern dress; a hero suitable for the more materialist worldview of the Victorians and the wider audience for whom these monuments were erected, many of whom would have failed to grasp the transformation of real hero into ideal nude. There is a point where the thing has to be retained, lest it disappear into incomprehensibility.

If the colonial hero was clothed, then his native charges were often unclothed. This inevitably forced a rethinking of the nude. On the one hand, the absence of clothing or drapery represented the highest state of humankind; on the other, it connoted the lowest. In the former case nudity was about thought, about ideal form; in the latter it was about things, about literal practices, bodies that were actually visible and on display. How was one to render the native beautiful enough for the monument not to be ugly or grotesque without imposing white values onto the native body? In other fields such as illustration, the native body was routinely made into a grotesque and horrible caricature, the very antithesis of the beautiful, but public sculpture

Fig.12
George Frederic Watts
Physical Energy
Kensington Gardens,
London
With the permission
of the Trustees of the
Watts Gallery

demanded a rather more elevated presentation of the body. How, then, did one steer a course between the dangers of over-idealising and of too much realism?

It is important to remember that nudity is not a fixed notion; that is, it does not always mean the same thing in all statues and monuments. Its significance is inflected by the overall setting and its sculptural context. Thus the nude could be used both to represent non-white peoples and confirm racial hierarchy at the same time. A good example is Weekes's monument to Bishop Daniel Corrie in Calcutta (fig.13). The work commemorates Corrie's evangelical work, bringing his Indian flock into the Christian fold, and shows him in his voluminous vestments, Bible in hand, standing with a barely clad young Indian man. It is this juxtaposition of the clothed and the unclothed that is the key here. Clearly, Corrie's dress is a sign of civilisation when placed next to his Indian convert, who simply holds a piece of drapery round him, covering the more indelicate parts of his anatomy. Weekes's treatment of the Indian is particularly interesting; in many respects the figure conforms to conventional aesthetic criteria with its well-proportioned body and clear smooth skin. While Indianness is signified by the features, the hair and the narrative, he is unmistakably a cousin of Foley's *Youth* or Gibson's *Narcissus*. The nude here seems to conform to general notions of the ephebic body, and yet also appears strangely enfeebled. He is not simply a child, for the body does not have a childlike morphology; it is proportioned as a young adult and its musculature seems to bear that out. The weakness of this nude emerges from the different scale of the two men; it is this which gives an appearance of adult and child. The figure of the Indian is too small in relation to the voluminous

presence of Corrie. Weekes has intensified this mismatch by manipulating the proportions of the two bodies. In the figure of Corrie the head is relatively small, and this makes the body loom gigantically; while in the figure of the Indian the head is larger in relation to the overall frame, and this gives the illusion of smallness. Weekes has been able both to maintain his aesthetic needs and at the same time make a figure which does not live up to idealised form. Ideality seems to hang off this body like an adult's coat on a child: garb which does not yet fit. While it may not appeal to contemporary aesthetic or political sensibilities, the monument is a deft reformulation of the thought–thing nexus to suit its colonial context.

Let us return to London where the well-to-do lady we met at the start of this essay is now in Bond Street, buying a statuette for her home. The kind of work she is planning to buy, both in terms of its genre and in terms of the sculptor, is an example of a renaissance in sculpture in the last quarter of the nineteenth century; a renaissance that has come to be known, in Edmund Gosse's phrase, as the New Sculpture. The New Sculpture is a notoriously vague and contested notion, but for Gosse, retrospectively heralding the movement in a series of articles in the *Art Journal* in 1894, British sculpture had undergone a sea change in this period.[12] This, he claimed, had been initiated by Frederic Leighton's *An Athlete Wrestling with a Python* of 1877 (no.153). For Gosse, and for other sculptural theorists, the New Sculpture was characterised by a rejection of cold, banal neo-classical conventions and a turn to a more naturalistic manner. This was, in essence, a question of French influence, both through exposure to the works of artists like Dubois and Mercié, and through the presence of French instructors like Dalou in such institutions as the South Kensington schools. What is most striking about Gosse's discussion of sculpture is his emphasis not on form but on surface. He criticises the traditional approach of sculptors like Weekes for insufficient naturalism, for emphasising formal masses at the expense of the skin and its pleasures.

This has profound consequences for the nude. We saw in the neo-classical ideal that the nude had to be generic rather than individual. A sense of the individual, of subjectivity even, was drained away in the search for

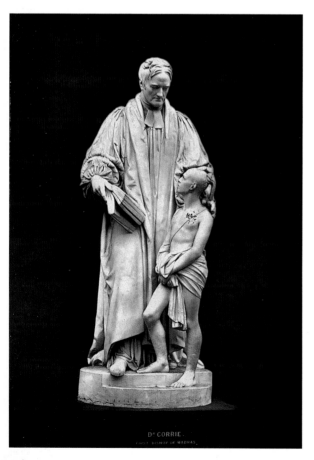

Fig.13
Henry Weekes
Daniel Corrie
Plate taken from
Henry Weekes's
Lectures on Art
National Art Library

John Gibson
Narcissus 1846
(no.45, detail)

the abstract and universal. Many of the New Sculptors worked in a very different way, moulding and sculpting bodies which were not embodied ideas, but were bodies of and about experience; and to represent the body as a vehicle of experience, as the means by which a subject engages with the world, the focus shifted from the form to the surface. Comparing the surfaces of, say, Gibson's *Narcissus* and Gilbert's *Perseus Arming* (no.49) one can see how the smooth planes emphasising solid volumetric forms in the former are replaced by a wealth of detail, of anatomical complexity and corporeal motion. In the jargon of the time, this kind of modelling was known as couleur. No longer is colour shunned as fatal to sculpture; it is encouraged either literally – many New Sculptors experimented with different materials, colours and textures – or nominatively in trying to suggest colour and change through surface modelling. This is also related to the revival of bronze casting, for bronze allows a far greater degree of surface detail and texture than marble; technical progress in the making of sculpture encouraged and enabled this redefinition of the sculpted body.

The treatment of the skin is a means of rethinking the thought–thing dichotomy. For Weekes and Westmacott, Jr., one did not so much resolve Anna Jameson's conundrum as overcome it. Sculpture took the matter of the body and the idea and used them to create something that was beyond the corporeal and yet visible: pure form. For Gosse, matter and idea were resolved in the body itself; the idea was expressed through the human subject, the body here and now rather than in some Platonic realm, and couleur prevented the body hardening into a reified object, it kept the body alive, signifying thought. At the same time, this emphasis on the materiality of the body, the representation of or allusion to tendons and veins and bodily movement, prevents the flesh being disavowed. It is as if the new style has found a way to capture the hybridity of Pygmalion's *Galatea*. A useful comparison in paint might be Henry Scott Tuke's bathing boys (no.179). Tuke creates his boys' bodies with a mosaic of colour, the skin represented as a surface made up of many moments of sensation, the feeling of sun or wind or water on the flesh. This attempt to capture the experience of embodiedness is at the same time an

attempt to visualise subjectivity, what it is like to be physically in the world. While there are greater limits to how far a sculptor may go, this self-conscious physicality is evident in the labouring body of Thornycroft's *Mower* (fig.14), the active straining body of Leighton's *Athlete*, and the trembling, sensual body of Gilbert's *Perseus*.

In spite of this new emphasis on corporeality, the New Sculpture often seems to endorse gender norms. Male and female nudes are still clearly polarised, and couleur is deployed in the development of distinctly gendered surfaces; of female bodies that are smooth, uninterrupted skins and male bodies where the surface is highly differentiated and textured. Both are sensual,

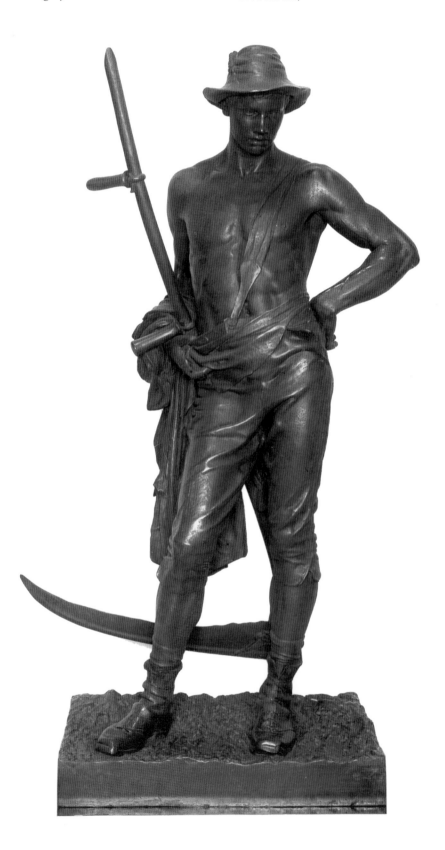

Fig.14
Hamo Thornycroft
The Mower c.1882–94
Bronze
Walker Art Gallery,
Liverpool

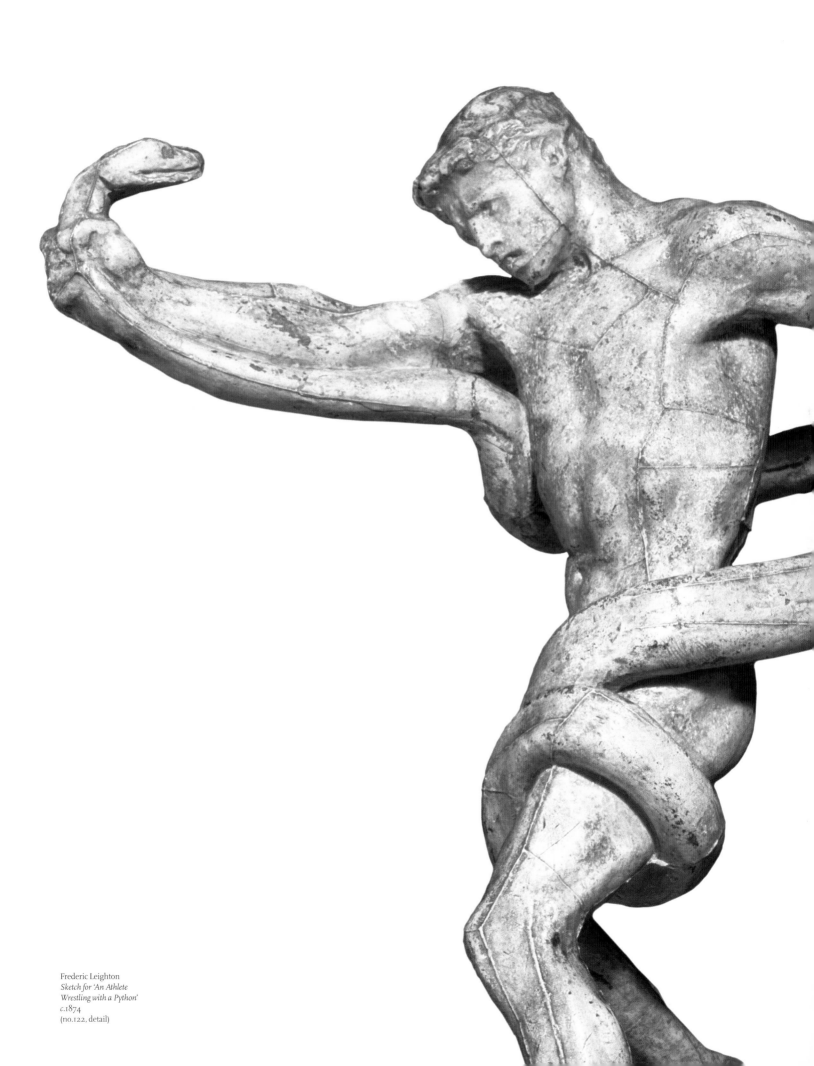

Frederic Leighton
*Sketch for 'An Athlete
Wrestling with a Python'*
*c.*1874
(no.122, detail)

but represent different kinds of tactile experience, as if the viewer is asked to imagine stroking the one and squeezing the other, perhaps. Such a distinction is evident in Leighton's *Athlete*, all heroic muscle, and Bates's *Pandora* (no.128), whose flesh is a single sensuous form. Indeed, Pandora is, for all its technical novelty, a highly conventional female nude. She crouches, holding her box, which is a separate object made from ivory and decorated with gold, a mix of media symptomatic of much New Sculpture. Her curiosity is about to get the better of her, and the viewer knows she will open it, releasing all the evils inside. Around the box are scenes of Pandora's own making, her fashioning by Hephaestus, the god who created her, and her transportation to earth as the first woman. Her perfect skin is uninflected, largely because this is a sculpture about sculpture. The unmarked surface is a sign of her having been made, of an absence of experience; the skin will become marked after the box has been opened and human suffering is introduced into the world. This clever work mixes traditional sculptural devices with New Sculptural ideas to reassert some familiar notions of femininity: happy sensual innocence opposed to unhappy sexual experience, with the transition from grace to evil effected by woman's curiosity. The parallel between Pandora and Eve is impossible to miss.

Masculinity, similarly, is consolidated by New Sculpture. This is exemplified in the connection between nudes like Leighton's and the living statue of physical culture. Physical culture magazines, such as Sandow's own publications, often printed images of classical and modern sculpture, clearly drawing an analogy between the ideal body of marble and bronze and the body for which advocates of bodybuilding aimed. The Athlete locked in struggle with the python, is the model young men should emulate. Indeed, Sandow, the great guru of health and bodily control, effectively turned himself into a sculpture: he posed like a statue, complete with plinth and fig-leaf, and dusted himself with white powder to give an effect of marble. The thing that is his body is transformed into the thought of a purified manly ideal. Just as the ideal body of sculpture represses desire and process, so the physical culturist's body is cleansed of its material baseness. It is this that makes his body a legitimate object of display. But, like the New Sculpture,

this is a living statue, one which does not deny the flesh; rather than repressing, it controls.

New Sculpture did, however, introduce some new bodily forms into the canon. While many works maintained the polarised notion of masculine and feminine, and of Herculean hero and Apollonian youth, others blurred these boundaries. The figure of the dead poet in Onslow Ford's *Shelley Memorial* (fig.15) is undoubtedly a man, but his pathetic body, represented as it is washed up, drowned, on the shore has a feminine grace and sensuality, and is more closely related to Pomeroy's similarly washed up *Nymph of Loch Awe* (no.156) than any male figure. What the juxtaposition of these diverse examples illustrates so well is how unstable the sculptural nude is. While it is the epitome of bodily decency, it also provides numerous possibilities for indecency. Viewed from this perspective, the New Sculpture and its redefinition of the nude does seem to challenge certain Victorian conventions. While the male nudes that are created are decent and licit, they open up a space for homosexuality to be articulated. This has always been the case with sculpture. The great antiquarian Winckelmann, whose work has so powerfully shaped art history, defines the male nude as the epitome of the aesthetic, a judgement in which desire is clearly instrumental. Similarly, Gosse's account of the New Sculpture, if read in the knowledge of his homosexuality and his deep love for Hamo Thornycroft, can be seen to emerge in part from sexual desire. The new conception of sculpture as an art of surface shifts the gaze of the viewer from abstract form to sensual detail; it transforms a look seeking disinterested and impersonal beauty into a look that finds personal pleasure and sensation. It is no accident that the category of the New Sculpture includes such eroticised bodies as those ephebes and boys by Havard Thomas or Goscombe John.

What enables this eroticisation is, of course, the very position of the sculptural nude. Because it is legitimate, so elevated, to look at it is beyond reproach; hence, the possibility opens up of looking not for thoughts but for things. Sandow provides a very clear example of this. While our suburban boy looks at his image of Sandow as an inspiration, the writer John Addington Symonds may also be looking at his photographs of the great man;

Gosse sent them to him from America where Sandow was appearing at the World's Fair in Chicago in 1893. Symonds's interest in Sandow was clearly more than aesthetic, and just as his scholarly concern for Michelangelo or Cellini is underpinned by his own homosexuality, here too his absorption in the male nude had other sources besides a search for art. The most decent and legitimate of nudes can, for Symonds, become an object of desire, a source of the most indecent and illegitimate of appetites. For Symonds, Gosse and other homosexual men, the elevated status of sculpture, be it by Phidias, Michelangelo, Leighton or Thornycroft, meant that the male nude could be stared at, scrutinised, enjoyed. The decorum of sculpture was a doorway to desire.

Night falls in London. The boy finishes his evening exercises; the lady places her statuette in the library; the prostitutes start to congregate in the shadow of Eros; Symonds stares at his photograph of Thornycroft's *Mower*; the clerk inserts his coin into the Kinetoscope and watches Madame Bertholdi twisting and contorting her extraordinary elastic body - how much better, he thinks, to see bodies in motion, images reanimated. Everywhere sculptural bodies mediate the real and the ideal, the decent and the indecent. The dangerous body is defused into aesthetic safety; and this safe body is reawakened into dangerous pleasure. Everywhere, thoughts become things, and things become thoughts.

1 *Sculptors' Journal*, 1863, p.1.

2 Rossetti 1867, p.341.

3 Peters 1854, p.8.

4 Jameson 1854, p.4.

5 Stephens 1894, p.85.

6 *Athenaeum*, 1854, p.123.

7 *Art Journal*, 1849, p.140.

8 Weekes 1880, p.169.

9 Westmacott 1859, p.232.

10 Watts 1912, I, p.272.

11 Ibid, III, p.15.

12 Gosse 1894.

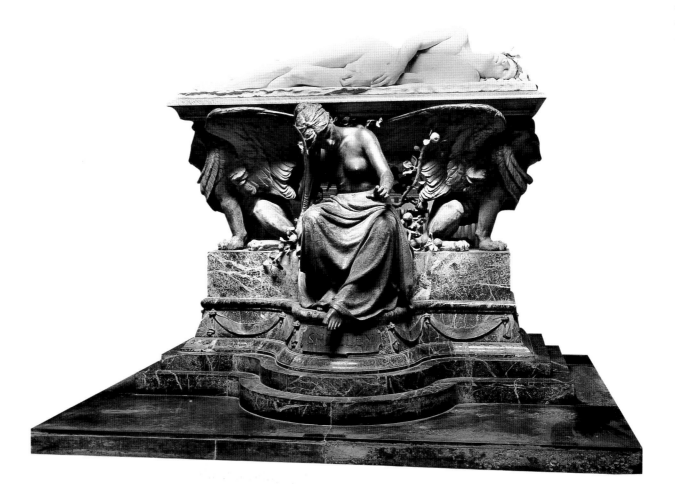

Fig.15
Edward Onslow Ford
The Shelley Memorial
1894
Marble and bronze
University College,
Oxford

Catalogue

Abbreviations

BI	British Institution
DG	Dudley Gallery
EB	Ecole des Beaux-Arts
FG	French Gallery
GG	Grosvenor Gallery
GPG	Georges Petit Gallerie
IPW	Institute of Painters in Watercolours
LG	Lawrence Gallery
NEAC	New English Art Club
OWS	Old Water-Colour Society
PSL	Photographic Society of London
RA	Royal Academy
RSA	Royal Scottish Academy
RSBA	Royal Society of British Artists
SA	Society of Arts
SBA	Society of British Artists
SPW	Society of Painters in Water-Colours

h.	height
w.	width

Authorship is indicated as follows:

AS	Alison Smith
MH	Michael Hatt
MM	Martin Myrone
RU	Robert Upstone
TB	Tim Batchelor
VD	Virginia Dodier

Measurements are given in centimetres, height before width, followed by inches in brackets.

The English Nude

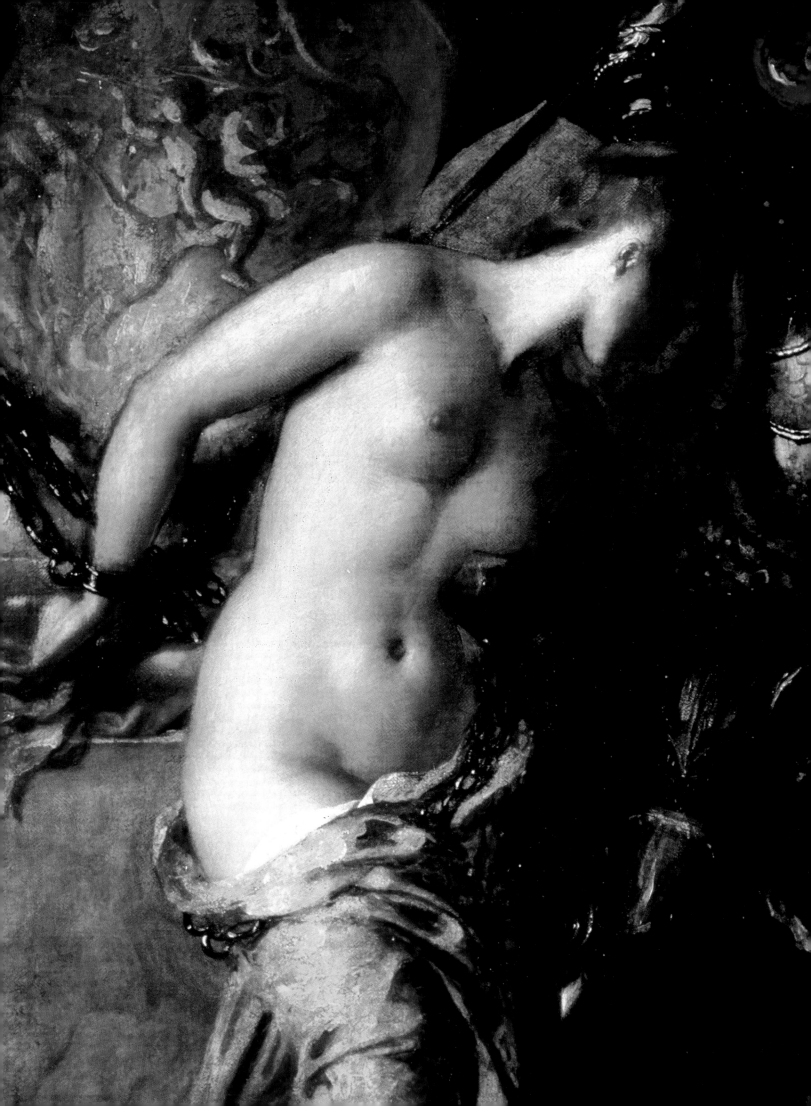

During the early Victorian period the nude was regarded as a rather rarified subject. Lack of either Church patronage or state support for the arts resulted in little demand for high art, the dominant subjects at exhibitions being portraiture, landscape and scenes of historical or literary genre. Although the nude was not censured as such, the associations drawn between images of the unclothed body and the morals of pagan and Catholic cultures were enough to deter British painters from specialising in the subject. William Etty was singular in his devotion to the nude but had to contend with accusations of lascivious motives. Sculpture was considered a more suitable medium for the 'undraped' figure because of its uncoloured, 'chaste' quality, despite being more tactile and by implication more ostensibly erotic than the painted nude. So widespread was the idea of sculptural purity that marble figures were considered suitable for reproduction in cheaper substitute materials as home decorations.

Despite its indebtedness to the Antique, the emergence of a distinct 'English' way of painting the nude in the 1840s owed much to the influence of the Venetian Renaissance, and to that of Rubens and the Flemish school. The importation of magnificent Italian Old Masters into Britain during the Napoleonic Wars and especially the impact of Titian's nudes on painters and connoisseurs alike led to his being elevated as the ideal exemplar for the national school by virtue of his naturalism, rich colour and rounded female types adorned with flowing golden hair. Indeed it was at this time, with the growth of museums and wider audiences for art generally, that Titian's nudes, long considered appropriate only for private delectation, were first assimilated into the public cultural sphere. Etty's full-bodied figures were conceived entirely in the painterly spirit of Titian and Rubens, whereas William Mulready toned down the eroticism of his sources in favour of a more sculptural treatment of form, and as a representative of a *juste milieu*, the Irishman became widely regarded as the modern master of the English nude, his colour being 'finer than the Venetian', his academic studies ranked among 'the finest drawings in the world' (*Illustrated London News*, 10 June 1848, p.377).

The paradox of the English nude was thus that it had to answer to the European stylistic canon yet be distinct in national and moral terms. The appendage of quotations from British literature assisted in the formulation of a female type that was perceived to be indigenous to the British Isles: fair, with generalised features, decorous gestures and outlines painted with crystalline precision. The contemporary concept of 'poetic pictorialism' – the union of literary and visual imagery – helped legitimise the nude by foregrounding the literary traditions on which it was often based, while retaining the English nude's relationship to established European conventions of representation. The *Illustrated London News*, for example, compared Spenser as a poet to Rubens as a painter: 'There is the same rich abundance in both' (10 June 1848, p.378). The blend of pagan and Christian sentiment found in poems such as the *Faerie Queene* allowed for the representation of violent, even sadistic confrontations while providing a moral framework for viewing the nude. The enthusiasm of Queen Victoria and Prince Albert for Spenserian and Miltonic subjects was essential in furthering the cause of the nude in Britain. The female figure was thus seen to incarnate the purity and innocence of a timeless British Arcadia, watched over by a 'faery' Queen, and it became man's duty to honour this ideal by maintaining a chivalric code of conduct based on self-discipline and a pure uncorrupted gaze.

The male nude was less dependent upon literary sources and more on the academic tradition of study from the male figure. The lack of a theoretical basis for drawing the female model resulted in the employment of literary pretexts to justify its representation in art, whereas the male figure was acceptable on grounds of anatomical analysis alone, especially when posed to conform to dominant notions of proactive masculinity. While female life-studies were considered improper in the public domain, male académies were more acceptable because the pugilists and prize fighters who served as models were regarded as modern-day equivalents to the athletes and gladiators of Antiquity. Assumptions made regarding female models and the sexual morals of the social classes from which they originated deterred artists from presenting an explicitly contemporary female nude in public. However, women represented in pastoral or mythological contexts were also suspect if they were seen to bear signs of being

Overleaf:
William Etty
*Britomart Redeems Faire
Amoret* 1833
(no.2, detail)

based on living urban models. Some of the women who posed for artists also performed in popular entertainments such as *tableaux vivants* or 'living pictures', and painters were sometimes accused of advertising the performative bodies of notorious individuals rather than the noble characters they impersonated. Tension between idealising and particularising tendencies in the British school thus resulted in the occasional slippage between generic literary types and the representation of specific, sexualised bodies. Etty, Mulready, Landseer and Millais were all criticised for failing to reconcile the observational skills required in the studio with the idealisation demanded of the nude in the public sphere. AS

William Edward Frost
The Sea Cave 1851
(no.7, detail)

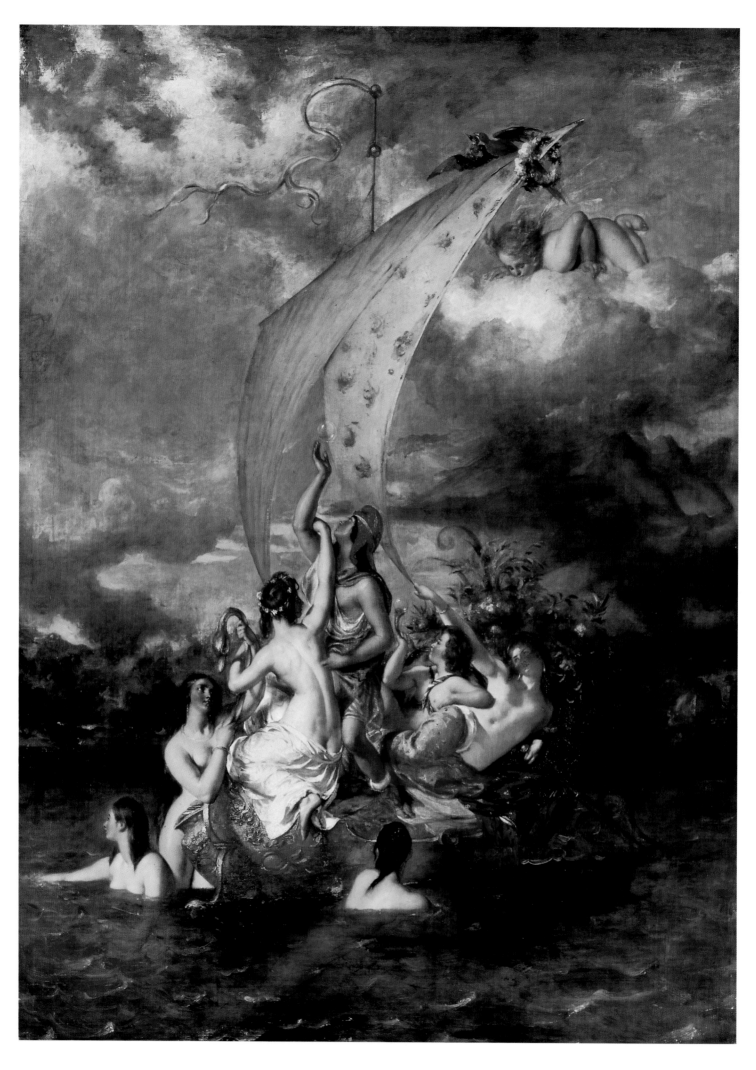

William Etty (1787–1849)

1 *Youth on the Prow, and Pleasure at the Helm*
1830–2
Exh. RA 1832
Oil on canvas
158·7 × 117·5 (62¹⁄₂ × 46¹⁄₄)
Tate. Presented by Robert Vernon 1847

✱

Etty was the first British artist to paint the nude with both seriousness and consistency, combining visual pleasure with high moral purpose. However, while he was admired for emulating the glowing colours of the Venetians and Rubens, his distinct 'unclassical' treatment of the nude was regarded as a deviation from the antique foundations of the English school as upheld by Flaxman and sculpture in general. 'The naked female figure may, in the severity of the antique, be modest,' declared the *Morning Chronicle* of this painting, 'but it is not so in the attitude of Mr Etty ... no decent family can hang such sights against their walls' (Farr 1958, p.63).

Youth and Pleasure belongs to the category of poetic romance. A youth cavorts with nymphs aboard a flimsy vessel, the prow of which seems to wilt from the heat of their sport. The intertwining limbs and languorously stretched bodies add to the theme of transient pleasure, an idea Etty pursued in another RA exhibit of 1832, *Phaedria and Cymocles on the Idle Lake*, a similar work in a number of features, and also expressive of women's sexual power over men.

As with an earlier version, shown at the British Institution in 1822, *Youth and Pleasure* was exhibited untitled but accompanied with lines from Thomas Gray's ode *The Bard* of 1757. The quotation offered a more profound reading of the painting than the image presented of youthful dalliance. However, the moral warning contained in the text and implied in the picture by the storm clouds among which lurks a harbinger of doom, passed unnoticed, eliciting a more forthright explanation from Etty in an undated letter to the engraver C.W. Wass: 'a general allegory on human life – its empty, vain pleasures – if not founded on the laws of Him who is the Rock of Ages'.

The role of the nude as a moral exemplar was one way of making the genre acceptable on ethical and religious grounds (see also no.18). How far the collector and army contractor Robert Vernon was interested in this when he purchased the painting for his unofficial 'National Gallery of British Art' in Pall Mall is unclear. John Constable was certainly surprised when Vernon planned to add his *The Valley Farm* to his collection which necessitated moving Etty's painting to a different position: 'My picture is to go into the place – where Etty's "Bumboat" is at present – his picture with its precious freight is to be brought down nearer to the nose' (letter to C.R. Leslie, Beckett, 1965, p.132). AS

William Etty

2 *Britomart Redeems Faire Amoret* 1833
Exh. RA 1833
Oil on canvas
90·8 × 66 (35³⁄₄ × 26)
Tate. Purchased 1958

✱

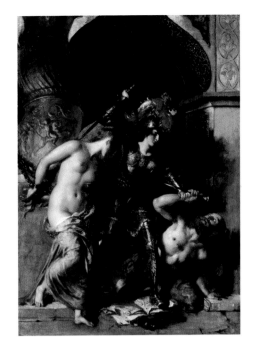

Etty ranked this painting among his major works. It was exhibited at both the Royal Academy and Royal Manchester Institution in 1833, where it was sold to a Manchester collector for the painter's price of £150. The scene is based on two verses from Book III, canto XII of Spenser's *Faerie Queene* (1590), which describe how the female knight Britomart rescues Amoret from the chains of the enchanter and torturer Busyrane. In keeping with the classical convention of representing the nude as wholesome and inviolate, Etty omits the gruesome details of Amoret's slashed breast and extracted trembling heart which according to the poem was healed following Britomart's despatch of Busyrane. Etty was not the first British artist to represent this particular episode, and he was probably aware of earlier precedents in the ways Opie, Stothard and Fuseli had approached the Britomart legend. Indeed it was probably to the latter that he was indebted in this instance for the loose, thin brushwork (the weave of the canvas is visible beneath the paint layers), and masochistic overtones.

The appeal of the *Faerie Queene* to artists of the romantic era was due not only to its wealth of pictorial incident, but also to its status as one of the key works of the English Renaissance and it was thus an attractive source for aspiring history painters. Spenser's fusion of pagan sensuality with Christian allegory was adopted by British artists as a means of introducing the nude to a largely Protestant audience. Etty's image blends classical with Christian iconography: Perseus and Andromeda, St Michael and the Devil. The Amazon knight, Britomart, with her impregnable, glistening body, is a synthetic type alluding to Athena, Minerva and Britannia. Britomart's essentially Christian triumph over the heathen Busyrane is further dramatised by the lurid pseudo-Moorish architecture of the sorcerer's chamber.

The subject also relates to the Arthurian quest for chivalric virtue. The androgynous Britomart embodies chastity, a quality prized by Etty, a bachelor artist renowned for his religiosity and temperance. Etty's challenge for the presumably male viewer was thus to vanquish lust and cast a pure gaze on vulnerable womanhood. Such a reading has to be seen in light of the perceived moral dangers surrounding the admission of women as models into the academic life-class, a practice Etty himself encouraged. In the painting a studio model (with right foot resting on a block) and a manikin in armour have been recontextualised into an imaginary setting. Although critics were relentless in criticising such direct transpositions from studio to story, making such a connection may have been deliberate on Etty's part. AS

William Etty

3 *Musidora: The Bather 'At the Doubtful Breeze Alarmed'* 1846
Oil on canvas
65·1 × 50·2 (25⅝ × 19¾)
Tate. Bequeathed by Jacob Bell 1859

✿

The scene of Musidora discovered by the swain Damon as she bathes innocently by an English stream, from James Thomson's *The Seasons* (1727), achieved unprecedented currency as a pretext for the nude in Britain from the late eighteenth century to the 1840s. This subject, the nation's surrogate Venus, was represented in painting, sculpture, Parian ware and book illustration by Gainsborough, Wilkie, Lough, Frost and Arthur Hughes among others. Etty exhibited two versions of the subject, one at the Royal Academy in 1843, the other at the British Institution in 1846, of which this is a copy. He also produced a number of further variations on the theme.

The subject was initially popularised by illustrated editions of Thomson's poem. Etty's painting was exhibited accompanied by lines 1313–20 of 'Summer', the most well-thumbed section of the poem according to Wordsworth (Altick 1985, p.392). But if voyeurism was encouraged by phrases such as 'fair exposed she stood, shrunk from herself, With fancy blushing', they were mitigated by reiterations of Musidora's chastity. 'What a pure, virginal, shrinking, chaste, delightful creature is his Musidora' wrote Haydon, for instance, praising Lough's 1828 version (diary, 16 March 1828).

For painters the encounter between Damon and Musidora represented a modern literary parallel to the stock mythological and biblical scenes of naked beauty surveyed: Ovid's Diana and Actaeon, Susannah and the Elders, and Bathsheba. Thomson's 'Summer' was also seen to offer a verbal realisation of the imagery and colour of the Old Masters, especially Titian, whose *Diana and Actaeon* had astonished the London art world at the Orléans sale of 1799. At the same time Thomson's phrase, 'so stands the statue that enchants the world', pays homage to the *Medici Venus* of Antiquity, a type similarly sanctioned by a bathing motif.

Etty's painting venerates both traditions. *Musidora* is an adaptation of both the *Venus Pudica* and the *Venus de' Medici*, while the loose handling of paint with reflected lights in the flesh tones recalls the Venetians. However, such references are subsumed in what is essentially an Anglo-Saxon ideal, with unbound auburn hair, fair skin and blushing complexion. The pastoral setting is also specifically 'English' being based on a pool in the grounds of The Plantation, Acomb, the residence of Etty's patron the Revd Isaac Spencer, whom the artist visited in 1842 (Farr 1958, p.101).

Partly as a result of its popularity, the Musidora theme inevitably became trite and conventionalised: 'a favourite subject for a dip of the brush', lamented the *Literary Gazette* in 1850 (9 Feb., p.112). Nevertheless, the 'surreptitious heterosexual peep' subject continued with the vogue for Lady Godiva following the publication of Tennyson's poem of 1842 (see nos.10, 16). AS

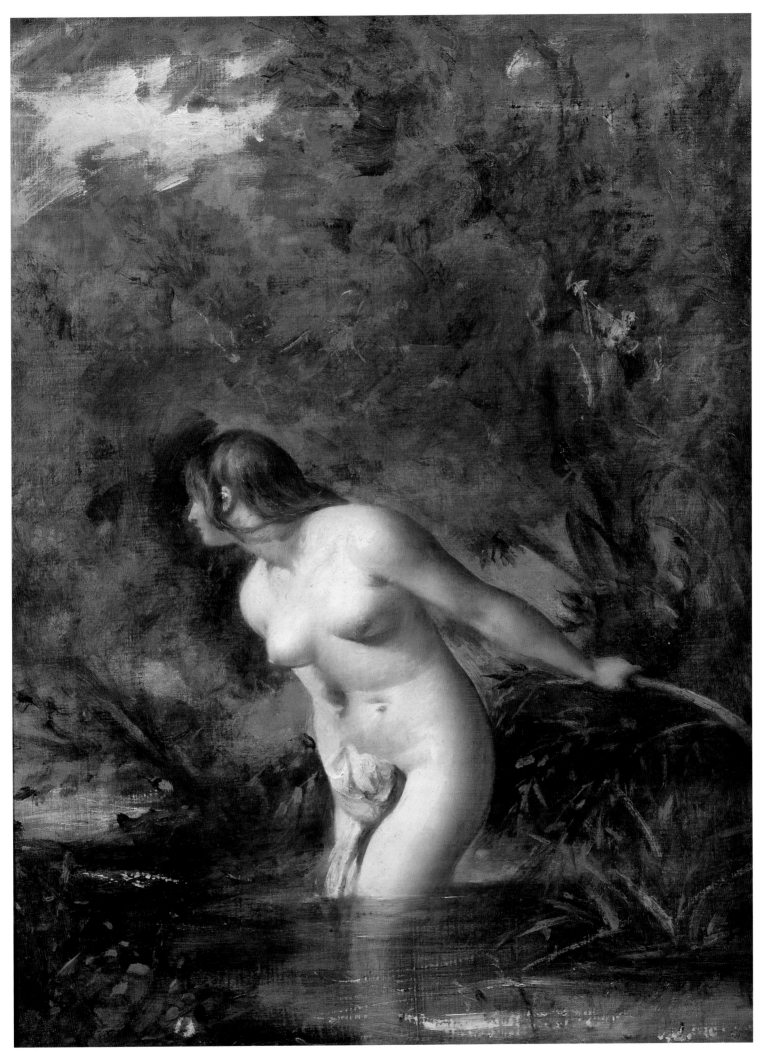

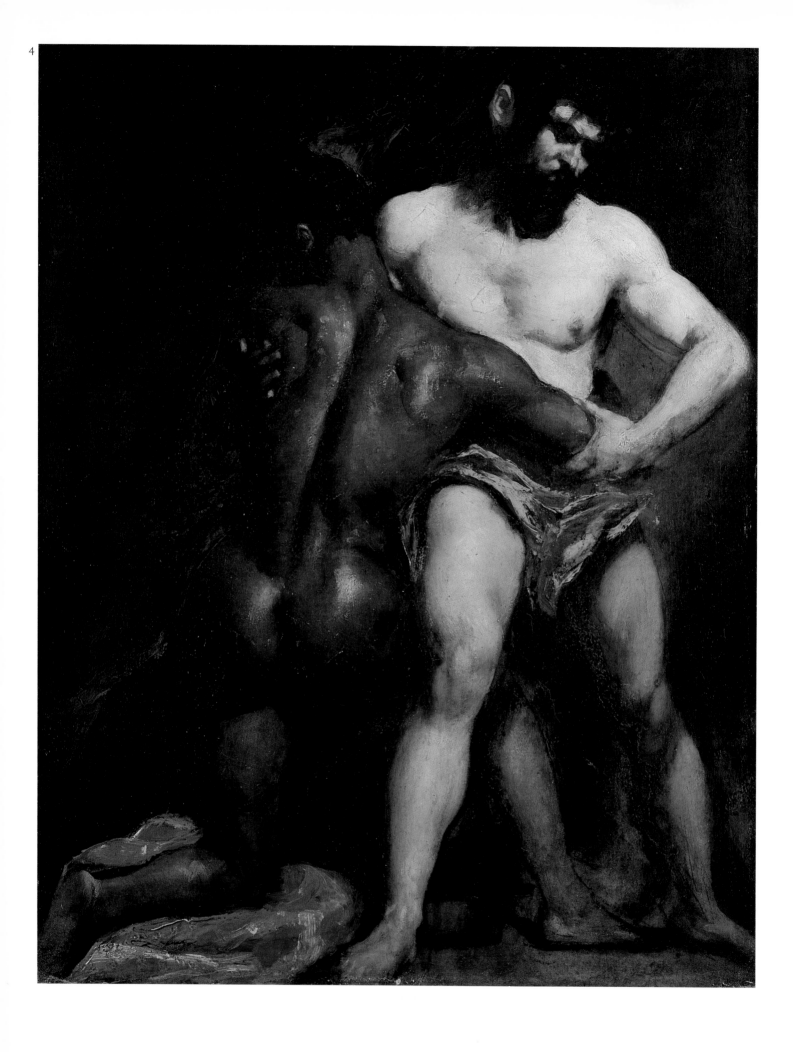

William Etty

4 *The Wrestlers* c.1840
Possibly exhibited SA 1849
Oil on millboard
68·5×53·3 (27×21)
York City Art Gallery (presented by the York
Civic Trust, 1947)

✿

In 1849 Etty exhibited *The Wrestlers* at the
Society of Arts retrospective of his career.
He also produced two other versions of the
composition, plus a number of life-studies
involving two men in action. It is not clear
whether this picture can be identified with that
exhibited in 1849 or whether it is an 'academy'
study with draperies added at a later date,
possibly after the studio sale following the
artist's death. Etty's penchant for staging
tableaux vivants in the life-class of the Academy,
adds to the difficulty of distinguishing between
his studies and finished works. Daniel Maclise
recalled Etty's practice of grouping models
together: 'a composition of two or three
Gladiators. Sometimes, a dark man … was
introduced, for picturesque contrast' (Gilchrist
1855, p.58).

The Wrestlers or *Pancrastinae* was one of the
Antique sculptures probationers were set to
draw from to gain admission to the Royal
Academy schools. At the same time, artists
were examining the physiques of living men as
modern examples of manly perfection, capable
of rivalling the Antique. The celebration of
virile masculinity in everyday situations formed
part of a broader search for new contexts for
the nude, as can be seen in Haydon's rapt
descriptions of naked guardsmen, Géricault's
lithographs of boxers and Mulready's
numerous studies of wrestlers.

In the early Victorian period, male models
tended to be pugilists or soldiers capable of
sustaining a pose and renowned for their
fine musculature. Haydon would present his
favourite models to students alongside antique
prototypes such as the Parthenon *Theseus* and
Ilissus. Etty shared a similar predilection for
strapping guardsmen: Higgins and Samuel
Strowger were just two of the soldier-models
who posed for him. The standing white model
in this picture may be the bearded John Wilton,
mentioned in the *Art Union* (Sept. 1841, p.160).
Etty also appreciated dark-skinned models and
earlier in his career painted the famous Wilson,
admired by Haydon for his 'perfect antique
figure'. Particularly around the time of
abolition, blacks tended to be viewed as
primitive noble savages, uncorrupted by
modern civilisation, yet were also considered
physically and mentally backward. While the
white wrestler here appears dominant, as if
confirming existing racial stereotypes, the
figures are in fact equally positioned in a well-
matched struggle. It is also likely, as Maclise
observed, that Etty was seeking dramatic
pictorial effect through rich contrasts of colour.
AS

William Mulready (1786–1863)

5 *The Bathers* 1848–9
Exh. RA 1849
Oil on millboard
46·4×35·6 (18¼×14)
Hugh Lane Gallery, Dublin

✿

Like Etty, Mulready maintained a regular
practice of drawing from the nude. As Visitor
at the Royal Academy he joined students in
drawing from the model, and attended a
life-class he helped establish in Kensington.
The extraordinary composition of this
painting, dominated by the single figure in
the foreground, must surely have begun as
an 'academy' (the support being humble
millboard), and subsequently worked up as a
finished painting with an extra strip added at
the top. Mulready may have been inspired by
the Etty retrospective at the Society of Arts in
1849 to paint the nude, combining skills of
observation attained through dedicated study
with inventive composition.

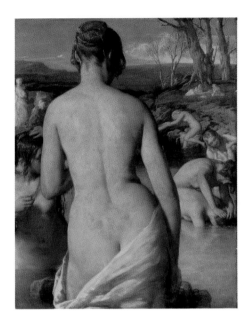

The transition from life-class to studio helps
explain Mulready's additive working procedure.
He adopted a similar method in other
experimental nude compositions, notably a
Diana and Actaeon of about 1853, drawn on
three joined pieces of paper (Cecil Higgins
Gallery, Bedford), and a larger drawing of
Bathers of about 1859 (National Gallery of
Scotland, Edinburgh). The fragmentary
character of *The Bathers* composition creates
a Mannerist sense of disturbance, a quality
which also distinguishes Rejlander's large
composite photograph *The Two Ways of Life*
(no.18). The juxtaposition of the foreground
statuesque figure with the romping girls behind
with their wet unbound locks, coupled with a
tension between idealising and individualising
tendencies, accentuates the overall
claustrophobia of the image. The central figure
is reminiscent of the *Venus de Milo* and Ingres's
Valpinçon Bather, but the coiffure, skin colour
and body shape have been fashioned to suggest
the effects of modern costume. Predictably,
some critics thought Mulready incapable of
transcending the life-room, arguing that his
style was cramped by a miniaturist approach,
as if he were working in watercolour or crayon
rather than oil.

Unlike so many other nudes of the period,
this work is not based on a literary source,
although the subject recalls the standard
bathing scenes of Diana and Actaeon,
Musidora, and Sabrina and her Nymphs.
Mulready's anonymous bathers seem to
embody the *genius loci* of the landscape, and are
nymph-like in their playful attitudes and animal
vigour of movement. Standing proudly aloof
from their antics, the principal figure seems
an almost surreal urbane interruption,
introducing a hint of artful eroticism into
what is otherwise a communal scene of
unselfconscious bliss. AS

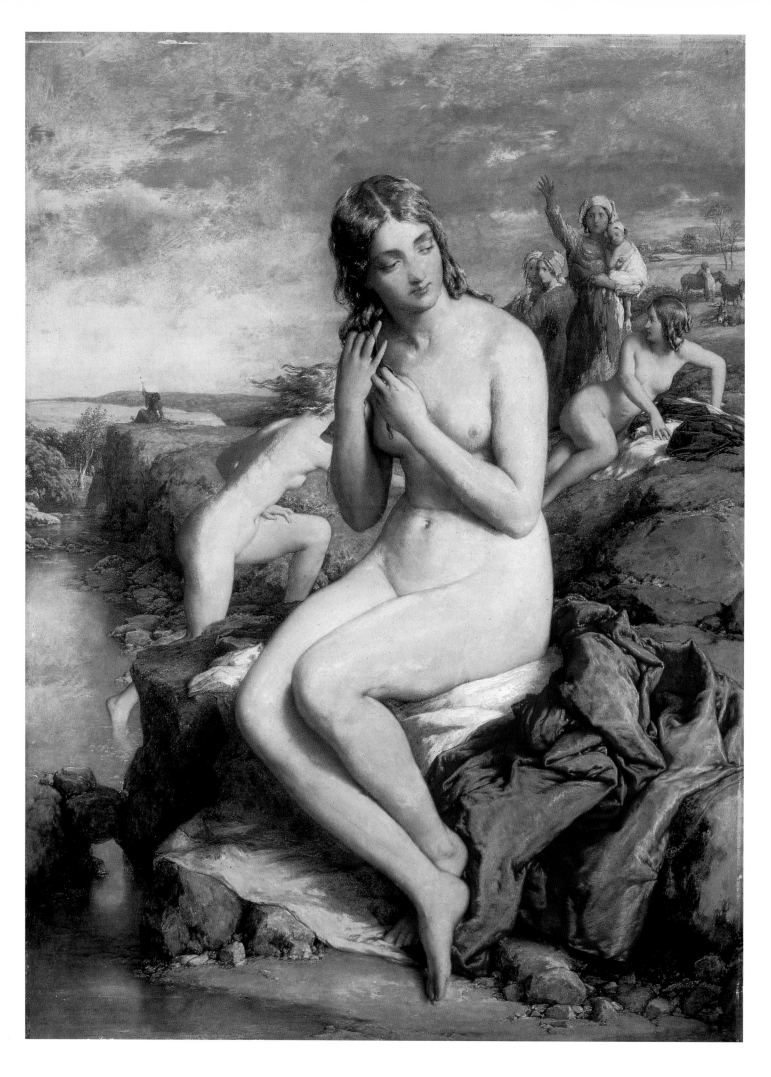

William Mulready

6 *Bathers Surprised* 1852–3
 Exh. Exposition Universelle, Paris 1855;
 Manchester Art Treasures 1857; International
 Exhibition, London 1862
 Oil on panel
 59·1 × 43·8 (23¹⁄₄ × 17¹⁄₄)
 National Gallery of Ireland

✿

Bathers Surprised was one of nine works selected
by Mulready for the International Exhibition
at Paris in 1855. He was awarded the Légion
d'Honneur on the basis of his skills as a
draughtsman (at a time when drawing was
regarded a British deficiency), and of his ability
to combine empirical observation with formal
arrangement. This painting exemplifies
Mulready's belief that the modern nude could
express beauty without being moulded by some
preconceived idea of the Antique (Redgrave and
Redgrave, 1890, p.298). Here he offers a fresh
interpretation of the Diana and Actaeon and
Musidora themes beloved by British painters
of the nude, instead presenting an open-ended
narrative in which the confusion heralded by
the announcement of a male intruder with his
dog in the distance is formally presented by the
disjunction between the urgent movement of
the lissom athletic bodies scrambling up the
bank and the tranquil seated figure oblivious
of the panic behind her.

Following the arrival of the Orléans
collection in London, and the return of British
artists (among them Wilkie and Etty) to Italy
following the end of the Napoleonic Wars, the
British school pronounced Titian to be the most
formidable of all painters of the nude. Mulready
took up the challenge of Titian by reference to
the Venetian's famous *Aphrodite Anadyomene*
of about 1520–5, in the Earl of Ellesmere's
collection at Bridgewater House, which
Mulready would have known well as art-tutor
to the Ellesmere family (Heleniak, 1980, p.258
n.20). Titian's painting was widely admired for
incarnating the spirit of Apelles's lost *Venus
Anadyomene*, thus blending antique form with
Venetian colouristic sensuousness (Ottley 1818,
p.36, no.12). Mulready offers a British Venus
with his naturalistic rendering of flesh under
sunlight, yet tempers any suggestion of
voluptuousness by a 'refined' dry chalky surface
achieved through a thin application of paint.
His delicate technique was perceived as a
healthy alternative to Etty's vigorous
brushwork, which became targeted as a corrupt
influence in the decade following the artist's
death. James Dafforne thought the central
figure in *Bathers Surprised* possessed 'a skin
of that fine stuff which alone was worn by
Mother Eve before she sinned' (1872, p.46).
As Mulready began to supersede Etty as the
foremost British artist of the nude, so he was
regarded as a worthy successor to past masters
of the genre. Both *The Bathers* (no.5) and
Bathers Surprised were purchased by the banker
Thomas Baring, a notable collector of both the
Old Masters and the modern British school
(Haskell 1980, p.128). AS

William Edward Frost (1810–1877)

7 *The Sea Cave* c.1851
 Exh. BI 1851; Exposition Universelle, Paris 1855;
 Manchester Art Treasures 1857
 Oil on canvas
 Image size (oval) 40·6 × 47 (16 × 18¹⁄₂)
 Russell-Cotes Art Gallery and Museum,
 Bournemouth

✿

Frost was widely regarded as the most
successful follower of Etty in painting small
fancy pictures of Miltonic and Spenserian
subjects. This image of a Nereid, with its
carefully rendered reflected lights and shadows,
was exhibited accompanied by some
appropriate lines from the poet Thomas
Doubleday. The painting bears all the hallmarks
of Frost's style, being delicate, charming and
classically refined: qualities which were
perceived to be in keeping with the painter's
own gentle, diffident character.

Frost's achievement in the 1840s and 1850s
was in making the nude acceptable amongst a
broader public than hitherto. *Sabrina* of 1845,
for example, was bought by the *Art Union* to be
engraved and issued to subscribers, and works
in the possession of notable private collectors
such as the Earl of Ellesmere and Lord
Northwick were well publicised: Queen
Victoria's purchases of 1847, 1848 and 1850
were recorded and published in the *Art Union*
and *Art Journal*. Although Frost was initially
praised for tempering the bravura of Etty's
manner, the repetitious uniformity of his poses
and settings encouraged criticism that he had
merely succeeded in trivialising the nude,
failing to meet the challenge of both the Old
Masters and Etty himself. By the early 1860s
Frost's reputation had begun to decline. AS

Joseph Noël Paton (1821–1901)

8 *The Reconciliation of Oberon and Titania* 1847
Exh. RSA 1847
Oil on canvas
76·2 × 122·6 (30 × 48¼)
National Gallery of Scotland

✿

The Reconciliation of Oberon and Titania established Paton as one of the most distinguished fairy painters of the mid-nineteenth century, a reputation sustained by the artist's fascination with folklore and Celtic myth. The work was painted in response to the competition announced by the Commission for the Decoration of the Palace of Westminster, which invited artists to submit scenes from Shakespeare, Spenser and Milton, as well as subjects from British history. Paton selected the episode from Act IV, scene I of *A Midsummer Night's Dream*, in which Oberon and Titania, having resolved their quarrel over the changeling, stand before the sleeping mortals in whose dreams this fairy fantasy is envisioned. The argument itself formed the subject of Paton's companion picture *The Quarrel of Oberon and Titania* exhibited at the Royal Scottish Academy in 1850. With these grand compositions Paton offered his contribution towards the development of romantic literary art in Britain, working in the tradition of Fuseli, Etty and Frost, with the added novelty of microscopic detail. He was awarded a £300 prize for *The Reconciliation* by the Commissioners and received offers for its purchase from the RSA, the Society of Arts and the Belgian King (it was bought by the RSA in 1848).

Fairy subjects were popularised through literature and stage productions as well as painting. The predominance of a sylph-like fairy type around mid-century had been encouraged by romantic ballets such as *La Sylphide* (performed in London in 1832), in which Marie Taglioni epitomised the fairy ideal with her delicate gliding movements. This neo-gothic drama set in an elf-inhabited Scotland may have influenced Paton's composition, where airy figures weave gracefully through a woodland glade. The belief that fairies dwelt in a liminal realm of consciousness or in remote regions of the British Isles may have emboldened Paton in his decision to introduce elements of erotic playfulness, notably the unrestrained movements of the fairies and their intricate couplings. Orientalist features such as the harp and head-dress of the musicians reinforce the overall feeling of exoticism and fantasy. Such elements would have been considered inappropriate in more conventional Spenserian or classical subjects, but by multiplying the details and embedding them within the picture surface, Paton invited a close reading of his subject. Lewis Carroll, for one, counted 165 fairies in the pendant picture of *The Quarrel* when he viewed it in Edinburgh in 1857 (Noël Paton and Campbell 1990, p.21).

Despite the revelry, the figures in *The Reconciliation* are treated with a miniature grace in keeping with the nude females of Frost and Pickersgill: the addition of gauze wings and wispy drapes adds to the sense of propriety. This dramatic centrifugal composition is moreover stabilised at its centre by the classically posed Oberon and Titania, who with their white statuesque bodies draw attention away from the grotesque rampant creatures which surround the sleeping humans. An article in the *Art Journal* in 1895 described Paton's figures as ideal: 'The Greek feeling for form prevails, in all its abounding grace. Hence the artist gives one the idea of a Greek who has steeped himself in the pages of Edmund Spenser' (Noël Paton and Campbell 1990, p.21). Although Paton was praised for his refined treatment, the theme of reckless abandon was not considered appropriate for the seat of government, as the *Spectator* confirmed: 'Art is always vagabond and lawless, because its essential laws must follow the elementary laws of human nature, and not those of custom or Parliament; and all true artists will show something of the wild estate' (3 Aug. 1850, p.732). AS

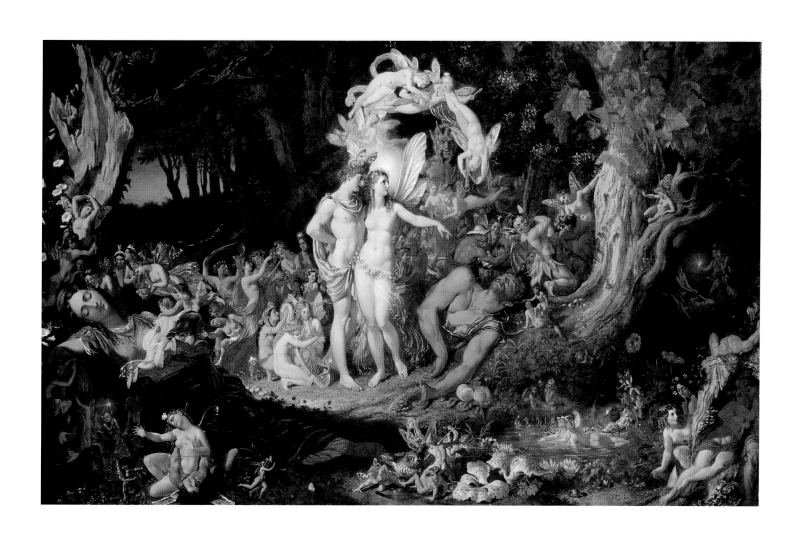

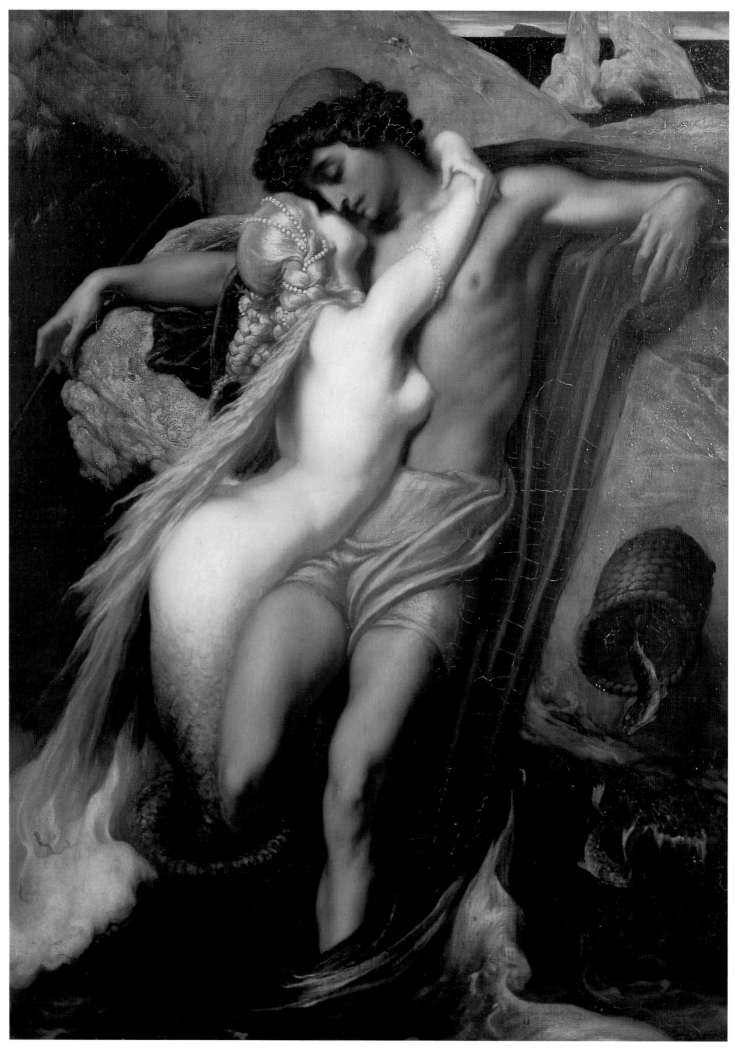

Frederic Leighton (1830–1896)

9 *The Fisherman and the Syren: from a ballad by Goethe c.*1856–8
Exh. RA 1858
Oil on canvas
66·4×48·9 (26⅛×19¼)
Bristol Museums and Art Gallery
✱

This picture was exhibited in 1858 accompanied with a translation of the final lines of Goethe's poem 'Der Fischer': 'Half drew she him, Half sunk he in, And never more was seen.' Both poem and painting are romantic adaptations of the theme of the seductive yet destructive sea maidens from Homer's *Odyssey*. Sirens also feature in Milton's masque *Comus* of 1637, another popular pretext for poetic nude subjects in the mid-nineteenth century. In folklore and legend the siren was closely identified with the mermaid, other variants including the kelpie, nixie and more obscure Lurley to whom Leighton's syren was compared by the *Art Journal* in 1858 (p.169). As well as art and literature, sirens and mermaids also appeared in the realm of entertainment, occasionally featuring as carnival freaks, the most famous 'fish composite' being the 'Feejee' mermaid shown in London and on Broadway in 1842.

The subject of unwary youth ensnared by female sexual appetite had formed the leitmotif of Etty's *Youth and Pleasure* of 1830–2 (no.1), and his notorious *The Sirens and Ulysses* of 1837. The audacious combination of sensuality and morbidity in the latter had resulted in a more temperate 'Miltonic' treatment of the subject by Etty's successors Frost and Pickersgill, who favoured smaller subjects focusing on the sirens' charms rather than dramatic confrontations. Therefore, in depicting a moment where a male passively succumbs to female lust, Leighton was showing considerable daring: as the *Saturday Review* acknowledged, the coupling 'may, and not unreasonably, elevate some eyebrows' (15 May 1858, p.500). However, by treating the subject as a fantasy on a relatively small scale, Leighton escaped censure.

The tapering extremities and arched torso of the syren reveal an awareness of the fairy type, and the *Daily Telegraph* thought the scene possessed a 'mystic Undine tinge', referring to de la Motte Fouqué's novel of 1811, a popular source for fairy painters (Barrington 1906, II, p.36). She is also a northern type, with streaming blond hair plaited and entwined with pearls and coral. Her pearly flesh tones are dramatically illuminated by contrast with the bronze complexion of the Italian-looking fisherman. This empassioned encounter, where north confronts south, is made palatable by the artist's fluid, sophisticated draughtsmanship, a quality that set Leighton apart from most English painters of the nude at this time. AS

Alfred Joseph Woolmer (1805–1892)

10 *Lady Godiva c.*1856
Exh. RSBA, 1856
Oil on canvas
87·6×78·8 (34½×31) in an oval frame
Herbert Art Gallery and Museum, Coventry.
Purchased with the assistance of the MGC/V&A Purchase Grant Fund, 1981
✱

'Almost any semi-nude subject may be turned into a Godiva', wrote the *Art Journal* of this painting in 1856 (p.135). The subject of Lady Godiva's naked ride through Coventry came to epitomise the idea of the English nude in the 1850s by virtue of its theme of redemptive nakedness (a fanciful derivation made the name Godiva mean 'Good Eve'). Godiva, said to have died in 1067, was venerated as a Saxon heroine who acted in defence of English liberty. According to legend, when her husband Leofric, Earl of Mercia, imposed heavy taxation on the citizens of Coventry, Godiva intervened pleading that he reduce the burden. Leofric replied that he would only do so if Godiva were to ride naked through the streets of Coventry. Heroically Godiva took up this deterring challenge and rode forth at night, having requested that the townspeople stay indoors behind closed shutters. Only one man betrayed her trust: the original 'Peeping Tom' who was struck blind for his voyeurism.

The story had been handed down through the centuries with various modifications, but attained iconic status following the publication of Tennyson's poem 'Godiva' in 1842. Artists were quick to take up the subject, selecting specific incidents from the poem, which led to the development of an established Godiva iconography in the 1840s. The poem also gave respectability to what hitherto had been a risqué subject, with its erotically suggestive association of horse and naked female rider. Tennyson's memorable phrase 'clothed on with chastity', was often quoted to establish the purity of the gaze of viewers of an image of Godiva, who could thus allow themselves to look upon her naked beauty without shame.

Woolmer shows Godiva in the act of disrobing. Behind her lies Leofric's proclamation while in the background her horse awaits as the sun sets. The main figure is adapted from the antique *Venus de Milo* of the second century BC, the awkward drawing of which is effectively disguised by a liquid freedom of paintwork, reminiscent of Turner, Watteau and Titian. As with most Victorian paintings of Godiva, Woolmer depicts her with unbound auburn hair, suggestive both of an Anglo-Saxon type and of Venetian Renaissance beauty. AS

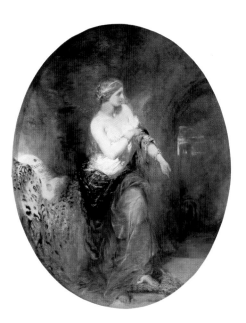

Edwin Landseer (1802–1873)

II *Lady Godiva's Prayer c.*1865
Exh. RA 1866
Oil on canvas
143 × 113 (56¼ × 44½)
Herbert Art Gallery and Museum, Coventry

✱

Started in the 1840s, this painting was not finished until 1865. '[B]y the express command of her Majesty' it was exhibited the following year at the Royal Academy, accompanied by a description of the Godiva legend (*Illustrated London News*, 12 May 1866, p.474). The time Landseer expended in completing this work would suggest that he was attempting a more original interpretation of the subject than the conventional images of Godiva undressing or descending a staircase to mount her steed. The Queen had been impressed by the picture when she visited Landseer's studio in March 1866, and her interest in the image may have prompted him to add the details of the ermine and crown.

Landseer's image is unique for its interplay between fact and fiction, in that it is as much a homage to a living woman as it is to a legendary character. Evidence would suggest that the figure of Godiva was based on 'Madame' Warton (the stage-name adopted by Eliza Crowe), famous in the 1840s and 1850s for her *tableaux vivants* staged by her sensational Walhalla troupe at Savile House, Leicester Square. Warton was also a well-known model (she had sat for Etty), who utilised her skills at striking and holding a pose in her performances. During the winter of 1847–8 she collaborated with Landseer by presenting his 'forthcoming picture' of *Lady Godiva's Prayer* with the Walhalla. Advertisements pronounced this act the *chef d'oeuvre* of her inimitable tableaux, one which had been received with 'acclamations of delight by fashionable and crowded audiences' that included leading members of the nobility (*Illustrated London News*, 15 Jan. 1848, p.29; 26 Feb., p.124).

Warton went on to take the role of Godiva in the Coventry Grand Show Fair of 1848. The introduction of a procession in the city in commemoration of Godiva's legendary ride came about in 1678 and continued more or less annually until the mid-nineteenth century when moralists succeeded in confining it to three-year intervals. However, in 1866 the Secretary of State sanctioned the procession provided public decency was upheld (Lancaster 1967, pp.59–60; *Coventry Standard*, 6 June 1866, p.69). The widespread publicity accorded to the procession thrived on the suggestion that Godiva would ride naked, although in fact the models who took the part actually wore fleshings, a skirt and veil. Warton's appearance in 1848 was so great a success that the citizens of Coventry presented her with an expensive gold watch on the back of which was an engraving of her own impersonation of Godiva in a tableau she staged at the Coventry theatre later in December 1848 (*Coventry Standard*, 5 Aug. 1892, p.218). Warton thus played a key role in popularising the image of Godiva in the late 1840s, and perhaps Landseer wanted to commemorate her performances with this picture, in which he elevates Warton above potential critics by presenting her as Godiva praying together with a pious matron in puritan costume, whose eyes are shown to be firmly closed. The three doves in the foreground and spire of St Michael's cathedral in the distance are further suggestive of her purity and noble aspirations.

If Landseer's painting was indeed intended as a gesture of veneration to a woman who had made honourable the role of Godiva, it was not greeted as such in 1866. Warton's premature death in 1857 (generally attributed to alcoholism) led not only to the break-up of her troupe, but to a decline in the reputation of the *tableau vivant* in the 1860s, which may explain why critics dismissed the work for its stagey composition and anachronistic features. The figure of Godiva was described as an 'Anonyma' – a current term for a prostitute (Smith 1996, p.109) – and the image was contrasted unfavourably with Watts's small *Thetis* (no.29), a work influential in paving the way for a rejuvenated classicism in the late 1860s, and which made Landseer's picture seem literal and vulgar by comparison. *Lady Godiva's Prayer* was to remain Landseer's only attempt at a nude subject. AS

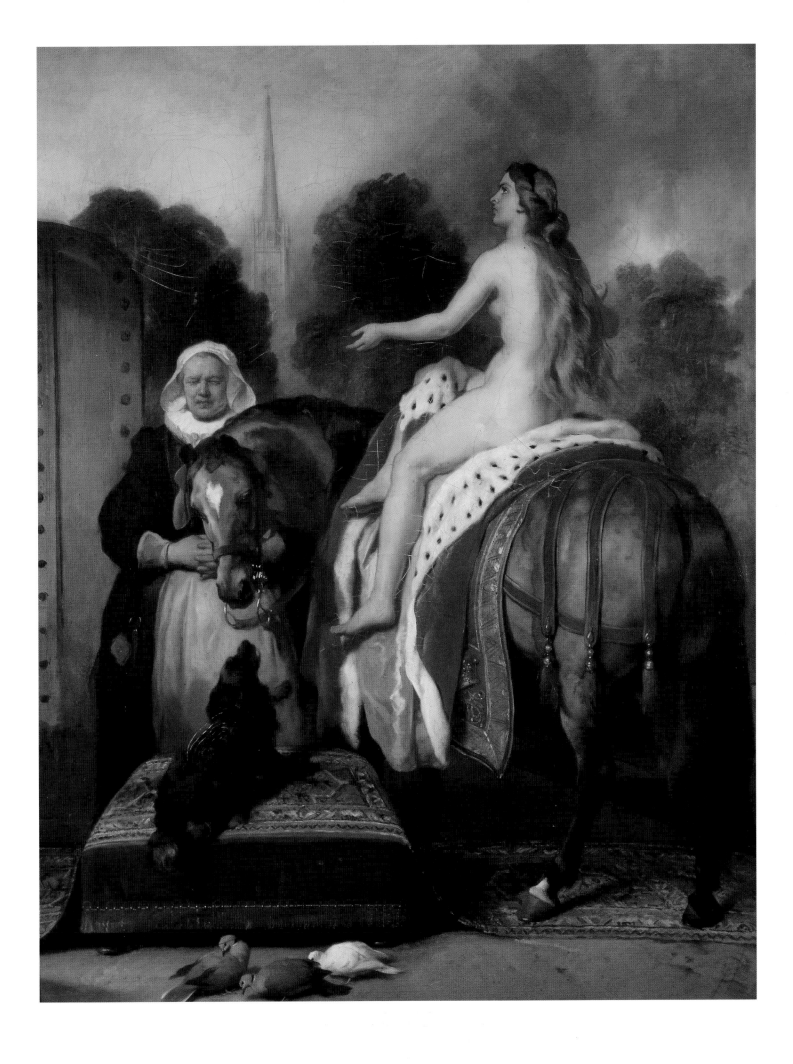

John Everett Millais (1829–1896)

12 *The Knight Errant* 1870

Exh. RA 1870; International Exhibition, London
1871

Oil on canvas

184·1 × 135·3 (72¹₂ × 53¹₄)

Tate. Presented by Sir Henry Tate 1894

✿

Millais exhibited *The Knight Errant* at the Royal
Academy in 1870 using in the catalogue a text
of his own invention: 'The Order of the Knight
Errant was instituted to protect widows and
orphans, and to succour maidens in distress.'
This open-ended narrative contains all the
ingredients of the Spenserian rescue scene: a
distressed female captive is released at a critical
moment by a fully armed knight who deftly
fends off her attackers. In painting *The Knight
Errant*, Millais set himself the ambitious task of
representing a scene of poetic romance without
resorting to the mannerisms of expression and
pose that had in his opinion marred the
productions of Etty's successors. In his only
previous attempts at nude subjects – the very
early *Tribe of Benjamin seizing the daughters of
Shiloh* (1847), and *Cymon and Iphigenia* (1848) –
Millais had struggled unhappily with the
problem of how to inject naturalism into an
ideal composition without the result looking
mawkish or dislocated. Dissatisfied with these
works he resumed the challenge in 1870,
probably provoked by the emergence of a
classical ideal of nude painting in the late
1860s. In order to revive the project of the
English nude, Millais painted a decidedly
unclassical figure, adapting the manner of
Etty as a viable alternative to the Continental
methods being employed by the classicists (see
no.31). According to J.G. Millais, the painter's
son, Etty was the only member of the 'old
school' for whom his father had any serious
regard, and Holman Hunt recalled how Millais
sought to penetrate the secrets of Etty's
technique, the lessons of which can be seen
in this painting with its umber-brown
underpainting enlivened by scumblings and
patches of red (Hunt 1905, I, p.75). Indeed, it
is tempting to speculate that in composing
this image, Millais consulted Etty's *Musidora*
donated to the National Gallery in 1859.
The other great influence on Millais was the
Venetians, whom Etty's art had designated

the main progenitors of the English nude on
account of their rich colour and vigorous
handling of paint, qualities displayed, for
example, in Tintoretto's *St George and the
Dragon* (fig.16), a chivalric rescue scene
bequeathed to the nation by the Revd Holwell
Carr in 1831 and no doubt familiar to Millais
from his days as a student at the Academy.

By depicting a full-blooded Englishwoman
in the style of Etty and the Venetians, Millais
was positing an alternative framework for the
English nude in contrast to the generic ideal
favoured by the classicists. Further, he was
hoping to demonstrate an advance upon the
achievement of Etty in that, while the painting
was completed quickly (in under six weeks)
using a loose *alla prima* technique, Millais's
image was underpinned by a thoroughly sound
anatomical draughtsmanship, the absence of
which, it was by now generally agreed, had
constituted the ultimate failure of Etty's
ambitions as a painter of the nude. Again, this
method might have been adopted as a healthy
alternative to the elaborate and lengthy
compositional procedures advocated by
Leighton, Poynter and Moore (see nos.36,
29, 30).

The Knight Errant was strongly praised for its
flesh tones: F.G. Stephens compared the 'inner
golden hue' of the figure with Titian's treatment
of flesh, and Baldry later ranked the work
alongside the best examples of Venetian
painting (*Athenaeum*, 30 April 1870, p.584;
Baldry 1899, p.53). But despite their admiration
for Millais's flesh tints, critics could not help
but see his nude maiden as a studio model
transposed into an imaginary setting. The
juxtaposition of quivering naked flesh against a
body encased in armour (which Millais based
on examples preserved in the Tower of London),
was seen to foreground the implications of rape
in the narrative. Traces of blood on the sword
and the patterns of soft red padding reflected in
the armour might further suggest violation.
Recent x-ray examinations of the picture reveal
that the woman's head and torso were originally
painted turning towards the knight thereby
establishing direct eye contact between the
couple (figs.17, 18). The suggestion thus
implied, that such a bold woman might have
been responsible for her predicament, gave the
work a distinct political edge, raising as it did

the vexed social problem of the double standard
of sexual morality currently being debated
following the passing of the controversial
Contagious Diseases Acts in the 1860s (for a
fuller discussion of this see Nead 1983; Smith
1996, pp.127–48).

Predominantly poor reviews, coupled with
the fact that the painting did not sell, compelled
Millais to cut out the head and chest of the
female figure and rework these parts to show
the woman turning modestly away (a close
examination of this area of the picture confirms
the cutting and re-patching). The extracted
section was subsequently sewn into another
canvas and completed as *The Martyr of the
Solway* in 1872 (fig.19). In the process of
negotiating the transition from morally
ambiguous naked damsel to Protestant martyr,
Millais altered the expression of the victim to
look less voluptuous, added an open-necked
shirt, and replaced the rope around the figure's
waist with a chain. AS

Fig.16
Jacopo Tintoretto
*Saint George and the
Dragon c.*1560
Oil on canvas
National Gallery, London

Fig.17
John Everett Millais
The Knight Errant 1870
Oil on canvas
X-ray photograph 2000
The angle of the neck and
face indicates that Millais
had several attempts at
resolving the final pose of
the maiden.
Tate

Fig.18
John Everett Millais
The Martyr of the Solway
1871
Oil on canvas
X-ray photograph 1999,
showing the original
position of the head and
torso.
Walker Art Gallery,
Liverpool

Fig.19
John Everett Millais
The Martyr of the Solway
1871
Oil on canvas
Walker Art Gallery,
Liverpool

Fig.16

Fig.17

Fig.18

Fig.19

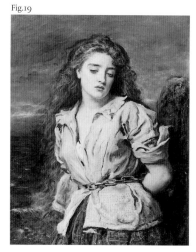

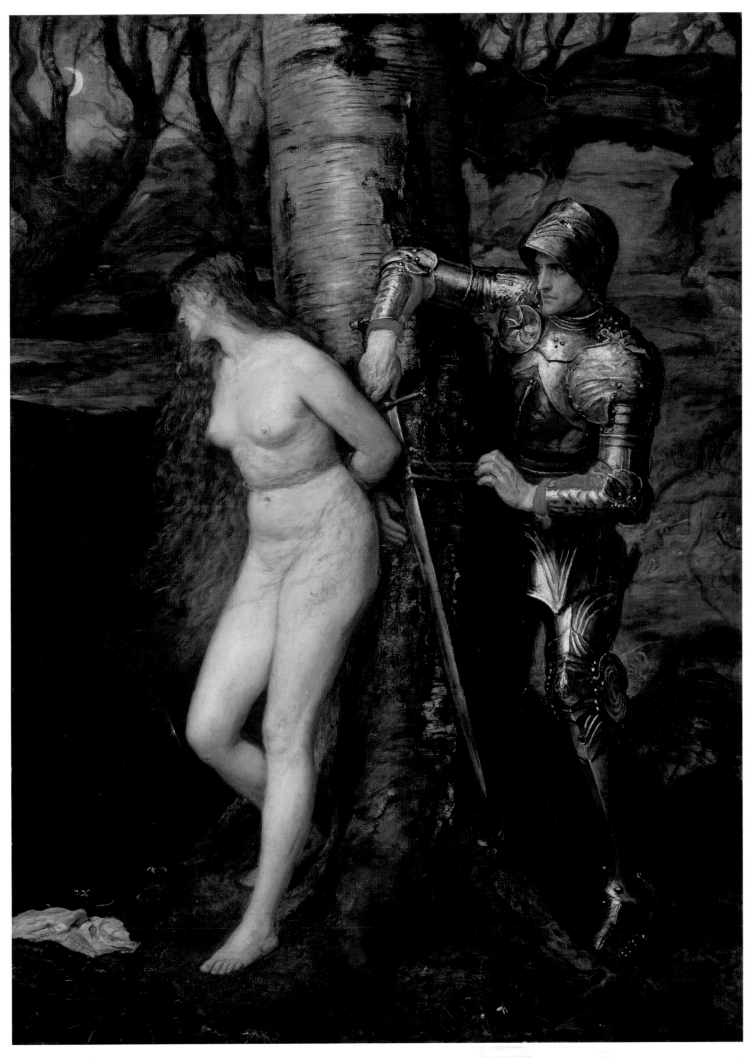

The development of the commercial potential of the nude at mid-century was boosted by what has been termed 'the Parian phenomonen': the appearance of statuary porcelain on the market following successful experiments with the new reproductive technique by the firms Copeland and Garrett, and Minton. The term 'Parian' was chosen because this highly vitrified bisque porcelain was seen to bear a visual resemblance to the pristine white translucent marble which had been quarried since Antiquity on the Cycladic island of Paros. Parian proved to be an excellent medium for figure production, being suitable for slip-casting and consequently smooth, pleasing to the touch and easy to clean. Benjamin Cheverton's recent invention of the Pantograph or reducing machine further helped in the reproduction of original works on a small scale.

The introduction of Parian coincided with a movement seeking to improve national taste through the dissemination of art objects at affordable prices. Originally sold for about two pounds, Parian ware was expensive although much cheaper and of more manageable proportions than marble or bronze, thus highly suitable for mantelpiece decoration. The reputation of sculpture as a more decorous art-form also explains the ready acceptance of Parian nudes in the home. John Gibson, for one, thought sculpture a more refined medium than painting: 'It is an art which requires chaste composition, beauty and correctness of form, high sentiment – painting, on the other hand, admits of a far greater range, it allows for the less beautiful and familiar' (Eastlake 1870, p.17). Such a belief in the edifying potential of sculpture further explains the predominance of single nude females exemplifying the virtues of innocent passive womanhood.

The promotion of Parian owed a lot to its association with the London Art Union and with Felix Summerley's Art Manufactures, established by Henry Cole (using his pseudonym) in 1847 with the intention of connecting art with everyday objects. The Art Union had a similar mission of improving public taste by awarding specially commissioned prizes to subscribers and lottery winners. The legalisation of Art Union lotteries in 1846 led to the development of such schemes throughout the British Isles, and an associated growth in Parian production. AS

John Bell (1812–1895)

13 *Una and the Lion* (also known as 'Purity') 1847
Exh. Great Exhibition 1851
Parian, Minton & Co.
36·8 × 37·5 (14$\frac{1}{2}$ × 14$\frac{3}{4}$)
Victoria & Albert Museum, London

✳

Una and the Lion was conceived in 1846 by Herbert Minton, Henry Cole and John Bell as a replica of the latter's life-size marble of the same subject. Both the original and this modified Parian reproduction were shown at the Great Exhibition in 1851. Other copies by Minton made in collaboration with the sculptor followed soon after – a series of slave subjects inspired by Hiram Powers' famous *Greek Slave* (also exh. 1851, no.46): *A Daughter of Eve* of 1853 (later retitled *The American Slave*), and the companion-pieces *The Octoroon* and *Abyssinian Slave* of 1867–8.

Una was originally sold through Summerley's Art Manufactures (thereafter by Minton's) in both white and coloured majolica versions for two pounds and sixteen shillings. The subject was taken from Book I, canto III of Spenser's *Faerie Queene*, which describes how Una, or True Religion, is protected by a lion symbolising England following her separation from the Red Cross Knight. Anna Jameson defended Bell's idea of representing Una nude, reminding her readers that Antique conceptions of Truth were always unveiled. She also praised the sculptor for generalising the idea, 'treating it with abstract fitness and grace' (Jameson 1854, quoted Barnes 1999, p.32). Bell's decision to show Una riding sideways on a lion, rather than the 'snowy Palfrey' (horse) of Spenser's poem, prompted Minton to market the work as a pair with *Ariadne*, after Henrich Dannecker's Meissen ornament of 1816. Respectively titled *Voluptuousness* and *Purity* – one sitting proudly erect, the other looking demurely away – the works effectively contrast the unabashed nakedness of the Antique with English modesty.

Una remained a popular work throughout the century until Parian was superseded by the vogue for bronze statuettes (see nos.49, 124). In 1883 due to falling sales, Minton decided to clear its stock of remaining figures: *Una* was reduced from two guineas to one. AS

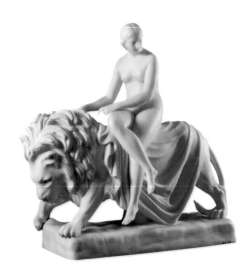

Joseph Pitts (fl. 1830–1870)

14 *Sir Calepine rescuing Serena* 1852
Parian, Coalport
H·46 (18¹⁸)
Victoria & Albert Museum, London

✱

Joseph Pitts, the little-known son of the sculptor William Pitts, produced four notable works in Parian for John Rose & Co. of Coalport in industrial Shropshire, all of which were based on scenes from the *Faerie Queene*. These were the companion-pieces *The Vision of the Red Cross Knight* and *Britomartis unveiling Amoret*, of about 1851, followed by another pair in 1852: *Sir Calepine rescuing Serena* and *Britomartis releasing Amoret*.

The episode of Sir Calepine rescuing Serena from Book VI, canto VIII of Spenser's poem (1596) had been the subject of paintings by both Opie (1798) and Hilton (1831), the latter now in a ruinous state in the Tate. Pitts represents what is essentially a rape scene: Serena lost amidst a savage nation is captured, stripped and bound to an altar as a human sacrifice, only to be saved by Sir Calepine from the priest's 'murdrous knife'. Although the sight of Serena's prostrate naked body beset by swords might have been considered rather distasteful in a mantelpiece, it would have been legitimised as a Spenserian subject elucidating the chivalric code of courtesy: Calepine's pure respect for vulnerable womanhood is set against the savages' rapacious lust as represented by their priest. In the standard book on chivalry, G.P.R. James wrote that courtesy 'taught devotion and reverence to those weak, fair beings, who but in their beauty and their gentleness have no defence' (James 1843, p.30). The details of the armour, the disciplining masculinity of which points up more explicitly the contrast with the provocatively contorted nude, may have been influenced by the writings of antiquarians such as Samuel Rush Meyrick who was responsible for arranging the armour at the Tower of London, a collection Pitts may well have consulted in fabricating this work. AS

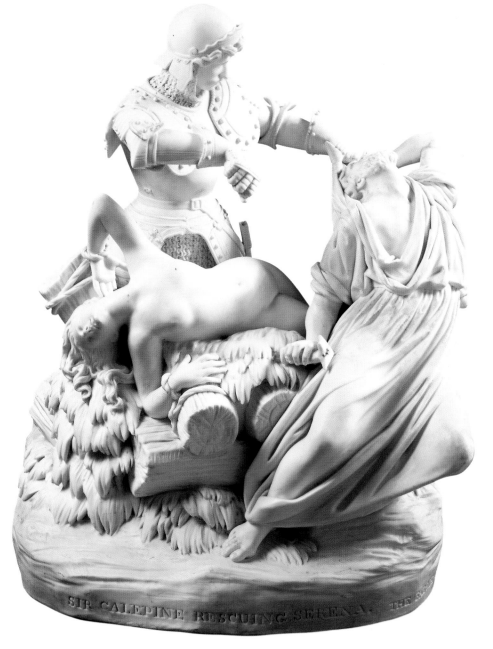

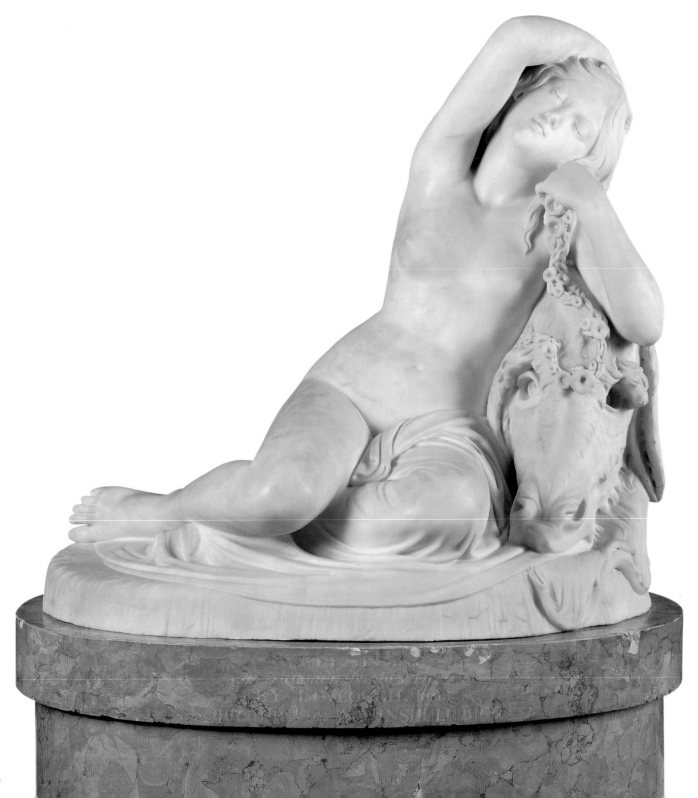

John Graham Lough (1798–1876)

15 *Titania and the Ass's Head* 1863
Marble
72×85×50 (28^3₈×33^1₂×19^5₈)
Victoria & Albert Museum, London

*

In 1841, having recently returned from a period of study in Rome, Lough embarked on the ambitious project of creating a new genre he termed 'lyric sculpture'. He later explained to Samuel Smiles that he had determined to strike a new path, believing that 'the Greeks had exhausted the Pantheistic, and that heathen gods had been overdone' (Lough and Merson 1987, p.57). This was a bold venture considering the prejudices which existed against sculpture as an appropriate medium for representing subjects of picturesque fantasy.

Titania is based on an original exhibited along with four other Shakespearean pieces at the Great Exhibition of 1851. When the Crystal Palace moved to Sydenham in 1854, *Titania* was included in the modern sculpture section together with the artist's *Puck* and *Ariel*. This 1863 version was commissioned by Lough's most loyal private patron, Sir Matthew White Ridley, a Shakespeare aficionado.

Ever since Boydell established his Shakespeare Gallery in 1789, *A Midsummer Night's Dream* had proved popular with British painters for the possibilities it offered for the representation of a fairy world of empyrean types which also suggested the fantasy of an uncorrupted British Arcadia. As the *Edinburgh Review* wrote in 1848 with regard to Shakespeare's fairies: 'our imagination has conversed with a more delicate creation than the sensuous divinities of Greece, or the vulgar spectres of the Walpurgis-Nacht' (quoted Jackson 1997, p.42). Titania was the most frequently represented subject from *A Midsummer Night's Dream*, epitomising as she did the Victorian ideal of ethereal womanhood. Fuseli, Etty, Dadd, Huskisson, Landseer, Paton (no.8) and John Simmons were just some of the artists to take up the theme. Lough's *Titania* follows painterly conventions in adopting a sweetened classicism: the fairy has a delicate face, small breasts and a gracefully raised arm, features which can also be seen in other nudes of the mid-century based on literary sources. The contrast here between Titania and the grotesque realism of the ass's head upon which she reclines so gently, confirms not only Lough's reputed skill in depicting animals, but more significantly his concern to carry over something of one of Shakespeare's most pungent visual images into the traditionally more bland medium of sculpture. AS

Pierre-Émile Jeannest (1813–1857)

16 *Lady Godiva*, based on a trial-piece of 1856; inscribed on base 'Given by the Queen to the Prince Consort, August 26th 1857'
Statuette of silver on a bronze base with champlevé enamelling
Elkington and Co.
79·4×62×42·5 (31^1₄×24^3₈×16^3₄)
Lent by Her Majesty The Queen

*

Émile Jeannest was the son of the bronzier Louis-François Jeannest of Paris. He trained under the great historical painter Delaroche from whom he developed an interest in English medievalism, as shown by the number of chivalric works he produced throughout his career. Around 1845 Jeannest moved to England where he worked as a ceramic modeller for Minton's in Stoke-on-Trent. In 1850 he transferred to Elkington's in Birmingham where he took charge of the Fine Art department while continuing to work as a designer and modeller. At Elkington's Jeannest also pioneered the use of champlevé enamels on secular pieces, of which this work is a notable example. Elkington's were known for their electroplate metalwork, having obtained a patent for various electrical processes of gilding and plating metals in 1840. Jeannest's statuette may well have been conceived partly as a demonstration of these techniques.

The statuette presents Godiva mounted on a magnificently adorned horse, the caparison of which is decorated with the insignia of Coventry. Her body conforms to a type often seen in mid-Victorian art, being curvaceous, graceful and veiled only by long flowing hair. The equestrian figure surmounts an elaborate plinth supported by twisted columns and decorated with champlevé ornamentation. On the long sides of the base are inserted two bronze relief panels with designs by Jeannest illustrating the key episodes of Godiva confronting Leofric, and her ride through the town observed by Peeping Tom. Both short sides are gilded with coats of arms.

Queen Victoria is not known ever to have witnessed the Godiva Procession, but Godiva's gesture of self-sacrifice may have appealed to her. In the 1840s she showed an interest in Landseer's painting of the subject (Lennie 1976, p.209), and received as a gift a poem titled *Lady Godiva* by one H.W. Hawkes (Burbidge 1952, p.54). In commissioning Jeannest's work she was effectively participating in the popular enthusiasm for Godiva as a national heroine and people's redeemer, in contrast to George IV who back in 1826 had denied any interest in the subject following rumours that he was going to purchase a life-size painting of *Lady Godiva of Coventry* then on show at a gallery in Pall Mall (Whitley 1930, pp.109–10). Victoria's patronage is indicative of a shift in perception of the Godiva legend following the publication of Tennyson's poem, but also illustrates the taste she shared with Albert for the nude. Jeannest's piece was one of several nude works commissioned by Victoria as birthday gifts for Albert; other presents included three paintings

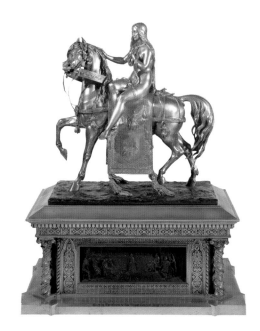

by W.E. Frost: *Una and the Wood Nymphs*, *L'Allegro* and *The Disarming of Cupid*, given respectively in 1847, 1848 and 1849. The royal motto 'Honi soit qui mal y pense' ('Shame on he who thinks ill of this') may have helped to sanction the taste of the Royal couple; and certainly these purchases helped confer greater respectability upon the nude itself. AS

Thomas Woolner (1825–1892)

17 *Lady Godiva, Countess of Coventry c.*1878
 Exh. RA 1878
 Marble
 135×36×24 (53^18×14^18×9^12)
 Herbert Art Gallery and Museum, Coventry
 ✱

Thomas Woolner is best known for his
membership of the Pre-Raphaelite
Brotherhood, with whom he shared a keen
interest in English literature and history. He
was also a poet on close terms with Tennyson
whose 'Godiva' of 1842 might have informed
this statuette. Before he entered the Royal
Academy schools in 1842, Woolner trained for
a while with the sculptor William Behnes who
exhibited a statuette of *Lady Godiva* at both the
Academy in 1844 and the Great Exhibition of
1851. A surviving plaster version of this work
in Coventry shows Godiva alighting from her
horse, a scene typical of its time except that
the heroine is conceived along classical lines,
lacking the rounded hips that distinguish most
female nudes of the period. How far Woolner
had Behnes's image in mind when he started
work on his sculpture many years later is
uncertain, but he too offers an antique Godiva,
with hair arranged in the Greek fashion and
garments falling around her waist in a
classicising manner. Only the details of her
girdle identify her as a medieval
Englishwoman.

 Woolner exhibited this statuette the year
after he was appointed Professor of Sculpture at
the Royal Academy, accompanied by some lines
he may have composed himself: 'No beauty she
doth miss | when all her robes are on | but
Beauty's self she is | when all her robes are
gone.' The idea of Godiva as being primarily an
embodiment of beauty rather than of morality
strikes a new Aesthetic note, and prefigures
the themes of Woolner's poem *Pygmalion*
(published 1881), in which he developed the
idea envisaged here of beauty revealed through
art. AS

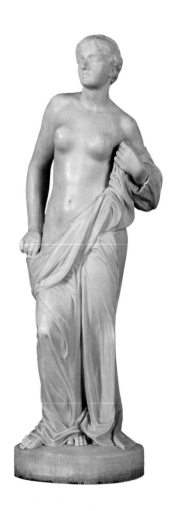

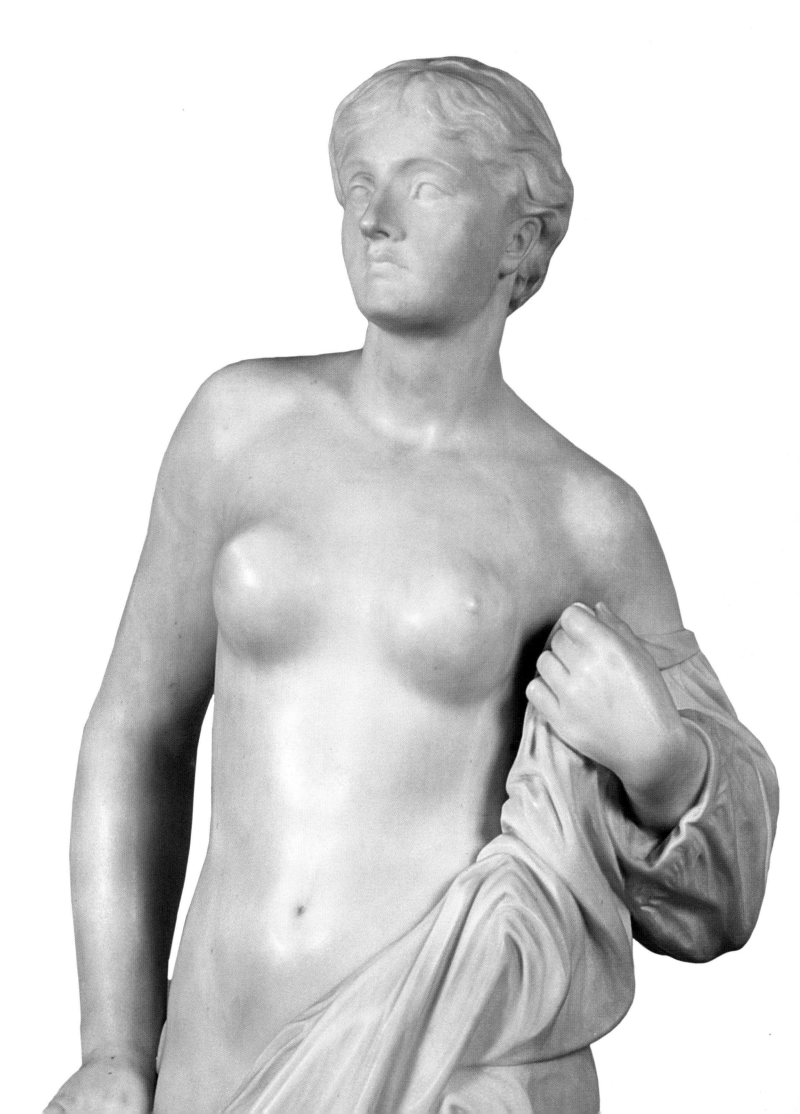

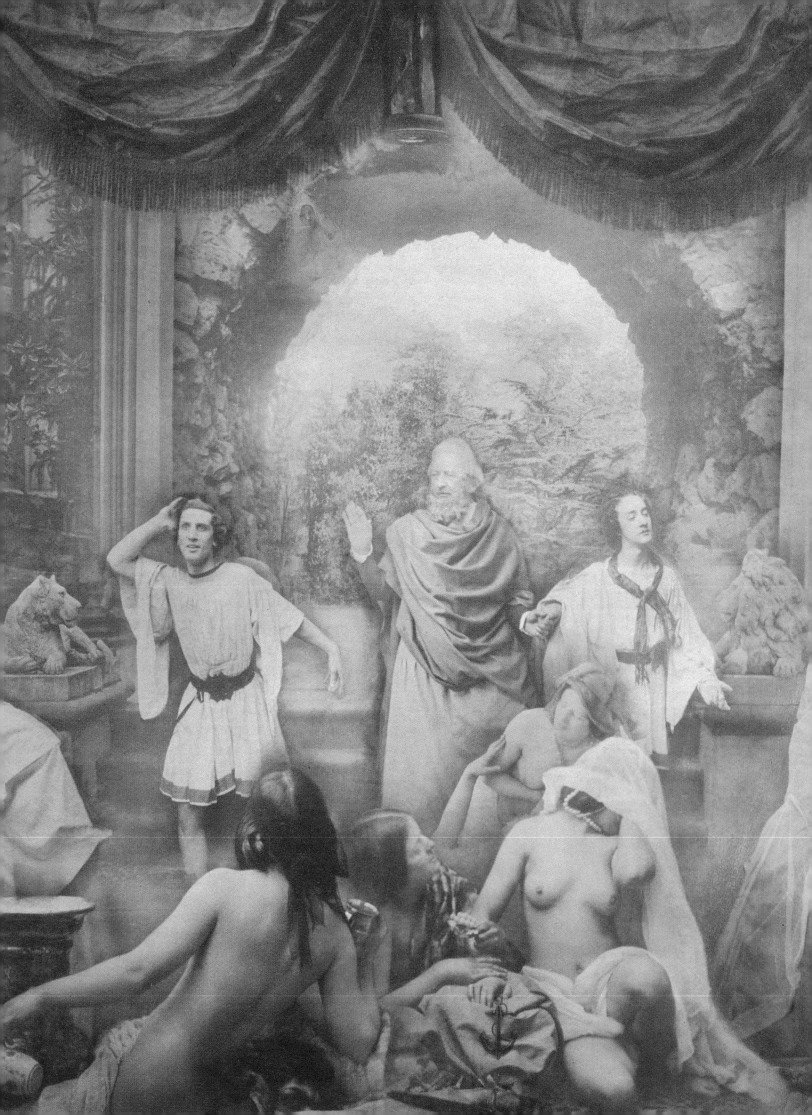

Oscar Gustave Rejlander (?1813–1875)

18 *The Two Ways of Life* 1857
Carbon print from the 32 original negatives,
1925
50·3×76 (19¾×30)
The Royal Photographic Society, Bath, UK
⚘

In April 1858, 'a long photographic year' after
producing *The Two Ways of Life*, O.G. Rejlander
was invited to appear before his fellow
members of the Photographic Society of
London to explain his motives and methods.
Rejlander laid out his purposes – to show that
British photographers could compete
internationally; to show how photography
could aid artists; and 'To show the plasticity of
photography ... [by] bring[ing] in figures draped
and nude ...' Aptly referring to the composition
as a stage, he 'lifted the curtain to introduce ...
the dramatis personae' (Rejlander 1858,
pp.191–2). He then explained the moralising
story (which he evidently invented) of two
youths setting out on life, one taking the high
road (to the right), the other the low road (to the
left). Rejlander explained precisely how he
contact-printed 32 glass negatives onto two
pieces of paper without breaking the laws of
perspective and composition. The whole project
had taken six weeks, rushing to be ready for
the Manchester Art Treasures exhibition,
where Queen Victoria purchased a copy for
Prince Albert.

His colleagues generally praised Rejlander's
achievement, but in the ensuing discussion
some voiced concerns about the nudity and
about the models. As a member, Mr Crace,
observed '... it certainly is to be regretted that
two or three figures in it, though, perhaps not
exactly indelicate, verge so closely upon it, as to
prevent ... general approval of the picture ...'
Rejlander replied that '... if the models were
not perfect, I tried to make the most of them.
I carefully selected, and where I could I draped.
I tried to show what was good, and hide what
was bad ...' Another member, Mr Buss,
commented 'I can scarcely conjecture where he
went for his models.' And a third, Mr Monson,
said that he had visited Rejlander at his studio
in Wolverhampton, which he deemed 'the most
unlikely place in the world for such a purpose'
(Rejlander 1858, pp.196–7).

The unarticulated subtext of these
comments was fear that Rejlander had stooped
to engaging prostitutes to pose naked for him,
which would belie his moralising and
undermine photography's claims to High Art
status. Since nudity is equated with vice in
Rejlander's *grande machine*, his colleagues can
hardly be blamed for their suppositions. Years
later Rejlander revealed he had employed
members of a touring pose plastique troupe,
performers used to holding frozen attitudes
derived from paintings and sculptures for long
periods on stage while clad only in fleshings,
tight body stockings that, at a distance,
approximated nudity. Since polite society
regarded the pose plastique as a low form of
entertainment, Rejlander would not have
burnished his reputation by admitting this
association to his colleagues. VD

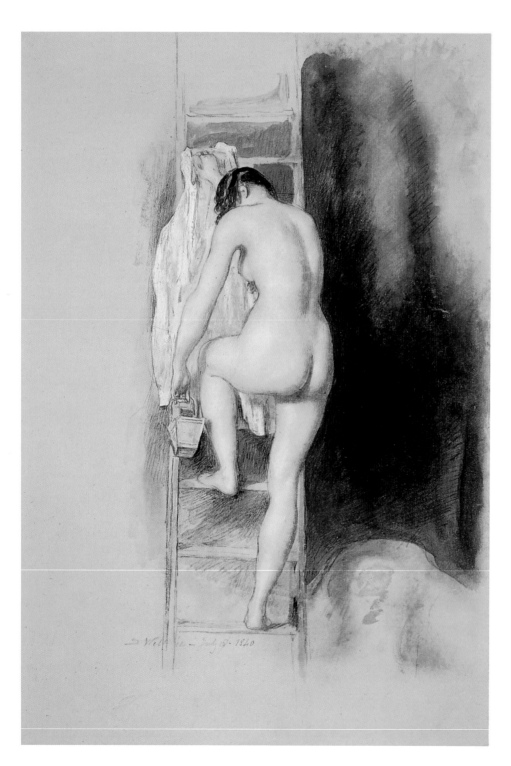

19 *Female Nude Climbing a Ladder*, 1840
Black and red chalk with watercolour, touched
with bodycolour on paper.
33·1 × 22·7 (13 × 9)
The British Museum, London

✱

Originally known as a genre painter, Wilkie
increasingly ventured into the ambitious realm
of history painting. This drawing was one of
several life-studies made in 1840, possibly
preparatory exercises for the historical
compositions he planned to produce following
his expedition that autumn to the Holy Land, a
visit from which he never returned.

It is not certain whether this drawing is an
académie or an intimate study made in the
private studio. The glimpse of a model pausing
on a ladder relates to the custom some teachers
at the Academy (notably Turner, Constable and
Etty) upheld in staging *tableaux vivants*, with the
aim of developing a wider repertory of poses
than admitted by the Antique. The inclusion of
the vessel introduces a hint of the quotidian as
well as functioning as a stabilising device: a
similar prop appears in Academy studies of
around the same date (see for example, no.20).

As for the ladder, Wilkie had made several
studies during the later 1830s of figures on
ladders in connection with his large historical
painting *Sir David Baird Discovering the Body of
Tipoo Sahib* exhibited in 1839. The interplay
between close observation and compositional
invention can also be seen in the life-studies of
Etty and Mulready; the latter's use of combined
chalks and habit of introducing narrative
suggestions into his drawings, may well have
been influenced by Wilkie's practice. Despite
its naturalistic appearance, this study betrays
a sound knowledge of the Old Masters,
particularly Rubens in the use of mixed media
and reflected colours. The precise contours
enclosing the figure and clear axial line linking
neck and foot would further suggest that the
artist did not forsake classical conventions
altogether in pursuing a more spontaneous
form of expression. AS

Charles West Cope (1811–1890)

20 *Two Life Studies* 1852
Pen and ink on white paper
21·1 × 14·3; 21·5 × 15·4 (8^1_4 × 5^5_8; 8^1_2 × 6^1_8)
(papersize)
Victoria & Albert Museum, London

❋

These two studies were produced by Cope during the time he served as Visitor to the Royal Academy life-class. Each year the institution appointed nine academicians to the position of teacher or 'Visitor' to the class, where, working one month in rotation, they were responsible for setting the pose and instructing students. Some Visitors taught through example, drawing alongside their students, and these studies may have been intended as guides in how to reconcile meticulous copying with the idealising aesthetic honoured by the Academy. The drawings present the same pose from different viewpoints. The model looks modestly down; her left hand rests on a plinth covered with a drape, her right hand holds a jar, while her left foot is raised upon a block. Such devices enable her to assume the contrapposto (or serpentine pose) of an Antique Venus. Her hairless pudenda and sharply defined contours reinforce the statuesque appearance of the figure. Only the coiffure and rounded proportions identify her as a contemporary model.

During the time Cope served as Visitor and later as Professor of Painting at the Academy (1866–75) there was considerable debate over how far the Visitor system benefited the development of the national school. While defenders approved of the careful and precise imitation instilled by the teachings of a succession of instructors, detractors advanced a French system which taught style and fluidity under the tutelage of one master in contrast to what they disparaged as the 'mechanical practice of statue copying' (*Athenaeum*, 30 Aug. 1862, p.281). Holman Hunt later recalled the tedious discipline required of him as a student at Sass's art school in London, the regular cross-hatching with 'a dot in every empty space' (Hunt 1905, p.34). Cope's drawing upholds this method; the figure is carefully blocked out, the lines follow the contours of the figure and together with the stippling create the effect of an engraving. So closely has the artist attended to the dotting that he loses sight of proportion in the areas of the feet and thighs in the frontally posed figure. AS

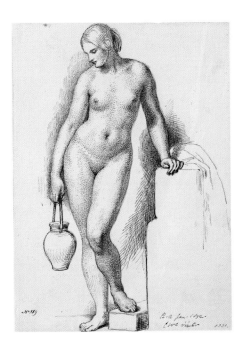

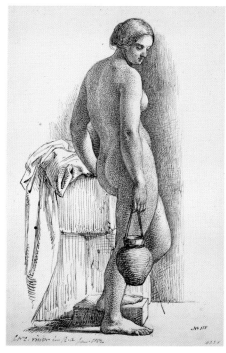

William Mulready (1786—1863)

21 *Male Academic Study* 1845
Black and red chalk on paper
48·2 × 34·3 (19 × 13¹₂) (papersize)
Victoria & Albert Museum, London

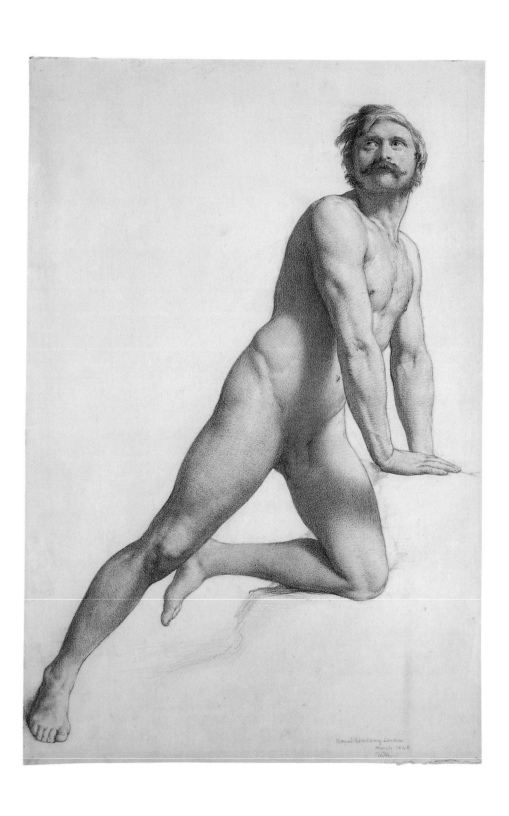

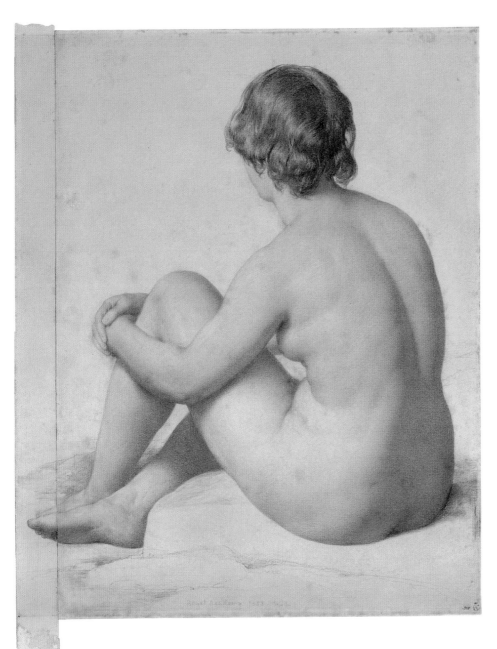

William Mulready (1786–1863)

22 *Academic Study of a Female Nude Seated on the Ground* 1853
Black and red chalk on paper
36·3 × 29·7 (14¼ × 11¾)
Victoria & Albert Museum, London
✻

Like Etty, Mulready was a long-standing devotee of the life-class, although it was only in the 1840s that he advanced the technique for which he became renowned: the meticulous combination of black and red chalks to convey the fall of light and shadow over solid form. This method he developed through arduous study at the Kensington Life Academy, a private society which met three evenings a week at the residence of the painter Richard Ansdell. Mulready also drew from models as Visitor to the Royal Academy life-class and at the South Kensington schools in the early 1860s. His life-studies came to epitomise the ideal of the English nude by virtue of his ability to simulate the appearance of wholesome flesh through a skilful employment of a 'stump' to blend chalks and bread to erase tones to create highlights. Evidence of Mulready's empirical methods are evinced by the extra strip added to the left side of the seated female study to extend the composition. Although his aim was to represent the nude with naturalism he was concerned to elevate the subject beyond the confines of the studio; a cushion has thus been transformed into a rock in the female study, while the male figure is presented as a dynamically posed athlete. Speaking at the Royal Academy Commission in 1863, Mulready criticised the Pre-Raphaelites for their 'indifference to beauty' and the Antique, just as Holman Hunt later condemned Mulready for his 'Dresden-china prettiness' (Royal Academy Commission 1863, p.170; Hunt 1905, I, p.49).

Mulready's drawings were frequently held up as exemplars of British draughtsmanship, partly to dispel accusations of inferiority in the field. Queen Victoria was one of Mulready's admirers and purchased a drawing for Albert after viewing a group of his life-studies at Gore House in 1853. Writing to the Queen's intermediary, Col. C.B. Phipps, about the purchase, Mulready expressed his hope that the Queen's interest would help promote life-study and thus further the cause of the British school (Mulready mss). However, enthusiasm for his drawings began to wane following the adoption of broader techniques in the late 1860s. Thomas Woolner was later to regret how Mulready's drawings came to be considered old-fashioned and deemed of little worth (Woolner 1917, p.280). Ruskin, never consistent in his opinions on the nude, described the artist's life-studies as 'more degraded and bestial than the worst grotesques of the Byzantine or even Indian image makers' (Complete Works, XXIII, p.18). AS

William Holman Hunt (1827–1910)

23 *Academic Study of a Female Nude* 1858
Pen and ink with bodycolour on buff paper
50·9 × 35·6 (20 × 14)
Birmingham Museums & Art Gallery
✿

Although the nude is virtually non-existent in
Hunt's painted oeuvre, he often drew from
models while developing compositional ideas.
He was trained to draw with mechanical
precision at Sass's art school, and later
benefited from Mulready's instruction as
Visitor to the Royal Academy life-class. This
study was produced at the Kensington Life
Academy, a private club where artists took it in
turns to position the model. Early members
included Frith, Leighton, Val Prinsep, John
Phillip and Mulready, to whom this drawing
is indebted for its close observation and linear
pen and ink technique. However, Hunt took
to greater extremes the concern for detached
scrutiny: the model is viewed from behind with
hard-edged accuracy and there is no attempt
to flatter or soften the form. AS

Frederick Sandys (1829–1904)

24 *Female Nude: Study for 'Bhanavar the Beautiful'*
c.1864
Black, red and white chalk on brown paper
39·7 × 26·4 (15⅝ × 10⅜)
Birmingham Museums & Art Gallery
✿

This drawing is one of two surviving studies
made by Sandys for the watercolour *Bhanavar
the Beautiful* commissioned by the publishers
Chapman and Hall as the frontispiece for the
second edition (1865) of George Meredith's
novel *The Shaving of Shagpat*. Sandys is known
to have stayed with Meredith in 1864 and the
idea of a figure dancing among serpents may
have evolved from discussions with the writer.

 The careful repeated observation of parts
such as the arms and hands is subsumed by a
general idealisation of form with the intention
of capturing the effect of undulating
movement. A figure of Ettyesque proportions
dissolves beneath the thighs into a loose
formation of entangled lines. Sandys trained at
the Norwich School of Design in the mid-1840s,
which, like other governmental schools, was
established for the education of designers of
ornament and decoration, and was legally
restricted from teaching drawing or painting
from the nude figure: instead students were set
to study from ornamental and vegetal models.
The emphasis on linear decoration seen in
this drawing would have been instilled by this
system and subsequently developed through
Sandys' work as an illustrator in the early
1860s. AS

Ford Madox Brown (1821–1893)

25 *Academic Study of a Man* late 1840s
Pencil on paper
17·2 × 14·2 (6¾ × 5⅝)
Birmingham Museums & Art Gallery
✿

Although never formally a member of the
Pre-Raphaelite Brotherhood, Brown played a
significant role in developing the objectives
of the movement. Trained in the academies of
Bruges, Ghent and Antwerp in the later 1830s,
he was taught to draw in a disciplined manner
which he later called 'hard, pedantic or Belgian'
(Rabin 1978, p.3). This study may date from
around 1847 when Brown worked for a while at
a studio in Camden Town made available to him
by the painter Charles Lucy who held a life-class
there. This school transferred to central London
in 1848 where it became the Maddox Street
Academy offering evening classes to
professionals and aspirants to the Royal
Academy schools. The drawing contains
something of the neo-classical austerity of
Brown's early education, coupled with the
objective analysis he strove for in the many
studies he made from living motifs. AS

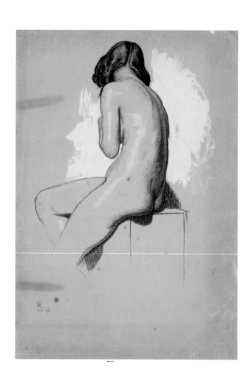

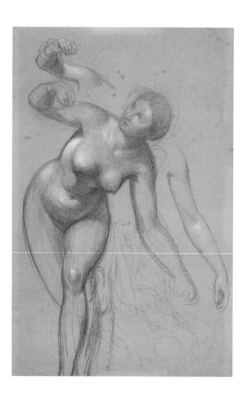

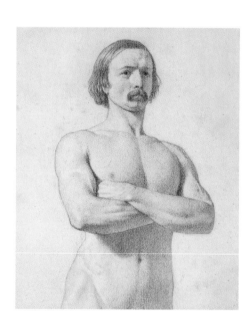

John Everett Millais (1829–1896)

26 *Study of a male nude seated as if on horseback*
c.1843–53
Pencil and pen and ink on white paper
31·8 × 21·8 (12¹₂ × 8⁵₈) (papersize)
Victoria & Albert Museum, London

❋

This life-study of a naked male positioned as if astride a horse is a striking example of the inventive posing that took place in life-classes during the mid-nineteenth century. The model sits confidently on a block which has been covered with a cushion and drape, holding props resembling a whip or sword in one hand and reins in the other. The drawing could date from 1843 when Millais was admitted to the life-class of the Royal Academy, where because of his age he could only study from the nude male model. However, it may have been executed during the mid-1850s, perhaps around the time he kept studio at Langham Chambers, where he is likely to have attended the Langham Sketch Club. The cross-hatching and stippling further relate to the technique Millais developed as an illustrator in the 1850s.

The drawing appears to be as much a portrait as a life-study, the individualised face contrasting with the more generalised forms of the body. The accentuated shoulder and pectoral muscles may well have been informed by the studies Millais made as a student from the Elgin Marbles at the British Museum. In keeping with the teachings of Haydon, Millais presents his model (probably a soldier) as a worthy successor to the Parthenon horsemen, except that the ease and grace of the latter have been transformed into a figure captured at a moment of violent action. The study might also relate to the sporting sketches Millais produced around 1853 when he befriended the *Punch* illustrator John Leech who introduced him to the excitement of riding to hounds. AS

The Classical Nude

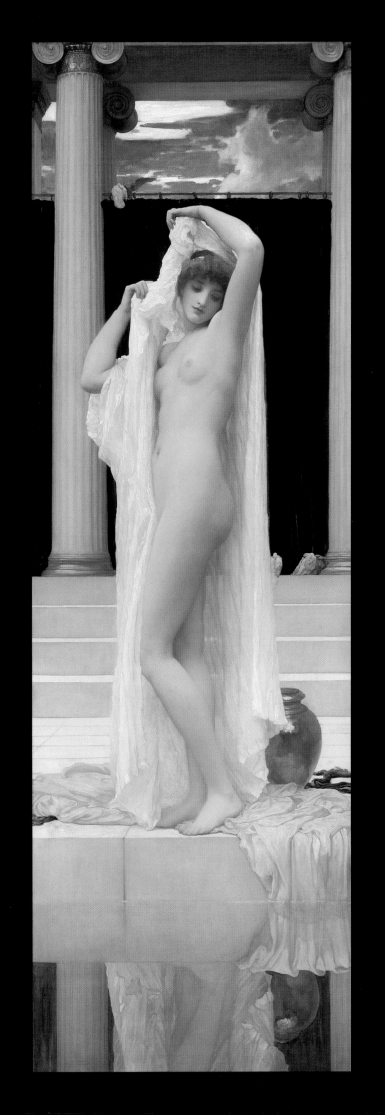

Although a classical tradition of representing the nude had existed in Britain since the eighteenth century, it received a renewed impetus in the 1860s when a group of young 'progressive' artists developed a more international conception of the figure. Several of these painters had trained abroad, some in Parisian ateliers, where they became conscious of the superior draughtsmanship of the French school as epitomised by Ingres and his followers. Reacting against what they considered to be the parochialism of the 'English Nude' and an unsystematic way of studying the subject in Britain, these artists presented their figures as essays in high art, emphasising classical themes, while decisively elevating style and form above narrative. The 'renaissance' of the nude was heralded by the exhibition of Leighton's *Venus Disrobing* at the Royal Academy in 1867 (fig.20), and developed thereafter among two interconnecting circles of artists centered on Leighton and Watts at Holland Park, and Rossetti at Cheyne Walk. These artists had the support of a number of influential writers and critics, including Swinburne, Sidney Colvin and F.G. Stephens, as well as a coterie of collectors, several of whom were Liberal MPs.

Associations with the Antique helped divorce the nude from any implication of sexuality. Following the periodisation of the eighteenth-century aesthetician Winckelmann, Greek sculpture of the fifth and fourth centuries BC was accorded the highest status, distinguished from both the 'primitive' work of the earlier period and 'decadent' later sculpture. This view corresponded with a widely accepted interpretation of classical history which was seen to have reached its moral zenith in fifth-century Athens, descending into corruption and lassitude in the Hellenistic era and Roman Empire. While some painters drew on the current interest in the material remains of Antiquity and adopted the idea of restoration as a justification of the nude, others looked beyond archaeological reconstruction in favour of emulating the spirit of a lost Greek ideal. Venus was naturally a key motif for the nude in the late 1860s: the accepted Antique form of the classical goddess of beauty was seen to elicit a pure disinterested response in the beholder and was of course sanctioned by a long western tradition of representation. Nevertheless, the residual equation between the subject

of Venus and carnal desire led some artists to 'purify' the female form by reference to the fifth-century Greek masculine ideal, hence the heavy musculature and impassive expressions that distinguish many female nudes of the period. At the same time artists sought to 'effeminise' the male nude, offering a more youthful ideal of masculine beauty than the stalwart Herculean types of the early Victorian era. Although the classical nude was still accused of promoting paganism and sensuality, a greater acceptance of the subject, albeit in select circles, owed much to the emergent doctrine of aestheticism, which argued that a work of art should appeal to the senses through its abstract, formal qualities, and that art was a concern exclusive of religion, morality or duty. This said, a key aspect of this pure art project was its engagement with both heterosexual and homosexual eroticism, which meant that despite its high art status, the artistic nude remained a morally ambiguous category.

In the broader cultural sphere the classical nude became important in the formation of public taste and morals. Cast collections were developed not only for study purposes in art schools, but were also established

Fig.20
Frederic Leighton
Venus Disrobing for the Bath 1866–7
Oil on canvas
Private Collection

by private enterprise and for commercial puroposes, Brucciani's gallery of plaster casts which opened in Covent Garden in 1864 being one notable example. Improvements in reproductive techniques with the development of reduction, pointing and mechanical carving machines, assisted in the broad dissemination of high-quality copies in a variety of sizes. As British culture became more cosmopolitan in the second half of the century, the classical ideal extended beyond the realm of fine art and became an important model of hygiene, medicine and social evolution. The Greek ideal of the gymnasium fuelled a male culture of athleticism and physical exercise, while the fuller waist and proportions of Venus were held up as a model for 'natural' womanhood, sustaining women's traditional biological purpose yet also the more controversial notion of female emancipation that was being projected around the time of the passing of the 1867 Reform Bill. The flexibility of the classical nude and its ability to support traditional, alternative and emergent ideas of masculinity and femininity thus gave it both authority and relevance in modern art and society. AS

Jean-Léon Gérôme
Phryne before the Tribunal 1861
(no.28, detail)

**After Jean-Auguste-Dominique Ingres
(1780–1867)**

27 *La Source* c.1859
Oil on canvas
24×12·5 (9⅜×5)
Musée du Louvre, départment des Peintures
Presented by Jean-Baptiste-Joseph Macotte-
Genlis, 1867

❀

Ingres was internationally regarded as the
master of the classical nude, and his figures
praised for representing a type that connoted
ideal beauty, aristocratic culture and the
stability of the classical tradition. *La Source* was
widely reproduced as an exemplar of the *figure
d'étude*, and this small version is probably a copy
made by one of Ingres's pupils after the artist's
celebrated 1856 original, itself a reworking of
an earlier *Venus Anadyomene* begun as early as
1808. The copy provides testimony to the group
discipline upheld by the French ateliers where
students worked under a single master,
subordinating individual expression to the
maintenance of a school style.

 The study displays the hallmarks of Ingres's
style and teaching: the figure is an exercise in
draughtsmanship in which contour and surface
transitions of light and shade are emphasised
above colour, anatomical correctness or any
suggestion of narrative. The exhibition of the
original at the International Exhibitions held in
London and Paris in 1862 and 1867 proved a
revelation to English critics and painters: here
was a figure that conveyed in paint the chaste
and formal qualities of sculpture, as F.G.
Stephens enthused in the *Athenaeum*: 'The
English people know little of this extraordinary
artist, whose treatment of the nude is so
ineffably chaste that we can only marvel whence
the critic who attributed a lascivious "motive"
to the result got his coloured spectacles' (1862,
p.563). *La Source* became the prototype for
a new classical style of nude painting that
developed in Britain during the late 1860s,
which elevated form above subject-matter (see
nos.29, 30). The transmission of the classical
figure beyond the French Academy not only led
to the development of an international ideal,
but also gave rise to a perception that Ingres
was ultimately responsible for a 'bland' de-
nationalised type of nude, which Camille
Mauclair for one dismissed as 'the woman ...
that has no racial characteristics' (Mauclair
1903, p.23). AS

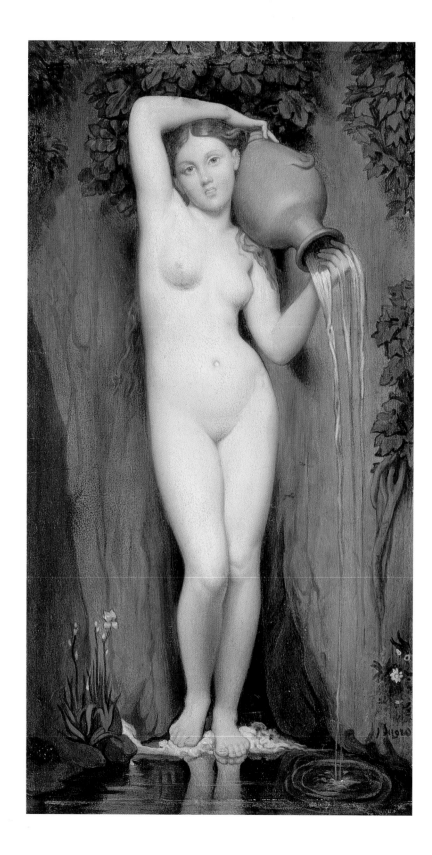

Jean-Léon Gérôme (1824–1904)

28 *Phryne before the Tribunal* 1861
Exh. Paris Salon 1861; FGPM, 1866; Exposition
Universelle, Paris, 1867
Oil on canvas
80 × 128 (31¹⁄₂ × 50³⁄₈)
Hamburger Kunsthalle

✿

Phryne, an Athenian courtesan of the fourth
century BC, was one of the celebrated Hetairai
or accomplished prostitutes of antiquity, and
was also reputed to be the model for her lover
Praxiteles' famous *Aphrodite of Cnidos*.
Gérôme's painting was based on the incident
recounted by Athenaeus, describing how Phryne
bathed audaciously in front of the pilgrims
assembled at the great festival of the Eleusinia,
a spectacle which inspired Apelles to paint his
legendary picture of *Aphrodite Anadyomene*.
Having dared to impersonate Aphrodite, Phryne
was tried for impiety before a tribunal of judges
but was acquitted on account of her beauty the
moment her lawyer (another former lover)
exposed her body before the jury.

During the nineteenth century the story
was often used to reinforce the belief that bodily
perfection invited a pure disinterested gaze,
an idea upheld by the Kantian aesthetic of
transcendent beauty. But Gérôme's picture
appears to belie such an aesthetic by placing
the unclothed Phryne near to an image of the
warrior maiden Athena: the excitement aroused
in the audience by the impact of the courtesan's
body results in a loss of that composure signified
in the picture by the armoured statuette of the
goddess. Certainly it was the leering expressions
of the judges that caused offence when the
painting was exhibited in London in 1866, for
it seemed that Gérôme was undermining the
idea that beauty was capable of exerting moral
control over the beholder. Moreover, the
elevation of Phryne on a platform, together with
her discarded garments and attitude of shame,
did little to allay anxieties being voiced at the
time over the morality of the life-school, both in
terms of the class of women employed and the
behaviour of students when confronted with a
naked model.

Viewed separately from the context of the
composition, Gérôme's *Phryne* was admired for
displaying the flawless draughtsmanship and
classical sculptural qualities of the French nude.
The figure is reminiscent of Pradier's marble
Phryne exhibited at the Great Exhibition of 1851,
not to mention Ingres's *La Source*. The painting
entered the collection of Heinrich Schröder, the
German proprietor of a London banking firm,
but became widely known through engraved
and sculpted reproductions. The controversy
over the narrative implications of the painting
seems to have encouraged English painters of
the nude to concentrate on the classical figure in
isolation. However, the combination of technical
mastery and sensationalism displayed here was
ultimately to prove irresistible, influencing a
later generation of British painters to study in
France (Gérôme was a Professor at the École
des Beaux-Arts from 1863) and to establish
their reputations at home with dramatic
archaeological nude subjects. AS

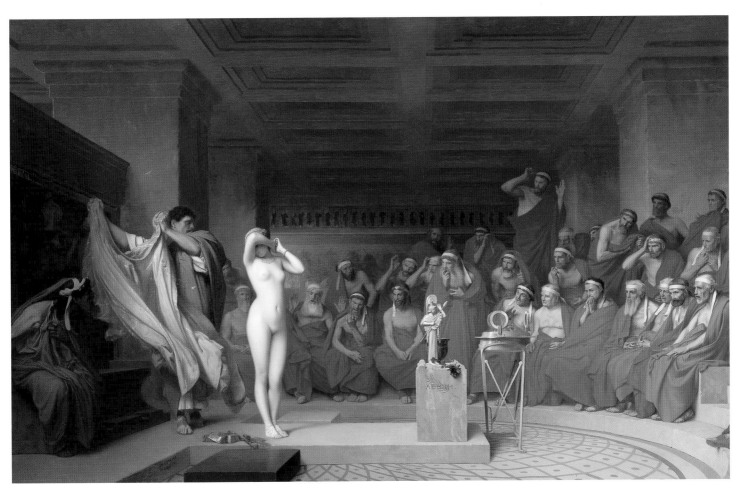

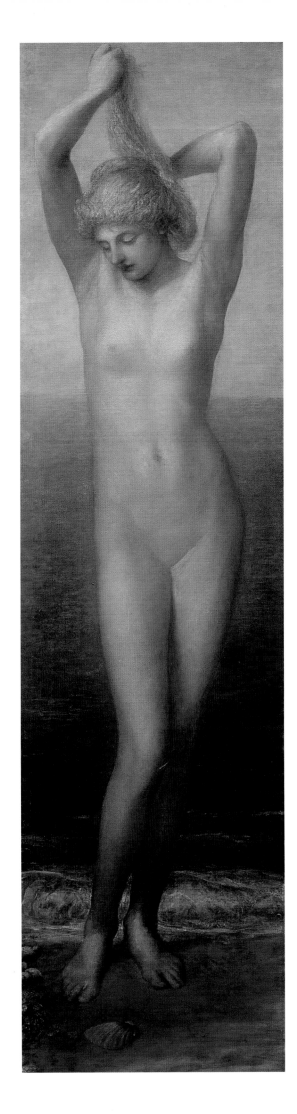

George Frederic Watts (1817–1904)

29 *Thetis* 1867–9
The original exh. RA 1866
Oil on canvas
192 × 54 (75⅝ × 21¼)
Trustees of the Watts Gallery

✱

Thetis was the first of a succession of standing
female nudes adapted from the format made
famous by Ingres with his *Venus Anadyomene*
and *La Source*, the original of which Watts
probably saw at Ingres's studio in Paris in 1856.
According to Mary Watts, the artist produced
three versions of *Thetis* between 1866 and
1869, all relating to a series of studies made
from a favourite model known as 'Long Mary'.
This painting is a much larger variant of the
original study Watts exhibited at the Royal
Academy in 1866.

 Thetis was seen to mark a radical departure
from the luxurious and fleshy nudes associated
with Etty and which Watts himself had painted
in the 1840s. Despite the titular reference to the
Nereid of Homer's *Iliad*, there is no emphasis
on character or narrative situation. Homer had
humanised Thetis as the protective mother of
Achilles, but Watts depicts her as a slender
pubescent girl with small hips and breasts.
The treatment of the form is general and typical
and, in keeping with the philosophy Watts
later espoused that 'indecency clings to the
idea of the individual', there is no suggestion
of a particular model (Watts 1912, III, p.11).
The figure is classical in terms of pose and
proportion (there are eight heads to the body),
and the hair is confined to the head, apart
from a raised lock that serves to accentuate the
elongation of the composition. The dry, fresco-
like paint surface further functions to suppress
any connotation of sexuality.

 It was precisely these qualities that
distinguished *Thetis* from the sensational nude
exhibits of 1866 (see nos.11, 28). Writing in
The Times, Tom Taylor thought the work stood
apart on account of its 'style' and appealed to
'the specially cultivated taste' (5 May 1866, p.9).
But such an argument for a detached, purely
aesthetic perception of the nude would at this
period have represented a rarefied, minority
position, albeit one which was shared by a
coterie of wealthy collectors, among whom
was the Liverpool shipping magnate Frederick
Leyland who so admired the study of *Thetis*
when it was exhibited at the Royal Academy
that he asked Rossetti for an introduction to the
artist and subsequently purchased the work. AS

Albert Moore (1841–1893)

30 *A Venus* 1869
Exh. RA 1869
Oil on canvas
159·8×76·1 (63×30)
York City Art Gallery (presented by the executors of Cecil French, 1954)

✽

In 1867 Moore painted a subjectless female nude entitled *A Wardrobe*. It was probably after viewing this work in Moore's studio that Frederick Leyland encouraged the artist to paint a life-size Venus to add to his collection of aesthetic nude pictures. *A Venus* was an ambitious and risky undertaking for Moore given the academic status of the nude and what he termed 'the unfortunate prejudice which exists against this kind of picture' (letter to Leyland, 22 Dec. 1868), and eventually Leyland's prevarication over the scale and purchase of the painting caused Moore both to reduce the dimensions and to adjust his original composition (see no.31).

Moore's revisions to the design of *A Venus* would suggest that he was experimenting with the nude in a similar aesthetic vein as Watts and Leighton. The use of the indefinite article in the title shows he was seeking to represent a type of ideal beauty rather than the mythological Roman goddess. The incorporation of Japanese accessories and the prominence accorded the date in the cartouche would further indicate that he was pursuing an ideal that transcended the vocabulary of the ancient world. References to the *Venus de Milo* in the torso and contrapposto, and to the male *Diadumenos* or fillet-binder in the figure's action of winding a ribbon around her head, provide evidence of Moore's intention of using the sculptural remains of the past, rather than a literary text, as a basis from which to assemble his ideal. The androgyny of the figure functions to separate the body from any particular identity, thereby reinforcing its artificiality. The imposition of graceful movement upon a sculptural torso cancels any hint of the erotic, and the autonomy of the figure is accentuated by the lack of facial expression and the depilated inpenetrable pudenda. Moore's application of a limited range of pale chromatic tones to a coarse canvas serve to suppress the rich saturated properties of the oil medium, lending the surface the texture of a wall painting.

It was largely due to the influence of Leighton and Watts (both recently elected to the Royal Academy) that *A Venus* was hung at the summer exhibition of 1869. Apart from a few defenders (notably Sidney Colvin and the Revd St John Tyrwhitt), the work was greeted with protests of incomprehension, striking as it did at the core of the paradox of the female nude: the idea that it had to be both pure and pleasurable. For most critics the figure was 'ugly' and 'repellent' because Moore had masculinised an essentially feminine subject. Most of the criticism was levelled at the flesh-denying surface which, in F.G. Stephens' words, functioned 'antipathetically to the subject of the goddess of Love' (*Athenaeum*, 29 May 1869, p.738). The generally negative reception given to *A Venus* in 1869 caused Moore to wait until 1885 before risking another large-scale nude at the Royal Academy: *White Hydrangea*, which met with an equally hostile response and was even defaced by an anonymous assailant. AS

Albert Moore

31 *Cartoon for 'A Venus'* 1869
Black chalk on brown paper
155·7×68·1 (61³⁄₈×26³⁄₄)
Victoria & Albert Museum, London

✽

The revival of the nude which took place in Britain during the late 1860s brought with it an emphasis on compositional design and draughtsmanship. Although cartoons were central to the European academic tradition, the custom of making a template for a finished painting was not integral to British studio practice, and it was only in the 1860s that empirical methods gave way to more systematic compositional procedures. Leighton, Poynter, Whistler and Moore made preparatory cartoons, these last two developing a close working relationship as shown by the similarity of Whistler's cartoon *Venus* (also dated 1869) to this drawing.

Moore's cartoon is indebted to his interest in ideal geometry and architectural design. As with his other figurative works he expended considerable time and effort in perfecting his composition. At the onset of the commission Moore produced a number of chalk drawings and an oil sketch which he subsequently developed through five studies, one of which he enlarged to a full-size cartoon. It was at this stage that he imposed a classical canon of proportion and refined the pose of the nude to suit the structural arrangement. Moore's pupil and biographer A.L. Baldry coined the term 'parallelism' to describe Moore's system of establishing an armature of lines suggested by the position of the figure (Baldry 1894, p.81). A small working diagram inserted to the right of the chair on the sheet indicates that he based the composition on an orthogonal grid overlaid with intersecting diagonals following the main limbs of the figure, with the cartouche functioning as a unit of measurement (Asleson 2000, p.105).

The geometric underpinning of Moore's system revealed his aim of subordinating nature to the discipline of abstraction. However, the appearance of revisions and marginal sketches, such as the small head in the upper right of this sheet, would suggest that the model remained a residual influence in enabling him to perfect his conception. AS

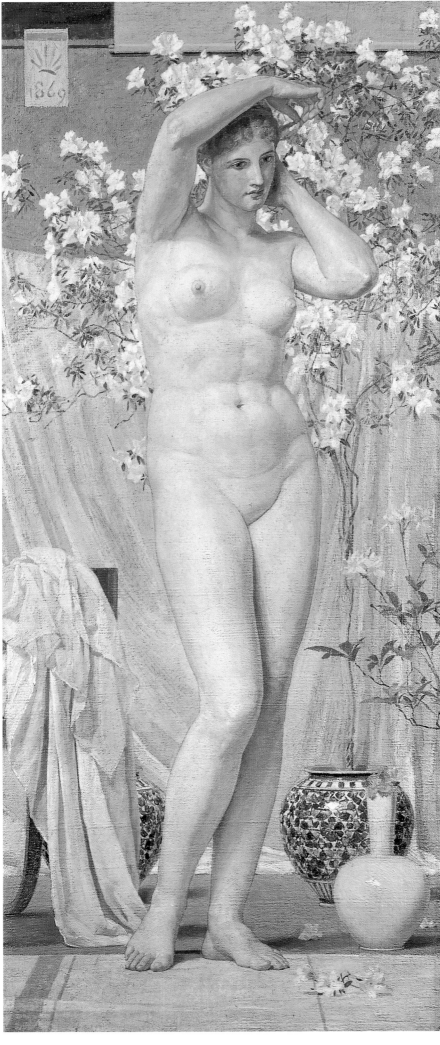

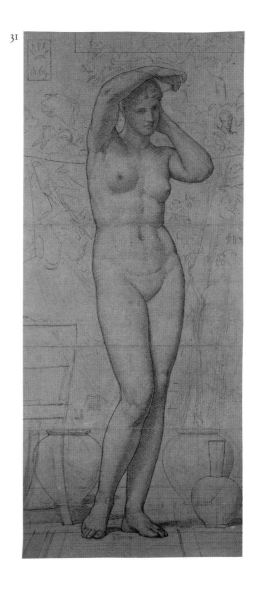

Edward John Poynter (1836–1919)

32 *Andromeda* 1869
Exh. RA 1870
Oil on canvas
51×35·8 (20⅛×14⅛)
Tate. Lent by Mr and Mrs C. Sena 1994
✳

Ovid's story of Andromeda, the daughter of the King of Ethiopia, chained to a rock as a sacrifice to a sea-monster and rescued by Perseus, was one of the most popular pretexts for the female nude during the Victorian era. The familiarity of the myth gave artists licence to play down the narrative in order to concentrate on the single figure without risking any implication of impropriety. For Poynter the nude fulfilled both a decorative and educational role, and it was thus customary for him to exhibit a small study of a subject one year and then follow it up with a larger more definitive version (no.33).

The image of *Andromeda* originated as a design for one of the tiles, dated 1868, in the Grill Room of the South Kensington Museum. The small oil was exhibited at the Royal Academy in 1870 where it was seen by the Earl of Wharncliffe, who subsequently commissioned Poynter to paint an expanded composition of *Perseus rescuing Andromeda from the sea-monster* for his billiard-room at Wortley Hall, Sheffield (1871–2). In enlarging the figure of Andromeda, Poynter was careful to secure the approval of his patron lest he be alarmed at the conspicuousness of the nude (letter dated 18 Dec. 1871, Inglis 1999, p.245).

Andromeda was highly acclaimed as a sophisticated single-figure composition that demonstrated skill in both draughtsmanship and colouring. In contrast to Millais's decidedly non-classical narrative of *The Knight Errant* (no.12), *Andromeda* appeared sculptural and pure, maintaining her dignity in dire straits. Tom Taylor wrote of the picture in *The Times*: 'The subject has been painted time without number. None supplies a better motive for the display of idealised female form. Such work now appeals to a small and special circle, and the painter who obeys the propriety of his own specially cultivated imagination towards this unpopular and unprofitable domain of his art deserves all honour' (18 May 1870, p.6). AS

Edward John Poynter

33 *Diadumenè* 1884
Exh. RA 1884
Oil on canvas
51×50·9 (20⅛×20)
Royal Albert Memorial Museum and Art
Gallery, Exeter
✳

This small painting was shown at the Royal
Academy in 1884 and possibly also at the
Grosvenor Gallery in 1885, the year Poynter
exhibited a large version of the subject at the
Academy (fig.21) which became the focus of a
controversy which raged around the suitability
of the nude as a subject for public exhibition.

In a letter to *The Times* (28 May 1885, p.4),
Poynter justified his decision to represent an
anonymous figure (diadumenè simply means
'fillet-binder' in Greek) from antiquity on the
grounds that he was presenting an
archaeological reconstruction of a Roman
bathing custom. In the late nineteenth century
the restoration of lost or damaged statues was
regarded as a legitimate aim for artists, offering
opportunities for both scholarly intervention
and artistic interpretation: while the sculptor
John Bell published his attempted restoration
of famous works such as the *Venus of Melos* and
Venus of Cnidos, the painters Alma-Tadema,
Moore and Poynter introduced archaeological
methodologies into the field of academic
composition. An important precedent for
Diadumenè was Alma-Tadema's *A Sculptor's
Model* exhibited in 1878 (fig 22), which was
conceived as a re-creation of the making of the

Venus Esquilina, a statue excavated in Rome in
1874 and preserved in the Capitol Museum
(fig.23). The hypothesis that this figure was
originally shown binding a fillet around her
head in preparation for a bath, was based on the
remaining evidence of Venus' left-hand little
finger on the back of her head, and the angle of
a ribbon once held by her right hand. Poynter
offers a variation on the restoration of the arms
presented by Alma-Tadema, and transforms the
ornamental baluster of the original sculpture
into a dressing-table.

Diadumenè also engages visually with the
debates surrounding the status of the *Venus
Esquilina*. Following its discovery there was
considerable disagreement as to whether this
was a copy of the original Greek *Venus of Scopas*
or a Roman portrait statue. In his letter to
The Times Poynter contended that the attitude
of the recently unearthed figure was too
unselfconscious for a Venus, but saw the simple
and innocent motive as worthy of
representation in painting as a genre subject.
Furthermore, Poynter drew a firm distinction
between his archaeologically based nude and
the baigneuses of modern French painters,
which for the British were beyond the pale of
respectability. Associations made at the time
between the supposed degeneracy of the
Hellenistic and Roman periods and modern
French morals may explain why Poynter sought
to chasten his figure by invoking the classical
Greek prototype of Polyclitus' male
Diadumenos, of which there were two copies in
the British Museum. Renowned for his sturdy

models of masculinity, Polyclitus' figures
were considered purer than later Attic
representations of women. Poynter's fusion
of these Greek and Roman models thus serves
to project an androgynous type, dissociated
from any particular sexual identity.

Poynter's compromise did not attract a
buyer for the large version of *Diadumenè*:
it was considered devoid of both beauty and
originality, and in 1893 Poynter felt compelled
to add draperies to the figure. However, he
remained undeterred in his project of the
nude and returned to the bathing motive the
following year with *Idle Fears*, a painting which
like the present picture, presents an adolescent
figure preparing for her bath, but with the
added precaution of a chaperone. AS

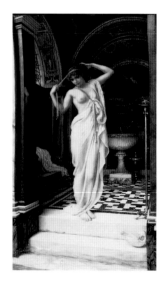

Fig.21
Edward Poynter
Diadumené 1885–93
Oil on canvas
Private Collection

Fig.22
Lawrence Alma-
Tadema
A Sculptor's Model 1877
Oil on canvas
Private Collection

Fig.23
Venus Esquilina
1st century BC
Marble
Musei Capitolini, Rome

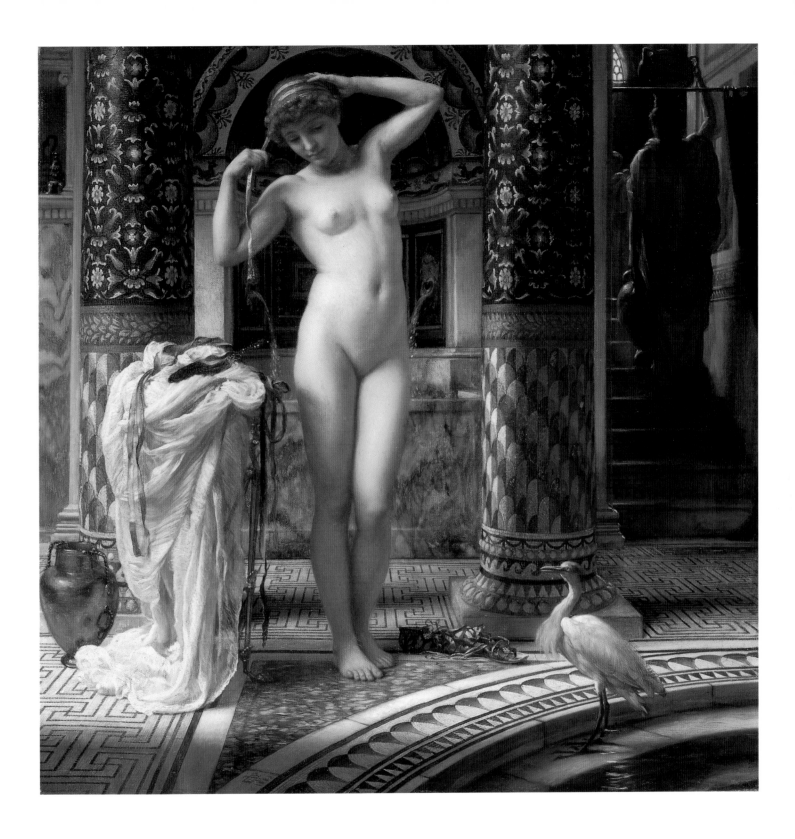

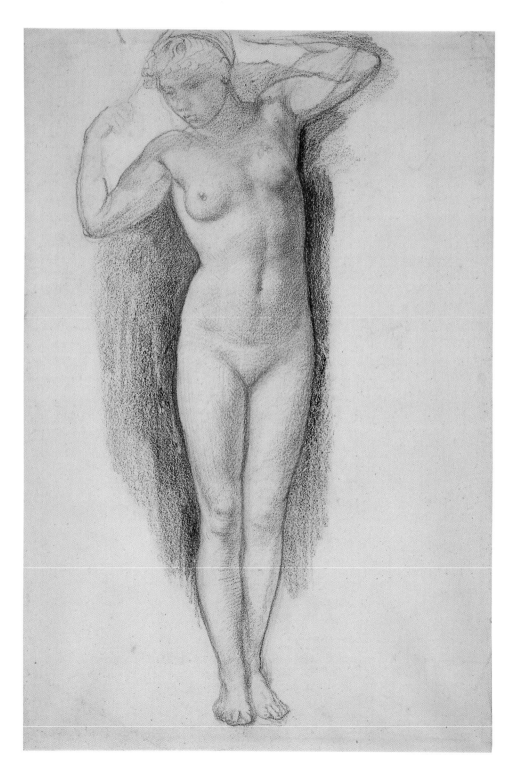

Edward John Poynter

34 *Study for 'Diadumenè'* 1884
Red and green chalk on white paper
29·7×20 (11¾×7⅞)
The British Museum, London
✱

In his roles as Professor at the Slade and then
Director of the National Art Training Schools at
South Kensington (1871–81), Poynter upheld
the importance of the nude in art education and
public exhibition. Following the methods he
had been taught as a student at Gleyre's atelier
in Paris (1856–9), which he later elucidated in
his influential *Ten Lectures* of 1879, Poynter
encouraged students to work accurately from
the model within a limited time frame, rather
than slaving over highly finished drawings.
However, in keeping with academic convention,
copying from past models remained central
to his practice and teaching, and Poynter was
instrumental in organising collections of casts
for study purposes at both institutions. *Venus
Esquilina* – one of the sources for *Diadumenè*
(see no.33) – was one of the casts selected by
the authorities of the Committee of Council
for Education around the time he was working
on the composition.

 This study is one of a group of drawings
relating to *Diadumenè*, all of which show how
Poynter used the model as an aid in finding
an appropriate pose for the figure. Since
restoration of the arms was central to his aim,
he pays particular attention to the upper
limbs, adjusting the position of the arms in
accordance with the movement of the model,
although he has yet to evolve the graceful
contrapposto of the finished painting. Poynter
combines elements of the male and female
figure without losing sight of the prototypes
from which he has constructed his idea. The
stocky proportions of the nude and the heavy
musculature of the arms suggest the male
schema of the *Diadumenos*, which Poynter
has revised in places to characterise his figure
as a young woman. AS

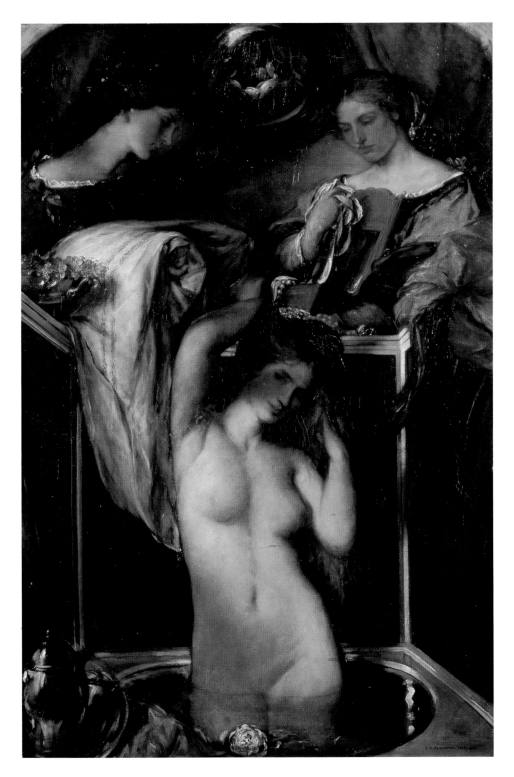

Charles Hazelwood Shannon (1863–1937)

35 *The Bath of Venus* 1898–1904
Exh. Guildhall 1904
Oil on canvas
146 × 97·8 (57½ × 38½)
Tate. Presented by Francis Howard 1940
⚹

The Bath of Venus preoccupied Shannon for
several years, as attested by the number of
studies he produced in relation to the picture
and the existence of another painted version
of the subject at the Watts Gallery (dated 1903).
This painting was shown at the exhibition of
Works by Irish Artists at the Guildhall in 1904
under its original title *The Marble Green Bath*,
recalling the artist's *Stone Bath* series of
lithographs of 1895–7.

The painting is conceived in an eclectic
spirit, synthesising past features such as the
Eyckian mirror and Antique torso, with
allusions to the contemporary work of Burne-
Jones, Rossetti and Watts. Indeed, it was to the
latter that Shannon was particularly indebted
for the blend of classical form and voluptuous
Venetian beauty: like Watts he was pursuing a
transhistoric affinity between different yet
complementary indices of beauty.

Shannon frequently painted the female
nude in water. The play of light across a variety
of reflecting surfaces heightens the sensuality
of the subject and this mood of languor is
reinforced by the echoing rhythms of the heavy
drapes and abundant flowing red hair (loose
hair being associated explicitly with the secrecy
of the bathroom and bedroom). The framing
walls of the bath, together with the enclosed
forms of the pool, rose, pot and mirror,
function as metaphors for containment and
contemplative reflection, intensifying the
overall suggestion of private, auto-erotic
pleasure. AS

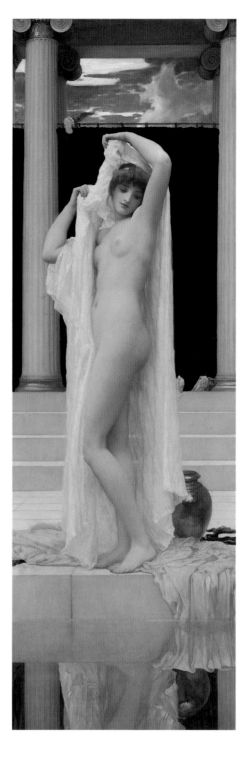

Frederic Leighton (1830–1896)

36 *The Bath of Psyche* c.1889–90
Exh. RA 1890
Oil on canvas
189·2 × 62·2 (74$\frac{1}{2}$ × 24$\frac{1}{2}$)
Tate. Presented by the Trustees of the Chantrey
Bequest 1890

✿

Originating as a panel decoration for the atrium
of Alma-Tadema's house in St John's Wood,
North London, this design – on an unusually
proportioned (3 : 1) canvas – was developed by
Leighton into an aesthetic composition in
which reflections and partitioning devices
effectively frame the figure and set it in
parenthesis. The reference to Apuleius's story
of Cupid and Psyche in the title would appear
to be incidental, there being no literary source
for a scene of Psyche bathing. Rather, the pose
approximates to that of Aphrodite preparing
for her bath, an association reinforced by the
attribute of the doves, as well as compositional
similarities to the artist's groundbreaking *Venus
Disrobing* of 1867: the first classical large-scale
female nude to appear at a public exhibition.

By 1890, when *The Bath of Psyche* was
bought for the nation through the Chantrey
Bequest, the classical nude had become more
widely accepted as a living ideal, and in an
Academy lecture of 1883 Leighton had argued
that the beauty of female classical sculpture
was comparable to that of contemporary
Englishwomen (Leighton 1896, p.89).
Although his Psyche is an idealised composite,
studied from a number of models and
assembled via a methodical compositional
process through which Leighton analysed and
synthesised each constituent part, the formality
of the design does not repress the erotic impact
of the figure. Indeed one of its sources was the
Venus Kallipygos (fig.24), which Leighton saw
at the Naples Museum in 1859, a sculpture
perceived at the time to be vulgar on account
of its prominent posterior, and consequently
kept in a reserved hall with access granted
only under surveillance (Fanin 1871, pp.5–6).
In keeping with his practice of transforming
prototypes to match his mental conception
of an idea, Leighton accentuates the verticality
of the posture, orientating the gaze away from
the buttocks towards the breasts and stomach,
thereby avoiding censure. However, in the
process of refining the design he foregrounds
the softness of the flesh: Mrs Barrington, for
one, thought that in his modelling of the torso
Leighton justified the title 'Praxiteles of the
brush' (1906, II, p.257). In the nineteenth
century Praxiteles was considered a carnal artist
on account of his smooth polished surfaces,
and associations with the 'sensuous sculptor'
sometimes cast suspicion on Leighton's
paintings, and ultimately, while the abstract
rectitude of this painting certainly serves to
contain the physicality of the nude, it cannot
entirely deny a sense of narcissistic self-
absorption. AS

Fig.24
Venus Kallipygos
1st century BC
Marble
Museo Archaeologico
Nazionale, Naples

Fig.25
Praxiteles
*Hermes carrying the
infant Dionysius*
c.330BC
Parian Marble
Archaeological
Museum, Olympia

Frederic Leighton

37 *Daedalus and Icarus* c.1869
Exh. RA 1869
Oil on canvas
138·2 × 106·5 (54¹₂ × 42)
The Faringdon Collection Trust, Buscot Park,
Oxfordshire

❋

Daedalus and Icarus reveals the full impact
of Greek culture on Leighton, not only in the
vividness with which he captures the dazzling
light and colour of the coastline, but in his
intuitive understanding of the Praxitelean ideal
of youthful male beauty. The image was painted
in the immediate aftermath of Leighton's visit
to Rhodes and Athens in 1867, and exhibited
at the first Royal Academy summer exhibition
held in the sumptuous new galleries at
Burlington House, following the move of the
institution from Trafalgar Square.

The subject derives from Ovid's
Metamorphoses, which relates how the inventor
Daedalus fabricated wings of feathers and
wax to enable himself and his son to escape the
wrath of King Minos of Crete. Exhilarated by
their flight Icarus ignored his father's warning,
flew too near the sun and drowned following a
dramatic descent into the sea. In selecting a
myth where the sun plays a narrative and
symbolic role, Leighton was probably inviting
comparison with another of his 1869 Academy
exhibits, *Helios and Rhodos*: in both pictures the
sun provides a leitmotif for the expression of
physical beauty. Both works compare pale and
dark skin tones, and with the ageing tawny body
of Daedalus, Leighton may have intended a
further thematic link with his Diploma painting
of *St Jerome* (also exhibited 1869), whose
Christian subjection of the flesh contrasts with
the pagan adulation of the body displayed in
these classical subjects. The figure of Icarus is a
re-creation of the fourth-century BC Athenian
male ideal epitomised by Praxiteles (fig.25), in
the elegant stance and soft musculature offset
by crisp draperies. However, in a culture which
venerated classical Greek art of the mid- to-late
fifth century, the sculpture of Praxiteles was
regarded as slightly decadent and associations
with the artist led to Leighton's figures being
considered artificial and effete in terms of
their refined surface qualities. *The Times*, for
example, thought Icarus possessed the air of 'a
maiden rather than a youth', and perceived in
his pectoral muscles 'the soft rounded contour
of a feminine breast' (1 May 1869, p.12). AS

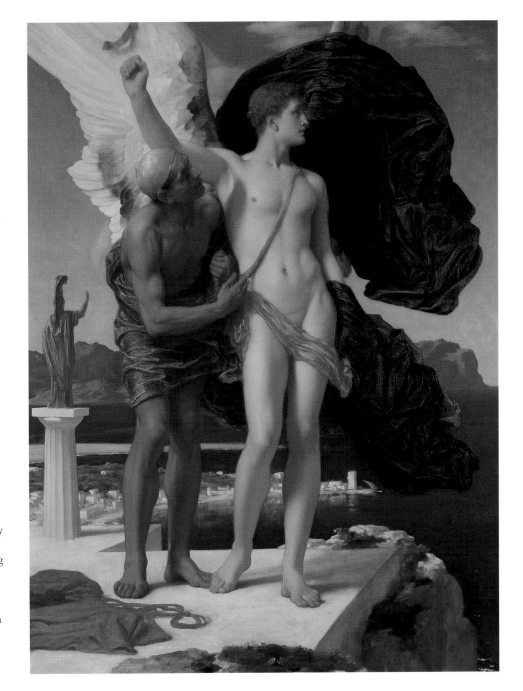

Frederic Leighton

38 *Studies for 'Daedalus and Icarus' c.*1868–9
Pencil on white paper
28·3 × 42·7
Royal Borough of Kensington & Chelsea,
Leighton House Museum

✱

Leighton's paintings were composed from
many separate studies of different elements,
in this instance drawings of both the nude
and draped figure as well as isolated body
fragments. The figure of Icarus is a translation
of sculptural form into the softer medium of
pencil, the crystalline contours of the nude
rendered through a strong outline which
encases what Leighton suggests to be ripe flesh.
He adopts a more Michelangelesque manner
for the taut limbs of Daedalus, using hatched
lines to emphasise musculature and
movement. The combination of naturalism and
perfectionism in this sheet is also indicative of
Leighton's allegiance to continental methods,
in particular the work of Ingres, Scheffer and
Bouguereau. AS

38

Simeon Solomon (1840–1905)

39 *Love in Autumn* 1866
Exh. DG 1872
Oil on canvas
84 × 64 (33 × 25¼)
Private Collection

✱

Love in Autumn was painted in Florence in
1866 and exhibited in 1872 at the Dudley
Gallery, an important forum for the work of
young 'progressive' artists. This painting was
for many years regarded as one of the most
notable of Solomon's images of androgynous
youth. Prior to his arrest for homosexual
activities in 1873, he was credited for
formulating a pathetic type of male beauty
fashioned from a range of cultural traditions.

Solomon's association with a group of
homosexuals in the late 1860s, together with
the controversial interpretations of his works
offered by writers as opposed in their views as
Swinburne (*Dark Blue*, July 1871) and the
Scottish poet Robert Buchanan (*Contemporary
Review*, Oct. 1871), gave rise to a perception of a
morbidly deviant artist given over to sensuality
and sado-masochistic impulses. In the context
of the 1860s, however, Solomon held similar
aesthetic views to artists who went on to
establish 'respectable' careers – Burne-Jones,
Richmond and Leighton – all of whom shared
an appreciation for youthful Italian male
models, along with androgyny as both a
physical and spiritual ideal. Although the image
of the androgyne was disturbing in challenging
conventional notions of virile masculinity, the
type was considered not so much feminised as
asexual. The sensuality of the youth in *Love in
Autumn*, suggested by his rapt expression and
blushing complexion, is offset by the drapes
and wings which mask his sexuality and impart
a wistful, spiritual aura to a scene in which the
threatening mood of nature mirrors the inner
desolation of the figure.

At a time when the category 'homosexual'
was beginning to be defined and recognised,
the idea of male–male love tended to be
expressed through complex allegorical codes.
Love in Autumn reverses the visual conventions
for the nude by presenting a single male (rather
than a female) as a vulnerable, suffering being.
The meanings embodied in this symbolic
journey of a figure through a hostile landscape
remained personal and obscure behind the
presentable façade of the classical nude, which
may explain why Solomon felt compelled to
develop his ideas in the form of a visionary
prose poem, *A Vision of Love Revealed in Sleep*,
which he published at his own expense in 1871.
This montage of apparitions apprehended by
the dreamer and his disembodied soul on their
quest for Love, includes the following passage
where Solomon presents in verbal form his
vision of *Love in Autumn*: 'his wings fell about
his perfect body; his locks, matted and the sharp
moisture of the sea, hung upon his brow, and
the fair garland on his head was broken, and its
leaves and blossoms fluttered to the earth in the
chill air' (Ford 1908, p.57). AS

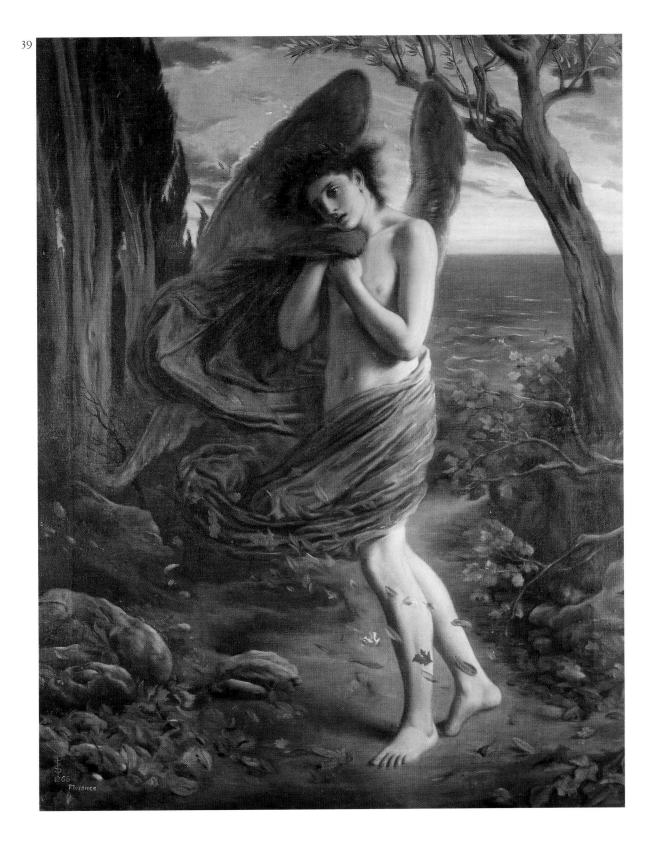

Edward John Poynter (1836–1919)

40 *Paul and Apollos* 1872
Fresco on panel
61×61 (24×24)
Tate. Purchased 1918

✤

In 1872 Poynter was commissioned by H.A. Palmer to produce a fresco for the church of St Stephen in South Dulwich, of which his son-in-law had been made first vicar. Designed by Charles Barry junior in a neo-Gothic style, the church was still under construction when Poynter executed his fresco during the winter of 1872–3. The painting fills a blind arch behind the choir stalls in the south wall of the chancel and illustrates two episodes, as recounted in Acts 7: 56–8, from the life of St Stephen, the first Christian martyr: the main portion presenting his vision before the High Priest's Council; the predella showing the saint led out of Jerusalem by Roman guards to be stoned by a group of fanatical witnesses.

Although Poynter had worked on other decorative schemes (see no.116), this was his first mural painting, and having recently taken up the post of Slade professor, he no doubt wanted to prove his technical expertise and also demonstrate his mastery of the nude figure in action. At Dulwich, Poynter adopted a similar compositional procedure to that used by Leighton, Moore and Richmond, producing separate figure studies which he enlarged to full-scale cartoons, as well as devoting considerable time to researching fresco methods. The quest to revive the true, or *buon* fresco technique in Britain had been prompted by the redecoration of the Palace of Westminster in the 1840s and 1860s, but had been thwarted by the almost immediate deterioration of the frescoes made at that time. Poynter's work is a rare example of durability, presenting all the characteristic features of the true-fresco technique with *secco* touches added after the plaster had dried (see Perry 1996, pp.1–2).

In testing the materials and method to be employed at Dulwich, Poynter produced this trial-panel executed in tempera on wet plaster one July day in 1872 and then handed it over to a chemist to certify the stability of the medium. Poynter was so pleased with the result that he exhibited the panel at the Dudley Gallery's

General Exhibition in February 1873 under the title *The Gardeners – sketch in fresco*. Enclosed within a painted illusionistic frame decorated with fruits, two nude men are shown planting and watering a small laurel tree against a background of ploughed fields and a walled city. With its dry surface, muted colour harmonies and frieze-like disposition of figures arranged to display their muscular physiques, this work parallels the 'subjectless' decorative compositions produced by Moore and Richmond around the same time. However, the scene is intended to represent two early converts to Christianity from different races, the Jewish Paul and the Greek Apollos, and illustrates the former's plea for Christian unity: 'I planted, Apollos watered; but God gave the increase' (see 1 Corinthians 3: 5–9). The image was eventually incorporated as a background detail in the lower part of the Dulwich fresco (fig.26), in which Paul therefore appears twice: once as Saul the Pharisee (before his conversion), in green, guarding the robes discarded by Stephen's executioners, and then naked with Apollos, as an emblem of the fraternal love nurtured by the Christian faith.
AS

Fig.26
Edward John Poynter
Fresco 1872–3
St Stephen's Dulwich

William Blake Richmond (1842–1921)

41 *The Bowlers* 1870
Exh. RA 1871
Oil on canvas
65 × 273 (25⅝ × 107½)
The Masters, Fellows and Scholars of Downing
College in the University of Cambridge
✱

The Bowlers provides a testimony to the years
Richmond spent in Italy between 1866 and
1869, nurturing an appreciation of Italian
culture and a more relaxed attitude to the body
than was permitted in Britain. The painting was
first exhibited at Richmond's Beavor Lodge
studio in Hammersmith in 1870, before being
shown at the Royal Academy in 1871. With its
unusual frieze-like proportions the picture
approximates to a wall painting, a characteristic
reinforced by the dry texture formed through the
application of a thick priming layer to a linen
canvas. In *The Bowlers* Richmond employed
tempera underpaints together with oil or resin
for the upper layers to create a fresco-like
surface, perhaps in emulation of the wall-
painting methods he had learned from
Francesco Podesti, the leading mural painter
in Rome (Reynolds 1995, p.39; Saint-George
1998). The composition itself was carefully
amalgamated from separate studies transposed
onto canvas, on which Richmond made an
underdrawing in pencil and a liquid medium.

An important precedent for *The Bowlers* was
Richmond's friend Frederick Walker's *Bathers*
(no.176), exhibited at the Academy in 1867.
Walker's painting was significant in signalling
the reappearance of the youthful male nude in
British art, and for subordinating the idea of
heroic manly endeavour to that of ordinary
action in a pastoral setting without sacrificing
the spirit of classical art. Despite similarities in
format and technique, Richmond's composition
is different from Walker's in that he presents a
classical 'genre' scene contrasting reposeful
types of male and female beauty. His more
overtly classical bodies were studied from the
physiques of the Italian models who came to
England during the 1860s and in the immediate
aftermath of the Franco-Prussian war, although
in orchestrating this display of graceful
movements Richmond combines observation
from the model with poses adapted from the
Antique. Sources include the *Discobolus of
Myron* in the stooping movement of the bowlers,
the two standing figures of *Castor and Pollux* for
the embracing male couple, and the seated
group from the east pediment of the Parthenon
for the reclining women on the left. However,
these models, together with allusions to specific
divinities such as Hermes and Mars, contribute
nothing in the way of narrative or meaning
beyond what the *Art Journal* termed 'a certain
dolce far niente style with a general Sybarite
state of mind' (1871, p.176). The juxtaposition
of loosely draped women with nude men,
although faithful to Greek sculpture and
painting, was here considered offensive,
The Times declaring the presence of maidens
at 'the exercises of perfectly nude young men ...
as inconsistent with Greek as with English
usage' (22 May 1871, p.6).

By contrasting examples of male volition,
seen in the sequential movements of the
taut, sinewy bodies on the right, with female
lassitude and nonchalance on the left, it may
have been Richmond's intention to bring
together two distinct areas of gendered
activity, a dichotomy established visually by the
Japanese compositional device of the wistaria
trunk which effectively divides the pictorial
field in half. The seeming indifference of the
women towards the men functions to deny any
suggestion of the erotic, assisting the academic
notion that the artistic nude should transcend
desire in the beholder and elicit an essentially
Platonic appreciation of the body. Such a
perception would have been sustained by the
Victorian ideology of sport which pointed to
the athletic customs of the ancients as evidence
that physical exertion taught continence and
discipline in men. The ideal of the Palaestra as
an exclusively masculine arena was also evoked
in the homoerotic writings of Winckelmann
and Walter Pater, and thus *The Bowlers*, while
honouring the fraternal integrity of the
Gymnasium, also admits a hint of desire in
the glances of the embracing male spectators
on the right. For most viewers, however, the
positioning of well-toned bodies within the
enclosed 'feminine' space of a garden replete
with butterflies, lilies and daisies, would have
signified emasculation. AS

Frederick Sandys (1829–1904)

42 *Two Male Nude Studies* 1860s
Black and white chalk on grey paper
32·2 × 27·4 (12⅝ × 10¾)
Birmingham Museums & Art Gallery
✲

During the 1860s, like the artists he associated with, Sandys produced a number of drawings of the male figure exploring an idealised nude type informed by Antique sculpture. The re-emergence of a classical conception of the nude at this time broadly relates to changes in art education and studio practice following criticisms levelled in the early part of the decade at English inadequacies in drawing the figure. On the recommendation of the Commission appointed by the government to investigate the teaching of the Royal Academy in 1863, the institution ordained that copies of casts be placed in the Life and Painting schools so that students could study the living model alongside the Antique, following the system pursued in Paris.

The standing figure on the left of this sheet is a studio study of a model presented in the attitude of a captive or athlete at rest. The relaxed contrapposto of the pose is developed in the drawing on the right where the model assumes the appearance of a Praxitelean statue with cropped hair, polished limbs, pronounced chest muscles and Iliac crest. The device of the ribbon around the waist appears to be an extension of the line demarcating the edge of the loincloth in the nude on the left, and introduces a note of self-conscious eroticism, emphasising the figure's slender hips and waist. Sandys may also have been thinking of Michelangelo's sculpture *The Dying Slave* (1513), and his painting *The Entombment* (1506), purchased by the National Gallery in 1868, works in which the use of a constrictive sash serves to accentuate both the physicality and pathos of the body. Illuminated in white, the knot of this belt functions to emphasise the flow of the figure's gaze towards his strongly marked genitals. AS

Frederick Sandys

43 *Standing Female Nude c.*1870
Black chalk heightened with white on brown paper
129·5 × 62·3 (51 × 24½)
Birmingham Museums & Art Gallery
✲

This large-scale drawing probably dates from the late 1860s when Sandys began to specialise in elaborate chalk compositions of the single female figure, and in size the sheet approximates to the large cartoons produced at the time by Whistler and Moore (no.31). As an academic study it shows how Sandys attempted to idealise the nude without relinquishing an innate inclination towards detailed observation. The limbs of the model are arranged around an implied perpendicular which runs from the nape of the neck, through the left hip to the right foot resting on a block. The pose is suggestive of a bathing Venus – the left hand positioned as if holding the customary cloth seen in antique statues of the goddess and the hair bound in classical fashion. The drawing is also closely observed from a particular model, perhaps Mary Jones who appeared in Sandys' work from around 1867. Her face could almost be described as a portrait, delineated in subtle gradations of black and white chalk, and the waves of the hair are rendered with the utmost precision. However, as was typical of the artists Sandys associated with, he idealises the features and exaggerates the curvature of the spine and buttocks. The combination of individual and ideal form thus represents a compromise between romantic and classic tendencies of the period. AS

42

Alphonse Legros (1837–1911)

44 *Study of a nude female figure with a vase* 1870s
Pencil on blue paper
40 × 22 (15³⁄₄ × 8⁵⁄₈)
Victoria & Albert Museum, London

✻

The French-born Legros was lured to London by
Whistler, and it was here that he settled in 1863
after becoming acquainted with Rossetti, Watts,
Leighton and Poynter. Legros had trained at the
Municipal Art School in Paris under Horace
Lecoq de Boisbaudran, an influential teacher
who upheld the importance of the Antique
while directing his students to draw from
memory, often from models moving about
out of doors. When Poynter was appointed
Director of the National Art Training Schools
he resigned the Slade Professorship in favour
of Legros, who took up the post in 1876
overcoming chauvinistic opposition. Legros's
instruction was more traditional than that of
Poynter who had made study from the model
the centre of the Slade system, and in 1878
Legros amended the curriculum so that
students had to draw from the Antique before
being admitted to the life-class. However,
adopting methods taught by Boisbaudran, he
brought vigour and directness to his teaching,
setting poses of short duration and working
alongside his pupils. Like Poynter, Legros
rejected the English method of laborious
stippling within a hard outline in favour of a
looser freehand technique. As an exponent of
the *premier coup* he would begin by indicating
the main junctions of the body and then shade
in a diagonal 'east wind' direction – a manner
derived from Leonardo and Raphael – which
became known as 'Slade shading' (Holroyd
1912, p.274).

This undated drawing of a powerfully built
female model holding a jar from which a stream
of water flows illustrates the method Legros
practised in front of his students, and it may
have been intended as a reinterpretation from
memory of Ingres's venerated *La Source*. The
sketch also relates to a series of studies for a
bas-relief titled 'La Source' (exhibited at the
Grosvenor Gallery in 1882), as well as
anticipating the bronze torso of a female nude
executed in 1890, also reminiscent of Ingres's
eponymous painting. 'La Source' was clearly a
cherished subject for Legros and this study may
have been produced as a personal homage to a
master he revered. AS

43

44

John Gibson (1791–1866)

45 *Narcissus* 1846
Parian, Copeland
h. 30·2 (11⅞)
Victoria & Albert Museum, London
✿

Trained under Canova and Thorwaldsen in Rome, Gibson settled there finding it a more conducive environment for the production of nude sculpture than he had known in his native Britain. It was in Rome that Gibson set about recreating the Greek ideal of human beauty, influenced both by the writings of Winckelmann and a Platonic conception of higher love. In her biography of the sculptor Elizabeth Eastlake recounted that in making *Narcissus* Gibson had repudiated the traditional story of self-obsessed youth in favour of an alternative reading of the legend offered by Pausanias who had described how Narcissus, seeing himself in the fountain, mistook his reflected image for that of this dead twin sister and pined away in grief (Eastlake 1870, p.104). In seeking to incarnate what he believed to be the essence of the classical ideal, it was characteristic of Gibson to establish some sort of 'celestial relationship' or internal dialogue with his subject. Although *Narcissus* was reputedly inspired by the attitude of a boy Gibson had seen sitting on the edge of a fountain, the image he produced of androgynous youth matches his conception of an earlier *Eros* of 1830 (*Love disguised as Reason*), in Gibson's words: 'the passion of love which my power inspires being equally divided between the sexes' (Matthews 1911, p.177).

Gibson produced four versions of *Narcissus* altogether, three of which were private commissions, the other exhibited at and retained by the Royal Academy in 1838 as a Diploma work. In 1845 a Parian porcelain replica was modelled by Edward Bowring Stephens as the template for the fifty copies produced by Copland and Garrett to be distributed as prizes by the Art Union in the following year. *Narcissus* was the first Parian nude issued by the Art Union and its committee had difficulties both in obtaining permission for reproduction from the Royal Academy, and in persuading certain of its own members to accept a nude. Although the figure was eventually passed on the condition that it should wear a fig-leaf, Stephens was adamant that his version should remain totally nude, although it is not shown so here. *Narcissus* subsequently became one of the best-known Parian figures in Britain, epitomising as it did the neo-classical belief that form and a clear contour were the main constituents of ideal beauty. It was not until later in the century, with the rise of the 'New Sculpture', that the primacy of form gave way to an alternative concept of surface. AS

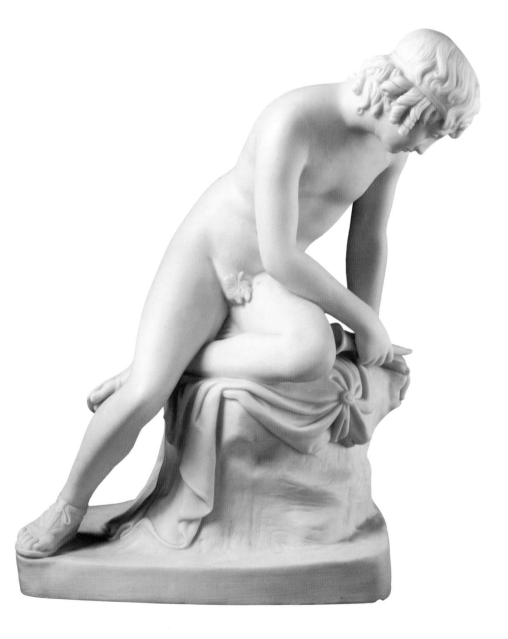

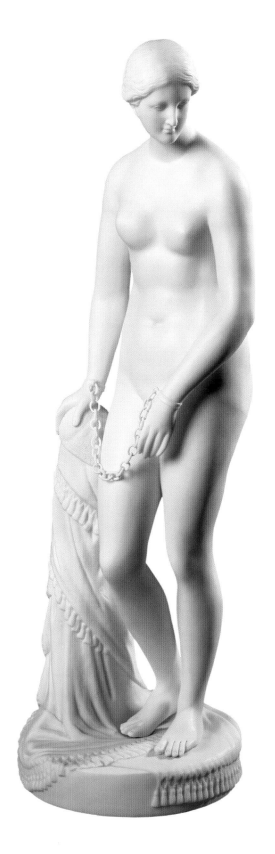

After Hiram Powers (1805–1873)

46 *The Greek Slave* c.1850–60
Parian
55·3 × 17·2 (at base) × 17·2 (at base)
(21³⁄₄ × 6³⁄₄ × 6³⁄₄)
On loan from the Fettes Thornton Collection
❋

The American sculptor Hiram Powers
exhibited the original *Greek Slave* – the most
famous nude composition of the mid-Victorian
period – at the Graves Gallery in London in 1845
and subsequently produced a marble replica for
the 1851 Great Exhibition as well as six further
large-scale versions between 1847 and 1866.
The imposition of a chain upon what is
essentially an antique Venus made *The Greek
Slave* a sensation, alluding not only to the
Ottoman custom of exposing slaves for sale at
bazaars, a practice condemned in Britain
around the time of the Greek War of
Independence (1821–32), but more topically to
the abolitionist cause in the United States. The
slave's degrading predicament is offset by her
modest expression and smooth white surface
which suggest courage and purity. However,
while the association between whiteness,
Christianity and Greek civilisation would have
been apparent to Powers' audience, the
exhibition of the sculpture in 1851 provided
the occasion for a number of commentators to
refer to the persistence of slavery in the United
States: 'We have the Greek Captive in dead
stone ... why not the Virginian slave in living
ebony?' wrote *Punch* derisively of the American
section of the Great Exhibition (24 May 1851,
p.209; Auerbach 1999, p.168).

The Greek Slave was popularised through
a wide dissemination of copies in a variety of
media. Summerley's Art Manufactures led the
way in 1849, marketing a 14 1/2-inch Parian
reproduction made by Minton. Further versions
were issued by Copeland, Robinson and
Leadbetter and other companies, each model
based on one of Powers' larger sculptures and
displaying variations in coiffure, drape, cap,
chain, body shape and base. This undated
version was one of the largest Parian replicas
produced, but like many copies does not carry
a potter's mark. Indeed, given the enormous
reputation of the work it was impossible for
Powers to control copyright and even though
he opposed the documentation of his statue by
commercial photography, the image was mass
produced photographically by both the London
Stereoscopic Company and a number of firms
in the United States (Hamber 1996, p.198).

During the late 1870s the Eastern slave
woman became equated by the Victorian public
with domestic prostitution, as 'White Slavery'
became the rallying cry for reformers anxious to
stir sympathy for young girls smuggled against
their will into prostitution centres in Europe.
It was around this time that the reputation of
The Greek Slave began to falter: the figure came
to be seen as somewhat anodyne, lacking the
anatomical and psychological realism that
made subsequent portrayals of slavery appear
more convincing and politically relevant (see
no.152). AS

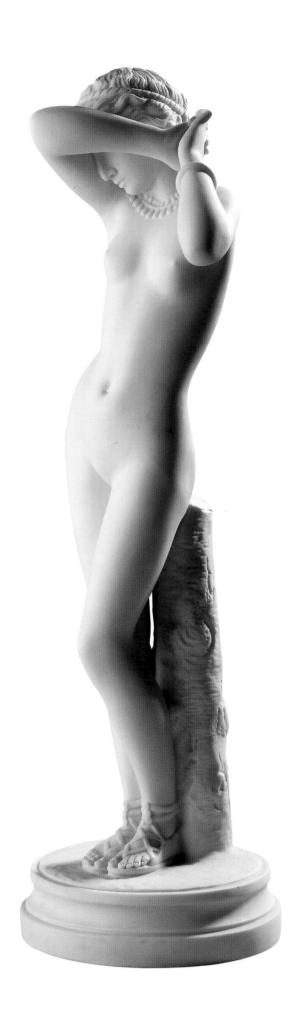

After Jean-Alexandre Falguière (1831–1900), copied from the painting by J.L. Gérôme (1824–1904)

47 *Phryne c.*1865
Parian, unknown maker
34·3 × 11·4 (at base) × 11·4 (at base)
(13$\frac{1}{2}$ × 4$\frac{1}{2}$ × 4$\frac{1}{2}$)
On loan from the Fettes Thornton Collection
✻

The ideal French classical nude was promoted
in Britain via reproductive prints such as
Leopold Flameng's engraving of Gérôme's
Phryne before the Tribunal (no.28), as well as by
small sculpted models in Parian and other
materials. The French sculptor Falguière was
renowned for his sensational female nudes and
was thus considered an appropriate artist to
translate Gérôme's celebrated image of *Phryne*
into three dimensions as a domestic decoration.
Gérôme's father-in-law, the dealer Goupil,
commissioned Falguière to model the figure
in plaster in collaboration with Gérôme who
added the finishing touches. *Phryne* was issued
by Goupil's in a bronze edition and was also
published in marble and ivory in a variety of
sizes. This particular piece, copied from
Falguière by an unknown modeller, was a less
costly interpretation of the subject. The smooth
porcelain figurine is designed to be held in
the hand, inviting private contemplation and
thereby offering the viewer the vicarious
pleasure of acting as both judge and
connoisseur. AS

George Frederic Watts (1817–1904)

48 *Clytie* c.1868–78
Bronze
86 × 66 × 43 (33⅞ × 26 × 17)
Tate. Presented by the artist 1900
✱

Clytie, the first large sculpture made by Watts, was based on Ovid's myth of the sea-nymph deserted by Apollo and transformed into a sunflower. The torsion of the figure, accentuated by the massive straining neck and shoulders, describe Clytie's fate, to follow the sun on its daily course from east to west.

The sculpture may originally have been conceived as a reworking of a Graeco-Roman bust in the British Museum, popularly known through Delpach's Parian *Clytie* issued by Copeland in 1855. In contrast to the smooth white surface of this replica, Watts intended his surface to be textured and motile. Altogether he produced six versions of *Clytie* in marble, bronze, plaster and terracotta, as well as a painting of the subject and various compositional studies in chalk. The original marble was exhibited unfinished at the Royal Academy in 1868 (it was later completed and is now in the Guildhall Art Gallery), the same year as the artist's *The Wife of Pygmalion* (no.129). By exhibiting *Clytie* in an unfinished state, Watts was perhaps concerned to convey both variety in texture and the process of metamorphosis, ideas communicated in another incomplete marble bust, *Daphne* of 1879–82. This idea of change was reiterated by Swinburne in an ekphrastic response to the sculpture: 'We seem to see the lessening sunset that she sees, and fear too soon to watch that stately beauty slowly suffer change and die into flower, that solid sweetness of body sink into petal and leaf' (1868, p.201). The theme of transformation also relates to Watts's choice of models for *Clytie*. Inspired generally by the supple form of his favourite model 'Long Mary', and memories of his first wife, Ellen Terry, the musculature was carefully studied from a male model, Angelo Colorossi, while the curves and masses were apparently suggested by the infant Margaret Burne-Jones (Blunt 1975, p.191). The interpenetration of male and female form in this work is further paralleled by the stylistic prototypes which influenced Watts around this time: the fifth-century Phidian masculine ideal, the twisting, sexually ambiguous figures of Michelangelo, and sensuous, 'feminine' Venetian types. In keeping with his interest in harmonising colour with form, Watts felt it was important to achieve an impression of tint in *Clytie*: the deep cutting of the marble casts strong shadows, and the Tate bronze was at some stage coated with lacquer. In a letter to Gladstone of 3 May 1868, Watts wrote that his aim was 'to get flexibility, impression of colour and largeness of character – qualities I own to be extremely necessary to sculpture' (Watts 1912, I, p.237). AS

Alfred Gilbert (1854–1934)

49 *Perseus Arming* 1882; this cast undated
Bronze
73·7×45·7 (at base) (29×18)
Courtesy of Peter Nahum at The Leicester
Galleries
✳

Gilbert's statue of the adolescent Perseus turning round to examine his winged sandal stands in the tradition of the slender male type formulated by Leighton, Solomon and Richmond in the 1860s. Like Leighton, Gilbert had benefited from a cosmopolitan education, having been trained at the Royal Academy, the École des Beaux-Arts and in Italy where he learned the *cire perdu* or lost-wax method of casting bronze at the foundry of Sabatino de Angelis of Naples, a process virtually unknown in Britain which enabled him to create surfaces of great refinement and deliquescence.

Perseus Arming, the first of a succession of male nudes, was modelled in Italy in the winter of 1880–1 and was first cast in bronze the following year for Henry Doulton. This early cast was probably made from the original plaster pattern from which a mould was taken to produce a number of waxes (Dorment 1986, p.23). The figure was partly conceived as a homage to Donatello's standing bronze *David* (mid-fifteenth century) which Gilbert had seen in Florence. Following Donatello's design, Gilbert integrates figure and base and uses a sinuous contrapposto to emphasise the youth and suppleness of the body, qualities accentuated by the projecting sword and headgear. Another less personal reference was to Benvenuto Cellini's statue of *Perseus and Andromeda* in the Loggia dei Lanzi, Florence, which influenced Gilbert in his use of fine detailing but 'left him cold' as he felt it would not allow for the projection of artistic personality. Following Leighton, Watts and Burne-Jones, Gilbert wanted the figure to express ideas that penetrated beyond the realm of illustration, as he later explained: 'I conceived the idea that Perseus before becoming a hero was a mere mortal, and that he had to look to his equipment' (Hatton 1903, p.10). Taking heart from this imagined example, in exhibiting another cast of the figure at the Grosvenor Gallery in 1882 (probably one belonging to Doulton or J.P. Heseltine), Gilbert hoped to repeat the transition from a nobody to a hero. Among the many he succeeded in astonishing was Leighton, who was apparently so impressed that he commissioned Gilbert to make another bronze on a subject of his own choice, and the sculptor obliged with *Icarus* (1884), another autobiographical statue but which was also conceived as a personal tribute to Leighton's *Daedalus and Icarus* of 1869 (no.37).

Although *Perseus Arming* was intended to be a work of art in its own right and not a bibelot for the drawing-room, both the novelty and elegance of the motive made it a desirable sculpture for the home. With the expansion of commercial foundaries towards the end of the century it was cast dozens of times in three different sizes: 29, 14½ and 6 inches. AS

Frederic Leighton (1830–1896)

50 *The Sluggard* 1885
Exh. RA 1886
Bronze
19·1×90·2×59·7 (75¼×35½×23½)
Tate. Presented by Sir Henry Tate 1894
✳

The Sluggard was the second of two life-sized bronzes made by Leighton in collaboration with the sculptor Thomas Brock, who later incorporated a small copy of the work into the monument he fabricated in Leighton's honour at St Paul's Cathedral. The figure was also issued in a limited edition by Arthur Collie as a domestic statuette.

Originally titled *An Athlete Awakening from Sleep*, the laurel-wreath under the youth's right foot suggests an unconscious abandonment of ambition in sleep: 'a potent will in abeyance' to quote F.G. Stephens (*Athenaeum*, 2 Jan. 1886, p.41). Always known as *The Sluggard*, the figure has been widely regarded as the indolent counterpart to Leighton's heroic *An Athlete Wrestling with a Python* (no.153), one who garners pleasure from his musculature rather than flexing it as a means of volition and control (the attitude was reputedly inspired by the glimpse of the model Gaetano Valvona stretching after a sitting). However, it would be an oversimplification to argue that Leighton intended this figure to be the narcissistic complement to his outwardly projecting hero for, as Edmund Gosse argued, the sculpture is essentially concerned with the development of sculptural form 'from hardness into suppleness and flexibility' (*Art Journal*, 1894, p.281).

As an icon of the New Sculpture movement, *The Sluggard*'s appeal resided in the way it fused physical presence with ideal form, and lassitude with dynamism, combinations of qualities also apparent in Leighton's painted male nudes and fostered through his long engagement with the body as both an inherited tradition and a palpable living experience. The languid pose relates to the two seemingly antithetical types of male beauty that Leighton explored in his painted oeuvre: the soft swaying ephebes who bring up the rear of the procession in *The Daphnephoria* of 1876, and the taut anatomy of the outstretched *Elijah* of 1878. *The Sluggard* represents a further stage in the artist's quest to embody a sensuous twisting movement without sacrificing the agitated surface provoked by emphatic musculature. The line which appears to bisect the chest of the reclining prophet is thus reiterated in three dimensions through the grooves that accentuate the front and back of the stretching youth, and the materiality of both body and statue is enhanced by the application of a distinct patination of brown oil paint.

In this groundbreaking work Leighton seems to engage with a wide range of sculptural archetypes, both ancient and modern. The sensuous but virile athlete evokes Winckelmann's categorisation of ancient Greek art into Pheidian (heroic) and Praxitilean (beautiful) modes of expression. Leighton may also have been referencing Michelangelo's *Dying Slave* in its combination of dynamic spiralling movement with inward inaccessible

feeling. More immediately he was likely to have been influenced by Gilbert's *Perseus Arming* of 1882 (no.49), both in the elasticity of the figure and the subtlety with which he merges the quivering planes of flesh. *The Sluggard* may also have been conceived as a response to Rodin's *Age of Bronze*, exhibited at the Royal Academy in 1884, in that while Leighton seems to acknowledge the dissolution of bodily form and legibility signalled by Rodin's controversial sculpture, he nevertheless abides by the principle of containment in terms of both surface and meaning.

In projecting the nude as a vehicle of corporeal motion and private pleasure, Leighton invests the classical tradition of the nude with modern unease and feeling. It is indeed tempting to view the figure as the physical incarnation of Walter Pater's meditation on the limitations of sculpture in The Renaissance: 'Against this tendency to the hard presentment of mere form trying vainly to compete with the reality of nature itself, all noble sculpture constantly struggles; each great system ... resisting, it in its own way, etheralising, spiritualising, relieving, its stiffness, its heaviness and death' (Pater 1986, p.42). AS

FUN.—October 30, 1869.

"OH, STAY!" OR, GRACES *versus* LACES.

Venus:—"MY STARS, WHAT *CAN* THAT THING BE UNDER A GLASS CASE? HOW *DO* THEY WEAR IT?"
The Graces:—"IT'S NO USE ASKING US: *WE* HAVE NOTHING TO DO WITH IT!"

Frederick Barnard (1846–1896)

51 '"Oh, Stay!" or, Graces versus Laces',
illustration in *Fun*, 30 October 1869,
engraved by Edward Dalziel
28·3 × 21·5 (11⅛ × 8½)
The London Library

✳

By the late 1860s the classical nude promoted by the aesthetic movement sustained a number of competing discourses surrounding the female body. While the Antique waist of Venus upheld essentialist notions concerning women's 'natural' reproductive role, a broad waist was also seen to encourage an emancipated lifestyle and a purpose for women beyond the home – a cause advocated by campaigners for social and political reform.

Barnard's cartoon presents two opposing ideas of the female waist by juxtaposing the 'progressive' yet time-honoured classical shape against modern 'primitive' standards shown by the two fashionably attired women gazing into a modiste's window at a variety of fetishistic *objets du désir* that include a crinoline and a corset in a domed glass case. The latter is in fact a 'ready-made' or manufactured stay which could be purchased off the shelf for a reasonable price and was widely advertised in popular magazines of the day. Although the corset was a signifier of fashion and self-restraint in women of the upper and middle classes (uncorseted women were often regarded as licentious), the democratisation of the garment in the 1860s led to it being adopted by working-class women and prostitutes who pushed it to a degree of showiness that scandalised dress reformers, leading to a paradoxical reversal of earlier associations and to an equation of tight-lacing with libidinous desire (Finch 1991, p.343).

The cartoon was probably conceived as a comment on the 'Girl of the Period' phenomenon of the late 1860s, a term used to describe the racy social and sartorial habits of the modern liberated young woman, who in her pursuit of artifice and pleasure was seen as transgressing the boundaries of class and respectability. By ridiculing the debilitatingly narrow waists of the heavily draped girls in the street, Barnard's classical troupe elevate the 'natural' nude body as a pure, aesthetic and hygenic entity. The dissemination of this view in popular magazines helped promote the classical nude as a moral exemplar amongst a broad public. AS

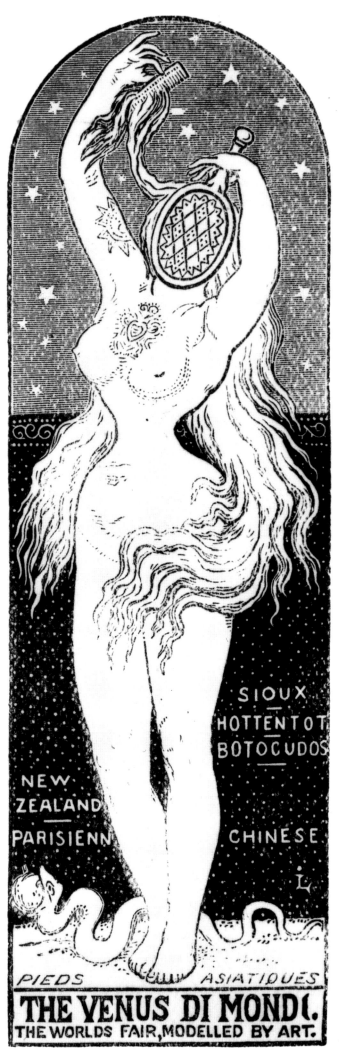

Anon

52 'The World's most Beautiful and Adorable Idol', wood-engraved line illustration in 'Luke Limner' [John Leighton], *Madre Natura versus the Moloch of Fashion, a Social Essay*, 1870
17·5 × 25·5 (open) (6⅞ × 10)
The British Library Board

✱

Madre Natura, written by the designer John Leighton under the pseudonym Luke Limner, was rated the most important medical text of the Dress Reform movement and was dedicated to John Marshall, Professor of Anatomy at both the Royal Academy and at the Government Schools of Art at South Kensington. In bringing together a number of related perspectives on the body – aesthetic, medical, social and anthropological – Leighton attacked the custom of tight-lacing as a perversion of the natural configuration of the body upheld by the classical tradition. The exaggerated hips of this Venus represents a deliberate distortion of the classical canon of proportion, reinforcing the author's thesis that woman's innate vanity and capriciousness made her vulnerable to degenerate influences.

By the 1870s the pelvis had become an important index for the classification of racial and social types, the study of 'pelvimetry' having been inspired by the anatomy of the 'Hottentot Venus', Saarah Bartman, first illustrated in Cuvier and Saint-Hilaire's *Histoire naturelle des mammifères* in 1824. Pelvimetry focused on the buttocks as a link between sexualised modern women and 'uncivilised' non-white races, as this image makes apparent. Allusions to foot-binding ('pieds Asiatiques') together with the tattooed body of Venus further suggest that the degenerate woman readily accepts pain and disfigurement as the price for adornment. References to 'primitive' women ('Sioux', 'Hottentot', 'New Zealand') are thus placed ironically alongside the fashionable 'Parisenn[e]'. AS

Edward Linley Sambourne (1844–1910)

53 'The Model "British Matron"', *Punch*, 24 October 1885
Wood-engraved by Joseph Swain after Sambourne
21×17·8 (8¼×7)
Royal Borough of Kensington & Chelsea, Linley Sambourne House

✷

A greater tolerance of the nude in art, encouraged by the promotion of the classical ideal, was compromised by the efforts of 'purity' movements to ban the subject from exhibitions on the premise that it threatened the morals both of models and uneducated sections of the viewing public. Purists drafted into their ranks a number of influential artists and critics, the most notable being John Callcott Horsley, Treasurer of the Royal Academy and a longstanding opponent of the nude and of the teaching of life-drawing to female art students.

The exhibition of an unprecedented number of nude works at the Academy and Grosvenor Gallery in 1885 provided the occasion for the appearance of a letter bearing the signature 'A British Matron' in *The Times* protesting against the nude and the threat it presented to public morals and national stability (20 May, p.10). This homily provoked a debate on the nude as newspapers were inundated with responses arguing for and against the undraped figure. Whether Horsley himself was behind the original 'British Matron' letter as was suspected is not altogether certain, but he certainly contributed to the discussion in the form of a carefully argued letter published in *The Times* signed 'H' in which he cited Poynter's *Diadumenè* (no.33) as an example of the 'failure' of the modern nude (25 May, p.10). That October Horsley renewed his attack in the form of a paper delivered to the Portsmouth Church Congress, at which he had been invited to speak by the Church of England Purity Society, and where he argued that life-study was unwomanly and violated Christian principles. The speech triggered a further spate of letters and satires, the most memorable being Sambourne's cartoon, which establishes a direct connection between Horsley and the 'British Matron' by showing the heavily draped Academician recoiling in horror from the *Venus de' Medici*, an unexceptionable paradigm of female perfection and beauty. As 'Matron', Horsley appears blind to the purifying influence of art and can only think of the model who had posed for the statue. The modest attitude of the Venus is mirrored by the prudish gesture of the Matron who gathers her skirts around her body only to reveal her petticoats and by implication her artfulness and hypocrisy. AS

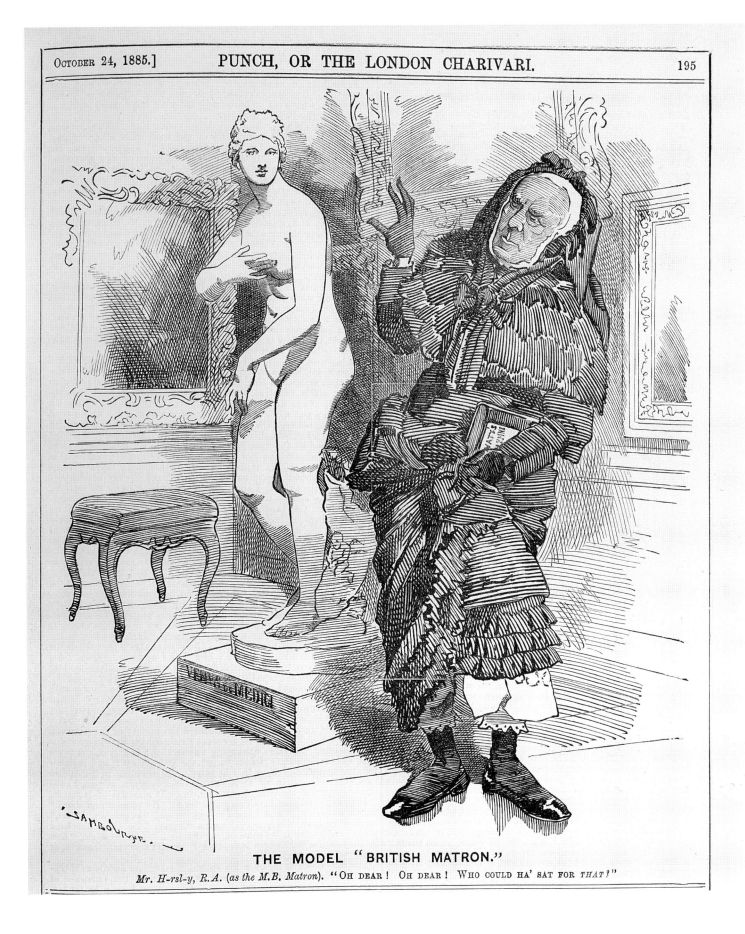

THE MODEL "BRITISH MATRON."

Mr. H–rsl–y, R.A. (as the M.B. Matron). "OH DEAR! OH DEAR! WHO COULD HA' SAT FOR *THAT?*"

Edward Linley Sambourne

54 Cover design for a concert programme
commemorating the Centenary of the Royal
College of Surgeons of England, 25 July 1900
Line illustration
24×18·5 (9½×7¼)
The Royal College of Surgeons of England

54

55

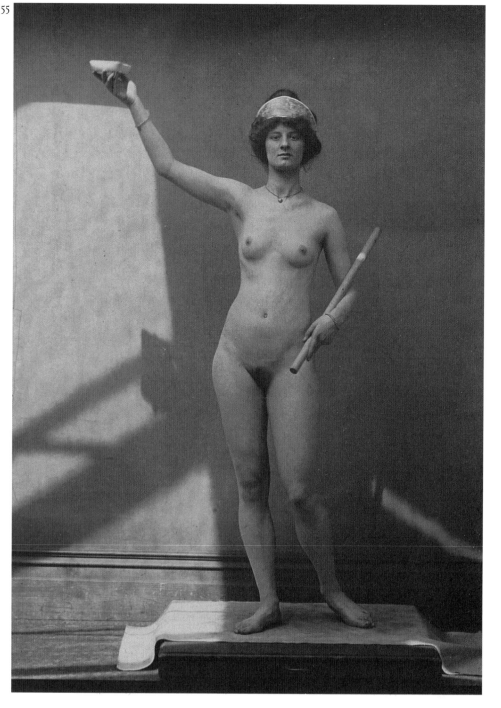

Edward Linley Sambourne

55 Model posing as 'Hygieia', dated 27 May 1900,
Cyanotype
15 × 11·2 (5⅞ × 4⅜)
Royal Borough of Kensington & Chelsea,
Linley Sambourne House

✱

Sambourne's photograph and illustration show
how the classical ideal of the body filtered out to
a broader level of consumption abetted by new
printing and reproductive technologies. Images
of the classical body, both nude and draped,
featured regularly in magazines and journals as
emblems of health, sanitation and beauty, and
this ideal of 'natural' form was upheld by the
medical profession which spoke out against the
physical distortions induced by modern corsets
and the fashionable practice of tight-lacing.

Despite being a regular cartoonist for *Punch*
as well as a freelance illustrator, Sambourne
had no fine art training and was unable to
draw either from memory or from the model.
Photography thus became a vital aid, enabling
him to work efficiently and accurately under
pressure. Having decided upon his design, he
would arrange and photograph a tableau of the
motif and then copy or trace selected elements
which were incorporated into the final scheme.
This allegorical figure of 'Hygieia' was based
on a number of photographs Sambourne took
from a professional model, Mabel Hall, a
regular employee at the Royal Academy who
also posed in private studios. Sambourne would
invariably photograph his models nude even
when he intended his finished designs draped.
Although there is a clear element of voyeurism
in these works, and Sambourne tended to take
more pictures than strictly required, his
compositional procedures paralleled the
academic methods used by painters such as
Leighton, Poynter and Moore, who also
assembled their designs from discrete nude
and draped studies. Following standard
conventions of composition Sambourne edits
signs of modernity such as her jewellery and
transforms the angular configurations of the
model to match the standard statuesque ideal.
For the drapery and props he would have
consulted images stored in the vast
photographic archive he had accumulated
as a working aid. As Sambourne became
increasingly dependent upon copying from the
camera his drawing style became rather arid
and formulaic, lacking either the animation
or inventiveness of his photographs. AS

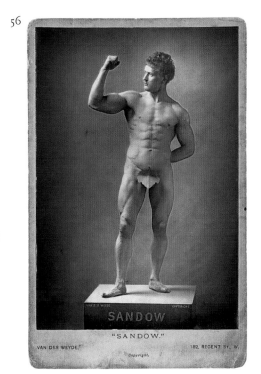

56

Henry Van der Weyde (1838–1924)

56 *Eugen Sandow* 1889
Carbon print
14 × 9·7 (5½ × 3⅞)
National Portrait Gallery, London

✱

Famous as the inventor of an electric light that
made it possible to photograph in the studio
late at night after the theatres closed, Henry Van
der Weyde (an American working in Britain)
published many cabinet card portraits of
celebrities. This example comes from a series
made during the sensational London stage
debut of Eugen Sandow (British, born Prussia,
1867–1925). Taking advantage of the *fin de siècle*
call for manlier men and capitalizing on the
popularity of the Greek ideal, Sandow used
photography as a cornerstone of his success and
presided over the launch of the still-flourishing
genre of physique photography. Photographs of
Sandow almost or completely nude were
distributed across Europe and America.
Bodybuilders came to accept the camera as a
tool as essential as the mirror in their efforts to
sculpt and mould their own flesh in Sandow's
image.

Not long after Van der Weyde's *Sandow*
series appeared, Edmund Gosse sent one from
London to his friend John Addington Symonds
in Switzerland. Symonds and Gosse – both
married men with children – communicated in
a coded language (much of it sited within the
exchange and appreciation of images) in which
they explored their homosexuality without risk.
Symonds thanked Gosse ecstatically, noting
'It seems to me rather odd ... that the authorities
should allow the wide circulation of this nude
portrait of a man ... Odd, I say, when one
remembers the extraordinary attitude of the
English law toward certain practices ...'
(Younger 1999, p.2).

At the same time, photographs of Sandow
were produced for, promoted to, and purchased
by women. Many attended his performances
and then paid a little extra to go backstage.
Sandow usually appeared at these soirées in his
stage costume of vest and tights, but at an 1894
lecture for women only he wore just a strip of
silk. Clearly Sandow understood that his sexual
magnetism and undoubted virility drew both
women and men – and it appears that he acted
on this knowledge in his private as well as his
professional life. VD

Hana Studios Ltd. (British, late nineteenth–early twentieth century)

57 *Untitled (pose plastique)* c.1900
Gelatin-silver print
18·2 × 13·5 (7$\frac{1}{8}$ × 5$\frac{3}{8}$)
Wellcome Library, London

57

Hana Studios Ltd. (British, late nineteenth–early twentieth century)

58 *Miss Viola Hamilton* c.1900
Gelatin-silver print
13·9 × 9·8 (5$\frac{1}{2}$ × 3$\frac{7}{8}$)
Wellcome Library, London
✳

Barely discernible 'fleshings' – body stockings made of some gossamer fabric – clothe both the unidentified *pose plastique* artiste and Miss Viola Hamilton (clearly a celebrity in her own time). Though their erotic charge is highly diluted a hundred years later, these photographs were probably marketed and collected as prize examples of the lovely, living female form and/or mementos of the performers' stage acts. As a genre the *pose plastique* is related to the *tableau vivant*, with the important difference that the performers appear to be naked, hence the other term used to describe this type of performance, 'clothed nudity'. On stage the *pose plastique* artistes would strike and hold motionless poses derived from famous sculptures or paintings. As long as the performers did not move, or only gradually shifted from one pose to another, the spectacle could be deemed Art. Audiences enjoyed the sensation of 'paintings come to life' and 'living sculptures'. Sculptural qualities were emphasised and enhanced. Any hint of naughtiness was well filtered. Fleshings covered body hair and smoothed out imperfections. Genitalia and nipples disappeared. A dusting of powder overall, including the hair, completed the illusion. In these examples the artistes prop themselves against a rather worn and dirty piece of studio furniture, a wooden box marbled to suggest a neo-classical plinth. The classicising treatment is carried further, in the hairstyle of the unidentified performer and in Viola Hamilton's garland of flowers and flowing draperies.

Pose plastique performances had an important impact on the fledgling profession of bodybuilding. Bodybuilders' poses, like those of the *pose plastique* artistes, primarily derived from classical sculptures, as well as from popular academic paintings, from the theatre and from modern dance. Eugen Sandow was 'tops when it came to posing', according to his contemporary and rival, Al 'Albert the Perfect Man' Treloar, 'and that's why his reputation has

not diminished with the passing years' (quoted Chapman 1994, p.63). Sandow's triumph as the beau ideal of transatlantic society came during his 1893 debut in New York, when he appeared in the final tableau of Adonis, a musical farce. The plot required the principal actor to climb atop a pedestal and pose as a statue. The curtain came down and when it rose again, lo and behold, Sandow was in place as the new Adonis. According to a critic, 'When New York has seen Sandow ... [it] will realize what a wretched, scrawny creature the usual well-built young gentleman is compared with a perfect man. Sandow, posing in various statuesque attitudes, is not only inspiring because of his enormous strength, but absolutely beautiful as a work of art as well' (quoted Chapman 1994, p.49).

These photographs, as well as the Guglielmo Plüschow and Wilhelm von Gloeden photographs in the exhibition, were collected by Edwin Nichol Fallaize (1877–1957) during the first part of the twentieth century. He gave or left a trunk full of photographs, many still in the original envelopes, to the Wellcome Library. The collection comprises 'pictures of naked and clothed boys and men, but also very many portraying naked and clothed women of all races ... as well as many studio portraits of actresses, bullfighters, peasants, and singers' (information from David Brady, Wellcome Library, currently cataloguing Fallaize's collection). Fallaize was honorary secretary of the Royal Anthropological Institute from 1919 to 1930, and an acquaintance of Sir Henry Wellcome, founder of the Wellcome Library. Not much is known about Fallaize or his connection with Wellcome, an avid collector who assembled a vast image world. As it is no longer easy to collect on the same scale as Fallaize and Wellcome, we are indeed fortunate that they left their prizes for posterity to rummage through. VD

Miss Viola Hamilton

The Private Nude

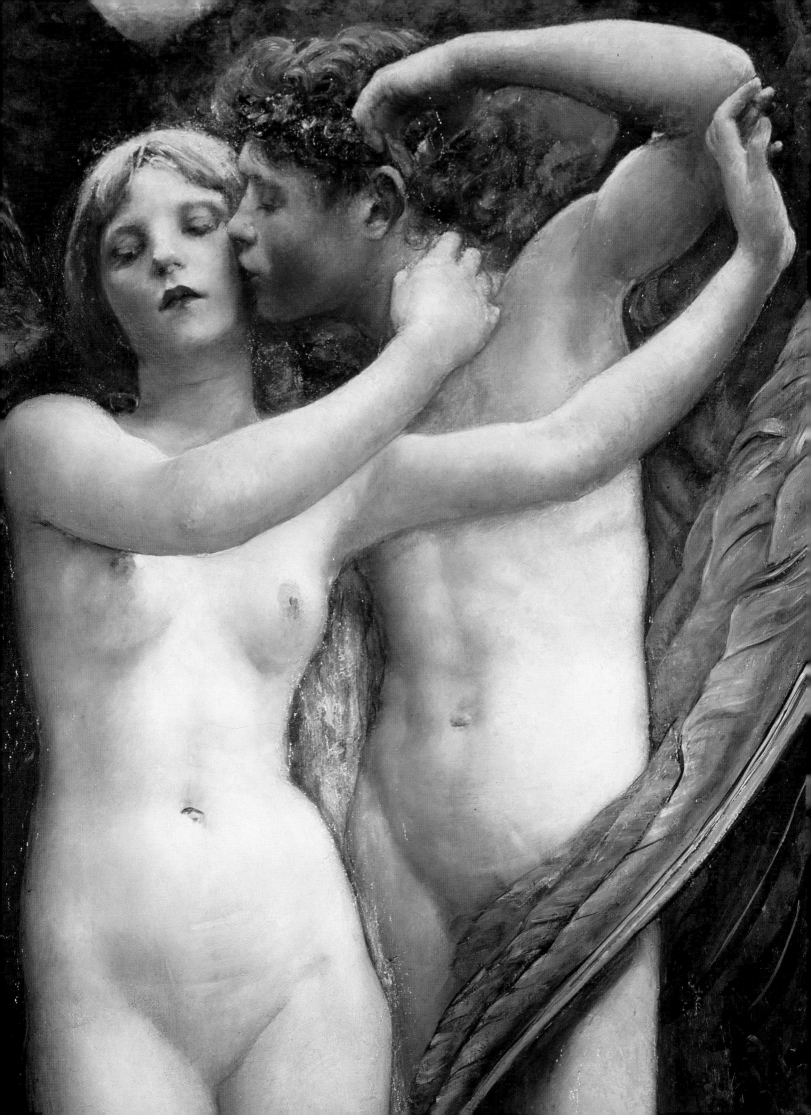

While the nude had a sensational exhibition presence, it also led a more private, more furtive domestic existence. Throughout the Victorian era, dealers offered collectors the opportunity to acquire intimate, smaller-scale works which were often a great deal more sensual than anything sent to public exhibitions. Artists also sold pictures of this kind directly to their patrons, such private commissions allowing even greater erotic treatment of the body, and also permitting the circulation of androgynous and homoerotic imagery that could not normally be shown in public. Private ownership of nude subjects allowed close scrutiny and contemplation, but the politics of seemliness in the Victorian household did not necessarily allow overtly voluptuous pictures to be displayed in parts of the home where they might be seen by visitors, women or servants. Instead, smaller-scale nudes would be confined to a private space or cabinet for perusal. The Presbyterian Scottish jute manufacturer and MP William Graham was one of the greatest patrons and connoisseurs of the nude. But he was often reduced to smuggling such works into his home to avoid his wife's objections, and he gave spurious saints' names to those nudes on prominent display to legitimise their presence.

Technology drove change throughout the Victorian era, and the development of photography created a whole new market for the nude. By the early 1860s nude photographs appear to have been widely available, varying in their pornographic level. In 1862 Arthur Munby recorded in his diary being offered photographs by touts, who told him they had little trouble finding models. Holywell Street, Drury Lane and the area around what is now Aldwych became a centre for shops that sold photographs and prints, of both artistic and specifically pornographic subjects. By 1907 these establishments were so commonplace that Joseph Conrad could have his lead character Mr Verloc run such a shop in his novel *The Secret Agent*, frequented by 'very young men, who hung about the window for a time before slipping in suddenly; or men of a mature age, but looking generally as if they were not in funds' (p.13). Munby in 1862 wrote of going 'into a small photographers shop on my way home, to buy a beautiful view of the Haunted House at Hampstead, the man, who was young and well drest, wanted to show me various

photographs of nude female figures. Producing one, of a young woman entirely naked. "This Sir", said he, "is Miss Peacock, the Academy model"!' (diary 22 March 1862, Hiley 1979, p.78).

Photography, so revolutionary, blurred the boundary between the real and fictive body, adding an erotic realism not possible in painting. Some of the photographs sold were of actual works of art; others were of nude figures set in poses derived from the Antique or Old Masters, a photographic version of the *poses plastiques*; many more photographic images were straightforwardly pornographic. French material was seen as particularly licentious, and although many photographs were imported, those originating in London were frequently marketed falsely as coming from the Continent. Cameras were rare and luxury items in the 1860s when Lewis Carroll revealed what some have interpreted as his paedophile sensibility by photographing little girls clothed and unclothed. But by the 1890s cameras and processing were cheaper, easier to use and quicker, allowing more complex poses. The *Punch* illustrator Linley Sambourne took photographs in vast numbers, invariably turning to nude models when his wife was away from home. Stereoscopic viewers, first seen at the Great Exhibition in 1851, offered three-dimensional photographic images, and this new invention too was quickly used for viewing the nude (no.91); by the 1860s almost every middle- and upper-class household had its stereoscope. Boudoir scenes featured among early films, and by the end of the century 'What the Butler Saw' had become synonymous with seaside licence and low-brow entertainment.

Homosexual images circulated both covertly and more openly. The photographs of languid Mediterranean youths by Plüschow and others seem to have been generally tolerated, regarded as illustrations of physical type or of a healthy outdoor existence. But homoerotic works of art such as those by Simeon Solomon, who was prosecuted for indecency with another man in a public lavatory in 1873, were confined to a select, elite audience. Solomon's sexually subversive drawings sometimes combined an interest in adolescents with sado-masochism and flogging, such as *Love among the Schoolboys* (1865) or *Spartan Boys about to be Scourged* (1865).

Overleaf:
Annie Swynnerton
(neé Robinson)
Cupid and Psyche 1891
(no.68, detail)

Simeon Solomon
The Bride, Bridegroom and Sad Love 1865
(no.79, detail)

The moral backlash against such a plethora of material went back to 1857 and the passing of the Obscene Publications Act (see pp.31–2), and successful prosecutions could bring severe penalties. In 1870, for instance, 850 photographs were seized from the premises of Henry Evans, and he was fined £50 and given two years' hard labour. The pressure group the Society for the Suppression of Vice brought more numerous prosecutions. Between 1868 and 1880 they seized over a quarter of a million photographs and prints from vendors and distributors. A longstanding defence used against prosecution for selling them was that they were intended for the instruction of artists.

The legal cases brought, and the Society's activities, led to intense and impassioned discussion of the boundaries between art and pornography, and the consideration of distinguishing what was socially acceptable from what was illicit and obscene. But, very gradually, art became increasingly immune from prosecution, if not from moral censure. RU

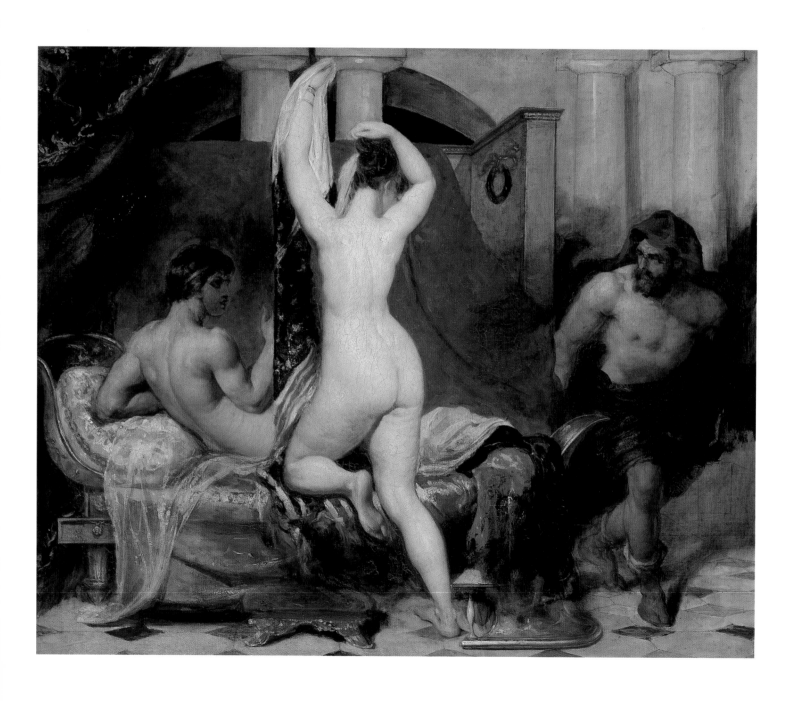

William Etty (1787–1849)

59 *Candaules, King of Lydia, Shews his Wife by*
Stealth to Gyges, One of his Ministers, as
She Goes to Bed 1830
Exh. RA 1830
Oil on canvas
45·1 × 55·9 (17³4 × 22)
Tate. Presented by Robert Vernon 1847

✱

With this cynical subject of voyeurism and
vengeance Etty was testing the limits of what
could be accepted as high art, which may
explain why he opted to represent the scene on
a modest scale. The painting depicts an episode
recounted by the Greek historian Herodotus
in which the Lydian king Candaules arranges
for his general Gyges secretly to view his wife
Nyssia as she disrobes. Furious at her
husband's impudence and betrayal, the queen
presents Gyges with the option of either
execution or murdering the king, a dilemma
which drives him to slay Candaules and marry
Nyssia.

The pose of Nyssia probably originated as a
life-study, with the rest of the subject developed
at a later stage. In positioning the principal
figure to be viewed from behind, Etty makes the
spectator complicit in Candaules' plot, our view
completing the circumspection of the queen.
The picture entered the collection of Robert
Vernon but when it became public property
following his gift to the nation in 1847, it was
regarded as something of an embarrassment to
the national school. S.C. Hall, editor of the *Art
Journal*, refused to have it engraved there, and
even Alexander Gilchrist, a staunch defender
of Etty and the nude, singled it out as 'almost
the only instance among Etty's works, of an
undeniably disagreeable, not to say
objectionable subject having been chosen as
the theme for interpreting nude form, and the
development of harmonious colour' (Gilchrist
1855, p.285). In short, opinion was unanimous
that Etty's picture was acceptable, if at all, only
for private viewing.

The spatial complexity of the composition
achieved through the rather illogical
deployment of drapes, columns and screens,
accentuates the violence and claustrophobia
of the image. The vertical line which runs
downward from the queen's raised left arm,
through her drapery to her knee, abruptly cuts
off the body of Candaules at the thigh, visually
reinforcing the presiding theme of female
power and emasculation. AS

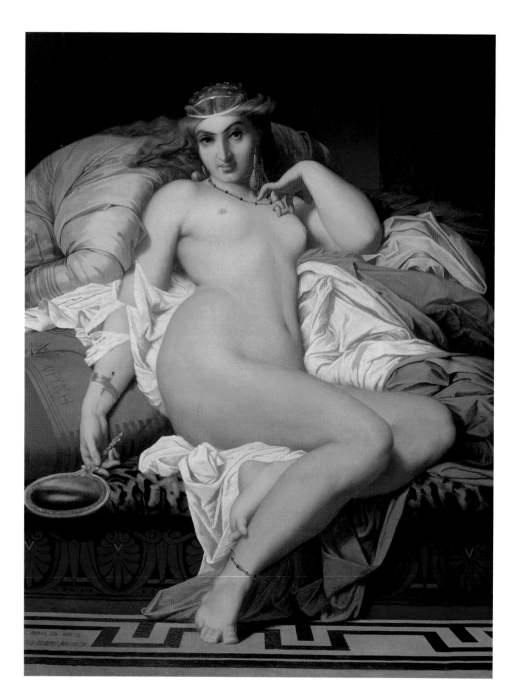

Gustave Boulanger (1824–1888)

60 *Phryne* 1850
Exh. EB 1851
Oil on canvas
140 × 106 (55⅛ × 41¾)
Van Gogh Museum, Amsterdam
✻

The most celebrated courtesan of ancient Greece, Phryne presented a natural subject for the painter of the nude (see no.28). While in his twenties Boulanger joined a group of young French painters called the 'néo-grecs' who were passionately interested in archaeologically correct reconstructions of Antiquity. He won the prestigious Prix de Rome in 1849 and travelled to Italy to paint and study, paying particular attention to the ruins of Pompeii. However, *Phryne*, the picture he sent back to Paris for the Salon exhibition, had little architectural or archaeological content. Instead it was a sizzlingly sensual portrayal of the Greek temptress. Reclining on a luxurious bed, her mirror fallen after a moment of narcissistic contemplation, she looks challengingly out at the picture viewer, fondling her necklace seductively. Her red hair denotes passion and her professional calling. The short foreground and closed off background make the figure fill the picture space. Boulanger has painted the flesh to look smooth and lifelike, and softened and rounded the form of the limbs and torso.

The picture's reception at the Salon was distinctly cool. Such an overtly sexual composition would require its display in a private cabinet, yet Boulanger's large scale would have demanded a more public setting. Such a work would have been considered beyond the pale in Britain. Nevertheless, the mirror narcissism, red hair, fleshly figure and opulent trappings are all attributes of Rossetti's later female pictures, although formally very different and usually not nudes. Rossetti was in Paris in 1848 with Holman Hunt, and it is tempting to speculate whether on this trip or subsequent ones he encountered Boulanger's work. RU

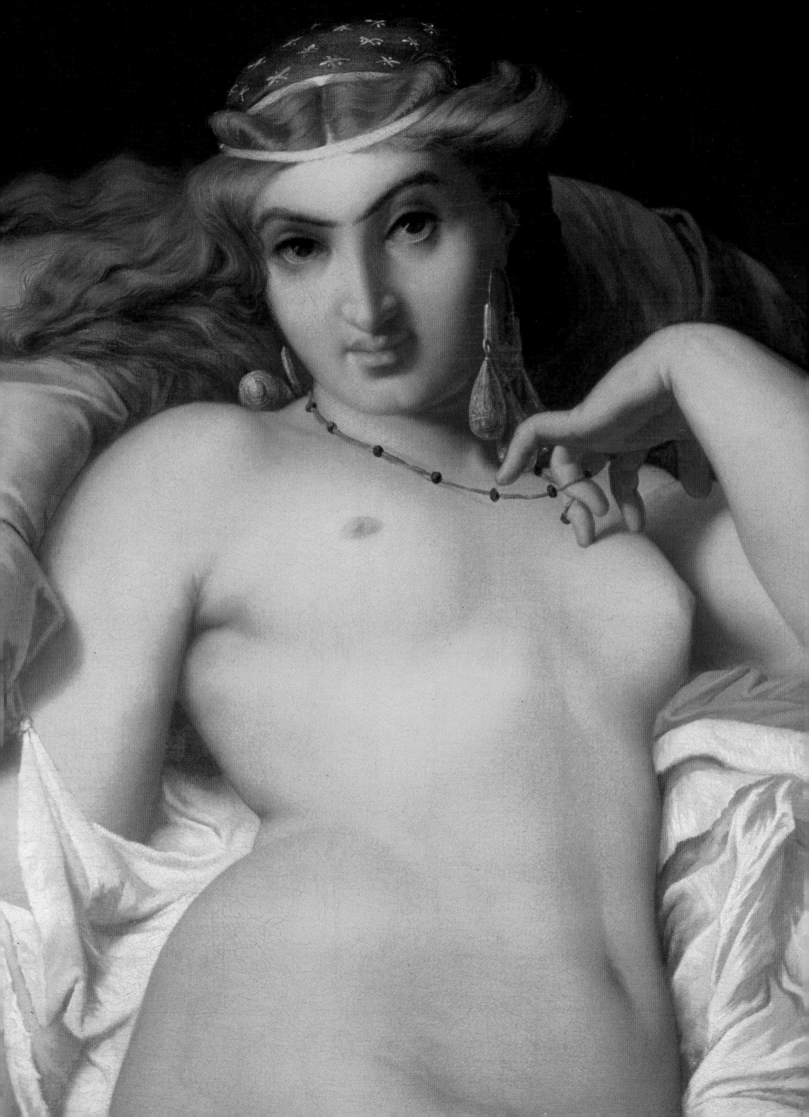

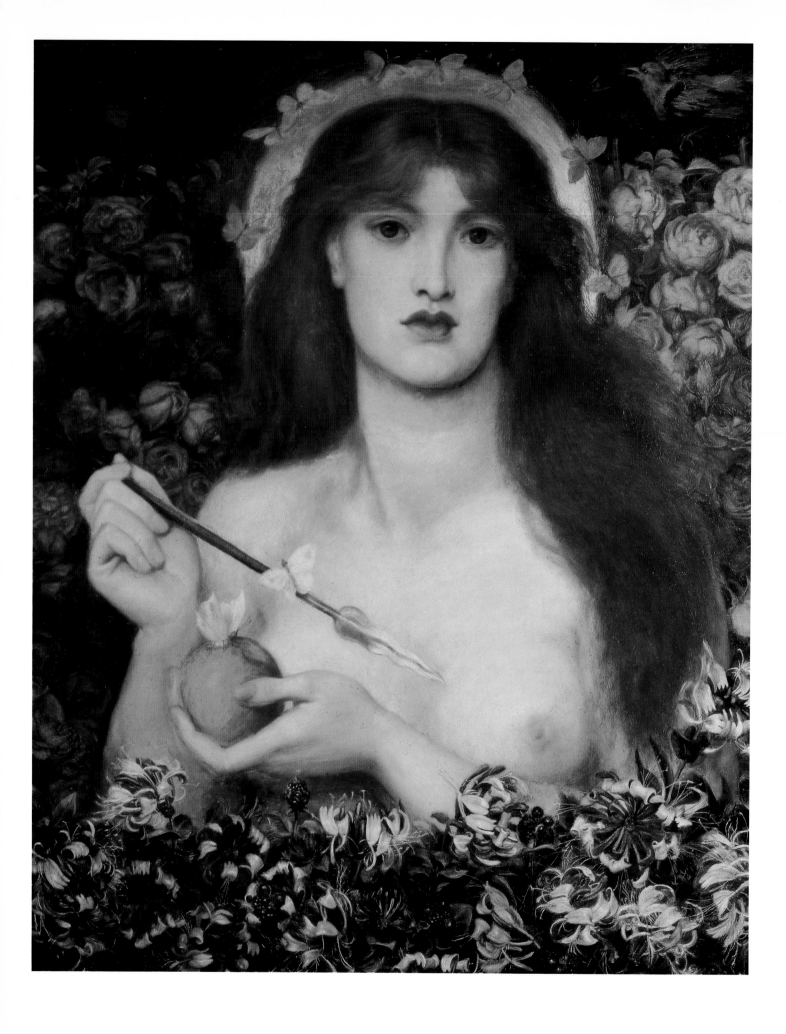

Dante Gabriel Rossetti (1828–82)

61 *Venus Verticordia* 1864–8
Oil on canvas
83·8 × 71·2 (33 × 28)
Russell-Cotes Art Gallery & Museum,
Bournemouth
✱

William Michael Rossetti recalled that

> my brother, being on the look out for some
> person to serve as a model for the head and
> the shoulders of his Venus, noticed in the
> street a handsome and striking woman, not
> very much less than six feet tall … He spoke
> to this person, who turned out to be a cook
> serving in some family in Portland Place,
> and from her he at first painted his large
> 'Venus, Verticordia'. That was the only
> picture, I think, for which the handsome
> Dame de cuisine sat to him. (*Art Journal*,
> 1884, p.167).

George Price Boyce confirmed in his diary that
the model was 'a very large young woman,
almost a giantess' (quoted Surtees 1971, I,
p.99). However, Rossetti subsequently painted
her out and substituted his regular model Alexa
Wilding. The picture was purchased by the
Yorkshire merchant John Mitchell, a man of
progressive views, who was apparently 'looked
down on as a cad rather', by some among the
Rossetti circle (quoted Marsh 1998, p.277).
George Rae, one of Rossetti's most important
patrons, had turned down the opportunity to
buy the picture, writing 'The oil painting struck
me as just a trifle too voluptuous … for a
respectable old sinner like me' (quoted Smith
1996, pp.145–6). He also initially declined a
smaller watercolour version saying he did not
admire 'Ettyism', but Rossetti persuaded him
to buy it, denying, correctly, any such influence
(Marillier 1899, p.92). Rae then asked if the
figure might be draped, but Rossetti steadfastly
refused. The watercolour was Rae's Christmas
present to his wife Julia, and by the summer
the couple's doubts had evaporated, describing
their 'little Venus' as 'our dear and charmingest
of all' (quoted Marsh 1998, p.281).

Rossetti's naked *Venus* was obviously
popular with his patrons, and other versions
were acquired by William Graham and
Frederick Leyland. Ruskin, however, was
appalled by the image. While recognising its
Titianesque, Venetian roots, sources for which
he had done so much to renew admiration,
Ruskin wrote to Rossetti objecting to the
picture's overt sensuality. Ruskin's reaction
should, however, not be viewed as overly
extreme, as this was a provocative image with
a disquieting set of symbols. Venus holds
the 'Apple of Discord', given to her by Paris.
His resulting reward led to the death and
destruction of Troy. The arrow Venus holds
refers both to Cupid's dart, but also to the
poisoned arrow which killed Paris at Troy.
The blue bird in the background, above roses
symbolising love, is an omen of bad luck.
Rossetti characterises Venus and male
weakness for feminine beauty, as dangerous.
Venus's halo, a Christian attribute assigned
here to a pagan deity, lends the picture further
profanity. Rossetti's friend F.G. Stephens
explained in the *Athenaeum*: 'Winner of hearts,
she reeks not of the soul; fraught with peril, her
ways are inscrutable; there is more evil than
good in her; she is victorious and indomitable'
(21 Oct. 1865, p.546). Rossetti's fascination
with dominating femmes fatales at this time
was undoubtedly fuelled by his friendship
with Swinburne, whose sado-masochistic
tastes were infamous. RU

Dante Gabriel Rossetti

62 *Ligeia Siren* 1873
Coloured chalks
80 × 55 (31$\frac{1}{2}$ × 21$\frac{5}{8}$)
Private Collection

✳

Rossetti's *Ligeia* was evidently originally intended to be wholly uncovered, lacking the twist of fabric which now covers her pudenda. Rossetti offered the drawing to both of his best patrons, Frederick Leyland and William Graham, who each turned it down on the grounds of its nudity. Rossetti therefore adapted the figure's headgear to offer some modesty, writing to Charles Augustus Howell: 'the unpopular central detail will eventually be masked by a fillet of flying drapery coming from a vent twisted in the hair so as to render it saleable' (quoted Macleod 1984, p.80, n.2). However, he did not find a buyer, and the same year it was made Rossetti gave it to Howell for arranging the sale of *Dante's Dream at the Time of Beatrice's Death*. The great fixer of the art world, Howell was unlikely to have been worried by the figure, for among his many dubious business pursuits he was rumoured to be a purveyor of pornographic visual material. As an MP and Presbyterian, William Graham's rejection of the picture may seem inevitable, but he was in fact an enthusiastic collector of nudes. However, his family life was a consideration in his choices. Graham's wife appears to have had strict views about such material, and it was reputedly she who forced the rejection of *Ligeia*. Others among Rossetti's patrons were stricter. The lawyer Leonard Valpy returned a sheet depicting two male nudes, sent him by Howell, 'which drawing, as being a nudity, was distasteful to Mr. Valpy' (Rossetti 1889, p.100). Marillier judged 'Mr Valpy was so particular that he hardly liked even a bare arm to be shown in the pictures he bought to hang on his walls' (Marillier 1809, p.135).

Infamous for his luxuriant portrayals of feminine beauty, Rossetti actually made very few nudes. Nevertheless, he had at first resisted covering Ligeia, writing to Howell: 'I should not have brought myself to use the fillet in the Siren drawing (which is not there either), had I not conceived that the flying veil would improve the composition. I shall put it or not as I find the case or not' (quoted Cline 1978, p.222).

But saleability prevailed and he wrote again a few weeks later that he had 'added a little drapery with great advantage to the composition, – to say nothing of its improving the market' (ibid.). The model for Ligeia was 'a singular housemaid of advanced ideas', Rossetti wrote, 'come hither as a model not a housemaid' (quoted Surtees 1971, I, p.134). She was selected and sent to him by Henry Treffry Dunn, his assistant. She stands amid foliage identical to that in Rossetti's *The Question* (no.76) of two years later, another picture about predatory women; the ship in the background is also the same. Ligeia was one of the three sirens of ancient Greek myth, whose beauty and enchanting music lured sailors unable to resist their charms to their deaths on the rocks. The sirens are therefore ciphers of male fear of powerlessness and compulsion in the face of sexual attraction, and a warning of woman's danger. It was an archetype which clearly held great interest for Rossetti as in 1868 he composed an opera libretto entitled *The Doom of the Sirens*, the denouement of which sees the roles reversed, and the sirens destroyed by their own unrequited love (see *Age of Rossetti* 1997, p.185, no.72). Rossetti's return to the subject for his 1873 *Ligeia* may perhaps be connected with his compulsive love for the unattainable Jane Morris. RU

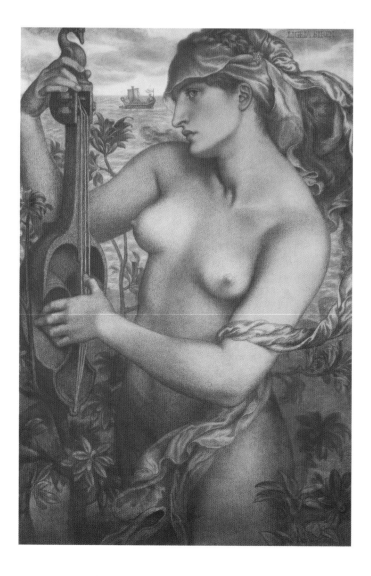

George Frederic Watts (1817–1904)

63 *A Study with the Peacock's Feathers* c.1862–5
Exh. FG 1865
Oil on panel
66 × 56 (26 × 22)
Pre-Raphaelite Inc by courtesy of Julian
Hartnoll

✱

With its rich colouring and luxuriant setting,
Watts's *Study* pays homage to Venetian nudes of
the Renaissance, but its lack of subject, strong
design and decorative elements place it firmly
among cutting-edge aesthetic pictures of the
1860s by Rossetti, Albert Moore and others.
The inclusion of peacock feathers may be a
direct allusion to the studies of Nanna Risi
made by Leighton, a younger artist whom Watts
knew and admired. The somewhat ambiguous
Whistlerian title indicates that it is presented
as a product of the studio, a study of a model.
Formally, it can be related to Watts's *Wife of
Plutus* (no.64). Watts sent his *Study* to the
French Gallery for exhibition, a venue which
suited its experimental aesthetic character, and
it was the subject of extensive critical praise by
F.G. Stephens in the *Athenaeum*: 'the tones are
most subtly pronounced, and the artist's skills
triumphantly manifested in the exquisite colour
of the work. We rarely see such true Art as this,
still more rarely does it present itself so wealthy
in beauty and completeness' (4 Nov. 1865,
pp.618–19). Venetian painting was greatly
admired in the 1860s by a number of
prominent critics, most notably Ruskin, for
its sensitive integration of form and colour.
But precisely how realistically flesh should be
treated was an area of some moral debate at
this time. Watts's model is treated sensuously
and naturalistically, her flesh warm and real,
making it a daring contribution to this
discussion. Her flushed cheeks may have
caused further unease. RU

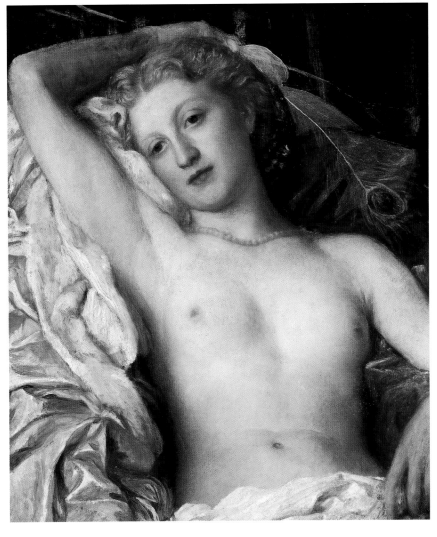

George Frederic Watts

64 *The Wife of Plutus c.*1877–86
Exh. New Gallery 1896–7
Oil on canvas
66·7 × 54 (26^14 × 21^14)
Board of Trustees of the National Museums and
Galleries on Merseyside (Walker Art Gallery,
Liverpool)

✱

Plutus was the Greek god of wealth, and Watts's
allegorical portrait of his wife is a diatribe
against the growing materialism of the
Victorian age. Bare-breasted, grasping pearls
and jewels amidst rich silks, Plutus's wife
writhes on her pillow. With her closed eyes
and flowing hair it is a pose which immediately
suggests the tense contractions of orgasm,
but which was actually intended to convey the
sickness and lack of fulfilment wealth might
bring. It might also be a gesture of grief at
Zeus's blinding of her husband so that his gifts
should be distributed arbitrarily and not just
to those who earned them. Nevertheless, Watts
presents a highly eroticised subject, in which
the figure's turned head allows the viewer
unchallenged, voyeuristic contemplation of
her body. Watts exhibited the picture at the
New Gallery in 1896–7 accompanied by a
misquotation from *Ecclesiastes*: 'And yet the soul
is not filled' (6: 7), summarising his belief in
the vacuity of accumulated possessions, but,
in view of its erotic character, hinting too at the
lack of fulfilment which sensory or sexual
excess can bring.

Compositionally, and in its treatment of the
torso, the picture is related to Watts's *Study with
the Peacock's Feathers* (no.63). Programmatically,
the picture fits into Watts's series of
ruminations on wealth in such pictures as
Mammon (1884–5), *Sic Transit* (1880–2) and
For he had great Possessions (1894). Watts wrote:
'Although I do not wish to preach ... [in] "The
Wife of Plutus" I wish to suggest the disease of
wealth like strength or any other possession
is a fine thing and may be used for general
benefit becoming a noble personal distinction,
but if loved only [for] self-gratification is one
of most valueless since it forms no part of the
possessor's personality' (letter to James Smith,
the picture's purchaser, 11 April 1890, MS,
Watts Gallery, Compton). RU

Edward Coley Burne-Jones (1833–1898)

65 *Pan and Psyche c.*1872–4
Exh. New Gallery 1898–9
Oil on canvas
61 × 53·3 (24 × 21)
Private Collection

✱

In Apuleius's *The Golden Ass* Psyche is warned
by her nocturnal lover Cupid never to try to gaze
upon him. When she breaks this promise, he
leaves her for ever. Bereft, Psyche tries to
commit suicide by hurling herself into a river.
But enchanted by her beauty the river god saves
her, and she is comforted by Pan and the water
nymphs. Burne-Jones had provided a long
series of designs for William Morris's poetic
cycle *The Earthly Paradise* (1868–70), part of
which tells the story of Cupid and Psyche.
His illustration for this scene, which with his
others was never published, was reused for this
oil version. Burne-Jones kept very closely to
Morris's verse description of the incident:

But the kind river even yet did deem
That she should live, and, with all gentle care,
Cast her ashore within a meadow fair
Upon the other side, where Shepherd Pan
Sat looking down upon the water wan.

Burne-Jones took the figure of Pan from Piero
di Cosimo's *Mythological Subject*, which had
been bought for the National Gallery in 1862,
and in which the Satyr gazes upon a dead, nude
maiden. For Burne-Jones the story of Psyche
held deep resonance in his own, secret life.
When he tried to break from his mistress Maria
Zambaco in 1868, when she may well have been
urging him to leave his wife, she tried to drown
herself (see no.66). Coincidentally, the picture's
first owner was the powerful Greek patron
Alexander Ionides, a relation of Zambaco. RU

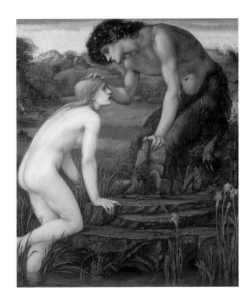

Edward Coley Burne-Jones

66 *Phyllis and Demophoön* 1870
Exh. OWS 1870
Watercolour and gouache on paper
91·5 × 45·8 (36 × 18)
Birmingham Museums & Art Gallery
✿

In a story related by both Ovid and Chaucer, Phyllis, the daughter of the King of Thrace, falls in love with the beautiful youth Demophoön, the son of Theseus. Demophoön leaves Thrace, but vows to return. When he fails to keep his promise Phyllis kills herself, but is transformed into an almond-tree by the gods. Demophoön eventually returns and, grief-stricken at the fate of his lover, embraces the tree. It immediately breaks into flower, signifying Phyllis's forgiveness.

When Burne-Jones exhibited his treatment of the subject at the Old Water-Colour Society in 1870 there was an immediate furore. Most objectionable seems to have been the androgynous lack of distinction between the male and female figures, prompting Tom Taylor to complain vociferously in *The Times* of there being 'no characterisation of sex between Demophoön and Phyllis' (27 April 1870, p.4). Demophoön's masculinity was impugned both by Burne-Jones's soft drawing and the weak, frightened and far from heroic pose of the figure. His uncovered but somewhat shrunken genitalia caused further distress, both because of being visible and worry about his lacking virile masculinity. The previous year the seemliness of Leighton's embracing couple *Helios and Rhodos* had been greatly discussed. But Burne-Jones's picture went much further, showing a predatory, flame-haired woman capturing and restraining her prey, a vivid illustration of feminine desire and power. Phyllis's eruption from the tree was entirely Burne-Jones's invention; it does not figure in any versions of the text. Taylor snorted 'the idea of a love chase, with a women follower, is not pleasant' (*The Times*, 27 April 1870, p.4). Other critics were repelled at Burne-Jones's rendering of the flesh, the *Illustrated London News* calling the picture 'nothing but a stony, bloodless figment of the fancy – something which, like the amatory poetry of the Swinburne school, might be loathsome were it not for its fantastic unreality' (30 April 1870, p.98).

To those in the know, and there were quite a few, the picture was also disquieting because of its personal dimension. Burne-Jones cast his mistress, the beautiful Greek sculptress Maria Zambaco, as Phyllis, in a knowing visualisation of his fear, compulsion and guilt. He had tried to end this affair several times, but it constantly revived through mutual instigation. On the most dramatic occasion Maria attempted suicide in 1868 by trying to jump into the Regent's Canal, Burne-Jones rolling with her on the ground to prevent it, and the police being called (see Doughty and Wahl 1965, p.685). The suicidal correlation between Maria and Phyllis, and Burne-Jones's fear of being trapped found explicit expression in his large watercolour.

Frederick Tayler, President of the Old Water-Colour Society, received an anonymous letter of complaint about the watercolour, evidently objecting to Demophoön's nudity. He approached Burne-Jones, who 'declined to make some slight alteration in removable chalk, and withdrew not only the picture from the walls, but himself from the Society' (Roget 1891, II, p.117). His letter of resignation from the Old Water-Colour Society stated: 'in so grave a matter as this, I cannot allow any feeling except the necessity for absolute freedom in my work to move me' (quoted Burne-Jones 1904, II, p.12). Nevertheless, when Burne-Jones returned to the composition in his large oil *The Tree of Forgiveness* (1881–2) he evidently thought it wise to introduce a wisp of drapery to cover Demophoön's genitalia, and gave him a more muscled physique. RU

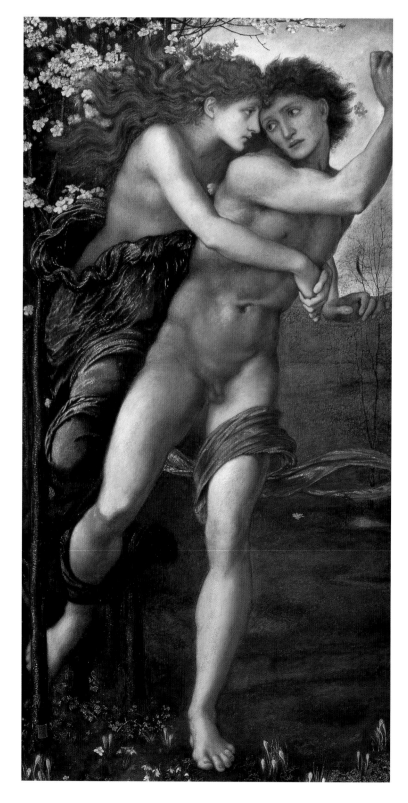

Alphonse Legros (1837–1911)

67 *Cupid and Psyche* 1867
Exh. RA 1867
Oil on canvas
116·8 × 141·4 (46 × 55⅝)
Tate. Bequeathed by Sir Charles Holroyd 1918

✳

Legros's experimental *Cupid and Psyche* reflects his engagement with classicism in the late 1860s as he moved away from realism to embrace a more eclectic style based on Old Master influences and study of the nude. The image developed during the time he was working from the model with his pupil George Howard, an aristocratic amateur artist and important patron of the Aesthetic movement who himself produced a presentation drawing titled *Cupid and Psyche* in 1869. In a diary entry for 14 July 1867, Rosalind Howard recorded her husband and Legros drawing together from the model and specifically mentioned an oil painting in which a Miss Wells figured as a wood nymph (see Wilcox 1987, p.78). This evidence, taken together with a recent technical report, would suggest that Legros started the work as a life-study and gradually transformed it into an imaginative mythological subject. Infra-red investigation has revealed detailed drawing for the head and hands of the female nude and also shows that few modifications were made to her, implying that the figure was painted directly onto the light ground, whereas the drapery, landscape and additional figure of Cupid all underwent considerable alteration, many adjustments being visible to the naked eye. The existence of a life-drawing of a similar date entitled *Reclining Venus* would further suggest that Legros envisaged his model as a Venus, reminiscent of Giorgione's *Sleeping Venus* (c.1510) and Titian's *Venus of Urbino* (1538), before he added the Cupid figure and turned the nude into Psyche.

The finished composition reflects Legros's diverse aesthetic allegiances of the time, acknowledging Rembrandt's etching *Jupiter and Antiope* of 1659, Ingres' *Odalisque and Slave* of 1839 and Manet's *Olympia* of 1865, as well as Moore and Whistler in the detail of the azalea branch in the lower left corner. It was certainly the realism of the nude that disturbed critics in 1867: F.G. Stephens described the sleeper as 'rather a commonplace naked young woman' (*Athenaeum*, 4 May 1867, p.667), while others dismissed her as a 'hard', 'unsavoury' and 'heavy' interpretation of the Venetian nude (*The Times*, 14 May 1867, p.6; *Illustrated London News*, 25 May 1867, p.519). The 'ordinary' aspects of the woman also made the image appear voyeuristic, more suited for artistic taste than general appreciation. The collector William Graham was deterred from purchasing the work and warned Legros 'that for the purpose of our English home life it is desirable that the figure should not be nude in so far as that can be avoided' (letter of 9 April 1869; see Wilcox 1981, p 47). The painting eventually entered the collection of Legros's assistant and admirer Charles Holroyd, who bequeathed it to the Tate in 1918. AS

Annie Swynnerton (neé Robinson, 1844–1933)

68 *Cupid and Psyche* 1891
Exh. New Gallery 1891
Oil on canvas
145×89 (57$\frac{1}{8}$×35)
Oldham Art Gallery & Museum, UK

✳

The Rome-based Annie Swynnerton was one of the most daring female painters of the nude, often shocking audiences with her robustly painted figures. Despite receiving some training at the Manchester School of Art and the Académie Julian, Swynnerton was largely self-taught which may explain the originality of her technique and vision. Although she upheld convention in representing mythological subjects (this painting was exhibited a year after Leighton's *Bath of Psyche*), and was often described as a follower of Burne-Jones and Watts, her treatment of the nude was more vivid and naturalistic, enlivened by a bold expressive manner.

The legend of Cupid and Psyche traditionally allowed for the representation of male and female couplings as well as the expression of human desire and emotion. Swynnerton depicts Cupid kissing Psyche who struggles to resist the temptation to open her eyes as dawn breaks behind distant mountains. The pose of Psyche resembles Swynnerton's *Mater Triumphalis* (also 1891), which similarly presents a full-length nude female figure in a rapt somnambulant state. The naturalness of Swynnerton's conception of adolescent lovers – their pale Anglo-Saxon characterisation setting off their blushes – startled critics. Claude Phillips was disturbed by the 'quivering reality' of the flesh painting, and described the figures as two 'vigorous and over-British young models' (*Art Journal*, 1891, p.189), while F.G. Stephens criticised Psyche for appearing 'vulgar' and 'coarse ... She has a mean air, her flesh is without the sweetness, evenness and purity of youth, and her feet are big, ill-formed, and swollen' (*Athenaeum*, 9 May 1891, p.610). AS

Dorothy Tennant (Lady Stanley, 1855–1926)

69 *The Death of Love* 1888
Oil on canvas
22·9 × 33·3 (9 × 13⅛)
Robert Coale, Chicago
✱

The nude played a strategic role in late-nineteenth-century British gender politics: for women it was a means of access to high art, while for the male-dominated art establishment it was a symbol of resistance to the challenge presented by women. The entrenched reluctance of institutions to admit female students to life-classes compelled many women to study abroad, in Italy or in the ateliers of Paris. Dorothy Tennant was one of the first women to benefit from the Slade system which permitted female students to study from the partially draped model in a separate class, and encouraged graduates to complete their studies in Paris: Tennant worked for a while in the atelier of Jean-Jacques Henner, a painter known for his classical genre subjects, many of which represented adolescent men in a soft naturalistic style.

From 1882 Tennant began to exhibit regularly at the Grosvenor Gallery, a venue which favoured idyllic nude subjects and whose management also proved sympathetic to women. Although it was customary for critics at this time to refer to an artist's influences, they were relentless in accusing female painters of the nude of pastiche: Henrietta Rae was thus denigrated as a mere imitator of Leighton, as was Swynnerton of Watts, De Morgan of Burne-Jones, and Tennant of Henner. Indeed, the figures in this painting are imaginative adaptations of Henner's *Joseph Bara, Young Hero of the Revolution* and *Nymph éplorée* (illustrated Lovoit 1912). Tennant in fact adopted a more cautious approach to the nude than her female contemporaries, painting on a small scale in a 'naive' manner and specialising in children and youths with many images dedicated to Cupid or Eros. Given titles such as *Cupid Disarmed* (1885), *Rival Suppliants* (1889) and *Love's Whisper* (1891), these rather saccharine subjects were generally approved because Tennant was seen to be working within her 'natural' limits as a woman.

The Death of Love strikes a more sombre, even macabre note than her usual output, with the pale prostrate body of Love shockingly illuminated against a dark ground and set off by sanguine wings. The startling juxtaposition of the nude boy and girl could be read as a rather daring interpretation of the Cupid and Psyche legend popular with artists of the Grosvenor circle, or it may be that Tennant was using the nude to convey some esoteric or private emotion. *The Death of Love* was painted during a time when her fiancé, the explorer Henry Morton Stanley, was rumoured to have died on his third expedition to Africa (1887–9). As in Anna Lea Merritt's *Love Locked Out* (no.146), the youthful grieving figures may personify the artist's fears during this period of anxiety, as an article in the *Pall Mall Budget* subsequently recalled around the time of their marriage in 1890:

> Times without number came the news of his death, and for many dreary months the air was full of terrible rumours of his fate. Now he had died like a dog in a fetid African swamp, now he had been slain by blacks, now he was caged up in Khartoum. Such was the only news which came to this courageous woman, whose sufferings in all this terrible time may be left to the imagination. (22 May 1890, p.652).

AS

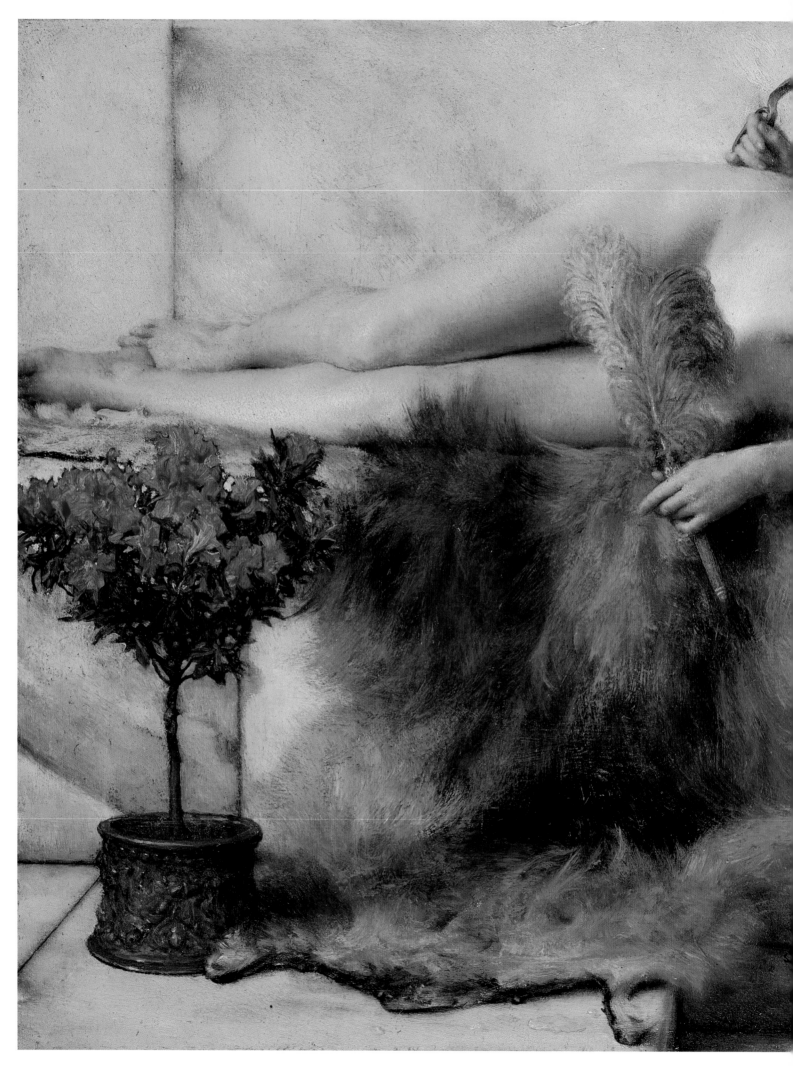

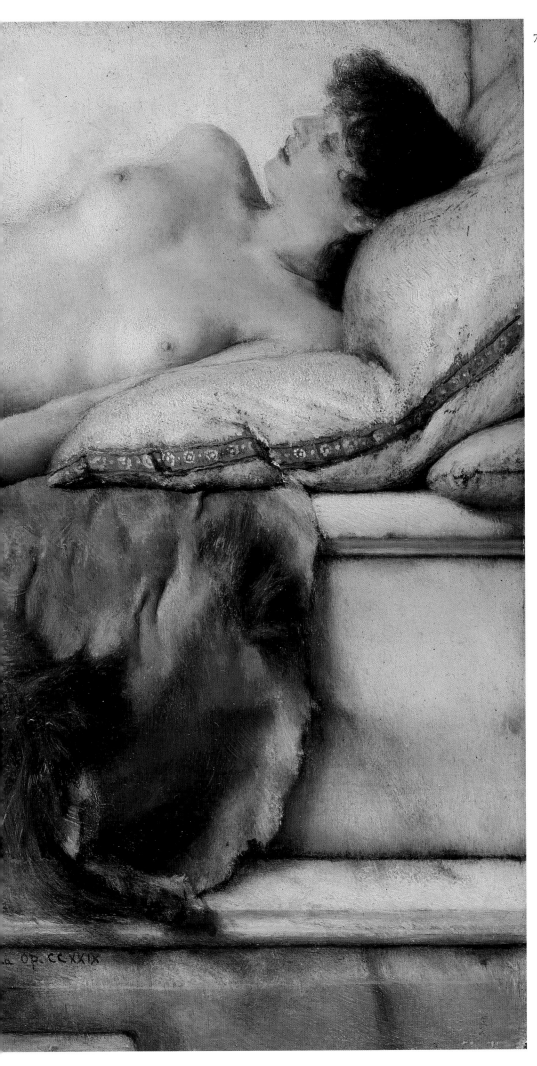

Lawrence Alma-Tadema (1836–1912)

70 *Tepidarium* 1882
Exh. GPG 1882; GG 1882
Oil on panel
24·2×33 (9½×13)
Board of Trustees of the National Museums and Galleries on Merseyside (Lady Lever Art Gallery, Port Sunlight)

✱

This small, intimate nude is one of Alma-Tadema's most erotic pictures. Only the strigil and title justify it as an historical scene. The recumbent woman's figure fills the painting's width, and the low viewpoint makes her appear as if she is raised on an altar rather than lying on a bench. The sensual atmosphere is heightened by her intense contemplation of the overtly phallic strigil, and the fan which keeps her modesty, but tantalisingly looks as if it is about to slip from her fingers. The contrasts of texture – feathers, silk and marble – accentuate the rich sensory experience of the scene and further add to its eroticism. The Tepidarium was an enervating lukewarm plunge bath, therefore not fitting the nude's flushed cheeks and languid, exhausted pose. Instead, this suggests the aftermath of vigorous physical activity. Perhaps worried that such a picture was too strong for British tastes, Alma-Tadema first showed it in Paris in 1882 at the Georges Petit Galerie. It was, however, included in the artist's large-scale London retrospective later that year at the Grosvenor Gallery, where it did not attract much attention. Its size clearly demarcated it as a piece for the private cabinet rather than public display, and this no doubt aided its acceptability. Often a vehicle for conservative criticism, the *Athenaeum* expressed relief that it was not so realistic a rendering of flesh as Alma-Tadema's *A Sculptor's Model* (see fig.22), a work greeted with outrage in some quarters. The review praised 'the smaller but choicer and immeasurably elegant form of the girl in the Tepidarium' and the 'solidity, splendid modelling and true drawing' (1882, pp.778–80). In 1890 *Tepidarium* was bought by Pears Soap for the large sum of £1,150, presumably, like similar purchases, for advertising purposes. But it was never used, probably because of increasing allegations of impropriety levelled against their advertisements depicting children in the 1880s.
RU

Lawrence Alma-Tadema

71 *Strigils and Sponges* 1879
Exh. SPW 1879
Watercolour on paper
31·8 × 14 (12¹⁄₂ × 5¹⁄₂)
The British Museum, London
❀

The Dutch-born Alma-Tadema achieved
enormous financial and critical success in
Britain with his carefully researched scenes of
daily life in ancient Rome. Bathing scenes, such
as his famous *A Favourite Custom* (1909) and
this watercolour, were always popular. Recent
archeological discoveries about the complicated
ablutions of Rome lent legitimacy to such
pseudo-historical portrayals of frolicsome
bathing women. Cleanliness was also a very
contemporary concern, with the desire for
drains and sewers and a fresh water supply
to stem disease among Britain's urban
population. Alma-Tadema carefully based his
pictures on well-researched archaeological
precedent, and accrued a vast and valuable
collection of photographs of antique
architecture and artifacts. The fountain here
is based on a marble group in the Naples
Museum. The water gushing onto the woman's
back adds a sensory frisson to the scene, and
wittily, the boy on the dolphin's back appears to
be scrutinising the left-hand figure's languid
progress with the strigil. RU

**Paul Adolphe Rajon (1843–1888) after
Lawrence Alma-Tadema**

72 *Strigils and Sponges* 1879
Trial proof etching on paper
31·8 × 14 (12¹⁄₂ × 5¹⁄₂)
The British Museum, London
❀

There was a ready market for Alma-Tadema
prints. This sheet is an intermediate trial proof,
the margins covered with Alma-Tadema's
suggested improvements to his engraver, Paul
Adolphe Rajon. Alma-Tadema was well known
for being a perfectionist, and the number of his
comments and their detail demonstrate the
care and control he took over the print-making
process. Along with small sketches to illustrate
his remarks, his comments stress: 'too much
light in jet of water ... the strigil in the shade
darker ... a bit more drawing in the hair on the
bronze ... the sponge should have more
variously shaped and deeper holes.' Perhaps
slightly embarrassed by this barrage of
criticism, Alma-Tadema added in a bolder hand
beneath, 'à mon cher ami Rajon'. Published by
Lefevre, this is the only print to have been made
after one of Alma-Tadema's watercolours; all
the others reproduced oils. RU

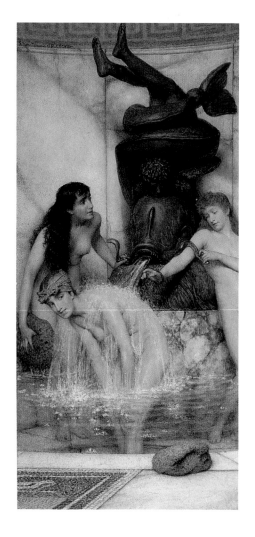

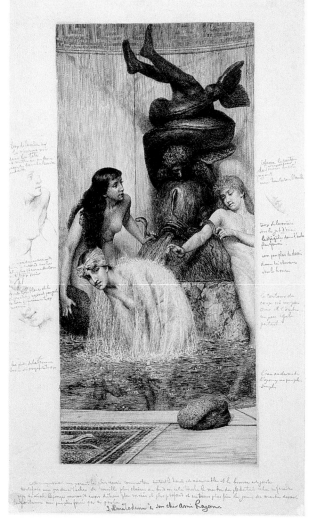

James Abbott McNeill Whistler (1834–1903)

73 *Venus* 1859
Etching on paper
15·2 × 22·9 (6 × 9)
The British Museum, London

❋

Whistler made a number of nudes later in his career, often draped and fulfilling a decorative function. But here, in one of his first nude subjects and despite a classical title, he shows an intimate, private scene apparently from his domestic life. Nevertheless, the artist's gaze here, and our own, is a prurient one. The rumpled, pushed back bedclothes and the exhausted pose of the model suggest the aftermath of sexual activity. Her sleeping, naked state allows unchallenged, voyeuristic contemplation of her body. Whistler made this etching on a visit to Paris immediately before he moved away to London. The new-found popularity of cutting-edge realist painters such as Courbet had greatly influenced him, and *Venus* has some similarities to the French artist's *Woman Resting* of the previous year. Whistler may also have had in mind Rembrandt's erotic print *Jupiter and Antiope* (1659) (see also no.67) which has a comparable composition and subject. The model for *Venus* was one of Whistler's two consecutive Parisian mistresses, Fumette and Finette; it is difficult to identify which with certainty. Fumette, whose real name was Eloise, was a Left-Bank milliner, a 'grisette'. She and Whistler lived together in a hotel in the rue St Sulpice but her bad temper equalled Whistler's, and they parted, Whistler making Finette his mistress soon after. Finette was a successful can-can dancer at the Bal Bullier, and later appeared in the London music-halls. Whistler broke off their relationship when he moved permanently to London in 1859. Whether they met again there is unrecorded. RU

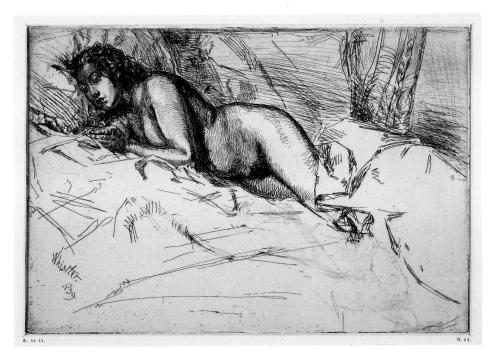

Joseph Mallord William Turner (1775–1851)

74 *A Copulating Couple c.?1805*
Pencil and sepia wash on paper
26·7 × 36·8 (10¹₂ × 14¹₂)
Tate. Bequeathed by the artist 1856

✱

Although neither nos. 74 nor 75 were produced in the Victorian period, both are included as illustrations of Ruskin's reaction to Turner's erotic imagination. Turner's studies of the nude sometimes veer towards the pornographic, but this sheet is more explicit than most of those surviving. Drawn in an 'Old Master' style which Turner favoured in the earlier part of the nineteenth century, in sex-manual-like detail he shows the progression from foreplay to intercourse. The male figure in the principal subject has been given elongated ears, suggesting he is a satyr. But contradictorily, he has human feet rather than the requisite hoofs. There is the possibility the drawing may be by Charles Reuben Ryley (*c.*1752–98), a group of whose anatomical drawings Turner is known to have purchased. However, on the reverse of the sheet is a crudely drawn scene of fellation which is almost undoubtedly by Turner. RU

Joseph Mallord William Turner

75 *Colour Studies No.1 Sketchbook: A Copulating Couple and Two Figures Watching c.1834*
Watercolour and pencil on paper
7·7 × 10·1 (3 × 4)
Tate. Bequeathed by the artist 1856

✱

Turner's sketchbooks include sporadic bursts of erotic material suggesting a lively sexual appetite. This extraordinary spread is in a sketchbook which contains a number of nude academic studies, the contemplation of which seems to have spurred Turner to more pornographic considerations. The left-hand sheet shows a couple making love; the right a woman reclining languidly on a bed watched by a couple, one of whom also appears to be female. This act of voyeurism seems to strike at the heart of Turner's interest in making such drawings, and may add validity to rumours of him watching sexual performances in the bawdy sailors' taverns of Wapping. How many drawings like this Turner made can only be guessed for Ruskin sifted through his bequest to the nation and felt compelled to take action. The sexually repressed Ruskin was deeply shocked by material which he described as 'grossly obscene'. The National Gallery administrated the Turner Bequest, and in December 1858 Ruskin and its Keeper, Ralph Wornum, agreed to destroy the offending material, 'for the sake of Turner's reputation (they having been assuredly drawn under a certain condition of insanity)'. Wornum was also concerned that the institution's ownership of such items might contravene obscenity laws. Together he and Ruskin burnt the drawings in the boiler room of the National Gallery (see Hilton 1985, pp.250–1). The erotic material's compromise of his view of Turner's heroic status, and the weight of carrying out this action, undoubtedly contributed to Ruskin's spiritual crisis of 1858 and the stirrings of his future madness. RU

74

75

Dante Gabriel Rossetti (1828–1882)

76 *The Question* 1875
Pencil on paper
48 × 41·5 (18⅞ × 16⅜)
Birmingham Museums & Art Gallery

✱

Rossetti explained to his friend F.G. Stephens that *The Question* departed from traditional Sphinx subjects in that it is the fearful female beast who is being interrogated, asked the eternal questions of mankind, to which she gives no answer:

> The subject represents three Greek pilgrims ... they have clambered over the crags to the elevated rocky platform on which the sphinx is enthroned in motionless mystery, her bosom jutting out ... The youth, about to put his question, falls in sudden swoon from the toils of the journey & the over-mastering emotion; the man leans forward over his falling body and peers into the eyes of the sphinx to read her answer; but those eyes are turned upwards and fixed without response ... the old man is seen still labouring upwards ... eager to the last for that secret which is never to be known ... In the symbolism of the picture ... the swoon of the youth may be taken to shadow forth the mystery of early death, one of the hardest of all impenetrable dooms. (unpublished letter quoted Surtees 1971, 1, p.140)

According to Rossetti's brother William Michael its subject of untimely death was a response to the loss of Ford Madox Brown's son Oliver at the age of 19. The composition was intended for an oil painting, but this did not materialise, possibly due to the problematic nudity. Rossetti explained to Jane Morris in March 1875:

> I have made the design nude, but propose to drape it in some degree when I paint it, which I fancy must be on a rather small scale, for two reasons; one being that to sell a big picture without women in it would be a double difficulty, and the other that a moonlight subject on a large scale is always monotonous. (Bryson 1976, pp.37–9)

In mentioning the draping of the figures Rossetti may have had in mind the difficulties he had in selling his *Ligeia Siren* in 1873 because its original undraped state (see no.62); and indeed, *The Question* itself remained unsold in his lifetime. The figure of the naked youth derives from *Menelaus with the Body of Patroclus*, a third-century BC Greek sculpture, of which casts circulated widely (fig.27). Rossetti's soft treatment eroticises the figure, and is reminiscent of Simeon Solomon, as is the overall tonal technique of the drawing. But the figure of the Sphinx and the warrior were copied fairly closely from Ingres. Rossetti saw Ingres's *Oedipus and the Sphinx* (1808) on his trip to Paris with Holman Hunt in 1849, and again when visiting the Exposition Universelle in 1855. He greatly admired Ingres, and Delacroix too, but regarded French art with fashionable disdain, telling Swinburne 'the whole of French art at present is a beastly slop and really makes one sick ... simple putrescence and decomposition' (quoted Marsh 1999, p.284). RU

Fig.27
*Menelaus with the Body
of Patroclus*
Marble
Loggis dei Lanzi,
Florence

The Question

Charles Ricketts (1866–1931)

77 *Oedipus and the Sphinx* 1891
Pen and ink on paper
23.6 x 15.5 (9 ¼ x 6 ⅛)
Tullie House Museum & Art Gallery

The Theban Sphinx set her victims an
impenetrable riddle, and when they inevitably
gave a wrong answer she ripped their bodies
apart and consumed them. Usually depicted as
a mixture of terrifying harpy and voluptuous
temptress, in the nineteenth century the subject
became a metaphor for men's fear of women.
It was Oedipus who finally solved the riddle and
so destroyed the Sphinx. Ricketts's drawing is
partly inspired by his hero Gustave Moreau's
two Sphinx paintings, but also by Ingres, whose
figure of Oedipus in *Oedipus Explains the Riddle
of the Sphinx* (1808) he closely followed. But
Ricketts introduces a remarkable sexual charge
with the lithe sensual Sphinx and muscular
Oedipus, their bodies locked together as she
tries to push him away. The exaggerated swag
of Oedipus's cloak hanging between his legs
accentuates his nudity and imitates the shape
of what it is covering. The drawing's eroticism
is further heightened by the surrounding
figures. The woman on the right appears in
orgasmic ecstasy, while the severed heads
recall contemporary depictions of Salome and
John the Baptist.

The drawing was commissioned by
Leighton, who left the choice of subject to
Ricketts. Greatly pleased with the result he
wrote to the young artist: 'the design is full of
imagination and a weird charm – it is also ... a
marvellous piece of penmanship. It is a great
pleasure for me to possess it' (Lewis 1938, p.18).
Ricketts himself always believed it his best
drawing, and he bought it back at Leighton's
sale in 1896. He published it that year in *The
Pageant*, a Christmas annual devoted to art and
literature edited by Gleeson White and Charles
Shannon. RU

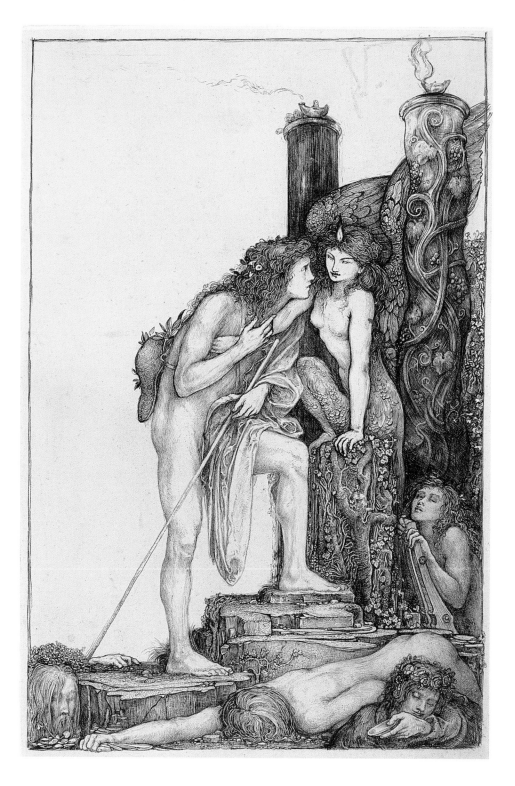

Simeon Solomon (1840–1905)

78 *Babylon hath been a Golden Cup* 1859
Exh. FG 1859
Pencil, pen and black and brown ink on paper
26·6 × 28·3 (10¹₂ × 11¹₈)
Birmingham Museums & Art Gallery

✱

Many of Solomon's earliest drawings were
based on Old Testament subjects. Here he
shows a scene of Babylonian licence,
accompanied in the catalogue at its showing at
the French Gallery by a passage from the Book
of Jeremiah: 'Babylon hath been a golden cup in
the hand of God, which hath made all the earth
drunken: the nations have drunken of her wine,
therefore all the nations are mad' (51: 7). This is
part of Jeremiah's lament for the tribes of Israel,
held captive in Babylon, who have come to
imitate Babylonian hedonism, and worship
false gods. In Solomon's vision, the King's
crown has slipped symbolically from his
fingers. Beneath a spreading vine, emblematic
of drunkenness, he is embraced by a naked
figure entwined erotically around him,
plucking the strings of a harp resting and
vibrating on his groin. His closed eyes suggest
complete seduction, immersed in the world
of the senses, as well as orgasmic delight.

Solomon was well known for the androgyny
of his figures. Here the nude figure wears
women's' jewellery, but looks very much like
a man, teasing the viewer to decide the precise
sex and if it is a homosexual relationship.
In the background a procession of nude and
half-draped figures add to the licentiousness
of the scene. This frieze-like element may
perhaps in part have been inspired by
Leighton's *Cimabue* (1854–5), a famous and
perfectly proper picture bought by Queen
Victoria, which it may have amused Solomon
to slyly subvert in this way. RU

Simeon Solomon

79 *The Bride, Bridegroom and Sad Love* 1865
Pencil on paper
24·8 × 17·1 (9¾ × 6¾)
Victoria & Albert Museum, London

✳

This is one of the most explicit and sexually provocative drawings by Solomon to have survived. Its theme of bisexual love and depiction of homosexual contact meant that it would have been seen only by Solomon's intimates. His sexual tastes were well known among the Chelsea set of aesthetes who gathered around Rossetti, but were secret from the public who saw his Hebraic watercolours on the walls of the Royal Academy. Solomon, however, became increasingly reckless and open as the 1860s progressed. He and Swinburne fuelled each other's sado-masochistic fantasies, and cavorted naked at Rossetti's Cheyne Walk house, greatly irritating the older artist. However, the permeation of Solomon's sexual identity into his exhibited art works began to be publicly noted. In a favourable review in the *Portfolio*, the critic Sidney Colvin nevertheless complained of 'affectation and overdoing in the facial type, of insufficient manliness in Solomon's pictures' (quoted Reynolds 1985, p.27), and Robert Buchanan's infamous attack on Rossetti's 'Fleshly School of Poetry' warned of the corrupting potential of Solomon's works which 'lend actual genius to worthless subjects and thereby produce monster-like the lovely devils that danced round St Anthony' (*Contemporary Review*, Oct. 1871). Even Robert Browning, in a similar vein, wrote to Isabella Blagdon: 'Simeon Solomon invited me the other day to see his pictures, but I could not give him the time: full of talent, they are too affected and effeminate. One great picture-show at the Academy – the old masters' exhibition – ought to act as a tonic on these girlish boys and boyish girls, with their Heavenly Bridegroom and such like' (24 Feb. 1870; quoted Reynolds 1985, p.28).

Solomon's physical types in *The Bride, Bridegroom and Sad Love* are, however, classical, the man muscular, upright and with cropped hair, obviously adapted from Michelangelo's *David*. But his athletic masculinity and embrace of his beautiful bride are subverted by congress with the figure of Love, apparently intended to

be a youth rather than an adult. It is an act apparently unseen by the Bride, and Solomon therefore addresses particularly sensitive and dangerous areas of hidden Victorian social mores – the homosexual activity of married men, and love between older men and youths, the latter a theme Solomon treated in *Love among the Schoolboys*, made the same year and later owned by Oscar Wilde. Solomon's own youthful interest in flogging had been encouraged by his liaison with the Eton master Oscar Browning, who was later to be publicly disgraced, as was Solomon. More subtly, *The Bride, Bridegroom and Sad Love* is about parting, the groom joining his male lover perhaps for the last time, moving from one phase of his life to another.

Although this drawing would not have been likely to have been among them, Frederic Hollyer published photographs of many of Solomon's pictures, including such risqué subjects as *Spartan Boys about to be Scourged* (1865). In 1865 he issued a portfolio of twenty photographs dedicated to Edward Poynter, and such images enjoyed widespread circulation in artistic and aesthetic circles despite, or because, of their subject-matter. RU

Simeon Solomon

80 *Socrates and his Agathodaemon c.*1865
Pen and ink on paper
24·8 × 12·7 (9¾ × 5)
Victoria & Albert Museum, London
✿

Ancient Greece was a source of inspiration to
Solomon, and the circle of homosexuals which
included his intimates Algernon Swinburne
and Walter Pater, as it provided a permissive
social model of love between men. Male
fellowship and loyalty in Greek society, and
acceptance of homosexual love, suggested
idealistic, democratic values, and at a time
when Britain was redefining its constitutional
boundaries, the ancient Greek state and its
social relations was a subject widely discussed
in academic circles. Agathodaemons were
guardian angels, whom the ancient Greeks
believed watched over man, one assigned to
each mortal. Invincible, they would guide their
charges throughout their lives, and die with
them. It was traditional to sacrifice milk and
honey to the agathodaemon on one's birthday,
and to pour a glass of wine for them each night
at supper. To live cheerfully and fruitfully
brought honour to one's agathodaemon;
melancholy or recklessness dishonoured them.
Solomon's drawing is essentially humorous,
contrasting the gnarled features and stubby
body of Socrates with that of his athletic,
handsome agathodaemon. Socrates's hard
view of life and enforced suicide may explain
the guardian angel's slightly rueful attitude.
Solomon has posed them wittily like a portrait
photograph, although the agathodaemon's
stance is adapted from classical precedents. RU

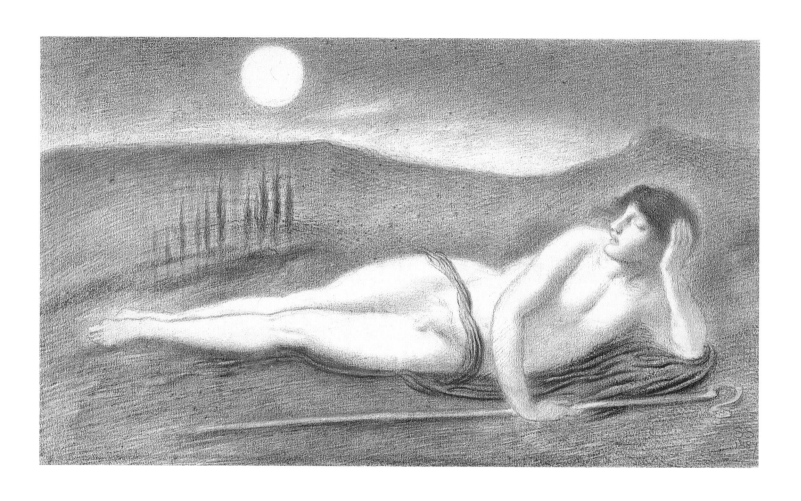

Simeon Solomon

81 *The Sleeping Endymion* 1887
Coloured chalks on paper
25·5 × 45·5 (10 × 17⅞)
Birmingham Museums & Art Gallery
✿

In Greek mythology, Zeus gave the beautiful shepherd boy Endymion eternal life and youth by allowing him to sleep perpetually. The moon goddess Selene fell in love with him, and visited nightly to gaze upon him. Solomon seems to have been attracted by the story, as it also formed the subject of his oil *The Moon and Sleep* (1894). His interest may have been encouraged by the long poem by Keats, for whom there was renewed enthusiasm at the end of the century, partly due to William Michael Rossetti's biography of 1887. Young decadents and aesthetes found in Keats's sensuous, sadness-tinged reveries an echo of homoerotic yearning. Solomon's images of men are deliberately effeminate or androgynous, a challenge to the muscular, heroic male imagery which was encouraged. His image of Endymion, watched by the moon, seems partly derived from Old Master depictions of Cupid and Psyche, a further act of sexual role-reversal. For Solomon the world of sleep and dreams held enormous fascination, and it was the subject of many of his pictures. In 1871 he published privately his story *A Vision of Love Revealed in Sleep*, a text suffused with sexual desire. Its opening paragraph relates how 'when dreams wrap us about more closely, when a brighter radiance is shed upon our spirits, the sayings of the wise King came unto me. These are they:– "I sleep, but my heart waketh"; also, "Many waters cannot quench love"; and again, "Until the day break, and the shadows flee away"; and I fell to musing and thinking much upon them' (quoted Reynolds 1985, p.43). RU

Charles Ricketts (1866–1931)

82 *Frontispiece to 'The Dial': The Worm* 1886
Colour lithograph on paper
20 × 13·7 (7⅞ × 5⅜)
Tate. Presented by Sir Charles Holmes 1924

❀

Ricketts was part of a younger generation
who in the closing decades of the nineteenth
century encouraged a rich decadence to flower
in British art and literature. Half-French, a
painter, book and theatre designer and art critic,
Ricketts greatly admired Continental Symbolist
artists and writers, and in particular Gustave
Moreau. In 1886 Ricketts and his partner
Charles Shannon decided to found their own
journal, *The Dial*. An 'occasional publication',
this was to be a forum for Ricketts's aesthetic
tastes, and was, he claimed, partly inspired by
the Pre-Raphaelite journal *The Germ* of 1850.
(Delaney 1990, p.41). Mixing stories with
poetry with essays about literature and art,
each issue contained an original print, and the
journal was richly designed by Ricketts and
appeared in a small, limited edition. The first
issue in 1886 was emphatically French in
subject-matter, containing an article by John
Gray on the Goncourt brothers and one by
Ricketts on Puvis de Chavannes. Ricketts's
frontispiece for the issue, shown here, was
clearly inspired by Moreau. The 1880s had seen
a number of influential, critical articles drawing
attention to Moreau, most notably Claude
Phillips in the *Magazine of Art* in 1885 (p.231);
his work had first been seen in Britain at the
Grosvenor Gallery in 1877.

Ricketts's naked girl is a sacrificial virgin –
she holds a white lily symbolising purity. Her
long flowing hair is Rossettian (another of
Ricketts's heroes) but the richly decorated
figure is inspired by Moreau's women, such as
the figure of Salome in *L'Apparition* (fig.28).
The worm, apparently an enormous slow-
worm, has seemingly come to consume her,
although it looks distinctly unthreatening and
the woman not tremendously concerned.
Ricketts may have had in mind legends of the
Laidly Worm, immortalised by Walter Crane's
painting of 1881, although this creature was
placated with offerings of milk rather than
human sacrifice. The landscape elements of
the print and the flat colouring are inspired
by Japanese prints, popular in aesthetic and
decadent circles at this time and collected
eagerly by Ricketts. Critical responses to the
first issue of *The Dial* were poor. The *Magazine
of Art* (Dec. 1889) dismissed it as 'nudity and
nonsense', clearly partly a reference to the
frontispiece, while the *Academy* (31 Aug. 1889)
stated that the 'cover, initial letters and the
plates alike make a fresh appeal to feelings and
to methods that have yet to win popularity in
this country'. Sent an unsolicited copy, Oscar
Wilde responded 'It is quite delightful but do
not bring out a second number, all perfect
things should be unique' (Ellmann 1987,
p.281). RU

Fig.28
Gustave Moreau
L'Apparition 1876
Watercolour
Louvre, D.A.G.
(fonds Orsay)

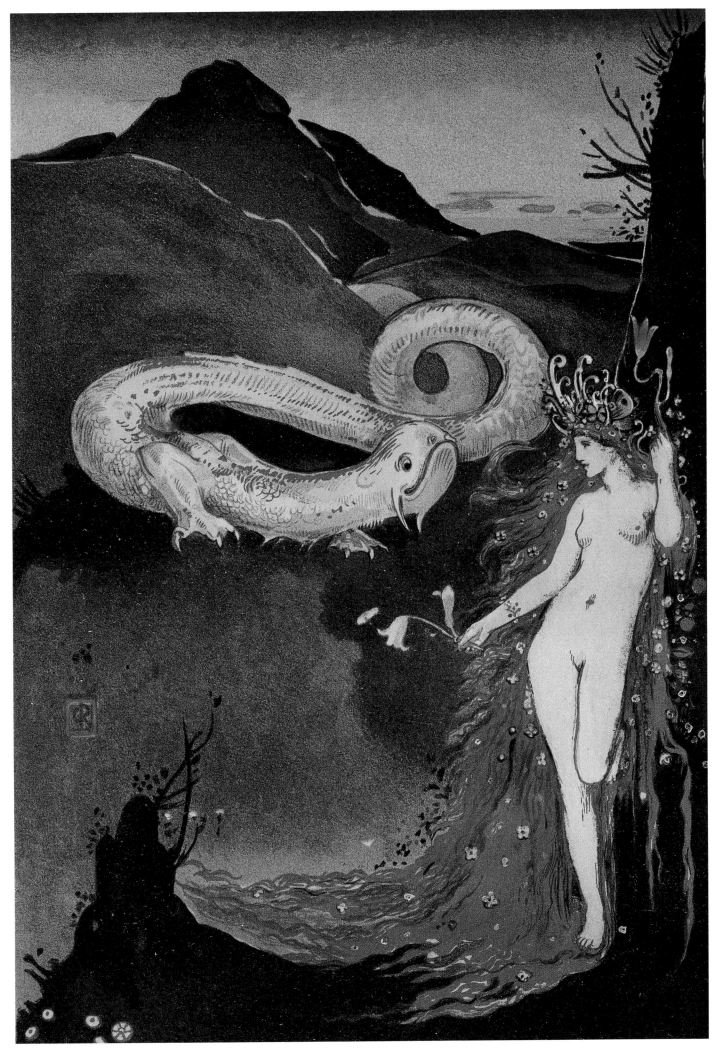

Aubrey Beardsley (1872–1898)

83 *Cinesias entreating Myrrhina to Coition* 1896
Pen and ink on paper
26.1 × 17.9 (10¼ × 7))
Victoria & Albert Museum, London

✻

Aristophanes's *Lysistrata* (411 BC) tells the story of an attempt by the women of Athens and Sparta to end the internecine war between the two city states. Led by Lysistrata, they tell their menfolk they will withhold sexual favours until peace is declared. Beardsley produced a series of designs illustrating a new translation of the play. This one shows one of the great comic moments when Myrrhina sexually teases her husband, who has just returned from the war. Despite his best attempts to catch her, he remains unsatisfied, his exaggerated phallus in Beardsley's design symbolising the strength of male desire over all else as well as the scale of his lust. The outsized penis was undoubtedly influenced by Japanese erotic prints, of which Beardsley was a great admirer. The artist William Rothenstein recalled:

> I had picked up a Japanese book in Paris, with pictures so outrageous that its possession was an embarrassment. It pleased Beardsley, however, so I gave it him. The next time I went to see him, he had taken out the most indecent prints ... and hung them around his bedroom. Seeing he lived with his mother and sister, I was rather taken aback. (Rothenstein 1931, p.134)

A further influence was the priapic figures found on Greek vases in the British Museum. Julius Meier-Graefe who interviewed him around this time wrote that Beardsley greatly admired 'the playful struggles of bald-headed satyrs with gay nymphs ... he had none of the prudishness of the curators. He owed it even more to the Greeks than to the Japanese that he had no need to be prudish' (quoted Calloway, 1998, pp.172–3).

Beardsley was asked to produce the *Lysistrata* illustrations by the publisher Leonard Smithers, whose interest in issuing the edition was perhaps encouraged by a recent popular production of the play in London. However, Smithers wanted his book to cash in on the market for pornographic imagery, and

Beardsley produced some of his most extreme images for the project. The book was published in a 'private edition' of just one hundred copies, designed to circumvent the obscenity laws. The spine was left deliberately blank, so the volume might sit unobtrusively on the owner's shelf and spare embarrassment. Such a book was intended for élite private perusal rather than mainstream distribution. Extraordinarily, because of their explicit, subversive nature, the drawings themselves were not fully reproduced again until 1966. As Beardsley lay dying, he came to deplore his obscene work for Smithers, and wrote to him: 'Jesus is our Lord and Judge. Dear Friend, I implore you to destroy all copies of Lysistrata and bad drawings ... By all that is holy all obscene drawings. In my death agony. Aubrey Beardsley' (7 March 1889; Maas, Duncan and Good 1970, p.439). Smithers did not carry out these instructions, to the shock of Beardsley's family when they discovered this. However, he was not fully in a position to do so. Although some were still in his possession, most of the *Lysistrata* drawings had been purchased from Beardsley by his friend Jerome Pollitt. A rich and decadent young man with a taste for transvestism, and the bisexual Aleister Crowley's lover, Pollitt declined Beardsley's mother's requests to destroy the drawings. RU

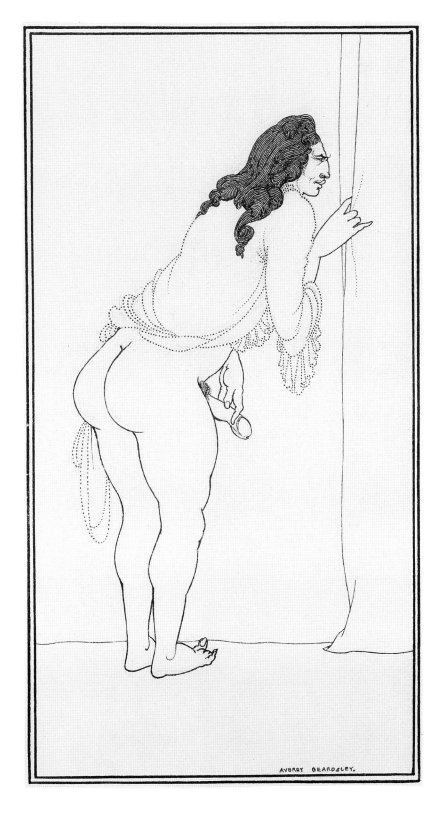

AVBREY BEARDSLEY.

Aubrey Beardsley

84 *The Impatient Adulterer* 1896
Pen and ink on paper
18.2 × 9.8 (7¹⁄₈ × 3⁷⁄₈)
Victoria & Albert Museum, London
✿

Following hard on the heels of *Lysistrata*,
Smithers commissioned Beardsley to illustrate
an edition of the late Roman poet Juvenal's
Sixth Satire, an infamous diatribe 'against
Women'. Beardsley intended to also provide the
English translation, although this remained
unfulfilled. Probably one of his most indecent
images, *The Impatient Adulterer*, shows a hidden
would-be seducer masturbating as he watches a
corrupt mother display her innocent daughter's
body to him. Although this was a tale of Roman
excess, Beardsley was fascinated by eighteenth-
century France, and this clearly influenced his
depiction of the adulterer.

It was when pursuing some Fragonard
prints in his shop in Arundel Street off the
Strand that Beardsley first met Leonard
Smithers, and he became a regular customer.
Noted for its rare books (at least one of which
was infamously on offer bound in human skin)
and other curios, the shop additionally supplied
pornographic material. This was the base from
which Smithers built a flourishing trade in
pornographic drawings, prints, books and
photographs. He was a key figure in late-
Victorian decadence, and became one of the
largest publishers of erotic books, usually
issued as private editions. A mark of the success
of his business was Smithers's purchase of a
grand house in Bedford Square. Smithers
trained as a lawyer in Yorkshire but, moving to
London, discovered the profitability of erotica.
A classical scholar, he assisted Sir Richard
Burton in the 1880s with the translation and
issue of exotic eastern classics such as *The
Perfumed Garden* and *The Arabian Nights*. His
continued publication of these after Burton's
death in 1890, probably in breach of copyright,
was believed by many contemporaries to
account for much of his wealth. Oscar Wilde,
whose *Ballad of Reading Gaol* Smithers bravely
published, wrote of him: 'He loves first
editions, especially of women: little girls are his
passion. He is the most learned erotomaniac in
Europe. He is also a delightful companion and
a dear fellow' (quoted Calloway 1998, p.147).

Beardsley and Smithers enjoyed wild
adventures together of drink, drugs and
brothels, exploits which contributed to the
artist's physical decline. Rothenstein thought
Smithers 'an evil influence', and snobbishly
described him as 'a bizarre and improbable
figure – a rough Yorkshireman with a strong
local accent and uncertain h's, the last man, one
had thought, to be a Latin scholar and a disciple
of M. Le Marquis de Sade' (Rothenstein 1931,
pp.244–5). RU

John Singer Sargent (1856–1925)

85 *Reclining Nude Male Model* 1890s
Watercolour and pencil on paper
48.4 × 54.7 (19 × 21¹₂)
National Museums & Galleries of Wales

❋

Sargent's commission in 1890 to decorate the
Boston Public Library with murals prompted a
long sequence of nude figure studies, most in
fact unrelated to the final designs. The reclining
figure was clearly a source of enormous
fascination, and in clothed form found its way
into a number of his exhibited oils. Here
Sargent shows Luigi Mancini, a member of a
well-known Italian modelling family in London.
He is set in close imitation of the famous
antique *Barberini Faun* (fig.29), although unlike
the original sculpture Sargent has discreetly
shielded his groin. Perhaps because of its
sculptural source, Sargent presented the
watercolour to his friend the sculptor William
Goscombe John (see no.186).

Sargent's devotion to nude studies at this
time was noted by his friend Edwin Austin
Abbey, another Boston muralist, who wrote of
seeing 'stacks of sketches of nude people ...
saints, I dare say, most of them, although from
my cursory observations of them they seemed
a bit earthy' (quoted Fairbrother 2000, p.104).
The Fogg Art Museum holds an album of
Sargent's nude male figure studies which he
carefully compiled. These, like the watercolour
shown here, are soft and intimate in
atmosphere. Although the male body-types
Sargent favoured for his models were muscular,
and reminiscent of contemporary images of
popular circus strongmen, he sets them in
relaxed, almost vulnerable poses similar to the
languid homoerotic photographs of Baron von
Gloeden (see no.107). Sargent was a bachelor,
and his sexual orientation has long been a topic
of speculation. Fairbrother has noted Sargent's
greater sense of involvement with his models
in his drawings of men, and their suggestion of
erotic response (2000, p.104). Sargent guarded
his private life and his emotions carefully,
leading his biographer Evan Charteris, writing
in 1927, to cite 'a network of repressions'.
After his death the artist Jacques-Émile Blanche
spoke of Sargent's active sexual relations with
men, and Bernard Berenson hinted 'He was
completely frigid as regards women'
(Fairbrother 2000, p.155). Sargent seems to
have possessed a fascination for body-type.
This was demonstrated by his compilation, a
sitter noted, of 'an enormous scrap album,
filled for the greater part with photographs
and reproductions of aboriginal types the
world over' (ibid. p.111). RU

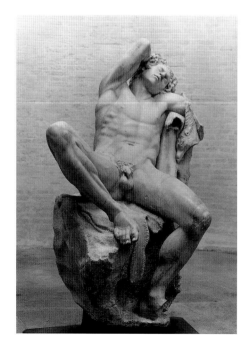

Fig.29
The Barberini Faun
*c.*220 BC
Marble
Glypothek, Munich

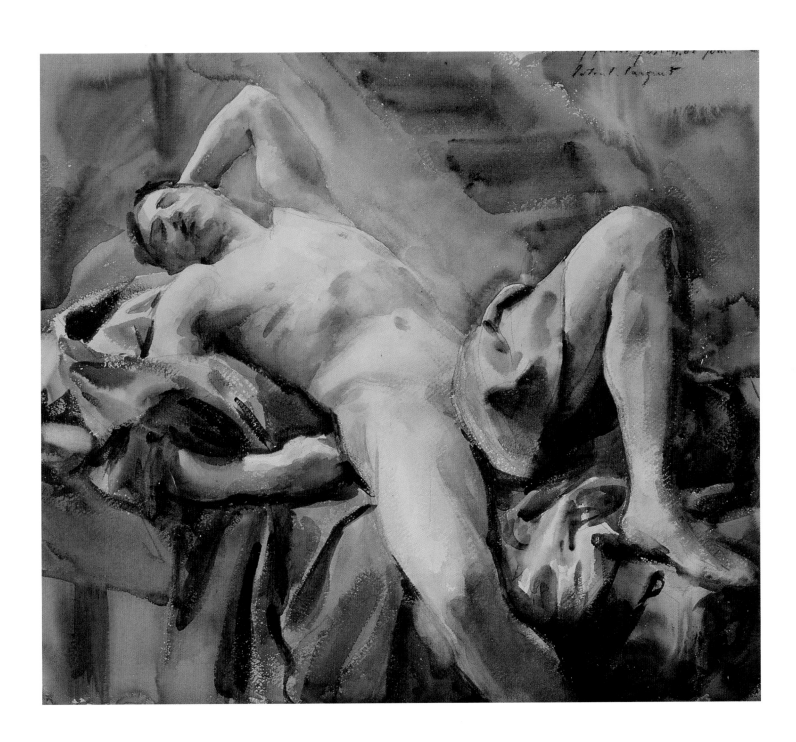

Julia Margaret Cameron (1815–1879)

86 *Venus Chiding Cupid and Removing his Wings*
1872
Albumen print
Image size 30·2 × 26·7 (11⁷⁄₈ × 10¹⁄₂)
The Royal Photographic Society, Bath, UK
✽

By 1872 Julia Margaret Cameron was copyrighting her photographs, publishing with Colnaghi's and exhibiting internationally. In her memoirs she wrote that she began in 1864 when her daughter gave her a camera, saying: 'It may amuse you, Mother, to try to photograph during your solitude ...' (Cameron 1984, p.154). Cameron's engagement with photography was not casual, and she was seldom alone. She 'had a notion that she was going to revolutionize photography and make money' (quoted Lukitsh 1986, p.5). Cameron perceived that her private life, filled with 'famous men and fair women' (Woolf and Fry 1926, introd.), had excellent public appeal. Boundaries blurred when Cameron treated 'the many-headed monster, the public, as her dear familiar and gossip, writing in large hand on [her] photographs, MY GRANDCHILD, JULIA MARGARET NORMAN ... and so on' (quoted Brookfield and Brookfield 1905, II, p.515).

In *Venus Chiding Cupid and Removing his Wings*, real and ideal, pagan and Christian collide. The bending figure reminds us that, to the Romans, Venus was Cupid's mother. Besides drawing a link between Venus-and-Cupid and Madonna-and-Child, Cameron's interest in Cupid probably began with a desire to depict children as angelic creatures. Though the relationship between Venus and Cupid was eroticised by artists including Sir Joshua Reynolds (as in *Cupid Unfastens the Belt of Venus*, 1788), Cameron's treatment remains neutral. The unmarked skin bespeaks the vulnerability of the child, Laura Gurney, as does her pose (which allowed for nakedness without indelicacy). During 1872 Laura and her sister Rachel posed for other Cupid/cherub images, including *Cupid Considering* and *Angel of the Nativity*. Laura recalled: 'we were scantily clad, and each had a pair of heavy swan's wings fastened to her narrow shoulders, while Aunt Julia, with ungentle touch, tousled our hair ... we never knew what Aunt Julia was going to do next, nor did anyone else ...' (quoted Harker 1983, p.6).

Though the source of *Venus Chiding Cupid and Removing his Wings* has not been identified, the motif was used by Reynolds in *Venus Chiding Cupid for Learning to Cast Accounts* (1771). VD

Lewis Carroll (Charles Lutwidge Dodgson, 1832–1898) and Anne Lydia Bond (?1822–1881)

87 *Untitled (Beatrice Hatch next to white cliffs)* 1873
Copy photograph of watercolour (by Bond) after a photograph (by Carroll)
14 × 15.2 (5¹⁄₂ × 6)
Rosenbach Museum & Library, Philadelphia

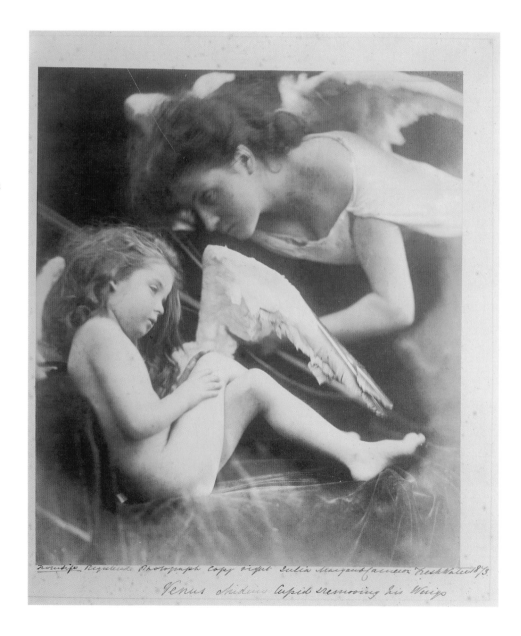

Lewis Carroll

88 *Untitled (Evelyn Hatch reclining) c.1879*
Copy photograph of photographic emulsion
on curved glass with oil highlights applied on
reverse, backed with a second piece of curved
glass painted in oil (painter unknown)
15.2 × 10.8 (6 × 4¼)
Rosenbach Museum & Library, Philadelphia
✱

These are two of five photographs of nude
children (four girls and a baby boy) by Lewis
Carroll known to be extant, though his diary
records that he took photographs of nude
children regularly between 1867 and 1880.
The originals (which are not available for loan)
derived from photographs Carroll took in his
Oxford studio, employing (as always) the wet
collodion on glass negative process. They were
altered at Carroll's request by artists who added
colour and background, effectively removing
these problematic images from their original
context.

These and the other surviving nude
photographs of girls (also altered, showing
Evelyn Hatch seated by a stream, and sisters
Annie and Frances Henderson as 'Misses
Robinson Crusoe' on rocks beside the sea)
share important characteristics. All four may
be considered examples of 'fancy pieces', a
genre dating back to the eighteenth century, in
which a nude or draped woman is depicted in a
secluded natural setting, usually beside water,
thus equating Woman with Nature. Also, each
of these images, as altered, is unique. They
were intended for private viewing only, and in
fact were not kept by Carroll but made for and
given to the girls' families. As he told Annie
and Frances' mother, he kept prints of her nude
children in an envelope marked 'to be burned
unopened' (Cohen and Green 1979, p.435).
He either destroyed his negatives and prints of
nudes, or left instructions for this to be done
after his death. That these studies were kept by
the families until the 1950s indicates that they
complied with Carroll's strict formulations of
intent and access. He carefully negotiated with
parents before a nude session, reassuring them
that he would not photograph the child nude if
she (or he) were uncomfortable, that he would
not be alone with the child, and that the child
would be undressed and dressed again by the
mother or another woman. He would test the

waters by first asking for 'bare feet' – he was
a connoisseur of legs, ankles and feet. If the
child and parents agreed, Carroll would then
progress to what he termed a 'full front view'
(such as that of Evelyn Hatch). As he confided
to his diary, 'I object to all partly clothed figures
... I will have none but wholly clothed, or wholly
nude (which to my mind, are not improper at
all)' (quoted Leach 1999, p.73).

Carroll insisted on the purity and innocence
of the girls, of his photographs, and of his
intentions. He was a man of his time, a time
when pictures of naked girls were not marginal
but mainstream. Still, Carroll knew that people
would talk, and he often referred to 'Mrs
Grundy' as an adversary. As he formulated it in
an unpublished essay, '... the real distinction
between sin and innocence, in pictures ... is
whether it stimulates ... sinful feelings, or not.
The case of the agent, and of the receiver, must
be kept distinct' (quoted Waggoner 2000,
p.214). Essentially, indecency was in the mind
of the beholder. Today, appreciating Carroll's
nudes with an innocent eye requires a
suspension of disbelief that may no longer be
possible, particularly when viewing little Evelyn
Hatch in the attitude of Titian's *Venus*, lying
back, her hands in her farouche hair (Carroll
loved flowing tresses), fixing the camera (and
Carroll) with a direct, womanly gaze.

Carroll's literary and visual imagination
lived in the child's world – whether his sexual
imagination also dwelt there is a matter of
speculation and conjecture. His extant diaries
(those covering some crucial years in the 1860s
were either lost or destroyed) have been 'sought
with thimbles' for evidence of sexual activity.
Like *Alice's Adventures in Wonderland*, the
diaries will long remain open to interpretation
and reinterpretation. VD

Guglielmo (Wilhelm von) Plüschow (1852–1930)

89 *Untitled (four nude girls)* c.1900
Gelatin-silver print
22·3 × 16·8 (8³⁄₄ × 6⁵⁄₈)
Wellcome Library, London

✽

This image of four pre-pubescent, beautiful and undoubtedly poor Italian girls completely undressed and standing against a wall conveys a palpable sense of discomfort and vulnerability, degradation and humiliation – key ingredients in pornography. We do not know who they are or how they were induced to pose for Plüschow, nor if they posed on more than one occasion or worked for other photographers. Surely they were paid, whether in money or in food. Perhaps a parent – the girls appear to be two sets of sisters – or an older sibling brought them to Plüschow's studio. Perhaps the photographer found them on the street. At any rate, there is no evidence of the kind of careful preparatory negotiations that Lewis Carroll made with children and parents – who were, after all, his friends.

Though the girls are undressed, the setting itself (probably Plüschow's garden) is dressed up with the trappings of Oriental-style richness, including a kilim, a throw and a velvet-tasselled stool. Though probably conceived as a device for heightening the illusion of a languid Never-never-land of nubile, innocent flesh, this set-dressing only makes it easier to identify the image as what it is: a product made according to formula for an established market with specific tastes (remembering that the trade in sexualised images of children was merely an adjunct to the trade in bodies). Plüschow's photographs of naked girls and boys are quite straightforward. Although not explicit, they are encoded in such a way that the viewer is aware that these photographs were made to be enjoyed – or not – as what would later be termed 'soft pornography'. Disseminated through studio sales, passed from hand to hand and publicised by discreet word of mouth, Plüschow's prints, like this one, bear the photographer's stamp with his street address (84, via Sardegna, Rome) and the negative number (in this instance, 10446), so that extra copies could be ordered easily. VD

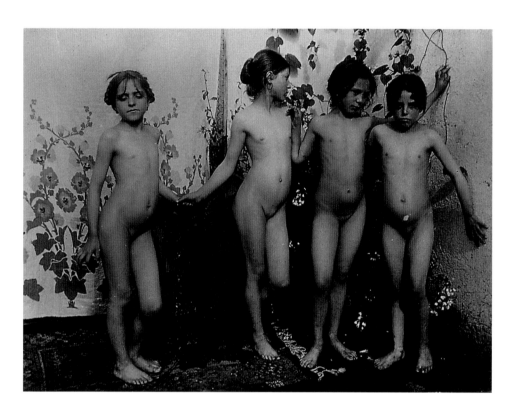

John Watson (active c.1853–1863)

90 *Academic Study* 1855
Exh. PSL 1856
Albumen print
33·7×26·1 (13¼ × 10¼)
Victoria & Albert Museum, London

❋

This is a rare example of a Victorian photograph that passed directly from public exhibition to public collection. In 1856 Henry Cole, founding director of the South Kensington Museum (now the Victoria & Albert Museum), purchased this print for one guinea (£1.05) from the third annual exhibition of the Photographic Society of London (now the Royal Photographic Society). Cole intended it for the use of artists and designers as well as students at the National Art Training School (now the Royal College of Art), since access to a professional nude model was limited and problematic.

With one hip slightly higher than the other, the model strikes the pose with which the Greek sculptors of the fifth century BC first suggested an ideal balance between rest and motion. As Kenneth Clark wrote, 'The full implications of this pose are more easily seen from behind …' (1980, p.35). Hers is a solid, unidealised female body, its imperfections corrected by retouching the outline of her head, profile, shoulders, and the cleft of her bottom. (Perhaps the photographer also arranged her hands out of sight because they didn't suit the classical ideal.)

Although titled *Academic Study* the photograph's setting is not a model's posing throne or platform, as would be found in an academy, but Watson's studio, dressed up to suggest a lady's boudoir. Though the flesh is reassuringly real, the scene retains an air of unreality that reinforces this simple study's claims to being a handmaiden to High Art. Like Velásquez' *The Toilet of Venus* ('The Rokeby Venus') (c.1647–51), she gazes for eternity into the mirror, but there is no reflection. She remains elusive, a body without a face, but with an undeniable presence.

John Watson's life and career are largely undocumented. Records show that his studio, John Watson & Co., had several locations in the Bond Street/Regent Street area of London. Sadly, his career ended prematurely when he lost his sight. VD

Unknown photographer (mid-nineteenth century)

91 *Untitled (reclining nude woman)* c.1855
Stereoscopic daguerreotype
6·3×5.6 (2½×2¼)
The Royal Photographic Society, Bath, UK

❋

The Victorians did not invent erotica and pornography – but they did invent photography, and photography invented erotic and pornographic imagery as these exist today. A glance through a collection of nineteenth-century images of sexual activities staged in front of the camera confirms that the catalogue of codes, gestures, props, costumes and situations was fixed some time ago. The nineteenth century saw the institution of pornography as an industry. Its products – never intended, after all, for public display – disappeared from sight for most of the twentieth century, reappearing from (mostly private) caches in the wake of post-modern preoccupations with gender, sex and the body.

In this French photograph the viewer is presented with a woman, whole. There is an element of confrontation which is surely part of the sexual frisson. She is no idealised beauty of classical proportions but a flesh-and-blood female, probably working class. The setting comprises basic elements of the genre: the divan suggesting a bedroom or boudoir, the basket of flowers evoking freshness, feminine allure and a touch of romance. The come-on could hardly be clearer, as the woman holds her breasts forward and plays with her nipples (the photographer taking full advantage of three-dimensional rendering). It can be assumed that the photographer was male, that the purchaser was male and affluent, that the model was paid for posing, and that the photographer made a profit.

A daguerreotype is a unique image and a precious object. A stereoscopic daguerreotype is a private viewing experience – no one else can catch the three-dimensional image at same time as the person looking at it through the viewer. VD

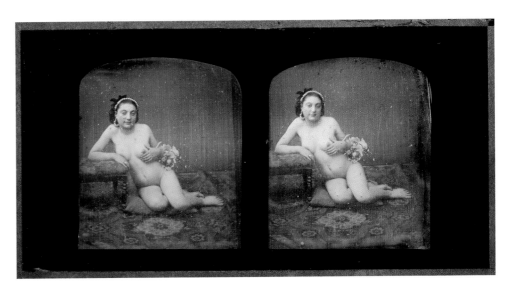

Edward Linley Sambourne (1844–1910)

92 Untitled (Lily Pettigrew nude, seated in an
armchair, at 54 Bedford Gardens, London) 31
August 1889
Albumen print
10·4 × 16·2 (4⅛ × 6⅜)
Royal Borough of Kensington & Chelsea,
Linley Sambourne House

Edward Linley Sambourne

93 *Untitled (Maud Easton nude, lying on a table, at
54 Bedford Gardens, London)* 1 August 1891
Platinum print
12 × 17·2 (4¾ × 6¾)
Royal Borough of Kensington & Chelsea,
Linley Sambourne House

Edward Linley Sambourne

94 *Untitled (Maud Easton nude, seated in an
armchair, at 54 Bedford Gardens, London)*
8 August 1891
Modern print from original glass negative
10·2 × 15·9 (4 × 6¼)
Royal Borough of Kensington & Chelsea,
Linley Sambourne House

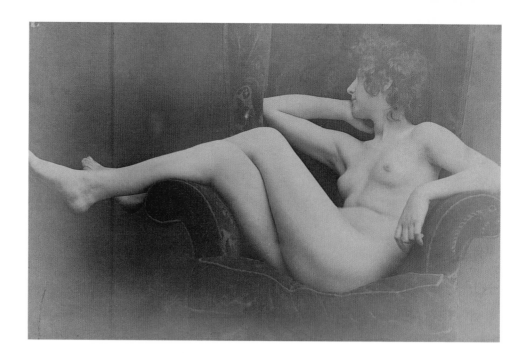

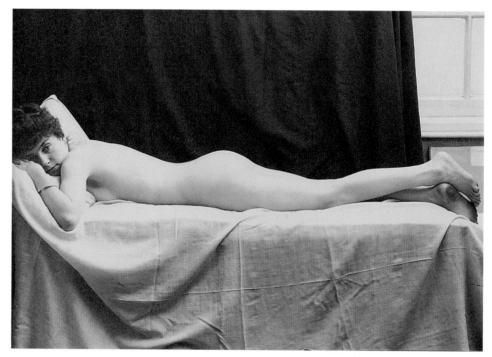

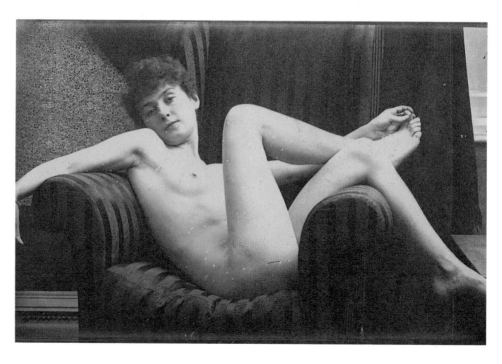

Edward Linley Sambourne

95 *Untitled (Maud Easton in Pulcinella costume,
legs open, seated in an armchair, at 54 Bedford
Gardens, London)* 30 September 1891
Gelatin-silver contact print from original
negative, 2000
21·4 × 16·4 (8⅜ × 6½)
Royal Borough of Kensington & Chelsea,
Linley Sambourne House

✱

Edward Linley Sambourne, the *Punch*
cartoonist, lived and worked in the home he
shared with his wife Marion and their two
children, Maud and Roy, at 18 Stafford Terrace,
Kensington, London. Today the house remains
more or less as the Sambournes knew it,
preserved as a house museum by the Victorian
Society and the Royal Borough of Kensington
and Chelsea. With four storeys and a basement,
plus a garden, the house is by no means small
but it is full to overflowing. Entering it is to
find an Aladdin's cave of bric-à-brac, pottery,
and pictures, mostly reproductions and
photographs (including an image from the
same series as *Venus Chiding Cupid and
Removing his Wings* by Julia Margaret Cameron),
all carefully framed and tastefully placed on
what seems to be every inch of available wall
space by Sambourne himself. In the south end
of the first-floor drawing-room, next to where
Sambourne worked at his drawing-board, is
the chest-of-drawers where he kept his treasure
trove of perhaps 30,000 images, all neatly
sorted and labelled by category. This was his
'morgue' or archive of photographs (his own
and others'), postcards, clippings, prints,
reproductions, all references for drawings.
A meticulous draughtsman, he did not wish to
sacrifice detail or veracity to weekly deadlines.
As Sambourne explained in an interview:

> Often I cannot get the model I require at
> a moment's notice ... [so] I use the camera
> instead, for I do not agree with those artists
> who condemn the use of photography
> altogether. On the contrary, I consider it a
> very useful adjunct to art ... a most useful
> servant but an impossible master ... [and
> although] people sneer at and turn up their
> eyes at the mention of photographs, in my
> work it is an invaluable help and means of
> getting studies, which, with all the subjects
> I may be called upon to draw, could be done
> by no other means, certainly not by direct
> drawing, even if one gave up sleep entirely.
> (quoted Roberts 1993, p.207)

In the early 1880s he began to take photographs
at home using his wife, children, servants and
friends as models, posing them in the back
garden in attitudes, costumes and draperies
that he then converted to 'Britannia', 'Mr
Gladstone' and so forth. Photography on the
scale that Sambourne pursued was problematic
for a married man whose 'studio' was a corner
of the drawing-room and whose darkroom was
a converted family bathroom. In her diaries
Marion Sambourne records her frustrations
with the disruptions and mess. 'Lin at those
everlasting photos', 'More of those hateful

photos, Lin wastes time, late with work', 'Lin
busy with photos, in and out, curtains taken
down for it' (Nicholson 1998, pp.15–16).

Marion certainly would not have tolerated
her husband taking photographs of nude
women at home – at least, not while she and
the children were in residence (she often
took them to visit her parents in the country).
Other, wealthier artists had homes large
enough to establish separate spheres, with
private entrances for the models. Sambourne's
solution was to move this part of his
photography activity off-site. As his own
diaries record, Sambourne first arranged to
photograph a nude model at the 54 Bedford
Gardens, Kensington, studio of his friend,
the painter Alfred Parsons. Sambourne listed
models' names and addresses in his diary,
sending a note when he needed them for
sessions. He also assessed their appearances
and abilities in his diary, making comments like
'good figure', 'long, slim legs', 'ugly and stupid',
'good hands' and so on (Roberts 1993, p.208).
He did not comment on Lily Pettigrew, but
according to her sister, Rose (one of Whistler's
favourite models and Philip Wilson Steer's
model and mistress), 'my sister Lily was lovely!
She had the most beautiful curly red gold hair,
violet eyes, a beautiful mouth, classic nose,
and beautifully shaped face, long neck, well set,
and a most exquisite figure; in fact, she was
perfection!' Rose Pettigrew recounts that an
art teacher urged her mother to take the girls to
London after their father's death, because 'you
have a small fortune in these lovely little girls'.
When the mother retorted that their father
'would turn in his grave if he knew his dear
little girls were posing for artists', she was told,
'you will be doing a very unwise thing by not
doing so. It will mean that you can all live in
comparative comfort, and that you can educate
them, which would be very much better than
letting them run the streets.' Mrs Pettigrew
reconsidered her options ('running the streets'
being a euphemism for prostitution), and as
Rose proudly recalled: 'We never, never posed
under half a guinea a day, which was a big sum
in those days of cheapness' (Laughton 1971,
pp.114–16).

In Sambourne's 1891 address list, Maud
Easton is described as 'Leslie Ward's model'
(Ward was the *Vanity Fair* cartoonist known as
'Spy'). Her undeniable presence comes through
as a kind of larkiness in these photographs –
Sambourne in his one of his characteristically
brief comments labelled her 'silly girl'
(Sambourne diaries, 20 Aug. 1891). One
wonders whether she or Sambourne dreamed
up the open-legged salute to Mr Punch? VD

Edward Linley Sambourne

96 *Untitled (Miss Derban and Mrs King nude, standing, embracing, at the Camera Club, London)*
15 April 1893
Cyanotype
$18 \times 11 \ (7^1_8 \times 4^3_8)$
Royal Borough of Kensington & Chelsea, Linley Sambourne House

Edward Linley Sambourne

97 *Untitled ('L.G.', in gypsy costume, topless, at the Camera Club, London)* 16 April 1898
Cyanotype
$11 \cdot 9 \times 16 \cdot 4 \ (4^5_8 \times 6^1_2)$
Royal Borough of Kensington & Chelsea, Linley Sambourne House

Unknown photographer (?French, late nineteenth century)

98 'Swede' (two nude women, one standing, one seated) c.1890
Albumen print
13·2 × 9·8 (5¼ × 3⅞)
Royal Borough of Kensington & Chelsea, Linley Sambourne House

Unknown photographer (?French, late nineteenth century)

99 'Swedish' (nude woman standing, tied to pillar) c.1890
Albumen print
16·4 × 9 (6½ × 3½)
Royal Borough of Kensington & Chelsea, Linley Sambourne House

✳

In April 1893 Sambourne became a member of the Camera Club, a photographers' association primarily for gentlemen not 'actually engaged in the production of photographs as a trade' (*British Journal of Photography*, 27 April 1888, p.267). Founded in 1887, the Camera Club was typical of London's Clubland in that era – a place for men to gather and socialise without women, with the added amenity of a photography studio. A contemporary writer described the Club's 28 Charing Cross Road premises, which opened in 1891, as being 'in efficiency and general commodiousness ... the most perfect of its kind now existing' (*British Journal of Photography*, 29 May 1891, p.341). As the Bedford Gardens studio was no longer available to him, Sambourne switched his nude photography sessions to the Camera Club and entered a new phase with typical gusto and voracity.

The taller of the two women in no.96, Mrs King, worked for Sambourne regularly. He noted in his 1896 diary: 'Took 42 photos of Mrs King ... this was her last sitting. She disappeared and, I heard in December this year, was dead, her little girl too. Good model' (Roberts 1993, p.209). This off-hand remark points up Sambourne's remarkable detachment from his models. There is no hint in either his diaries or his wife Marion's that there was any kind of personal, sentimental, romantic or sexual attachment between him and any of the women. This puts paid to any latter-day sentimentalising about the relationship between artist and model, though it is difficult to reconcile Sambourne's apparent coldness with the fact that for many years he invested time, energy and money in opportunities for photographing women in the nude. While we are conditioned to see the person's identity, whole, with or without clothing, Sambourne was not.

The pairing of Miss Derban and Mrs King is not overtly sexualised. They may be posing as sisters or friends comforting each other; in other Sambourne photographs they are shown walking arm in arm, nude. However, the print that Sambourne labelled 'Swede' (and no doubt filed under that category in his archive) clearly has sexual overtones, though it was produced probably for the 'aids for artists' market. The photographer has not been identified, nor has the source. Sambourne collected many examples of female nudes in the same vein, probably acquiring them from print-sellers in the West End. Rather than representing national types, this tableau seems more likely to be intended to spark the standard male fantasy of a lesbian encounter, as the standing (dominant) woman removes the veil from her sleeping (submissive) partner. Also

masquerading as an academic study is the image, labelled 'Swedish' by Sambourne, of a nude woman tied to a pillar, Andromeda-like. Her wild-eyed emoting tends to deflate any titillation that the suggestion of bondage might otherwise generate.

In addition to his work, Sambourne spent a good deal of time socialising with his men friends in the clubs. The day he made the photograph of the woman in the gypsy costume appears to have been typical, as he noted in his diary: '[Left Stafford Terrace] by 1.10 [and went] by cab to C.C. [Camera Club]. Called [at] Garricks [club]. Lunch with [Harry] Furniss [a *Punch* colleague]. ... After to C.C. No costume. Sent to May's [costumier] for it. Curious dark day heavy cloud & black. Cleared after. At 2.50 ... L.G. came. Sat in gitana dress. Out at 5.0 & on to the Athenaeum' (Sambourne diaries, 16 April 1898). Other photographs Sambourne took in the same session show the model from the waist up, her beautiful breasts and full nipples exposed, with her hair flying. Judging by her appearance, she may have been one of the Italian models favoured by British artists for their dark looks and their refined hands and feet. In 1879 the artist E.J. Poynter promised his Slade School students that he would hire for them only the best Italian models, because they 'are not only in general build and proportion, and in natural grace and dignity far superior to our English models; but they have a natural beauty, especially in the extremities which no amount of hard labour seems to spoil' (quoted Smith 1996, p.196). VD

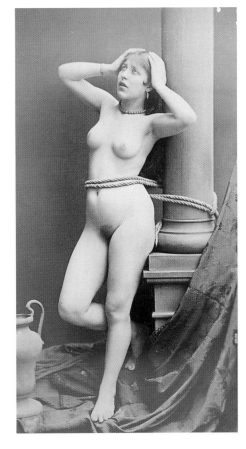

Edward Linley Sambourne

100 *Untitled (Dorothy, nude, hands behind back, standing on table at the Camera Club, London)*
8 August 1903
Cyanotype
12·5 × 9·4 (4⁷⁸ × 3³⁴)
Royal Borough of Kensington & Chelsea,
Linley Sambourne House

Edward Linley Sambourne

101 *Untitled (Dorothy, nude, arms outstretched, left foot on box, standing on table at the Camera Club, London)* 8 August 1903
Cyanotype
12·2 × 9·3 (4³⁴ × 3⁵⁸)
Royal Borough of Kensington & Chelsea,
Linley Sambourne House

Edward Linley Sambourne

102 *Untitled (Dorothy, nude, head down, hands to eyes, standing on table at the Camera Club, London)*
8 August 1903
Cyanotype
11·9 × 9·2 (4⁵⁸ × 3⁵⁸)
Royal Borough of Kensington & Chelsea,
Linley Sambourne House

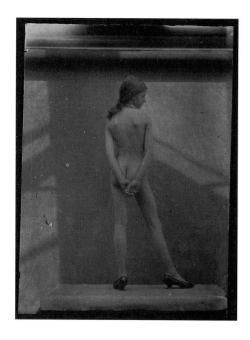

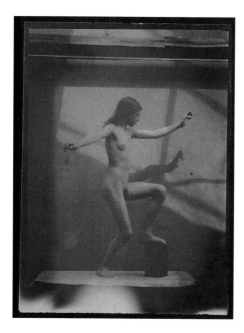

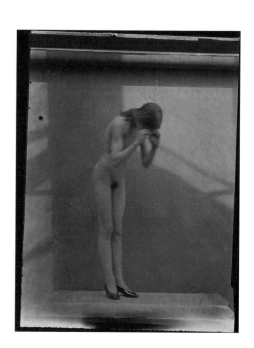

Edward Linley Sambourne

103 *Untitled (Dorothy, nude, reclining on table at the Camera Club, London)* 8 August 1903
Cyanotype
18·3 × 24·7 (7¹4 × 9³4)
Royal Borough of Kensington & Chelsea, Linley Sambourne House
Not exhibited

Edward Linley Sambourne

104 *Untitled (unidentified woman from waist down, standing, lifting petticoat above knees, at the Camera Club?, London)* 7 May 1904
Cyanotype
11·8 × 8·9 (4⁵8 × 3¹2)
Royal Borough of Kensington & Chelsea, Linley Sambourne House

104

Edward Linley Sambourne

105 *Untitled (unidentified woman from waist down, standing, lifting petticoat above waist, at the Camera Club?, London)* 28 May 1904
Cyanotype
9·9 × 8 (3⁷8 × 3¹8)
Royal Borough of Kensington & Chelsea, Linley Sambourne House

✿

On 8 August 1903 Sambourne noted in his diary that he went to the Camera Club and 'Photod actress child … Extraordinary'. Indeed the girl, identified only as 'Dorothy' in Sambourne's handwriting on the backs of the prints, was an extraordinary model, as these examples attest. Her coltish limbs and small breasts look somehow right to us, used as we are to ever-thinner teenage super-models. She takes the stage, a draped tabletop, and assumes the poses requested by Sambourne with aplomb and the hint of a smile. We want to know what kind of career she had. Did her star qualities serve her well? Three of the photographs appear to have been taken in succession. Sambourne must have enjoyed the girl's energy and spontaneity, and responded by making some of the most photographic images in his oeuvre. The shadow-play on the wall behind Dorothy, and the way in which the light catches her figure and models it, demonstrate a feel for the medium's unique possibilities that Sambourne rarely indulged.

In the fourth image – the one that Sambourne selected for enlargement – Dorothy appears as uncomfortable as might be expected, faced as she was with a middle-aged man wielding a camera almost directly at her crotch, which is just slightly off dead centre and at eye level. It is difficult to conjecture what possible use such a pose could have had to Sambourne in his work for *Punch* – this is more a 'beaver shot' than anything else. When we consider that Sambourne knew the actress was only a child, the image and his reasons for taking – and enlarging – it become even more disquieting.

As post-modern commentators have noted, the fragmentation of the body for purposes of sexual voyeurism began with the invention of photography. The two photographs suggesting a strip-tease actually come from two separate sessions taken three weeks apart by Sambourne at the Camera Club. Perhaps when he took the trouble to replicate everything from the first session in the second, Sambourne was simply experimenting, trying to get the formula right, or maybe he was compulsively re-enacting a favourite fantasy. These photographs need to be considered next to the surreptitious snapshots of Kensington schoolgirls that Sambourne began making (with a detective camera disguised as a pair of binoculars) around 1905, during a period when the Camera Club was closed temporarily. Dark stockings, dark shoes and light dresses were the schoolgirl style of the day. Sambourne appears to have been more than casually interested in what was above the knee, though whether he ever wished (or was able) to act on his desires is unknown.

After Sambourne's death in 1910, his wife Marion found his nude photographs among the things left in his studio. Though she may well have been shocked at the nature and extent of his activities in this line, to her credit she did not destroy them, but set the nudes aside with the rest of his photographs to await the attention they have only recently begun to receive. VD

Robert Crawshay (1817–1879)

106 *Untitled (two men in a Turkish bath) c.1866–8*
Collodion positive, cased
13·8 × 11·2 (5³⁄₈ × 4¹⁄₂)
Victoria & Albert Museum, London
❋

As scions of the 'Iron Kings' of Merthyr Tydfil,
Robert and his cousin George Crawshay could
afford their enthusiasms – Robert's for
photography and George's for the Turkish bath .
This is one of three related images acquired
from a Crawshay descendant who indicated that
they were made in the Turkish bath at George's
home. He further suggested that the subjects
might have been George's sons, Arthur and
Martin, demonstrating the use of his bath.
They are possibly the earliest extant
photographs of a Turkish bath in England.

Robert Crawshay, who began running the
family iron works at the age of 22, suffered a
debilitating stroke in 1860 which impaired his
hearing and vision. It appears that he acquired
his first photographic equipment in 1866 and
in 1867 he was elected to the Photographic
Society of London. At the 1873 and 1874
exhibitions he offered cash prizes to encourage
photographs made 'direct from life'
(*Photographic Journal*, 21 Nov. 1872, pp.2–3).
His extant photographs, now at Cyfarthfa Castle
(the family estate, now a museum and art
gallery), include landscapes, portraits, tableaux
and genre pieces featuring his daughters.

Against this background the Turkish bath
images retain an evanescent, enigmatic quality.
One of the enigmas is the light source, so bright
it casts a shadow – was it a magnesium flare?
Another puzzle is in the nature of the
encounter. Latter-day (particularly American)
viewers may associate 'the baths' generically
with homosexual activities, though it is
probably going too far to discern a homoerotic
intent here. Still, our attention to this possibility
is awakened by the precise definition of the
collodion positive process which affords a
tactile sense of flesh pressing on flesh.
Massage, as we understand it, was never part
of the Turkish bath ritual. Instead, an attendant
shampooed the bather using a rough mitten.
This might be followed by treatment akin to
modern osteopathic manipulation. But is either
being demonstrated here? VD

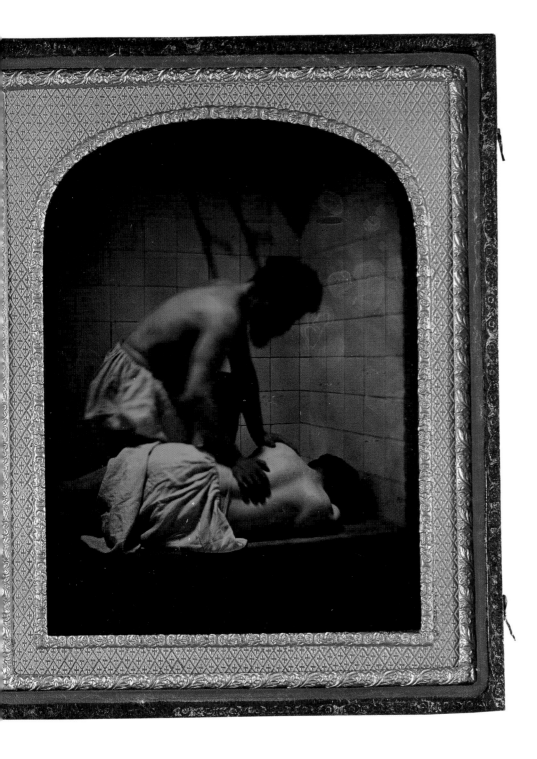

Baron Wilhelm von Gloeden (1856–1931)

107 *Untitled (two nude youths in a landscape)* 1900
Gelatin-silver print
22·5 × 16·9 (8⅞ × 6⅝)
Wellcome Library, London

Guglielmo (Wilhelm von) Plüschow (1852–1930)

108 *Untitled (two nude youths)* c.1900
Gelatin-silver print
22·3 × 16·8 (8¾ × 6⅝)
Wellcome Library, London

✱

'Nudes pour in on me from Sicily & Naples. I have quite a vast collection now – enough to paper a little room … They become monotonous, but one goes [on] seeking the supreme form & the perfect picture' (Younger 1999, p.8). When John Addington Symonds wrote this to Edmund Gosse, he was updating his friend (and fellow collector of homoerotic photographs) on the progress of his research on the male nude. Symonds lived in Switzerland but often visited Italy, patronising the studios of Wilhelm von Gloeden, in Taormina, Sicily, and Guglielmo Plüschow, in Naples and (after about 1892) in Rome. Symonds was voracious (buying 96 prints from Plüschow in a single transaction), but his collection of hundreds of male nudes has apparently been either dispersed or destroyed.

Symonds was a connoisseur of the male body. In his opinion no drawing could do justice to this 'living miracle' (Symonds 1887). Comparing a reproduction of a Raphael drawing to a photograph (undoubtedly by von Gloeden or Plüschow), Symonds wrote: 'The model in my photograph is somewhat coarse and vulgar. Yet no one … can fail … to acknowledge the superiority of the more literal transcript from nature' (ibid.). Like many collectors, Symonds made little distinction between the model as subject (of desire) and object (of admiration).

But Symonds was not an uncritical consumer. In 1890 he wrote to Gosse (in the discreet language that they both employed when referring to their common interest in *l'amour de l'impossible*):

> If you really care for [a photograph], I will order it, & beg you to keep it. I can always get these things from Sicily, though the photographers are rather tiresome & casual in their execution of orders. I will sort out some other 'visions of the woodland', really pretty bits of studied humanity in natural surroundings. Only, I thought that this class of study struck you as artificial – you said something once about their reminding you of the bouquets of zoophytes which used to adorn your late respected father's books. (Younger 1999, p.8)

Nearly one hundred years later, Roland Barthes discerned in von Gloeden's photographs the same elements of nature and artifice mixed in a 'carnival of contradictions', and responded to the traces of the physical presence of the (by then) long-dead models. 'These little Greek gods (already a contradiction because of their dark color) have peasants' hands, somewhat dirty, with large misshapen nails; hardened feet, not very clean; and swollen, clearly visible prepuces which are unstylized, that is, not slenderized and tapered: our attention is drawn to the fact they are clearly uncircumcised: the Baron's photographs are at the same time sublime and anatomical' (quoted in Woody 1986).

Plüschow and von Gloeden were cousins. Plüschow established a photographic portrait studio in Naples in the 1870s, and von Gloeden settled in Sicily about 1880. In 1889 von Gloeden turned to photography to make a living, learning technique from his cousin. Though he photographed the landscapes and monuments of Sicily, by the early 1890s von Gloeden had begun to focus on male nudes while also making pornographic images of youths in sexual encounters for a more restricted market. Plüschow apparently entered the field, sometimes collaborating with von Gloeden, when he saw the success his cousin enjoyed. After von Gloeden's death, his studio was maintained by a friend and former model, Pancrazio Bucini. In 1936 Italian Fascists accused Bucini of keeping pornography and von Gloeden's approximately 3,000 glass negatives were either impounded or destroyed. Though the estate was later cleared of charges only a few hundred negatives were salvaged. Recently the remainder were acquired by the photographic archive Fratelli Alinari, Florence. VD

107

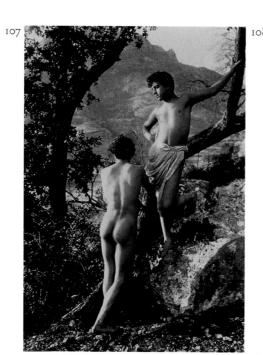

108

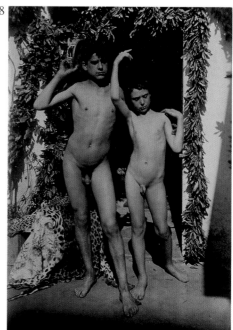

'Get the abomination stopped.' So wrote the outraged 'AF' in a letter titled 'Animated Photographs – A Protest' to the *Southport Visiter* (5 Jan. 1899) in response to the Mutoscope film *Studio Troubles* (1898), also known as *Wicked Willie*. Within only a few years of the invention of film, erotic subjects were arousing interest and indignation in towns and cities across the country.

Projected film was first introduced in Britain in 1896. From March that year the Lumière Brothers' 'Cinématographe' was showing films at the Empire Theatre of Varieties in Leicester Square. That same month the 'Theatrograph', the invention of the British entrepreneur and film-maker Robert W. Paul, was showing films at the nearby Alhambra Theatre of Varieties. Many other companies followed as film was enthusiastically received by the public. Primitive moving image was available through Thomas Edison's 'Kinetoscope' – the first Kinetoscope 'Parlour' opening in Oxford Street, London, on 14 April 1894. These 'what the butler saw' penny-in-the-slot machines were joined by the rival 'Mutoscope' with the incorporation of the Mutoscope and Biograph Syndicate on the 21 July 1897 (later to be known as the British Mutoscope and Biograph Company). While projected film reached large audiences through theatres, the single-view Mutoscope machines could be found in shops, railway stations and leisure complexes such as Blackpool Tower and Crystal Palace.

Most early films tended to be factual in subject-matter – military affairs, Royal events and sporting scenes such as the Derby. However, there were also risqué or erotic films, often referred to as 'smoking concert films', made for a predominately male audience to stimulate sexual desire and offer gratification. Fine art references were often incorporated to justify the display of the nude – the artist's studio and classical bathing scenes being typical motifs. The use of comedy was also an important device in legitimising nudity and sexual innuendo.

One of the earliest British films of a risqué nature, R.W. Paul's *Come Along, Do!* (1898), also known as *Exhibition*, is set in an art gallery. The scene opens with a couple from the country who are visiting the town, sitting on a bench eating their sandwiches to the amusement of passers-by. They notice an exhibition and decide to enter. The man catches sight of a statue of Venus and examines it with glee, but his wife catches him leering at the nude sculpture and drags him away in anger. The various companies were aware of the sensitive nature of such films. In Rhyl, May 1899, the North Wales Mutoscope Company decided to place four of its machines inside the male public toilets to avoid causing offence to any women or young girls, but the revenue of the public toilets soared by seven times the normal rate, and the exhibition was subsequently closed after the council was accused of profiteering from 'obscene pictures'. A more organised and calculated campaign against

erotic films was launched in Southport after the display of *Studio Troubles* (fig.31) Probably inspired by Frank Hyde's amusing painting *The Eton Boy* of the late 1880s (fig.32), the film shows an artist in his studio with a nude female model posing for him. A woman and her adolescent son enter causing the model to retreat behind a screen. But while the woman is in conversation with the artist, the boy discovers the model and starts tickling her. The mother sees what is happening and hauls the boy away, the model blowing kisses to him as he leaves. The campaign was victorious and the film subsequently withdrawn from the programme.

The issue of titillating films soon became a political concern (fig.30). On 24 July 1899, Samuel Smith, Liberal MP for Flintshire in North Wales, asked the Home Secretary, Matthew White-Ridley, if he could persuade local authorities to suppress these 'indecent exhibitions'. Whether Smith was prompted by his Scottish Presbyterian religious beliefs, or was acting out of pure political opportunism is uncertain. Although the Home Secretary was basically indifferent to the matter, it was not long before the first prosecution. On 27 November 1900, the Folkstone Police seized five reels of film deemed objectionable under the Obscene Publications Act of 1857. The British Biograph Company fought the prosecution but failed with the result that three films: *Ignorance is Bliss*, *Should Ladies wear Bloomers?*, and *A Mouse in a Girl's Bedroom*, were condemned for destruction. However, this did little to curb the future production of erotic films. TB

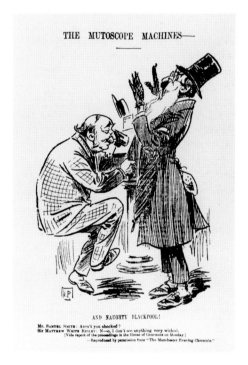

Fig.30
'The Mutoscope Machines'
Cartoon published in the *Blackpool Herald* 28 July 1899, R. Brown and A. Barry, *A Victorian Film Enterprise* Flicks Books, courtesy of Richard Brown

Fig.31
'Studio Troubles'
R. Brown and A. Barry, *A Victorian Film Enterprise* Flicks Books

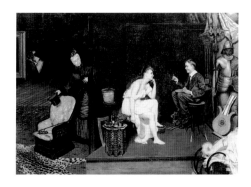

Fig.32
Frank Hyde
The Eton Boy c.1880s
Oil on canvas
Private Collection, courtesy of Sotheby's

Attr. Esmé Collings

109 *A Victorian Lady in her Boudoir*
Britain 1896
35 mm black and white silent film – 45 secs
British Film Institute

✻

Originally attributed to Skladanowsky, this early short film is now believed to be the work of Esmé Collings. Examination of the original negative shows that the perforations correspond to those produced by Collings' own perforator, fabricated for him by Alfred Darling.

Whilst London was the centre of the emerging film industry in Britain, Leeds, Bradford and Brighton were also important in the development of cinematography. Esmé Collings was a successful portrait photographer, working in partnership with William Friese-Greene. Based in Brighton, he also had two studios in Bath and three in London. In 1896 he took up the production of film, producing over thirty films in just one year.

The scene of the film opens with a woman in a set resembling a boudoir. She takes off her hat, placing it on a stand on the mantelpiece and proceeds to disrobe, finally reclining in a wicker chair and reaching for a book. Full nudity is not presented as the model retains her chemise – such was the caution of the British film industry at this stage. The sober expression of the model is broken briefly at a mid-point in the film when a comment from someone behind the camera elicits a response and smile. But this is short-lived as she returns to her contemplative state, staring into the camera at the end. TB

Pathé Frères

110 *Five Ladies – Peintre et Modèle*
France 1903
35 mm black and white silent film – 25 secs
Pathé Archives, France

✻

Founded in 1896 under the direction of Charles Pathé, Pathé Frères soon established itself as the leading film company in France and across the world. From humble beginnings selling Kinetoscopes (produced by R.W. Paul) at provincial French fairgrounds, the company started producing its own equipment, film stock and films. It quickly took control of film production, exhibition and distribution, dominating the market in both Europe and America. French films were regarded in Britain as being of high quality and far more risqué in their content than British films. Pathé Frères were quick to realise the demand for erotic subjects, and produced many films of this nature to satisfy the market. Thus for British audiences, a French title or any allusion to France or Paris soon came to signify eroticism. Titles were readily available through distributors such as Philip Wolff – one of the largest suppliers in Europe who had branches in London, Paris and Berlin

The first in this compilation of smoking-concert films, *Peintre et Modèle* opens with the model taking off her robe as she turns her back to the camera, handing her fan to the passive black servant seated on the floor in the background. The artist, seated at his easel smoking, instructs the model to take up various attitudes, probably inspired by the painter Gérôme, finally deciding on a pose. He sketches for a while before the model covers the lower half of her body with her robe and joins the artist to view his work. The inclusion of the black servant – echoing Manet's sensational painting *Olympia* (1865) – adds an exotic element to the scene and together with the oriental design of the model's fan reinforces the sexual message of the film. TB

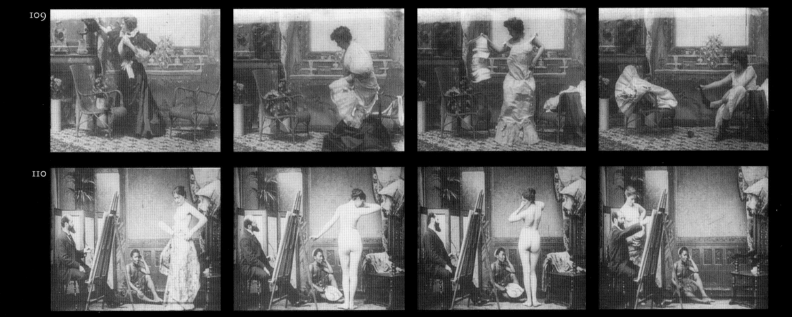

Pathé Frères

111 *Five Ladies – A French Lady's Bath*
France 1903
35 mm black and white silent film – 20 secs
Pathé Archives, France

✱

The fourth film in the compilation, *A French Lady's Bath* depicts a young woman washing herself in an interior setting. Behind the curtain to the right of the scene a 'Peeping Tom' surreptitiously watches her ablutions. Turning and communicating with the viewer, he becomes increasingly excited and agitated at the sight, throwing his hat to the ground in frustration. Unaware of his gaze, the woman lifts her towel revealing her upper thigh, at first to the Peeping Tom and then to the camera.

An important influence on the development of film was the music-hall. The comic figure of the Peeping Tom spying through keyholes, cracks in walls or from behind screens, was well established in music hall entertainment, serving to contain the sexual potency of the scene, thereby freeing the viewer from potential embarrassment or excitement. TB

Pathé Frères

112 *Peintre Facétieux*
France 1899
35 mm black and white silent film – 1 minute
23 seconds
Pathé Archives, France

✱

The artist, clearly identifiable with palette in hand, invites a young female model into his studio. To her slight surprise he asks her to undress, assisting her in the opening of her jacket revealing her breasts, and instructs her to remove the rest of her clothing. As she is about to remove her chemise the film bleaches out into total whiteness. When the image returns a few frames later the model appears to be wearing a body stocking. The bleaching may have been caused by a burning or wearing of the film through excessive use at this point, yet the filming of the scene must have been stopped at this juncture to allow the model to change into the body stocking. A break in the filming is substantiated by the fact that a painting hanging in the background has moved to a different position, and the artist is now wearing his beret, which was previously hanging on the wall. As the narrative continues the model assumes a pose while the painter begins his work, with his back to the camera allowing the viewer to see his creation. The model, usually a passive figure in films of this nature, starts to make mocking, aggressive and provocative gestures to the oblivious painter, smiling to herself as she does so. Meanwhile, the artist is portraying her as a cow. When the finished canvas is presented to her she smashes the offending article over the head of the artist, who throws down his beret in astonishment. TB

Clarence Lansing

113 *The Nude in Art* 1896
Book
48 × 34 (19 × 13³⁄₈)
The British Library Board
[Illustrated as fig.10, p.33]

✱

Published in November 1896 by H.S. Nichols of Piccadilly and Soho Square, *The Nude in Art* advertised itself as 'A collection of forty-five photogravures reproduced from the original paintings, selected from the best works of the most famous painters of the nude'. Many of the works illustrated were by French painters, Bougereau featuring no less than six times, but British painters of the nude such as Henrietta Rae, Solomon J. Solomon and Edward Poynter were also included. Such compendia of nude imagery were always open to criticism, or even to the attention of the law in the form of the Obscene Publications Act, and Clarence Lansing's introduction is at great pains to establish the propriety and seriousness of the project. It is worth quoting at length as it gives a snapshot of the criticisms and defences still surrounding the nude at the very end of the nineteenth century. 'The mission of this book', Lansing wrote:

> is a high and noble one. Its aim is to offer to its patrons the best examples of what is refined, noble, and pure in art … As to the nude itself as an element in art … its propriety and necessity are now admitted by all who have given the subject serious thought or study. There is nothing to give offence to clean-minded persons in the artistic use of the undraped human figure. The best minds are agreed upon this … yet … we find a small class of ignorant or bigoted persons to whom an undraped figure, whether male or female, young or old, is an abomination. Without being conscious of it, many of these possess minds so prurient that the most godlike figure, standing in all its nude majesty, conveys to them no idea but one of licentiousness (pp.1–2)

This strategy of defence, which combined claims for artistic and instructive merit with an accusation of 'honi soit qui mal y pense' was one frequently marshalled against claims of obscenity, and there are echoes of it to be found in the twentieth-century obscenity trials of D.H. Lawrence's *Lady Chatterley's Lover*, and *Oz* magazine.

A further protection for *The Nude in Art* was its price. At four guineas it was an élite publication which only the affluent could afford, the respectable and responsible middle and upper classes, generally viewed in law as being more resistant to material likely to deprave or corrupt. This book was aimed at connoisseurs, but cheaper publications were often billed as being for the education and training of art students. This was a stratagem specifically aimed at deflecting the Obscene Publications Act. Sickert noted its hypocrisy in his 1910 article 'The Naked and the Nude': 'Will any clear-headed person maintain that …

such catalogues as 'Le nu au Salon', owe their stimulus to purely artistic grounds? Does not every petty dealer convicted of the sale of photographs of the naked put up a plea that they are necessary for the use of artists? Has anyone ever heard of an artist who had the slightest use for such things?' (*New Age*, 21 July 1910; quoted Robins 2000, p.261).

The book is open at the spread reproducing *The Disarranged Toilet* by Fernand Lequesne (1856–1932), a French painter well known for his nude subjects sent to the Salon. It is a characteristically voyeuristic composition of nude women, but combined with the peculiar element of their entanglement in a spider's web, perhaps an attempt at moral allegory. Lansing interpreted the action:

> A group of graceful nymphs, while arranging their toilets, are alarmed at the approach of some intruder; and in their haste and confusion have become entangled in a gigantic spider's web. In the foreground the nymphs are struggling with their embarrassment, while in the distance are their companions, rushing to give warning of the approaching stranger. The picture, like all of Le Quesne's, is wholly satisfying in all respects. (p.10)
RU

The Artist's Studio

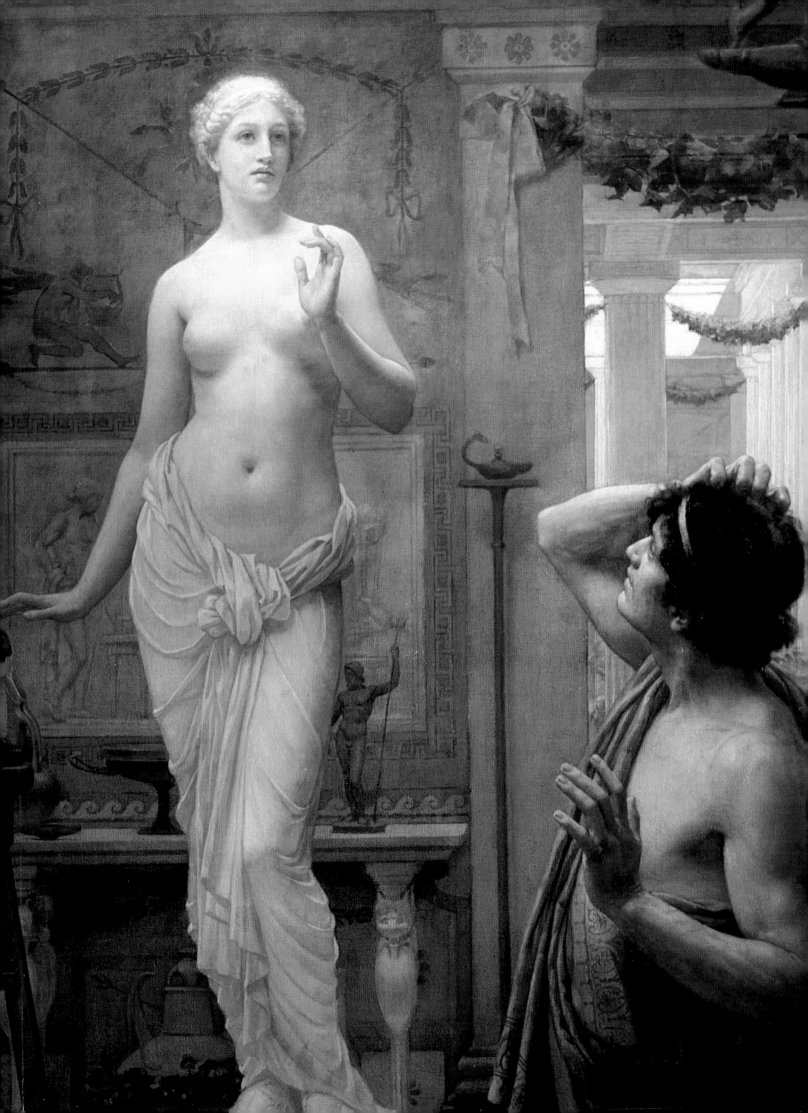

For the outsider, the artist's studio was perceived as a place of mystery and fascination, and an environment freed from the rigid social strictures of everyday life. It was the cradle of creativity and artistic inspiration, and central to this was the presence in the studio of the model, who would, in the popular imagination, inevitably and willingly pose nude under the direction and control of the artist. There was a good deal of truth in this, and the relaxed lifestyle and camaraderie celebrated in George du Maurier's novel *Trilby* (1894) was a reasonably accurate portrait of the late-century artistic milieu. But in their relationships with their models propriety was important for artists of the calibre and reputation of Watts and Leighton, the latter even having a special entrance for models constructed in his house to separate them from domestic life.

Artistic practice was a further source of great interest and formed a topic of discussion in publications such as the *Studio* and the *Art Journal*. The studio was the venue for transformation, where the nude figure was sketched in whole or in part, but the body figuratively dissected and rebuilt, reassembled in a self-conscious drive for perfection, as exemplified in Edwin Long's enormously popular *The Chosen Five* (1885, no.136). This approach underlay much contemporary artistic practice, as it had for centuries. Even greater transformation occurred in Leighton's studies for *Summer Slumber* where he uses a naked boy for a female figure, progressively re-sexing the subject before eventually draping the nude for the finished design (nos.119–21). And the direct transforming touch of the artist was seen in mimetic clay and wax nude sketches, part of the British sculptural renaissance that took place from the 1870s.

But the creation of a perfect natural, lifelike form was a danger as well as an inspiration. John Gibson's coloured nude sculpture *Tinted Venus* (c.1851) (fig.11, p.39) was greeted with horror, not only because it undermined traditional expectations about the pure whiteness of classical sculpture, but because it appeared lifelike. Its colouring greatly disgusted Elizabeth Barrett Browning who judged she had 'seldom ... seen so indecent a statue' and believed it 'rather a grisette than a goddess' (Kenyon 1897, II, pp.148, 155). But she greatly admired Hiram Powers's, eroticised, sado-masochistic, uncoloured *Greek Slave* at the Great Exhibition for its cool detachment.

The disturbing power of the sculpted nude, and the relationship of the artist to his subject, found greatest expression in the closing decades of the century with the contemporary obsession with the story of Pygmalion. Ovid related that the Cypriot sculptor Pygmalion loathed the lasciviousness of 'all womankind', and lived alone. But his sexual desire found expression in his carving of a beautiful, lifelike ivory woman. So perfect is his creation he falls in love with it, and repeatedly runs his hands over it and kisses its mouth. Pygmalion buys his statue lavish gifts, dresses it up, and eventually takes it to bed. On the feast of Venus he prays for her to come to life, and the goddess grants his wish. Touching his figure again, Pygmalion feels the warmth in her flesh, and kissing her she comes to life.

The story was painted by artists as diverse as Burne-Jones, Tenniel and Normand (nos.130–33, 134, 135), was the subject of a twelve-volume verse cycle by the sculptor Thomas Woolner (1881), a part of William Morris's *Earthly Paradise* (1868), a play by W.S. Gilbert, and innumerable other poems, dramatisations and narratives, particularly in the 1880s. Contemporary fixation with the story denoted deep responses, and the story touches various aspects of the Victorian psyche. The concept of man-made perfection can easily be linked with growing enthusiasm for the theory of eugenics, which perpetuated unwholesome ideas of selective human breeding being the path to racial excellence and the eradication of disease. Such racist concepts must underlie Ernest Normand's portrayal of Pygmalion's creation (no.135) as an athletic, Aryan amazon.

Man-made creations coming to life, and warnings about the consequences, featured in related nineteenth-century tales such as *Frankenstein* (1818), *Coppelia* (1870) and *Pinocchio* (1881), and interestingly also in our own era in films such as *The Stepford Wives* (1975) and *Westworld* (1973). But the Pygmalion myth also touched male fears about women and their changing social status through access to education and the world outside the home. It was a comforting story for frightened men – not only does Pygmalion create his ideal woman, he also owns her, and combined with his smothering, elevated veneration, mirrors the dynamics of Victorian marital relations, or stereotyped male expectations of how they should be.

Overleaf:
Ernest Normand
Pygmalion and Galatea
1886
(no.135, detail)

Edward Coley Burne-Jones
Pygmalion and the Image: The Godhead Fires 1875–8
(no.132, detail)

Pygmalion's statue was a reflection of himself, and also an act of sexless creation not requiring sex, linking further to male fear of women; Ovid himself emphasises Pygmalion's misogyny at the beginning of the story. Yet it was also a narrative that perfectly fitted the artistic process and the putting of the artist's self into his object. John Gibson recalled of his *Tinted Venus*: 'At moments I forgot that I was gazing at my own production; there I sat before her, long and often. How was I ever to part with her?' (Eastlake 1870, p.212).

In a sense too, the relationship between artist and model followed Pygmalion's dynamic – his direction of the model imposed control, gave her life, and fashioned how she was perceived. Sometimes this control extended into everyday life. Considering marriage, in the 1850s Holman Hunt tried to turn his model Annie Miller into a gentlewoman through elocution lessons and education. Later, Leighton devised a similar programme for Dorothy Dene, and her example is said to have been the partial inspiration for George Bernard Shaw's play *Pygmalion* (1913). RU

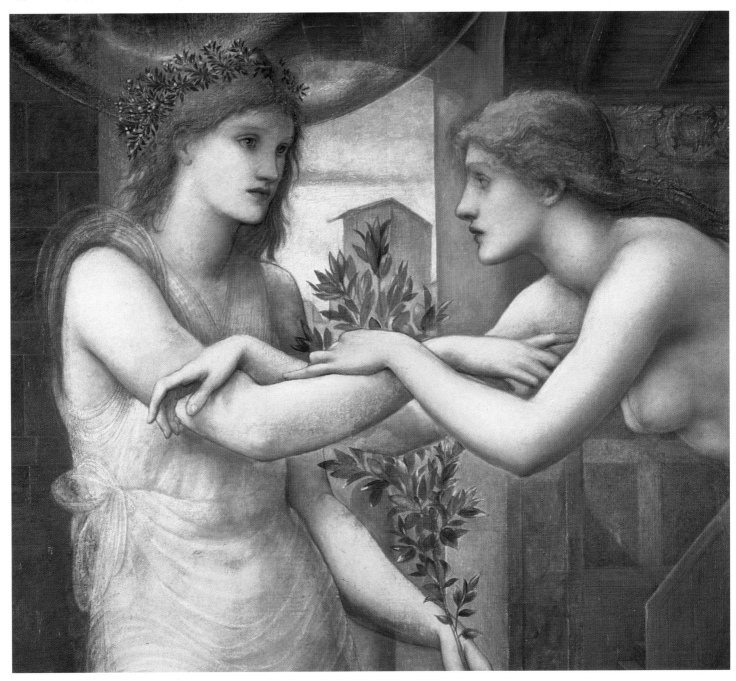

Ford Madox Brown (1821–93)

114 *Study of a Corpse for 'The Prisoner of Chillon'* 1856
Pencil on paper
16·5 × 28 (6½ × 11)
Birmingham Museums & Art Gallery
❋

In 1856 Brown was commissioned by the
Dalziel brothers to make a wood engraving
illustration to Byron's famous poem 'The
Prisoner of Chillon' (1816). This was to be
included in *The Poets of the Nineteenth Century*,
a selection edited by Robert Willmott and
published in 1857. A gothic chiller, Byron's
poem tells of the horrifying incarceration of a
man and his two younger brothers in a dungeon
on Lake Leman. Each chained to a separate
pillar, the narrator watches his brothers weaken
and die one by one. Brown chooses to illustrate
the moment when the first brother hanging
dead from his chain, is released and buried in
a shallow grave in the dungeon. In pursuit of
Pre-Raphaelite truth to life, Brown arranged to
make this drawing from a real corpse, to lend
his composition accuracy. His friend John
Marshall was assistant surgeon at University
College Hospital in London and gained him
access to the corpses used there for surgical
instruction. The body, Brown recorded in his
diary on 13 March 1856,

> was in the vaults under the dissecting room.
> When I saw it first, what with the dim light,
> the brown and parchment like appearance of
> it and the shaven head, I took it for a wooden
> [s]imulation of the thing. Often as I have
> seen horrors I really did not remember how
> hideous the shell of a poor creature may
> remain when the substance contained is
> fled. Yet we both in our joy at the obtainment
> of what we sought declared it to be a lovely
> and splendid corps[e]. (Surtees 1981, p.167)

Brown and Marshall evidently fixed a rope to
the body and partly suspended it, to capture the
effect of a dead weight hanging from a chain,
as was to be shown in the finished illustration.
The mention in Brown's diary entry of the
vault, the dim light and colour of the corpse
are all reminiscent of Byron's description of the
subterranean dungeon in the poem. Brown
was a great admirer of Byron, and he had in
1843 been moved to make an oil of 'The
Prisoner of Chillon'. RU

Alfred Stevens (1817–1875)

115 *Study for the Wellington Memorial* c.1856
Red chalk on paper
34·6 × 59·8 (13⅝ × 23½)
Board of Trustees of the National Museums and
Galleries on Merseyside (Walker Art Gallery,
Liverpool)
❋

Stevens was an early Victorian artistic
polymath, equally adept at painting, drawing,
sculpture and design. Like his other work, his
decorative schemes were meticulously planned
and prepared, with equal care given to central
architectural features as to the minutiae of door
furniture. During 1840–2 he had trained in
Thorwaldsen's atelier in Rome, and was a gifted
sculptor, interested in the potential of dynamic
pose and surface. In 1856 Stevens scored the
great success of being selected to make the
monument to the Duke of Wellington in St
Paul's Cathedral. The central equestrian statue
remained unrealised for many years, but the
pair of bronze allegorical figure groups, *Valour
and Cowardice* and *Truth and Falsehood*, were
greatly admired for their inventiveness. The
drawing exhibited here is apparently related to
the first of these subjects, in which the figure
of Cowardice is crushed beneath a shield by
Valour. Stevens's abilities as a draughtsman are
clearly visible, and so too is his characteristic
fastidiousness. Positioning himself below his
subject to imitate the spectator's viewpoint
when looking up at the memorial, he has joined
several pieces of paper, suggesting that the
complicated and tiring pose may have been
created from different models or sittings.
More remarkable too is his écorché treatment
of different figure parts, looking into the body
so that the straining musculature is visible
and laid bare. RU

115
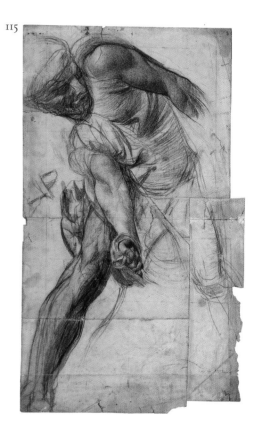

114
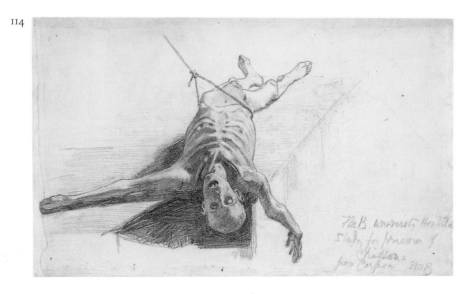

Edward John Poynter (1836–1919)

116 *Study for the mosaic of St George, Central Lobby,
Palace of Westminster* 10 August 1869
Black chalk, heightened with white on brown
paper, squared for transfer
40·6×30·5 (16×12)
The British Museum, London

✽

In 1847 the commission appointed to oversee
the decoration of the new Palace of Westminster
approved a scheme for embellishing the central
lobby with representations of the four patron
saints of the United Kingdom. However, the
project was not started until 1869 when Austen
Henry Layard (First Commissioner of the Board
of Works) asked Poynter to produce designs for
St George for England and *St David for Wales*,
both of which were executed in mosaic by the
Venetian firm of Salviati.

This study of St George was one of many
Poynter produced for the design in which he
analysed the constituent parts of the body and
armour with rigorous scrutiny. Based on a life-
model and perhaps also an écorché, the body
is examined in terms of its muscular structure
as if to demonstrate that a seemingly relaxed
contrapposto stance depends upon the
understanding of an underlying system of
complex anatomical configurations. The use of
white chalk helps to indicate the construction
of the body as well as to suggest the armoured
form of the final design, while the application
of a grid functions to contain these internal
and external formations within a rational
proportional system and to square the design
for transfer. AS

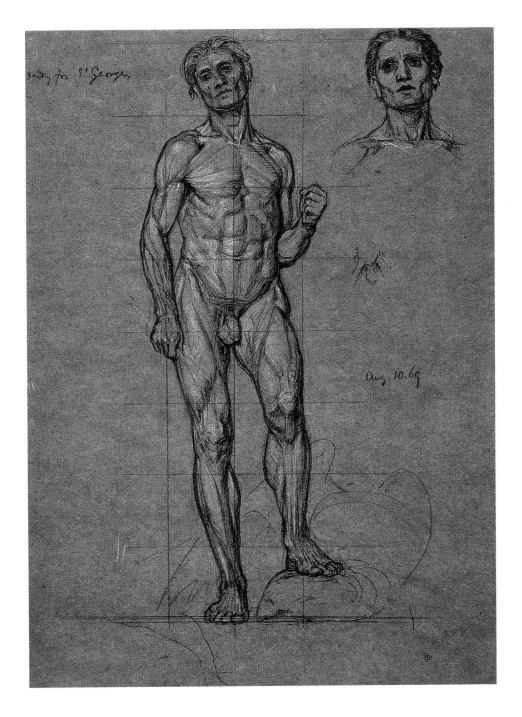

Edward John Poynter

117 *Study for the fresco of St Stephen at South Dulwich*
1872–3
Black chalk on white paper
27·8 × 42·8 (11 × 16⅞)
The British Museum, London
✱

Poynter's drawing of a man bending over to pick up a stone relates to the figure on the extreme right of the fresco depicting the martyrdom of St Stephen at South Dulwich (fig.33, see also no.40). Although the figure is shown truncated in the finished work, it is typical of Poynter's exacting compositional procedure that he should produce a study for the whole figure, demonstrating his authoritative knowledge of musculature as well as the underlying skeletal structure upon which the man's movement depends. A separate study for the left hand reaching out towards a rock indicates how Poynter adjusted the original hand position in realising his final conception of the figure.

Through a confident use of hatching and blending Poynter explores the bodily terrain emphasising points of depression, elevation and torsion. His concern to represent the figure as both machine and animate being relates to his admiration for Michelangelo, whose figure style he was later to defend against Ruskin's charge of anatomical excess (see Poynter 1879, Lecture IX). While this study can indeed be seen as a homage to High Renaissance principles of draughtsmanship, the finished fresco also shows the influence of the quattrocento artists Andrea Mantegna and Antonio Pollaiuolo whose over-wrought anatomies may have helped to determine the straining bodies and exaggerated expressions of Stephen's executioners. The repetition of poses in the martyrdom scene (the pose of this figure being a mirror-image of a man stooping to his left) was probably suggested by Pollaiuolo's *Martyrdom of St Sebastian* of 1475, purchased by the National Gallery in 1857. AS

Edward John Poynter

118 *Arm and drapery studies for 'Nausicaa and her Maidens Playing at Ball'*, inscribed 'Jan 8 79'
Red, white and black chalk on paper tinted pink
44·1 × 35 (17⅜ × 13¾)
The British Museum, London
✱

This elaborately prepared drawing was one of a number of studies Poynter executed in red chalk for the large decorative painting *Nausicaa and her Maidens Playing at Ball,* exhibited at the Royal Academy in 1879, one of four works commissioned by the Earl of Wharncliffe to adorn his billiard room at Wortley Hall near Sheffield (the paintings were destroyed in the Second World War). Public interest in the work increased when it became known that several fashionable women, including Lily Langtry and Lady Wharncliffe, had agreed to model for the figures (Inglis 1999, p.261).

The upper part of the sheet comprises five arm studies for the two women on the left of the finished painting who are represented steeping linen in a stream. Poynter presents a rotating sequence of arm positions not only to test out which were most appropriate for these figures, but also to investigate the structure of the limb on all sides. Black chalk is used to pick out the delicate veins and tendons exposed in the arm on the far left, in contrast to the adjacent limb where chalks are blended to create the effect of reflected lights in the shadow areas of protective skin. The graceful movement of each branch-like arm is echoed in the descending flow of drapery in the lower section of the composition. AS

117

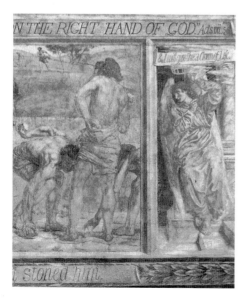

Fig.33
Edward John Poynter
1872–3
Fresco
St Stephen's, Dulwich
(detail)

Jan. 8. 79

Jan. 6. 79

Frederic Leighton (1830–1896)

119 *Figure Studies c.*1882
Black and white chalk on brown paper
27·3 × 26·8 (10³⁄₄ × 10¹⁄₂)
Royal Borough of Kensington & Chelsea,
Leighton House Museum

Frederic Leighton

120 *Study for 'Summer Slumber' c.*1893–4
Black and white chalk on brown paper
28·2 × 37 (11$\frac{1}{8}$ × 14$\frac{5}{8}$)
Royal Borough of Kensington & Chelsea,
Leighton House Museum

Frederic Leighton

121 *Draped Female Figure Study for 'Summer*
*Slumber' c.*1894
Black and white chalk on brown paper
91·4 × 148·6 (36 × 58$\frac{1}{2}$)
Royal Borough of Kensington & Chelsea,
Leighton House Museum
❋

This sequence of three drawings demonstrates
Leighton's use of a male model for a female
subject, its evolution and transmogrification.
The first sheet shows him experimenting with
a young male model, recording different
positions of legs and arms. In the second
drawing Leighton has settled the pose, but
transformed the boy into a woman, altering the
figure to a feminine ideal, and adding longer
hair. For the final study, Leighton has draped
the figure, as it was to appear in the finished oil,
Summer Slumber (c.1894). The practice of both
using a slender male for a female picture, and
initially working from the nude even for a
clothed subject was an established studio
practice which dated back to the Renaissance.
Leighton cared passionately about the correct
choice of model for his pictures, and he had
particular favourites. Dorothy Dene, an actress
with a slight, boyish figure, became almost an
obsession for him, perhaps because of her
combination of masculine and feminine traits.
RU

Frederic Leighton

123 *Study for 'Needless Alarms' c.*1886
Wax
53·3·22·5×15.9 (21×8⅞×6¼)
Tate. Presented by Charles Fairfax Murray 1913

Frederic Leighton

124 *Needless Alarms* 1886
Exh. RA 1886
Bronze
50·8×22·5×15·9 (20×8⅞×6¼)
Tate. Presented by Lady Aberconway 1940

✿

Leighton showed *Needless Alarms*, depicting a girl startled by a toad, at the Royal Academy in 1886, the same year he exhibited his much larger, but perhaps more conventional *The Sluggard*. Leighton's principal concern was to capture the gentle contours of the figure, in what is a challenging pose for a sculptor. In depicting a young girl it fitted into the growing interest in images of nude young people of both sexes and is also evidence of Leighton's preference for 'boyish' female models such as Dorothy Dene.

Although today the least known of Leighton's three 'ideal' sculptures, *Needless Alarms* was highly influential, and pieces as diverse as Alfred Gilbert's *Comedy and Tragedy* (*c.*1882) and Goscombe John's *Boy at Play* (1895, no.186) owe it a debt. Critical responses at the time of its Royal Academy showing were varied. The *Saturday Review* admired it but believed *The Sluggard* more successful (1886, p.883), while Leonora Lang in the *Art Journal* believed Leighton had 'never done anything more charming, or that appealed to a larger number' (1886, p.332). The market for statuettes was booming, and, perfect for a domestic interior, the work was issued in a series of bronze editions. The wax shown here, presented to the Tate Gallery by the painter Charles Fairfax Murray, was the original model for subsequent bronzes. Two original bronze versions were cast using the lost-wax method, which would have given a crisper, more vibrant surface. One of these was the cast shown at the Royal Academy, and acquired by Millais, but, along with the other retained by Leighton, both are now untraced. RU

123 124

George Frederic Watts (1817–1904)

125 *Sketch for 'Love and Life'* c.1882
Plaster
59×38×32 (23¹4×15×12⁵8)
Trustees of the Watts Gallery

❋

Like Leighton, Watts sometimes made small clay figures to help him resolve complex or large-scale picture compositions. He clearly valued the stimulus that the physical presence of such pieces, or a live model, brought to the creative process. Watts was also an enormously gifted sculptor, as pieces such as *Physical Energy* (1883–1904, Kensington Gardens) and *Clytie* (no.48) testify, works which were made independently of paintings.

The plaster sketch shown here of his famous oil *Love and Life* (no.145) seems to fall between these two categories. It is bigger than most 'composition casts', and more highly finished, but it is unknown if Watts intended it as a piece of sculpture in its own right. It is just possible it may have been intended for the lucrative statuette market, which as a version of one of Watts's most famous paintings would have made it particularly desirable. The arrangement of the figures is virtually identical to the painted composition, the principal difference being that Love lacks his wings, bends lower over Life, and has slightly more exuberant hair than in the picture. Where Life's forearm is missing the simple metal armature shows through, revealing the structure of the sculpture. In the 1870s Watts had discovered from the Italian sculptor Fabruzzi the advantages of the plaster technique 'gesso grosso'. This is a mixture of size, plaster powder and tow strands which dries very quickly and extremely hard, but can then be carved. It gave Watts the opportunity to develop the surface texture he valued so much, and also avoided aggravating the rheumatism that had plagued him when working with wet clay. RU

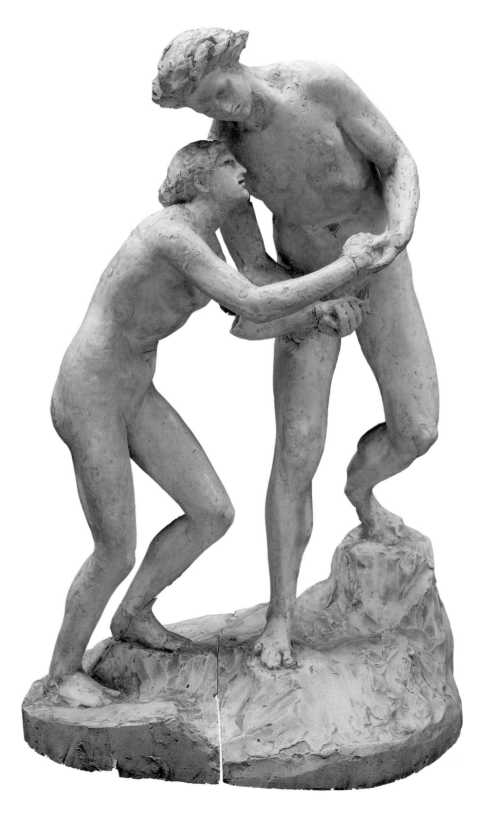

William Strang (1859–1921)

126 *Female Nude* 1884
Plaster
37 × 10 × 11 (14⅝ × 4 × 4⅜)
Bradford Art Galleries and Museums
✿

In the 1880s Strang was beginning to be
recognised as one of the outstanding etchers
of his generation. His prints were often of a
deliberately ambiguous or disturbing nature;
his 1882 nude etching *The Model*, for instance,
depicts himself and another man intensely
watching a sleeping girl on a bed in a shadowy
room. Made in 1884, *Female Nude* is Strang's
only known piece of sculpture, and like his
graphic work, uses the figure's pose for
symbolic suggestion. What motivated Strang to
make it is unclear, although the growing market
and lucrative returns for statuettes may have
been a factor. Alphonse Legros, Strang's teacher
at the Slade and afterwards his friend, was a
great advocate of the New Sculpture movement
bursting upon London in the 1880s and he may
have encouraged him to experiment in a new
medium. The plaster was presented to Bradford
Art Gallery by Strang's friend Ernest Sichel
(1862–1941) to commemorate Strang's death in
1921. Principally known for his still lifes, Sichel
also made statuettes and bibelots of subjects
such as sea nymphs, and it is possible he too
may perhaps have encouraged Strang to try his
hand at sculpture. RU

James Havard Thomas (1854–1921)

127 *Castagnettes No.2*, 1900
Bronze
33·7 × 26·7 × 13·5 (13¼ × 10½ × 5⅜)
Tate. Bequeathed by Dr Bluett Duncan 1934

✱

Principally a sculptor of figures, portrait busts
and reliefs, Havard Thomas was a pioneer in
the revival of ancient methods, particularly
the use of black wax in large-scale works. He
trained at the Royal College of Art and at the
École des Beaux-Arts in Paris under Cavelier,
and he spent the years 1889 to 1906 living in
Italy and working at a foundry near Naples.
As will be the subject of a forthcoming article
by David Getsy, Havard Thomas developed his
own scientific method for measuring the body
and each part in relation to the other. He saw
the human body as essentially a system, in
which each part and every movement affected
and inflected the others. This process was first
fully addressed in *Lycidas* (1902–8), but in
Castagnettes No.2 Havard Thomas explored the
potential of extreme movement. The subject
clearly fascinated him, and he made three
versions of *Castagnettes*, each slightly differently
posed, seeking to capture the vitality of rhythm
and movement. The subject may well have been
partly suggested by the famous ancient *Dancing
Faun* in the Uffizi Gallery in Florence, or the
bronze of the same title in the Museo Borbonico
in Naples, both of which Havard Thomas is
likely to have studied. However, the crouching,
highly complex, stance of Havard Thomas's
dancer is unique. Two drawings of a clothed
dancer with castanettes are in Havard Thomas's
papers in Tate Archive, but here the pose is far
more upright; however, they establish that he
clearly had models dance before him to record
their movement. The archive also includes
correspondence relating to Havard Thomas's
sale of a silver cast of *Castagnettes* for the
considerable sum of £400, although which
one of the trilogy is not specified. RU

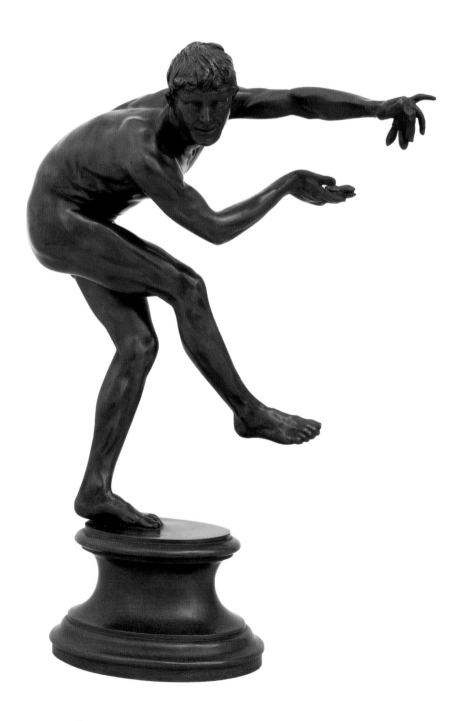

Harry Bates (1850–1899)

128 *Pandora* c.1890
Marble, ivory, bronze and gilt
94 × 50·8 × 73·7 (37 × 20 × 29)
Tate. Presented by the Trustees of the
Chantrey Bequest 1891

✿

Bates was one of the leading talents of the
so-called 'New Sculpture' movement who
sought to reinvigorate British sculpture
through the emotive potential of surface, pose
and serious subject-matter. In *Pandora*, Bates
accentuates the nakedness of the figure with
soft, sensuous curving and gentle flowing
lines; the rich decoration and materials of the
box serving to emphasise the simplicity and
naturalism of the figure. The pose is an
adaptation of a classical precedent, the much-
copied and illustrated *Crouching Venus* in the
Uffizi Gallery in Florence. Emphasising the
mood of consideration and temptation, Pandora
is shown in a crucial moment of hesitation, her
finger on the clasp of the box, which she will
open and release all of the ills of the world. In
many ways Pandora is a mythical figure parallel
to Eve, whose biting of the forbidden apple
led to man's fall. Pandora was the first mortal
woman, whom Zeus decreed should be
beautiful but also foolhardy. Formed from clay,
she was imbued by each of the gods with
different attributes of character and body, a
creation story that has affinities with that of
Pygmalion's Galatea. Bates has shown a
detailed account of her creation in the scenes
carved on the ivory box and he may have
intended parallels with the role of the sculptor,
creating a perfect, lifelike form from inert raw
materials. The desire to create life alone, in a
rejection of sex and nature, seems to mirror
male anxieties about woman and reproduction.
In the nineteenth century Pandora was used in
art and literature as an archetype for ambivalent
feelings of fear of women and feminine blame
(see Warner 1985, ch.10). Certainly the story
of Pandora's creation was suited to the
relationship of a sculptor to his work. RU

George Frederic Watts (1817–1904)

129 *The Wife of Pygmalion, A Translation from the Greek* 1868
Exh. RA 1868
Oil on canvas
67.3×53.3 (26½×21)
The Faringdon Collection Trust, Buscot Park, Oxfordshire

✳

In 1867, Watts visited the Ashmolean Museum, Oxford, with the archaeologist Sir Charles Newton to view the Arundel Marbles. It was here that he alighted upon a bust comprising two fragments of a head and torso which had been pieced together in the seventeenth century to form a bust that was titled *Sappho*. Together, they decided that the bust was a portrait and assigned it the title *Aspasia*, a specific reference to the mistress of Pericles. Watts subsequently had a cast made of this sculpture, which was to remain in his studio as a source of inspiration. In painting *The Wife of Pygmalion*, Watts set out to demonstrate the correspondence he believed existed between classical Greek sculpture and Venetian Renaissance painting. While the form possesses the solidity and restraint of the Phidian ideal, the subtle modulations of colour and the compositional formula bear homage to Venetian painting, a combination of features which can also be seen in Watts's other half-length figures of the 1860s, *The Wife of Plutus* (no.64), *Rhodophis* and *Clytie*. The word 'translation' in the title thus intends an aim beyond archaeological restoration, suggesting an aesthetic concern to see one medium transposed into another. In particular, Watts was attempting to revive and fuse the way Greek sculptors used drapery to reveal underlying form, together with the partial-clothing of the figure seen in Venetian pictures of beloved women. In so doing he was inviting comparison with both Apelles and Titian, the latter having himself attempted a re-creation of the Greek painter's lost Aphrodite with his *Venus Anadyomene* of around 1520, in the Sutherland Collection.

In 1868 William Morris published his poetic version of the Pygmalion and Galatea myth, and Burne-Jones began the first of his two series of pictures based on Morris's poem (nos.130–33). With this conceptual fusion of marble, paint and flesh, Watts presents his own personal incarnation of Galatea without resorting to action or narrative. The painting was exhibited at the Royal Academy in 1868 where it was seen by Gladstone, who wrote to Watts in the hope of purchasing the work only to discover that it was already claimed by another Liberal MP, the collector Eustace Smith (Watts 1912, I, p.237).
AS

Edward Coley Burne-Jones (1833–1898)

130 *Pygmalion and the Image: The Heart Desires* 1875
Exh. GG 1879
Oil on canvas
99 × 76·3 (39 × 30)
Birmingham Museums & Art Gallery

Edward Coley Burne-Jones

131 *Pygmalion and the Image: The Hand Refrains*
c.1868
Exh. GG 1879
Oil on canvas
99 × 76·3 (39 × 30)
Birmingham Museums & Art Gallery

Edward Coley Burne-Jones

132 *Pygmalion and the Image: The Godhead Fires*
1875–8
Exh. GG 1879
Oil on canvas
99 × 76·3 (39 × 30)
Birmingham Museums & Art Gallery

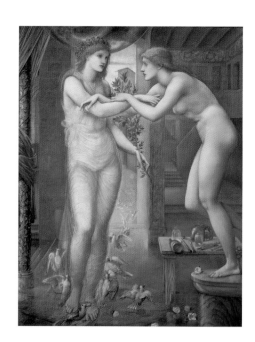

Edward Coley Burne-Jones

133 *Pygmalion and the Image: The Soul Attains*
1868–78
Exh. GG 1879
Oil on canvas
99×76·3 (39×30)
Birmingham Museums & Art Gallery
❀

Burne-Jones first treated the story of Pygmalion in 1867 in a sequence of drawings for a proposed, but never published, illustrated edition of William Morris's *The Earthly Paradise*. This epic cycle of Morris's verses included his short poem 'Pygmalion and the Image', which closely followed Ovid's story. In 1868 Burne-Jones started his first series of paintings of the story, distilling the narrative into four scenes. These were produced for Euphrosyne Cassavetti, the mother of Maria Zambaco, a beautiful young Greek sculptress with whom Burne-Jones had fallen passionately in love. Clearly fascinated by the story of Pygmalion, Burne-Jones made the second series of larger canvases exhibited here between 1875 and 1878. In both series he was exploring the creative power of physical desire, a state which enabled Pygmalion to make his perfect statue and Burne-Jones, in his years as Maria's lover, to produce his most original works. A study for *Galatea* dated 1870 (pencil, repr. Birmingham 1995, fig.98) is clearly Maria Zambaco's face, testimony to Burne-Jones's obsession with her and the connection in his mind with Pygmalion's love for his creation's perfection. In both painting cycles Burne-Jones diluted any resemblance to Maria.

In some ways tackling the topic of the abstraction of art from life, the pictures also contrast the construction of an aesthetic ideal with the more overwhelming forces of physical passion and compulsion. In Malcolm Bell's book about Burne-Jones, published during the artist's lifetime and with his apparent input, he described each of the pictures: 'The first … is the idealisation of unsatisfied longing for the unknown … A sculptured group of the three graces … typifies the cold beauty of artifice' (1892, p.85). Through the doorway Burne-Jones shows two of the Cypriot women, whose lasciviousness Pygmalion despised. In *The Hand Refrains* Pygmalion stands in wonder before his creation, but is also evidently disturbed, perhaps because of the deep feelings his statue stirs within him. While Pygmalion is away praying for his figure to be made real, Venus descends to his studio and breathes life into Galatea, whose stance as she moves from the pedestal suggests the difficult first steps of a new creature. In the final scene, *The Soul Attains*, 'heart and soul are satisfied', Bell wrote (1892, p.96). Yet there seems some atmosphere of failure or disjunction here. Galatea looks abstractedly past Pygmalion, her face impassive and unmoved, and she does not appear to respond with any warmth of feeling to the sculptor's touch; their eyes do not meet. The rose of love lies abandoned on the floor between them, perhaps suggesting a destructive outcome, as Burne-Jones had experienced in the wake of his affair with Maria Zambaco.

The pictures were exhibited at the Grosvenor Gallery in 1879. Critical opinion was generally positive, the *Art Journal* writing that although Burne-Jones 'must be studied from his own standpoint, and by his own canons … We can scarcely imagine the story of Pygmalion being told more beautifully, and the canvas on which we see Venus imparting to Galatea the gift of life is worthy of Raphael' (July 1879, p.135). RU

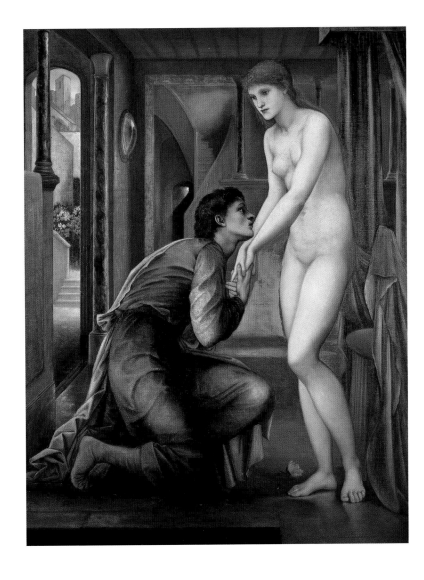

203

John Tenniel (1820–1914)

134 *Pygmalion and the Image* 1878
Exh. IPW 1878
Watercolour on paper
58·4 × 36·5 (23 × 14⅜)
Victoria & Albert Museum, London

✴

Tenniel was one of the best known and
successful illustrators of Victorian Britain.
He contributed hundreds of social and
political satires to *Punch*, and earned lasting
public fame with his illustrations to Lewis
Carroll's *Alice's Adventures in Wonderland*.
Like Cruikshank before him, however, Tenniel
hungered to be seen as more than an illustrator
and to be recognised as capable of making
high art. He sent a number of works to the
Royal Academy and the Institute of Painters in
Watercolours but it was very difficult to break
down how he was perceived, and in truth such
works attracted little critical attention, nor
were they as financially lucrative as his
illustrations. Tenniel's *Pygmalion* shows off
his great skills of draughtsmanship and
composition, and was made at the height of
contemporary obsession with Ovid's story,
and its literary, dramatic and artistic
spin-offs. Pygmalion grasps Galatea tightly
just as Ovid describes, but Tenniel shows her
coming to life under his touch, her now rosy
flesh warmed by the shaft of sunlight bursting
into the studio. This was a relatively sensual
treatment of the story, as it involved physical
contact. In the background is a vast head of
Zeus, evidently copied from one of the many
illustrated re-creations of his great throned
statue at the temple at Olympia published in
the nineteenth century. RU

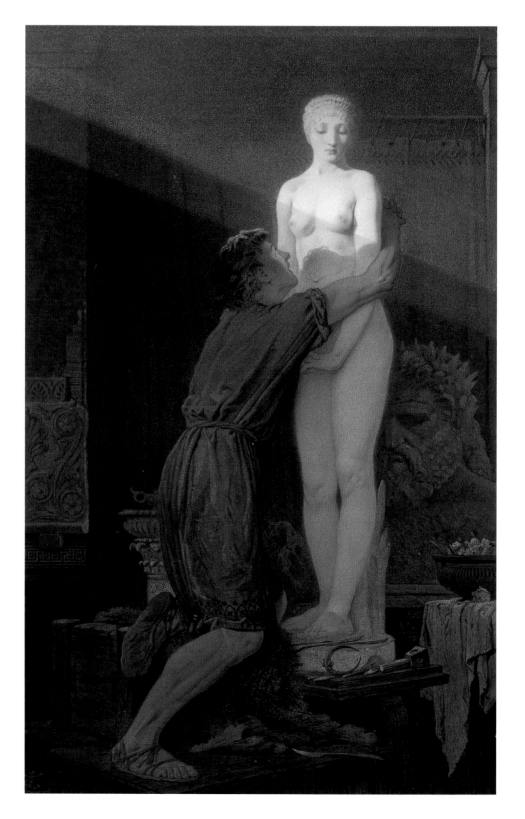

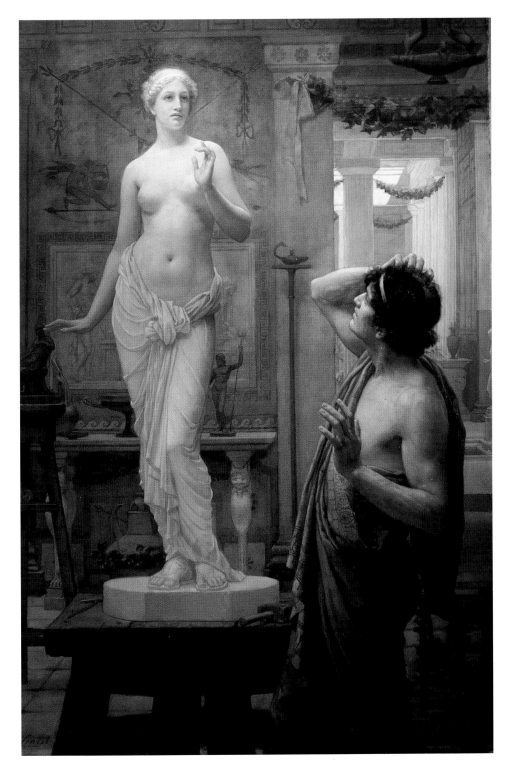

Ernest Normand (1857–1923)

135 *Pygmalion and Galatea* 1886
Exh. RA 1886
Oil on canvas
152·5 × 121 (60 × 47⅝)
Atkinson Art Gallery, Southport Arts & Cultural
Services, Sefton M.B.C.
✳

Normand's portrayal of the Pygmalion story took the precaution of recreating a suitable pseudo-archeological classical setting in the manner of Alma-Tadema. Nevertheless, his lifelike treatment of the nude, and the tangible warmth of her flesh made it somewhat risqué and potentially open to criticism, exhibited so close to John Callcott Horsley's infamous attack on the probity of the nude as subject. Pygmalion gazes up awe-struck as he discovers Galatea coming to life in his studio. The upper half of her body is already flesh, as her rosy lips, nipples and fingers indicate, while the transformation into life is incomplete below her waist, and her feet are still cold marble. Interestingly, Normand has based Galatea on the famous *Venus de Milo*, but, necessarily, has reconstituted it to its complete state by adding arms. This was no mere witticism, as there was considerable contemporary discussion of the statue's date and complete state, and Normand has considered carefully and convincingly the likely position of the arms. The *Venus de Milo* was widely available at the time as a plaster statuette but Normand would have been able to see the original in the Louvre during his honeymoon in Paris in 1884. Normand has also copied the sculpture's exaggeratedly elongated physical proportions, the original standing over six feet in height. Galatea's blond hair and pale complexion are clearly not Mediterranean, as logically they should be, and Normand may have mirrored unwholesome contemporary beliefs about the perfection of this racial type. However, Galatea also bears some slight facial resemblance to Normand's wife, Henrietta Rae (1858–1928), also a painter of nudes, and this picture may therefore be a tribute to her, casting her as both Venus and Galatea. RU

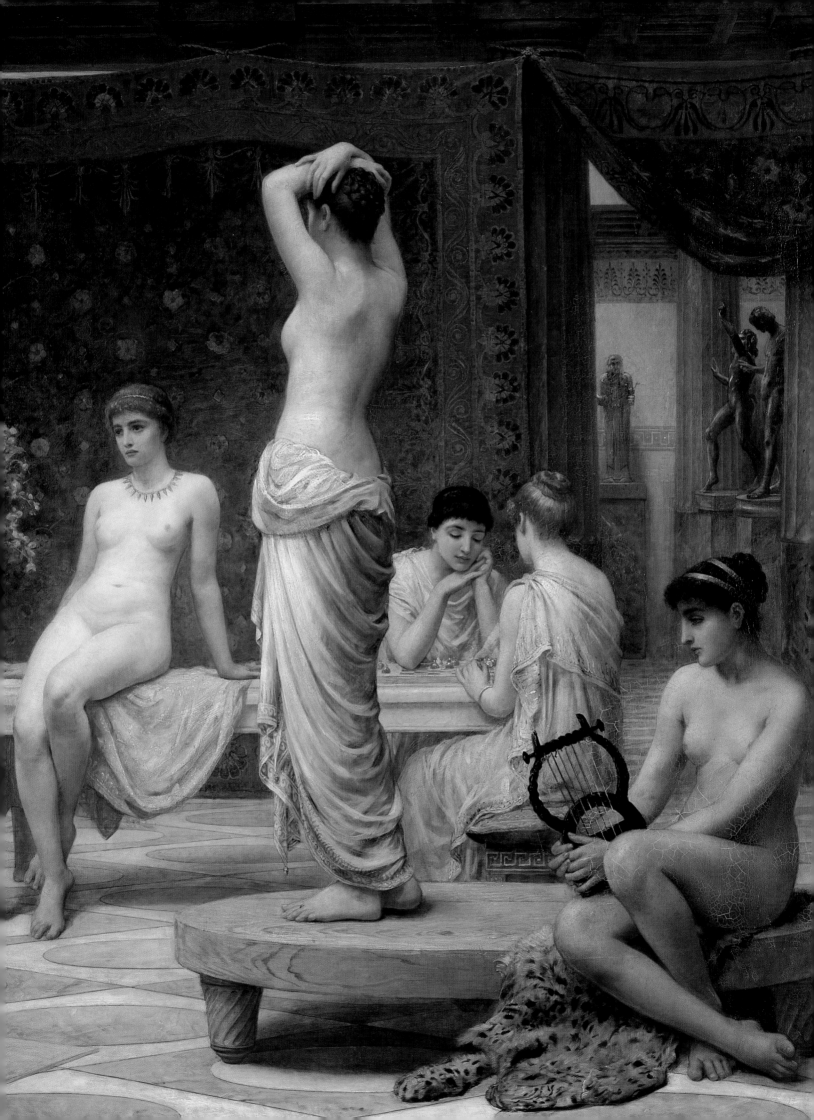

Edwin Long (1829–1891)

136 *The Chosen Five* 1885
Exh. LG 1885
Oil on canvas
152·4×243·8 (60×96)
Russell-Cotes Museum & Art Gallery,
Bournemouth

✽

Long took as his subject a story told by Cicero about the ancient Greek painter Zeuxis, commissioned by the people of Crotona to paint a picture of Helen of Troy for their newly built temple. Reputedly the most beautiful woman in the world, Helen was the apotheosis of perfection. Zeuxis knew he could never find one model alone who could do the subject justice, so he selected five, each representing a different aspect of physical beauty. As Cicero relates: 'he knew he could find no single form possessing all the characteristics of perfect beauty, which impartial Nature distributes among her children, accompanying each charm with a defect, that she may not be at a loss what to give the rest by lavishing all she has to afford one' (*De Inventione*, II.iii). This practical solution was a paradigm of modern studio practice, and Long shows Zeuxis calmly making drawings to build up his composite ideal.

Long was already a successful artist, whose *Babylonian Marriage Market* (1875) had changed hands in 1882 for the vast sum of £6,615. The Lawrence Gallery in Bond Street exhibited *The Chosen Five* in 1885 alongside its companion, *The Search for Beauty*, which depicted Zeuxis selecting his models. People visited this exhibition in large numbers, paying a shilling entrance, a considerable fee that may have been intentionally designed to ensure a 'respectable' audience. A large mixed-method engraving was published of each of the pictures by Fairless & Beeforth, a recognition of its commercial potential. Critical comment too was extremely positive. Long had taken what could easily have been a prurient scene and treated it with detachment and dignity as a depiction of serious studio practice, something most reviewers commented upon. The women have a statuesque quality, and Long allowed himself little painterly sensuousness in technique. The critic of the *World* wrote: 'the academic atmosphere throws, as it were, a veil over those undisguised humanities which should, I think, tend to keep them pure in the mind of Mrs Boyn from the category of "hussies" ', while the *Standard* praised 'the interest of Zeuxis buckling seriously to the task, minutely observant, as only the trained eye can be, of every excellent or characteristic contour, and the steadiness of the model is well expressed, and the pose of the girl who looks from behind, and leans back, half reclining as she looks, has a singular grace and charm. The painting, too, is of brilliant and solid quality. There is a large public whom these canvases may rightly fascinate' (quoted 'Anno Domini', exh. cat., Lawrence Gallery, 1885). Long lent the subject further seriousness by painting a quasi-archaeological vision of the Greek painter's studio. In the background are classical statues which include the famous *Dancing Faun*.

The picture's subject of the composite achievement of perfection held resonance for the contemporary obsession with eugenics. Francis Galton (1822–1911) had proposed in *Hereditary Genius* (1868) and *Inquiries into Human Faculty* (1882) that controlled selective human breeding could produce a perfect race of superhumans, and underpinned negative views of different races' abilities and weaknesses (see p.186). Theories about human selective breeding were not however new, and can be traced back to ancient Greece itself, being mentioned in Plato's *Republic*. RU

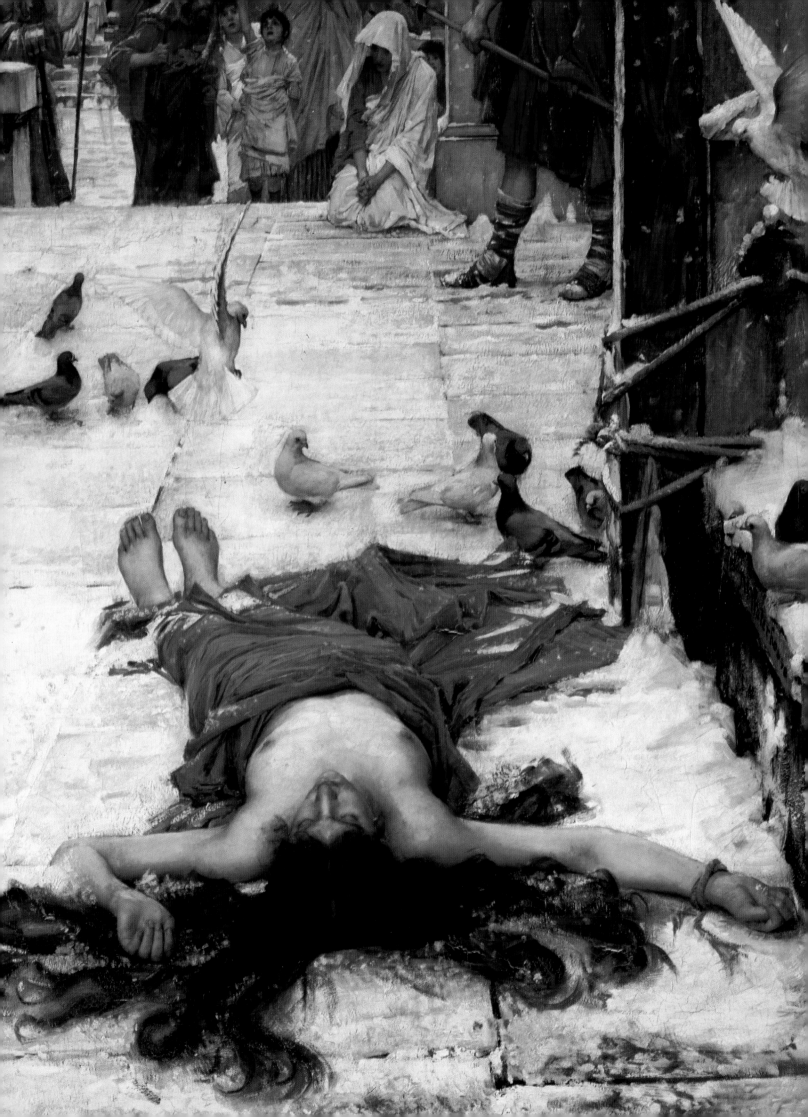

Here is a word, the 'nude', which conveys the most different ideas to the clergyman, the middle-class respectable provincial woman, and the artist who has passed through the schools. The first sees it as a falling off from ecclesiastical civilisation ... and a return to a kind of paganism; the second sees only a shameless immodesty; whilst to the third, the artist, the word 'nude' conveys simply the idea of discipline in study, as the word 'grammar' does to a scholar, or 'dissection' to a physiologist. (Hamerton 1892, p.33)

The polarisation of attitudes towards the nude noted by P.G. Hamerton in 1892 owed much to the ways in which the subject became sensationalised in the later Victorian period. History painting remained the most conspicuous opportunity for the nude, but the body was now represented with unprecedented daring, shown in states of subjection, exertion and arousal, and on a spectacular scale. A greater eclecticism in subject-matter, with Roman, Oriental, Christian and allegorical themes expanding the traditional repertoire of Greek motifs, encouraged artists to explore sensual and sadistic treatments of the nude, testing the boundaries of what was permissible in high art without actually transgressing into the area of explicit violence or sexuality. The rise of the 'sensational' nude was associated with the decline of academic-ethical theories of the nude and with a renewed emphasis on paganism (as Hamerton's clergyman feared), or a pantheistic equation between the body and the natural realm. With the rise of scientific and sociological perspectives on the body, many artists used the nude to explore theories of human evolution and racial difference. The artistic nude thus came to be recruited in support of a variety of competing views of the body, giving it currency and meaning beyond the specialist vocabulary of the art world.

This greater spirit of adventure with the nude can partly be attributed to the transmission of French methods via the Parisian ateliers run by successful Salon painters. These attracted large numbers of British students in the 1870s and 1880s, mainly because the Continental system placed particular emphasis on study from the living model. Many of the artists who trained in France, more of whom, remarkably, came from well-to-do backgrounds than had been usual for artists, went on to establish reputations at home as professional painters of the nude. In this they were supported by a wealthy élite who patronised the Royal Academy and Grosvenor Gallery exhibitions, as well as by the broader audiences nurtured by the new municipal galleries. The Chantrey Bequest which came into effect in 1877 was also significant in securing important nude works for the national collection: these were displayed initially at South Kensington and after 1897 at the National Gallery of British Art on Millbank (the Tate Gallery). The expansion of new photo-mechanical reproductive technologies for painting, as well as the growth in the market for affordable sculptural reproductions, further assisted in relaying images of the undraped figure to a wider constituency, signalling a greater acceptance of the subject in the public domain.

However, the publicity accorded the nude also invited opposition, particularly on the part of religious and moral groups who perceived the subject as a corrupting influence. Some of their objections were taken up from within the main art institutions, from conservative factions anxious to protect the British school from 'contaminating' French influences and from the supposed threat presented by female painters of the nude. The outbreak of a number of related moral panics in the mid-1880s centring on the victimisation of children, adolescents and women by abusive men led to the nude being targeted as an instrument of vice and exploitation, especially subjects represented by female artists or those that were seen to expose the model unduly. However, the politicisation of the nude provoked by the demand for regulation and censorship did little to halt its visibility in public. Rather the scandal and publicity granted the subject by both opponents and the media, helped generate audience curiosity and with it a general tolerance for the nude in the face of what was dismissed as 'philistine' opinion. AS

Overleaf:
John William
Waterhouse
Saint Eulalia 1885
(no.149, detail)

Ernest Normand
Bondage c. 1895
(no.152, detail)

210

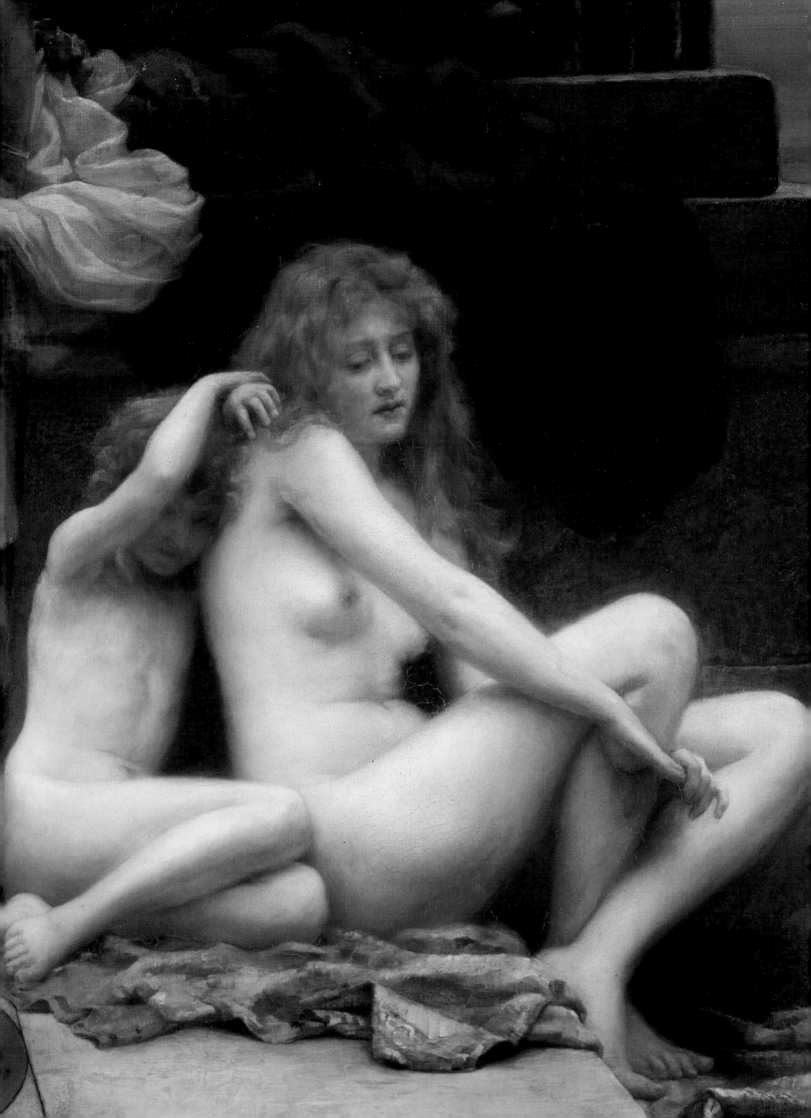

Evelyn De Morgan (née Pickering, 1855–1919)

137 *Cadmus and Harmonia* 1877
　　Exh. DG 1877
　　Oil on canvas
　　102·3 × 43·8 (40¼ × 17¼)
　　The De Morgan Foundation
　　✳

Cadmus and Harmonia was one of the first
nudes painted by a woman to appear in public,
and it was on the basis of this daring
submission to the Dudley Gallery that Evelyn
Pickering was invited to participate in the
inaugural Grosvenor Gallery exhibition in 1877.
Pickering trained under Poynter at the Slade,
leaving the school in 1875 to pursue a separate
course of study in Italy. *Cadmus and Harmonia*
was painted upon her return to London, ten
years before her marriage to the ceramicist
William De Morgan, when she was beginning
to establish herself as an independent woman.
The picture reveals a precocious interest in
Italian Renaissance culture: the figure of
Harmonia adapted from Botticelli's *The Birth
of Venus*, the landscape reminiscent of the
landscapes seen in quattrocento painting, while
the subject itself is based on an obscure story
from Ovid's *Metamorphoses*, an important
pretext for the nude in the Renaissance.
Pickering shows Cadmus, transformed into a
serpent while recalling a past exploit,
desperately trying to communicate with his
wife Harmonia. The painting was exhibited
accompanied by the following lines from Ovid:
'With lambent tongue he kissed her patient
face, | Crept in her bosom as his dwelling place,
| Entwined her neck, and shared the loved
embrace.' Anxious not to lose her husband,
Harmonia was also turned into a snake and the
couple remained together as benign creatures
remembering their former status. Ironically
the painting entered the collection of the
Conservative MP Sir Charles Dilke, whose
lack of marital fidelity was well publicised.

　　Cadmus and Harmonia was exhibited in the
same year that Leighton's *An Athlete Wrestling
with a Python* was shown at the Academy
(no.153). From this point onwards the
interaction of reptilian and human flesh was
to become a popular motif in sensational nude
subjects, and was used either to represent the
limits of physical endurance or, as was the
case here, to open up new psycho-sexual
perspectives on the body. AS

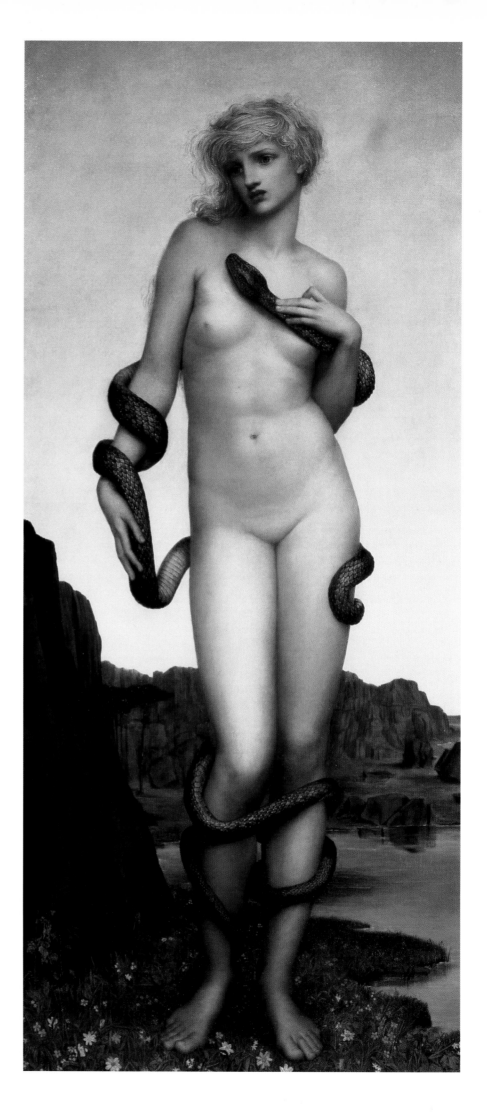

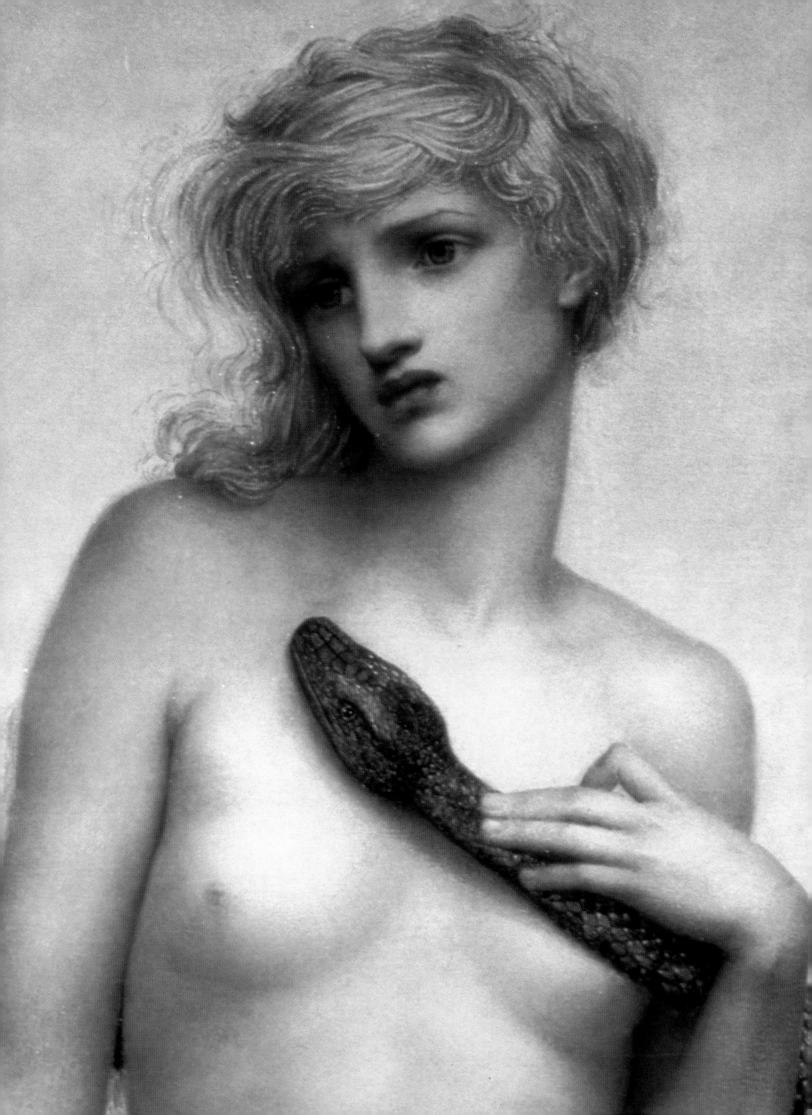

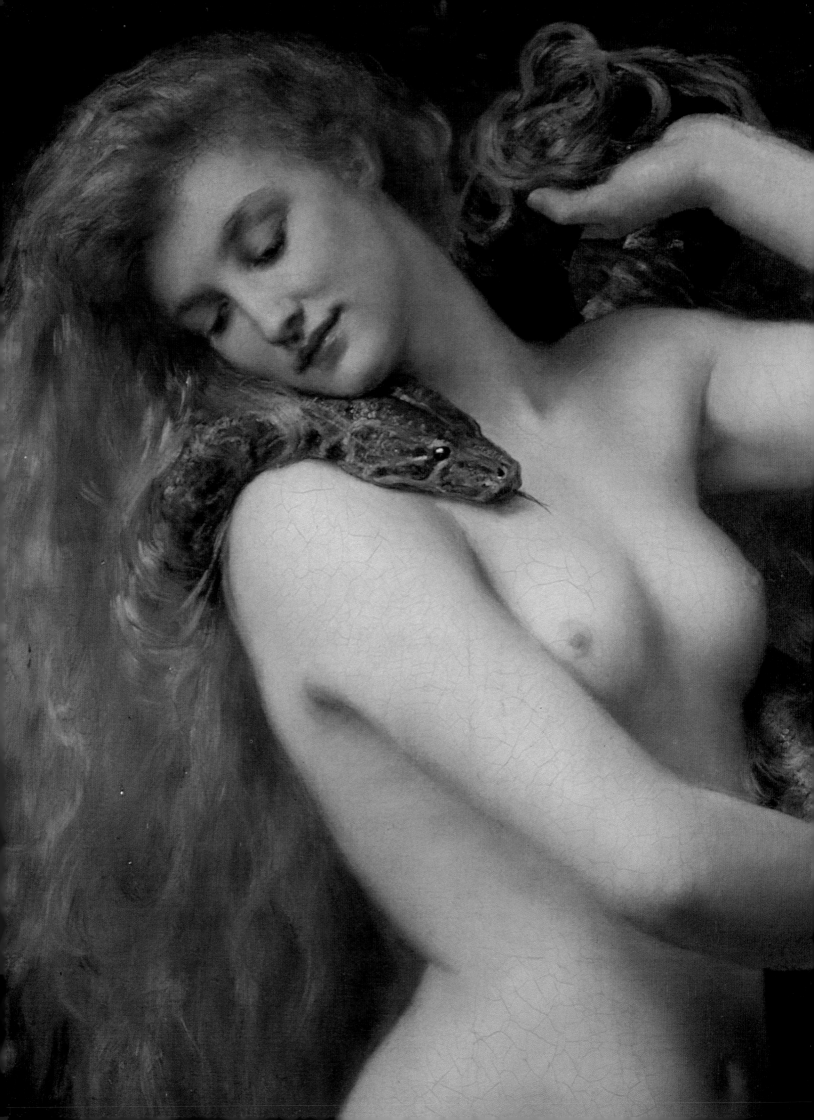

John Collier (1850–1934)

138 *Lilith* 1887
Exh. GG 1887
Oil on canvas
200×104 (78¾×41)
Atkinson Art Gallery, Southport. Arts &
Cultural Services, Sefton M.B.C.

✿

John Collier was the younger son of Judge
Robert Porrett Collier (later made Lord
Monkswell), an amateur painter who
encouraged his son to pursue painting as a
profession. Educated in Heidelberg, at the
Slade under Poynter, then in Paris with J.P.
Laurens and later in Munich, Collier rounded
off his training by observing (on his father's
recommendation) Alma-Tadema at work on
his sensational *A Sculptor's Model* (see fig.22).

Collier's cosmopolitan background instilled
in him a technical proficiency and confidence
(conservation of *Lilith* in 1996 proved just how
sound his method was). A year before *Lilith*
was exhibited, Collier published *A Manual
of Oil Painting* in which he emphasised the
importance of observation while maintaining
ideality in art. He was particularly adamant that
a picture should 'look real' and recommended
the Parisian principle of establishing truth in
tint and texture so that flesh appeared 'fleshy':
'The human figure is covered with little hairs,
too minute to be seen separately ... but
sufficiently visible to render the outlines soft
and blurred' (1903, pp.33–4). *Lilith* puts this
theory into practice: the soft texture of the
woman's skin is set off by the scaly coils of a
serpent carefully studied from snakes in the
Zoological Gardens in London.

In selecting the subject of Lilith, Collier
may have been thinking of Flaubert's novel
Salammbô of 1862, with its magnetic
description of heroine and serpent. But a more
specific source for *Lilith* itself was D.G.
Rossetti's sonnets 'Eden Bower' and 'Body's
Beauty', the latter composed by the artist to
accompany his painting *Lady Lilith* of 1864–8.
The fascination of Lilith for Rossetti resided in
her legendary malignancy and amorality:
according to Talmudic myth she was the first
wife of Adam, who abandoned her partner after
he denied her equality, and as a demon vowed
vengeance on her successor Eve by murdering
children and pregnant women. Collier
represents Lilith addressing her lover, the
serpent, whose form she wished to assume in
order to re-enter Eden and wreak destruction.
For Rossetti and his circle Lilith was the
archetypal femme fatale as well as the first
independent-minded woman, qualities which
gave her contemporary relevance as the original
advocate of women's rights. In 1883 Frederick
Leyland, the owner of Rossetti's *Lady Lilith*, lent
the picture to the first public exhibition of the
artist's work at the Burlington Fine Arts Club,
and the subject became immediately pertinent
for a generation for whom the term 'New
Woman' had become a political reality.
Disregarding the painterly treatment and
complex symbolism used by Rossetti, Collier's
Lilith appears modern, real and alluring: 'it
cannot be said of her "Not a drop of her blood is

human"', wrote the *Magazine of Art* (1887,
p.344), alluding to Rossetti's 'Eden Bower'.

Collier worked on the painting in 1887 when
his wife Marian, daughter of the scientist T.H.
Huxley and also a 'New Woman' as a painter of
the nude, was pregnant with their first child.
Although Collier was a convinced Rationalist,
it must surely have struck him as a cruel irony
when Marian died on 18 November, following
a long illness and after giving birth to a
daughter. AS

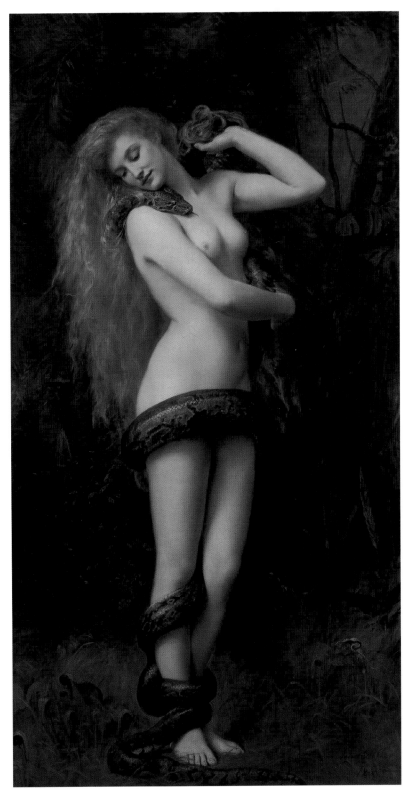

John Collier

139 *In the Venusberg* 1901
Exh. RA 1901, Manchester 1901
Oil on canvas
243 × 168 (95⅝ × 66⅛)
Atkinson Art Gallery, Southport. Arts &
Cultural Services, Sefton M.B.C.

The Germanic legend of Venus and Tannhäuser
was probably known to Collier from his days
as a student in Heidelberg when he served as
a fighting member of the Schwaben corps.
This chivalric subject of servitude to ideal
womanhood would have had a wide resonance
at a time when a knightly code of conduct was
seen to instil discipline and sexual restraint
in men.

The medieval hero Tannhäuser chose to
abandon his aspiration towards religious
salvation when the Pope refused to grant
absolution for his life of pleasure in the
Venusberg unless a miracle could convince
him otherwise. Collier depicts the moment
when Tannhäuser returns to the enclave of
the goddess to resume an existence of sensual
delight. Collier was no doubt familiar with
Swinburne's poem 'Laus Veneris', published in
Poems and Ballads in 1866, and Burne-Jones's
painting of the same title exhibited at the
Grosvenor Gallery in 1878, both of which
convey the enervation of being trapped in a
realm of sterile beauty. Through strikingly
different methods Collier's image captures a
similar sense of ennui as Venus languidly raises
a crown of vine-leaves and roses, guarded by
an attendant who looks listlessly away
indifferent to the knight's act of supplication.

As a Rationalist, Collier clearly had no
scruples in basing his subject on a *sacra
conversazione*, enshrining Venus in place of the
Madonna, and substituting a pagan nude for a
saint. By divesting the scene of any sense of
mystery, he abides by the method set out in his
Manual of Oil Painting: the verisimilitude of the
flesh tones attained by emphasising external
observation above what he termed 'misplaced
anatomical knowledge' (1903, p.35). In the
words of Frank Rinder, this is 'essentially a
scholarly production', the carpet derived from
Giorgione's *Castelfranco Altarpiece*, the palisade
based on Florentine Renaissance examples,
the cypresses reminiscent of Verrocchio and
Lorenzo di Credi (*Art Journal* 1901, p.165).
Such a 'scholarly' approach perfectly suits the
aridity of the story. AS

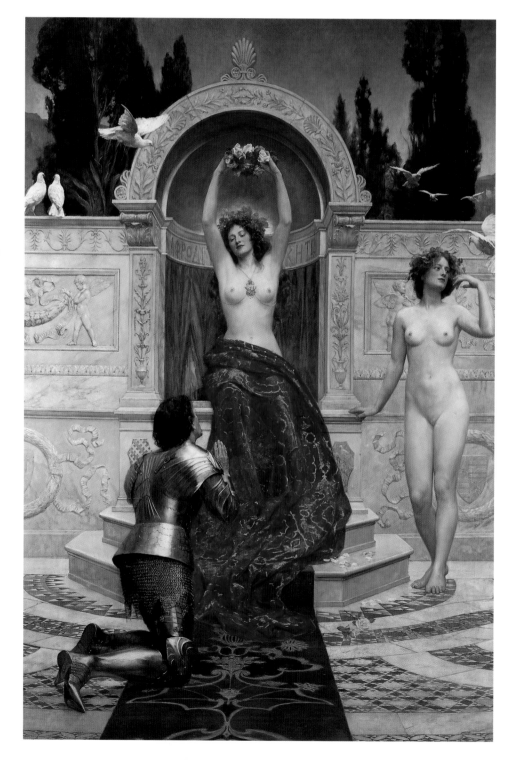

Herbert Draper (1863–1920)

140 *The Lament for Icarus* 1898
Exh. RA 1898
Oil on canvas
182·9 × 155·6 (72 × 61¼)
Tate. Presented by the Trustees of the Chantrey
Bequest 1898

✿

Primarily a painter of mythological marine
subjects, Draper is often regarded as a
successor to Leighton more by virtue of his
consummate technique than his subject-matter.
Trained at the Royal Academy and at the
Académie Julian in Paris where he worked
under Boulanger (no.60) and Lefèbvre, he
was awarded a Gold Medal and travelling
scholarship by the Royal Academy in 1889
which enabled him to continue his studies in
Europe before completing his education in
Rome.

 The Lament for Icarus, with its liquid light
effects and mastery of form, provides testimony
to Draper's Continental allegiances. The
painting is an imaginative adaptation of the
Icarus legend which had become a popular
pretext for the representation of ephebic beauty
following the exhibition of Leighton's *Daedalus
and Icarus* in 1869 (no.37). The body of Icarus
is shown draped almost languidly on his
wings and attended by three sea nymphs who,
overawed at this image of physical perfection,
are shown lamenting his death. The theme of
transience is reiterated by the symbols of the
lyre and wreath, and through the passage of
sunlight which casts an iridescent glow on
distant cliffs. In developing the composition
Draper adopted Leighton's method of making
separate figure studies for which he employed
four youthful models – Ethel Gurden, Ethel
Warwick, Florence Bird and Luigi di Luca – all
of whom were Academy professionals.
Although Draper abided by the persistent
studio convention of posing male and female
models separately, by the late nineteenth
century audiences had come to accept the
frankly erotic interaction of those models on
the canvas, so much so that it was now possible
to place the male nude under the desiring
female gaze. Indeed, so worthy was the work
considered when exhibited at the Academy in
1898 that it was purchased by the Chantrey
Bequest on behalf of the nation.

 The Lament for Icarus may have been
conceived a tribute to Leighton who had died in
1896, but as Simon Toll has recently suggested,
it may also be a more private statement of loss,
following the death of Draper's father in 1898
(Toll 2001). The use of the male body as a
vehicle for the projection of subjective emotion
is a characteristic of late-Victorian painting and
sculpture, and here the rippling wings and
drapery gently caress the surface of a body that
appears to melt within the arms of the nymph,
accentuating the theme of human mutability.
AS

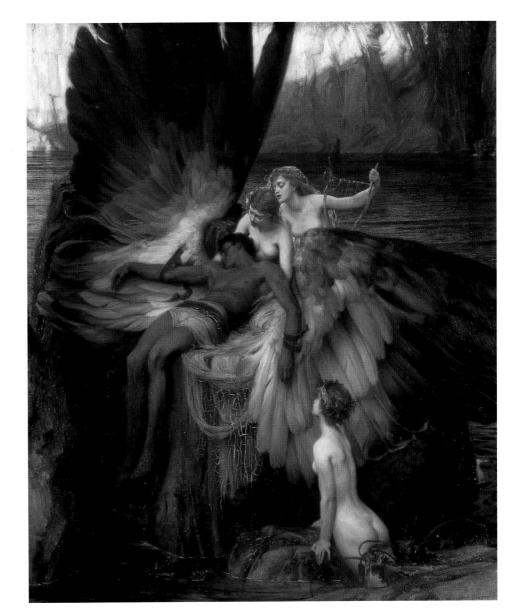

Herbert Draper

141 *The Gates of Dawn* 1900
 Exh. RA 1900
 Oil on canvas
 194 × 106 (76³⁄₈ × 41³⁄₄)
 The Drapers' Company of the City of London
 ✻

This resplendent image of Aurora opening the
gilded portals of dawn, adorned with emblems
of Apollo and the planets, to proclaim a new
century, is an ambitious fusion of natural
observation with Symbolist suggestiveness.
Draper himself identified the figure as Aurora
or Eos, and his depiction of her certainly
accords with Homer's description of dawn as
'rosy fingered', as well as with the following
line from Ovid's *Metamorphoses*: 'far in the
crimsoning east wakeful Dawn threw wide
the shining doors of her rosefilled chambers.'

 The seductive allure of Aurora is achieved
by a radiant combination of crimson, purple
and golden hues, together with the heavy
spread of drapes and roses at her feet, features
reminiscent of Leighton's *Helios and Rhodos*,
the sensation of the Academy back in 1869.
The roses and bindweed flowers that adorn
the goddess's hair have been interpreted as
symbols of Aurora's obsessive and inexorable
passion for young men; at the same time these
features connect her with the cycle of death and
rebirth which forms the presiding theme of
the painting.

 Draper presents Aurora as a decidedly
modern woman with lithe limbs and
triumphant expression, while the cloths falling
around her limbs suggest the sensual ambience
of a boudoir or bathroom. The model who
posed for Dawn was Florence Bird (see no.140),
a professional whose relaxed and confident
posture dominates the composition. The use of
the female body to embody both natural forces
and ideas of progressive womanhood is a
marked characteristic of the late-nineteenth-
century nude and allowed for a variety of
interpretations. Thus, while Aurora can be seen
as a magnificent restatement of the 'eternal
feminine' in nature, she also stands as a
modern icon of female autonomy and sexual
energy. AS

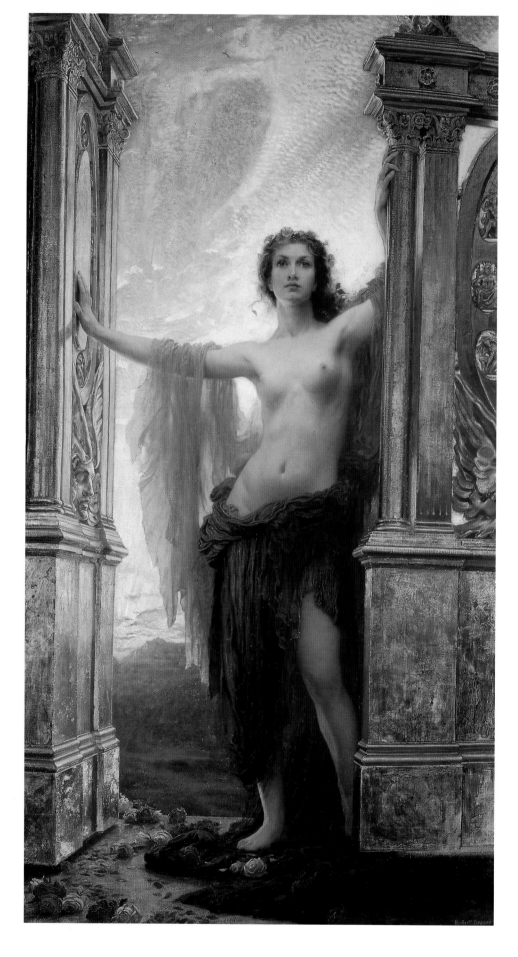

Herbert Draper

142 *Ulysses and the Sirens* 1909
Exh. RA 1909
Oil on canvas
177 × 213·5 (69¾ × 84)
Ferens Art Gallery: Hull City Museums
and Art Gallery

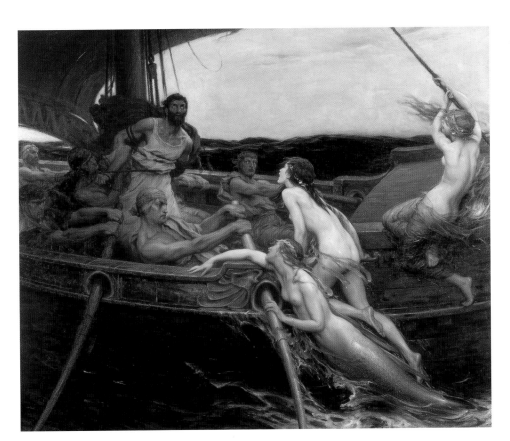

Draper's vivid presentation of *Ulysses and the Sirens*, although painted in the Edwardian era, is nevertheless a classic Victorian image of female predatory sexuality whose origins can be traced back to Etty's sensational depiction of the theme in 1837, a work widely condemned for its combination of voluptuousness and morbidity. Sirens enjoyed a renewed popularity in the late nineteenth century following the publication of Jane Harrison's writings on Homer's *Odyssey* in 1882 and 1887. The subject was dramatically treated in 1891 by Waterhouse, who had cast his sirens as birds, in contrast to Draper's nubile mermaid. Draper himself had long been fascinated by the idea of the female sea-creature, and precedents for this painting can be found in earlier works of his featuring ichthyoidal hybrids, notably *The Sea Maiden* (1894), *The Foam Spirit* (1897) and *A Deep Sea Idyll* (1902).

Ulysses and the Sirens is based on the passage in the Odyssey which describes how, during his return from the Trojan wars, Ulysses was forewarned of the sirens by Circe and took the precaution of having his mariners' ears blocked with beeswax and himself lashed to the mast of his ship to avoid being lured onto rocks by the sirens' melodic song. The theme of manly self-control, emphasised by the brawny physiques and steely expressions of the crew, is played off against the idea of female sexual danger epitomised by the pale glistening bodies of the agile girls who cling seductively to the side of the boat. By representing two of the sirens as young women (devoid of the customary wings, claw or tail), Draper would appear to suggest that the destructive allure of these sea-monsters is in fact a property of 'ordinary' women. AS

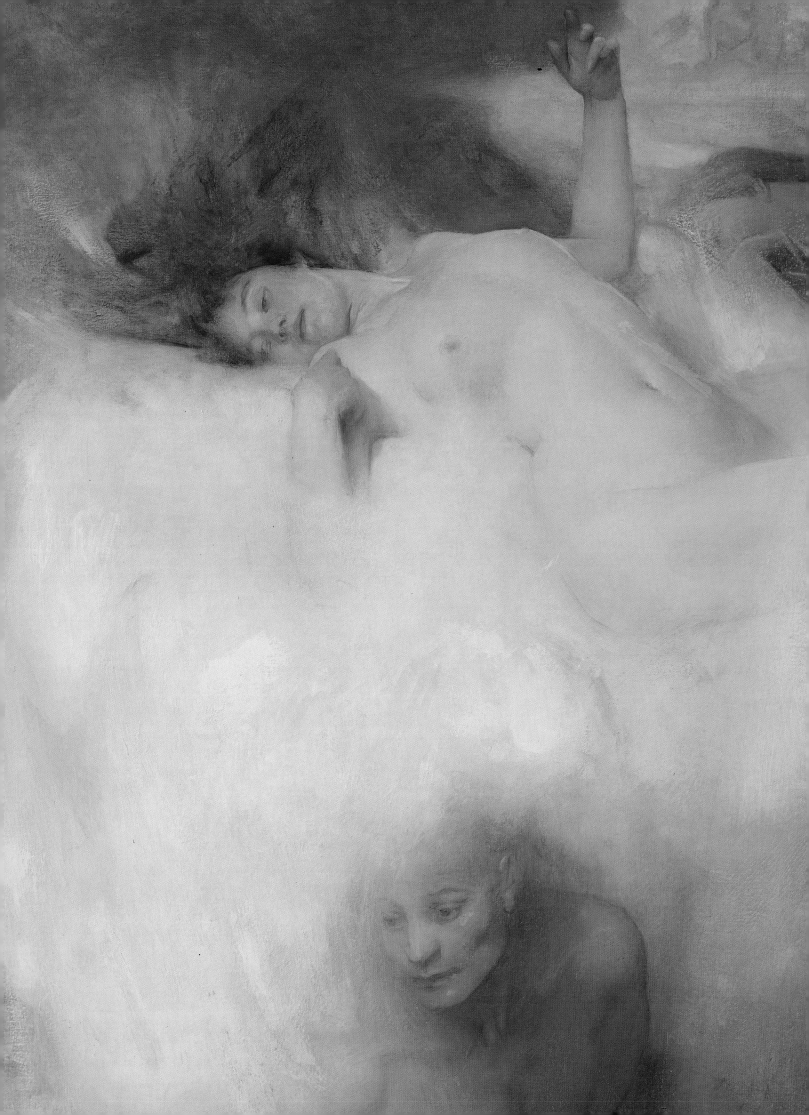

Arthur Hacker (1858–1919)

143 *The Cloud* 1901
Exh. RA 1901
Oil on canvas
127·7 × 130 (50¹4 × 51¹4)
Bradford Art Galleries and Museums

❋

Arthur Hacker was one of a younger generation of painters who, dissatisfied with the teachings of the Royal Academy, opted to complete their studies in the ateliers of Paris: he enrolled at the studio of Léon Bonnat in 1880. It was in Paris that he came under the spell of both plein air Realists and Salon painters of the nude, influences which informed his subsequent output and allegiances, for he not only became a regular exhibitor at the Royal Academy, but was also an early supporter of the francophile New English Art Club.

The Cloud with its sophisticated draughtsmanship and Symbolist blend of fact and fantasy is indicative of Hacker's Continental training: a supine nude is borne aloft on a fleecy cumulus illuminated by the opalescent rays of a passing rainbow. The custom of placing the female nude in natural settings, often in a somnolent state, was long-established in French painting, allowing for an undisturbed voyeuristic appreciation of the female form. Precedents for this languid figure reclining in a sexually inviting pose can be found in works such as Cabanel's *The Birth of Venus* of 1863 (exhibited in London in 1869 and probably known to Hacker via his friend Solomon J. Solomon who had trained with Cabanel), and Henri Gervex's notorious *Rolla* of 1878. The erotic positioning of the principal nude's legs in *The Cloud*, with one foot provocatively caressing the other, put critics more in mind of the bedroom or studio couch than the ethereal heights, as the *Art Journal* noted: 'these creatures are not of the buoyant, large-hearted air, but rather of the studio' (1901, p.176).

Hacker's nude compositions tend to be panpsychistic, his figures personifying some natural form or force as in *Syrinx* (1892), *The Sleep of the Gods* (1893), and *Leaf Drift* (1903). It was also characteristic of him to append quotations from poets such as Elizabeth Barrett Browning and Thomas Woolner to allow for the projection of human emotion and desire onto the natural world. *The Cloud* was exhibited accompanied by the following lines from Shelley's poem of the same name: 'And I all the while bask in heaven's blue smile | While he is dissolving in rains.' By the end of the century sun iconography had become an important means for justifying the representation of the body beautiful and the expression of physical rapture and evolution: the motif also appears in Tuke's *The Coming of Day*, another Academy exhibit of 1901. In *The Cloud* natural forces determine physical and mental responses, the sun eliciting sexuality and lassitude, the rain introspection and dejection. By gendering these elements feminine and masculine, Hacker casts the former as a femme fatale with the latter as her victim. AS

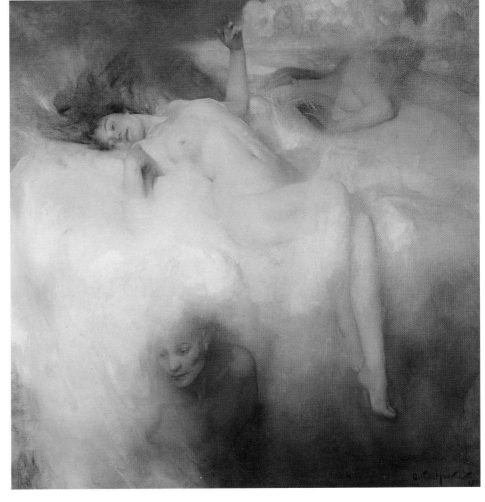

William Stott (1857–1900)

144 *The Birth of Venus* 1887
Exh. SBA 1887
Oil on canvas
182·8 × 182·8 (72 × 72)
Oldham Art Gallery & Museum, UK
✱

The Oldham-born painter William Stott received most of his education in Paris, working in the ateliers of Bonnat and Gérôme in the late 1870s, before entering the École des Beaux-Arts in 1880. In France he became associated with an international colony of artists at Grez-sur-Loing near Fontainebleau, where he produced *Le Passeur* and *La Baignade*, for which he was awarded a third-class medal at the Salon of 1882.

Returning to England, Stott became one of Whistler's protégés, on whose recommendation he was elected a member of the Society of British Artists in 1886, the year Whistler himself became its President. Whistler's controversial reforms included the introduction of new members and a more spacious hang, and as an ardent supporter of his presidency Stott spoke out in defence of his mentor's policies: a letter he wrote to the *Court and Society Review* in July 1886 praised Whistler's individualism in refusing to pander to the prevailing taste for narrative subjects conveying moral sentiments. *The Birth of Venus* is indicative of the aestheticised classicism Stott adopted around 1886–7 with its narrow colour range, elaborate patterns and reflections. The painting was exhibited accompanied by the following lines from Hesiod's *Theogony*: 'Her, gods and men name Aphrodite, the foam-sprung Goddess and fair-wreathed Cytherea', and is indeed an ambitious fusion of myth and plein air realism: employing the Renaissance tondo format, Stott presents a modern-day Venus whose streaming hair and open arms echo the undulations of the waves as they meet the shore.

The model for the goddess was Whistler's mistress, Maud Franklin, also a painter and exhibitor with the Society of British Artists. In the summer of 1886 Whistler and Maud visited Stott at his studio in Ravenglass on the Cumberland coast, where Stott produced a pastel of Maud sitting fully clothed in a rocking-chair. As Whistler drifted apart from Maud around the time of his attachment to Beatrice Godwin, he was unaware of her visits to Stott's suburban London studio, and paid little attention to her in the role of Venus when the work was hung at the SBA's 1887 exhibition, which also included a clothed portrait of her by Whistler, *Harmony in Black, No.10*. Stott's painting was met with savage criticism: 'Why outrage so cruelly the Cyprian goddess by giving her name to a repellent, imperfectly developed type of atelier model?' asked Marion Spielmann in the *Magazine of Art* (1887, p.110), while Whistler's enemy Harry Quilter singled the nude out as 'a red-haired vulgar folly' (*Spectator*, 10 Dec. 1887, p.1704). Such violent antipathy caused Whistler to take notice of the work to discover that the offending Venus was Maud. Furious at what he considered to be a slur on his reputation, he broke off relations with both Maud and Stott, a breach that culminated in a violent incident at the Hogarth Club in January 1889. The quarrel left Stott ostracised from the Whistler faction and Maud herself humiliated by the publicity and popular interest incited by Press criticism, for the work was now in constant demand for loan exhibitions in Britain and abroad. The scandal of a female painter shown naked would also have fuelled the campaign against female artists and models set in motion by Horsley the previous year (see no.53), and can only have reinforced the prejudice that modelling 'nude' was degrading for both artist and model. AS

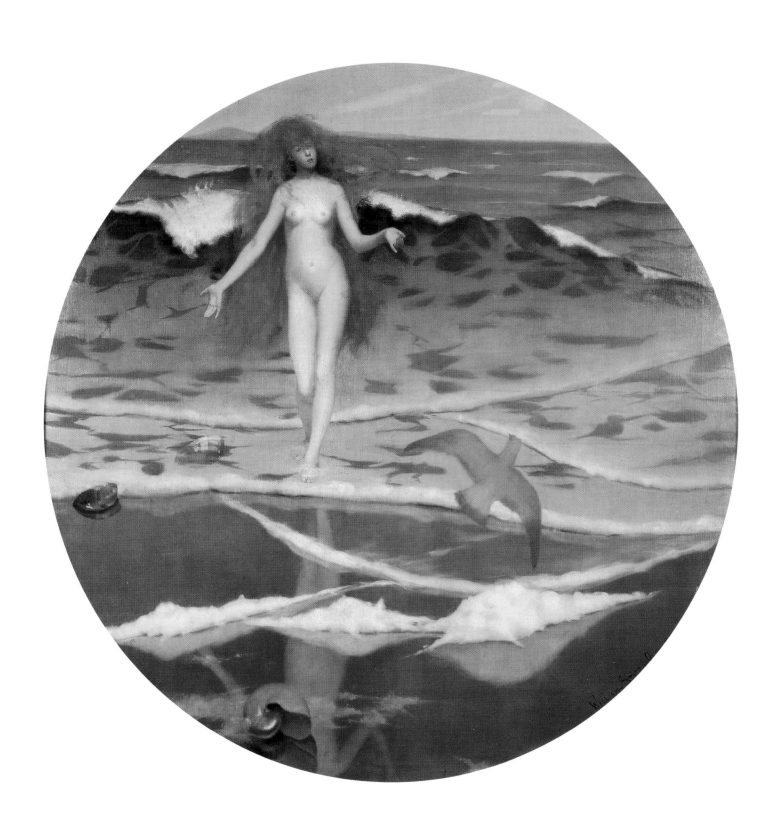

George Frederic Watts (1817–1904)

145 *Love and Life* 1885
Exh. GG 1885
Oil on canvas
222·2 × 121·9 (87¾ × 48)
Tate. Presented by the artist 1897
✱

Love and Life was one of many nude subjects exhibited in London during the summer of 1885, which incited 'A British Matron' to launch a campaign against the display of such 'morally corrupt' images in public (no.53). Although Watts's slight and pathetic figure of Life at first perturbed critics, a painful reminder perhaps of the reports of abused women that filled newspaper columns that year, they were won over by the moral message of the picture. Hugh Macmillan later argued that had Watts painted the female as a *Venus de' Medici*, self-sufficient and strong, he would have detracted from his allegory of helpless Life strengthened by the altruistic force of Love (1903, p.249). In the wake of Horsley's diatribe against female models at the Portsmouth Church Congress, Watts wrote to his friend chiding him for pandering to the prejudices of an uneducated section of the population. His warning relates to his own mission of civilising the nation by transforming the language of history painting to meet the spiritual needs of a new audience for art encouraged by the growth of public museums. *Love and Life* was central to this ambition, Watts himself emphasising that it 'best portrayed his message to his generation': 'naked, bare life sustained and helped up the steeps of human conditions, the path from the baser existence to the nobler region of thought and character' (Bateman 1901, p.22). In the picture, as the figures are shown ascending a mountain path, violets blossom on jagged rocks and the clouds disperse to reveal an ethereal blue sky. The painting was one of eighteen works given by Watts to the National Gallery of British Art in 1897 as part of his universal 'religion of love', and was received as a statement of hope and consolation to an increasingly secular society; as the *Daily News* noted of the crowds that thronged through the Watts Galleries at Millbank on Sundays, 'no visitor leaves the Gallery without having seen a sermon at least as impressive as any he would be likely to hear elsewhere' (9 June 1898).

In 1893 Watts took his 'sermon' on *Love and Life* overseas when the original version was exhibited at the Chicago World Fair and subsequently presented by Watts (on the recommendation of Mary Mead Abbey, wife of the painter Edwin Austin Abbey) to the government of the United States. When President Cleveland proposed hanging this gift in the White House, an American matron, Mrs Emily D. Martin, National Superintendent of Purity in Literature and Art for the Women's Christian Temperance Union of the United States, protested at the idea of displaying an 'immoral' painting in the Presidential mansion and urged members of her Union to write to the President, urging him as Chief Executive to veto the work. In order to pre-empt any controversy the painting was swiftly dispatched to the more acceptable 'art' space of the Corcoran Gallery in Washington, but in 1902 President Roosevelt recalled it for display in the dining-room of the White House, prompting Mrs Martin to write another indignant letter on behalf of her sex: 'It will be very disillusioning for the women who have admired him [the President] to learn that he has given a place on the walls of the White House to this vulgar nude painting of Watts ... 'Love' and 'Life' are represented by two naked figures in atrocious postures' (Blunt 1975, p.156).

To be accused of purveying pornography was very distressing for Watts, but, as he himself had warned Horsley back in 1885, such responses were to be expected if the élitist form of the nude was exposed to unsophisticated audiences. In 1893 the Luxembourg Museum in Paris purchased another modified version of *Love and Life* for its collection, and here the timorous figure of Life must have appeared an awkward ingénue in a city famous for its erotic nude productions. AS

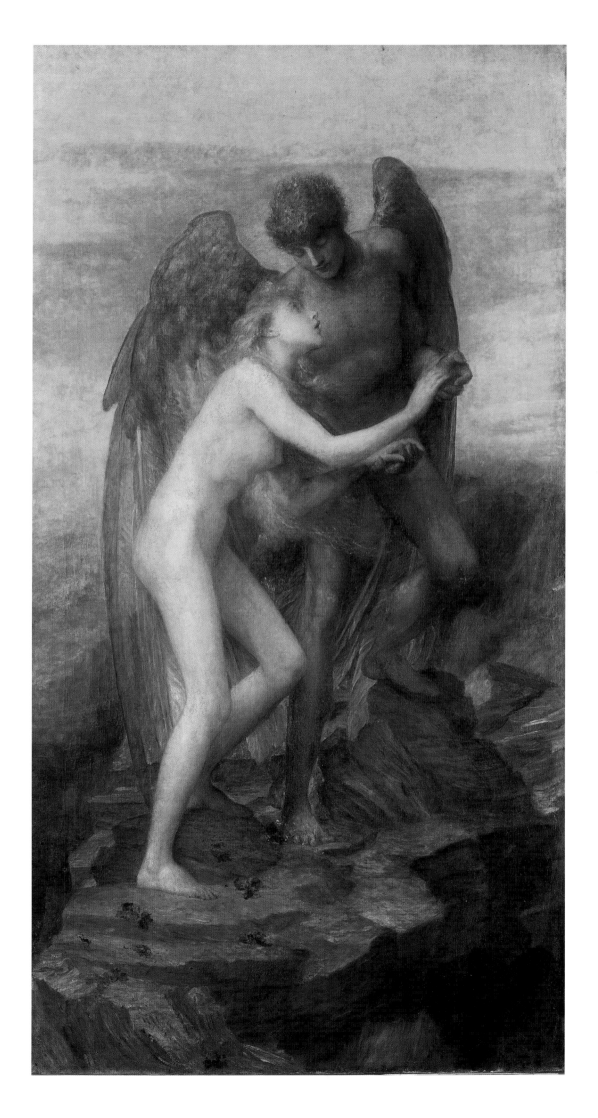

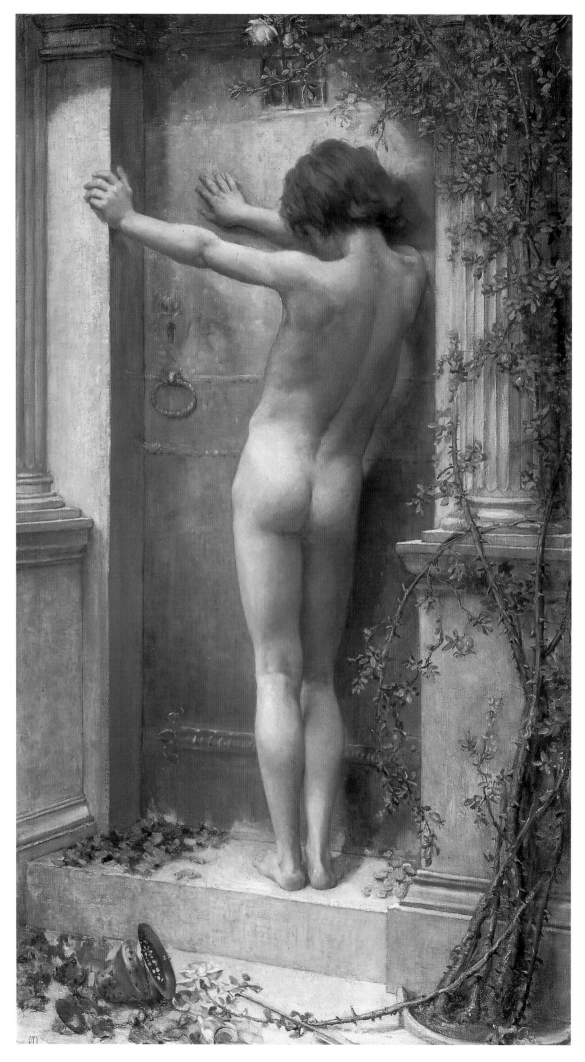

Anna Lea Merritt (1844–1930)

146 *Love Locked Out* 1889
Exh. RA 1890
Oil on canvas
115·6 × 64·1 (45¹₂ × 25¹₄)
Tate. Presented by the Trustees of the Chantrey
Bequest 1890
✻

Love Locked Out was purchased by the Chantrey Bequest in 1890, the first work by a woman to be presented to the nation and all the more remarkable at the time in that the image was of a nude. For female artists the acquisition must have represented a vindication of the right of women both to study and to exhibit in public the undraped figure.

Anna Massey Lea was brought up in Philadelphia but received most of her training in Europe where she took private classes from a succession of male tutors in Florence, Dresden, Paris and London, being barred as a woman from entering the most prestigious academies. She settled in London in 1870 and in April 1877 married her teacher, the painting conservator Henry Merritt who died three months later. *Love Locked Out* was originally intended as a private memorial to be cast as a bronze relief and placed at the head of her husband's grave, anticipating the time when they would be reunited. Deterred by the cost of the bronze she decided to paint the subject instead, employing a professional boy model Niccolò Marcantonio, who may also have posed for Goscombe John's *A Boy at Play* (no.186). Merritt had only seriously started to study the nude in the 1880s, which may explain the difficulties she experienced in determining the position of the boy's left shoulder blade (pentimenti are visible beneath the paint layers). *Love Locked Out* was, however, not her first nude: *Camilla, a Nymph of Diana* and *Eve* had been exhibited at the Academy in 1883 and 1885 respectively, but received a lukewarm reception. In painting a nude boy Merritt may have wanted to avoid censure, for child nude subjects were regarded as simple and natural and thus more appropriate for women artists than the exacting adult body. Merritt herself approved of child models because she felt they were unconscious of nudity and had 'no sense of shame before artists' (Gorokhoff 1982, pp.132–3). She also believed that emotion was better expressed through bodily gesture than facial expression and preferred to avoid representing the face, as is the case here. Despite the appeal of *Love Locked Out* to the Victorian public Merritt refused to have the work reproduced as an engraving, not so much for personal reasons but because she feared people might interpret the boy as a symbol of forbidden love (ibid., p.164).

The simple emblematic structure of the image recalls the iconography of Watts, whose *Love and Life* (no.145), was exhibited in the British section of the Chicago World Fair of 1893, when Merritt showed a replica of *Love Locked Out* in the American section. Merritt was both intrigued and shocked by the objections which met Watts's painting when it was hung in the White House. Interviewed by the *Philadelphia Ledger* she spoke out in defence of the nude: 'I suggested that those who had found fault with Life for having no clothes should provide a fashion-design suitable; otherwise the garment which every soul brought into the world, the body God gave her, ought to be the proper dress' (Gorokhoff 1982, p.133). AS

Annie Swynnerton (neé Robinson, 1844–1933)

147

New Risen Hope 1904
Oil on canvas
57 × 51·9 (221$_2$ × 203$_8$)
Tate. Presented by the Trustees of the Chantrey
Bequest 1924

❋

This is probably the first of two versions of
the same subject in which a child portrait is
transformed into a Wattsian allegory of
evolution. The image was painted over a piece
of previously painted-on canvas and may have
been an experimental development of an earlier
portrait motif (see Storey 1929, pp.201, 203).
The other, more elaborate version, also dated
1904, was bought on the recommendation of
George Clausen by the Felton Bequest for the
National Gallery of Victoria, Melbourne, in
1906 following its exhibition at the New
English Art Club. The Tate painting was
purchased by the Chantrey Bequest in 1924,
two years after Swynnerton was elected an
Associate of the Royal Academy, the first
woman ARA to be elected by ballot. Although
Swynnerton's career was advanced by
supporters such as Clausen and Sargent, who
presented her *Oreads* to the Tate in 1922, her
success owed more to her tenacity and New
Woman convictions. Swynnerton was a well-
known publicist for women's rights, having
founded the Manchester Society of Women
Painters with Susan Isabel Dacre in 1879, and
was one of the signatories of the declaration in
favour of women's suffrage in 1889. *New Risen
Hope* may therefore have been conceived as a
statement of female emancipation, an
affirmative alternative to Watts's forlorn *Hope*
exhibited in 1886: a sprightly child, reminiscent
of Baroque personifications of the Christian
soul, rises up to greet a new era and is glorified
as a symbol of female energy and optimism. AS

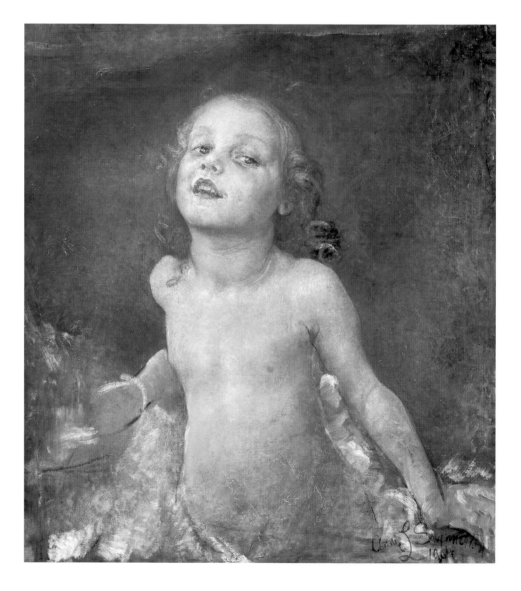

Charles William Mitchell (1854–1903)

148 *Hypatia* 1885
Exh. GG 1885
Oil on canvas
244.5 × 152.5 (96¼ × 60)
Laing Art Gallery, Newcastle upon Tyne
(Tyne and Wear Museums)

✿

Mitchell was the son of the wealthy shipbuilder
and collector Charles Mitchell of Jesmond
Towers, Newcastle. He studied in Paris under
P.C. le Comte, and this dramatic painting of
Hypatia with its vigorous draughtsmanship
and concentrated design shows the fruits of a
French education.

The painting was exhibited accompanied
by an excerpt from Charles Kingsley's historical
novel *Hypatia, or New Foes with an Old Face*
(1853), set among the conflicts between rival
religious sects in fifth-century AD Alexandria,
a time when the Roman Empire was collapsing.
Mitchell depicts the moment when the pagan
philosopher Hypatia, stripped and dragged by
her murderers – a mob of fanatical monks –
through the nave of the church up to the altar
'rose for one moment to her full height, naked,
snow-white against the dusky mass around –
shame and indignation in those wide clear eyes,
but not a stain of fear. With one hand she
clasped her golden locks around her; the other
long white arm was stretched upward towards
the great still Christ, appealing – and who dare
say, in vain? – from man to God' (quotation
from ch.XXIX). The full-length figure of
Hypatia, in an unusually elastic and elongated
pose, is framed and illuminated by the
surrounding architecture, her dignified yet
exposed body contrasting with the Christian
denial of the flesh symbolised by the rigid cold
mosaics (the fragment of Christ amalgamated
from mosaics at S. Vitale and S. Apollinare
Nuovo in Ravenna).

The theme of religious bigotry would have
been pertinent in 1885 when a number of
denominations rose in protest against the
nude in art, encouraging the counterargument
that the naked body was itself divine. Charles
Kingsley, both clergyman and novelist, was
an advocate of the artistic nude as an agent of
social and spiritual evolution, and was often
quoted by defenders of the subject. In essays
such as *Nausicaa in London, or the Lower
Education of Women* of 1873, Kingsley
complained that contemporary morals retarded
women physically and mentally, and he urged a
larger classical physique which would indicate
strength and health 'not merely of the muscles
but of the brain itself' (p.116). *Hypatia* would
appear to illustrate this ideal with its athletic,
almost androgynous heroine who is
represented as firm in both body and mind.
So striking was the treatment of the figure
that it was seized upon as an opportunity for
sculptural interpretation, and in the 1890s F.J.
Williamson and Richard Belt each produced a
life-sized marble *Hypatia* replicating the pose
and attitude made famous by Mitchell. AS

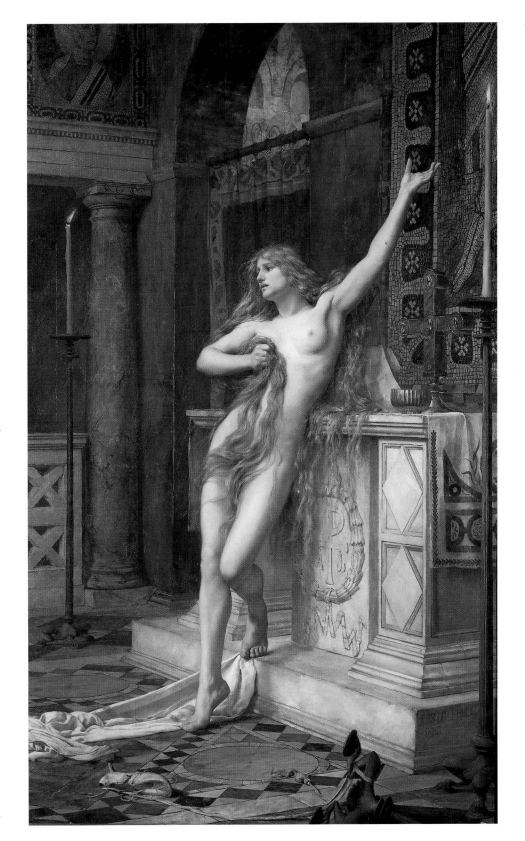

John William Waterhouse (1849–1917)

149 *Saint Eulalia* 1885
Exh. RA 1885
Oil on canvas
188·6 × 117·5 (74¹⁄₄ × 46¹⁄₄)
Tate. Presented by Sir Henry Tate 1894
✳

Saint Eulalia was one of several nude subjects exhibited in 1885 which presented a lean and youthful female under physical duress (see nos.148, 151). That same year the Royal Academy displayed several other works depicting female Christian martyrs, notably F. Hamilton Jackson's *St Dorothea* and A.W. Bayes' *Dream of a Christian Martyr*. Like Mitchell's *Hypatia*, *Saint Eulalia* is placed in an archaeologically authentic setting and similarly represents a female martyr of the early Christian era. The painting was exhibited accompanied by a brief explanatory text citing the fourth-century Spanish poet Prudentius who describes Eulalia as a courageous 12-year-old from Estremadura who was put to death in AD 313 for refusing to obey an edict of Diocletian ordering all Roman subjects to sacrifice to the imperial gods. At the moment of her martyrdom a miraculous fall of snow occurred and doves issued from her mouth causing her executioners to flee in terror. Waterhouse took a number of liberties with Prudentius' text, showing Eulalia as a young woman rather than a child and omitting the gruesome details of her death: the serene body bears no evidence of either the iron hooks which tore at her flesh or the torches applied to her breasts, sides and hair. Although Waterhouse was honouring the tradition within history painting of presenting the sublimated aftermath of violence, a sensation of pain is nevertheless suggested by the ice-cold flakes and the hair which spills out blood-like towards the viewer.

The painting is based on a complex perspectival system which leads the viewer to confront Eulalia's naked foreshortened body, where the frisson of palpable exposed flesh is heightened by the surrounding snow. Comparison with a small preparatory study (fig.34) reveals certain modifications to the design. The finished image does away with the slashes across Eulalia's stomach in the sketch, and Waterhouse replaces the statue on the right with a cross as well as repositioning the soldier to heighten the impact of the figure in the foreground. Crucifixion subjects were rare in British art mainly because of a longstanding distaste for what was perceived as Catholic iconography. However, at a time when the supernatural aspects of the Bible and lives of the saints were being questioned, this powerful motif would have been acceptable as an historical fact rather than a symbol. A number of critics acknowledged Waterhouse's achievement in staging a miraculous event in an objective way without the result looking mawkish or grotesque. However, the work was also criticised for being too factual a presentment of a holy, transcendent moment, Eulalia's pose bearing a closer resemblance to a corpse in an anatomy theatre than a soul triumphant over death. The potential such an image offered for sadistic voyeurism would not have been lost on an audience shocked by recent lurid revelations concerning the victimisation of young women. AS

Fig.34
John William
Waterhouse
Study for 'St Eulalia'
c.1885
Drawing and
watercolour on paper
Tate

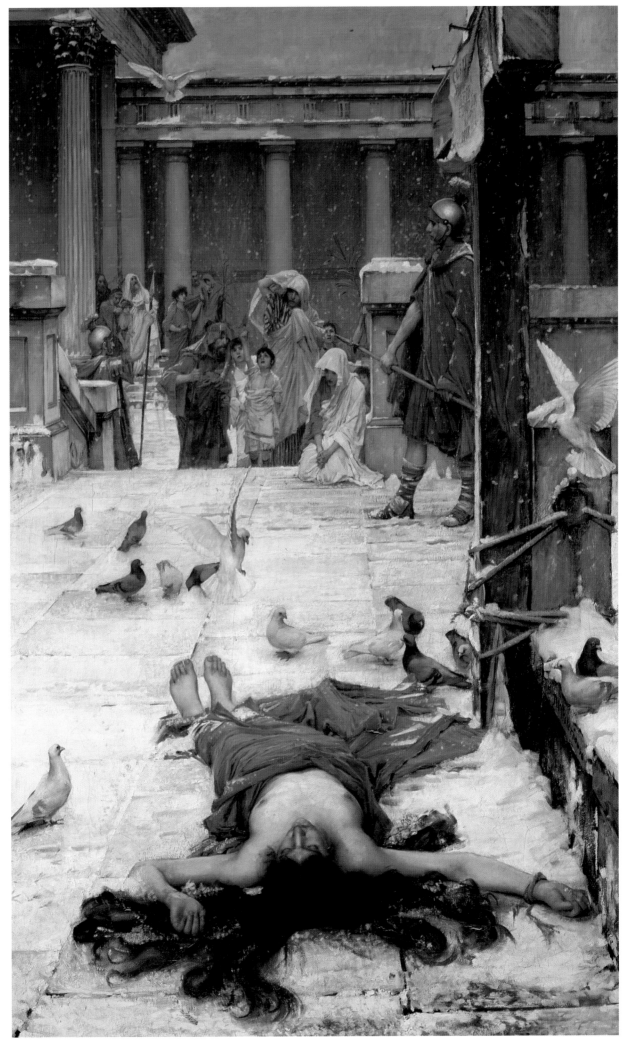

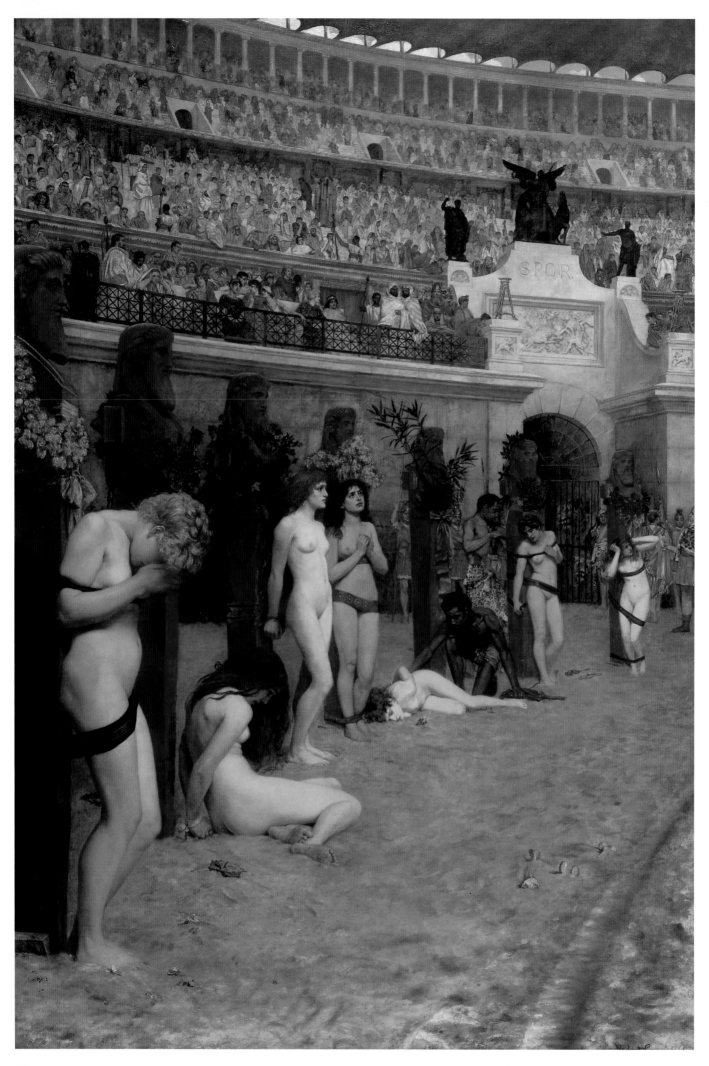

Herbert Schmalz (Carmichael, 1857–1935)

150 *Faithful unto Death. 'Christianes ad Leones!'* 1888
Exh. RA 1888
Oil on canvas
162·6 × 110·5 (64 × 43½)
Horst M. Rechelbacher

✻

The son of German-Scottish parents, Schmalz trained at the Royal Academy under Leighton and Alma-Tadema, completing his education at the Antwerp Academy before establishing a career as a painter of elaborately staged biblical and historical subjects. In order to authenticate the horror of the episode presented in *Faithful unto Death*, the artist attached a quotation from an unidentified source to the stretcher of his canvas:

> The sect who were first called Christians at Antioch had that day born good witness to their faith, in Rome. There in the fierce glare of the Arena, waiting for the end. Waiting, under the pitiless eyes of a blood thirsty multitude, from Senator and Patrician dame, to low baffoone parisite. Waiting, till fear becomes hope, and shame grows shameless before the promise of Death!

The scene is staged in a Roman amphitheatre, perhaps the Circus Maximus as suggested by the grooves of chariot wheels in the sand, during the time of Nero's persecution of Christians. As a testimony to the Emperor's reputed taste for spectacular executions, Schmalz presents a group of young female martyrs of mixed racial origin tied to herms festooned with flowers and grapes in honour of Bacchus as they await the onslaught of lions lurking behind a gate in the distance. Schmalz was clearly influenced by Gérôme in both his choice of subject-matter (the line of dejected women recalls the French painter's notorious slave markets), and panoramic viewpoint: the focus on both victims and crowd, together with details such as the bronze biga and wheel marks, were probably adapted from Gérôme's famous *The Christian Martyrs' Last Prayer* of 1863–83, which Schmalz would have known through photogravures. Like Normand's *Bondage* (no.152), the *mise-en-scène* is carefully amalgamated from a variety of archaeological sources – imperial statuary, antique marble friezes and Pompeian painted columns – the splendour of the setting contrasting with the cruelty and lassitude of the crowd.

While the sado-erotic implications of the nudes and herms could be interpreted as a censorious depiction of Roman perversity, the image could also be seen as a statement of female virtue and courage in the face of ferocious death. However, the lack of central focus along with the oblique perspective and mimetic brushwork serve to neutralise the viewer's indignation; indeed Claude Phillips thought the background appeared as if it had been created 'by some mechanical process' which destroyed any sense of drama (*Academy*, 26 May 1888, p.365). The victims themselves can be read as studio models arranged in conventional nude poses: the two figures on the right are presented in the attitude of an Andromeda, the woman slumped on the ground is a standard pathetic type (compare no.156), while the other three strike the stock postures of courage, faith and prayer. The combination of nudity with impending violence establishes a frisson between the idea of the artistic body (each figure has a smooth pudendum) and mutilated flesh, signified by the animal blood marks on the arm of the stoic upright woman and the gruesome traces of blood and bones in the sand. One critic noted that the straps binding the girl in the foreground to her column 'cut into the soft flesh of her arms', a 'realisation' he put down to the artist's directive practice: 'for Mr Schmalz had a post erected in his studio and bound the girl to it exactly as represented' (*Strand Magazine*, 24, 1888, quoted Dakers 1999, p.215). Although *Faithful unto Death* was considered distasteful by critics, it was popularised through reproductive prints and in the twentieth century came to influence cinematic extravaganzas such as Cecil B. De Mille's *The Sign of the Cross* of 1932, which includes a similar scene in which a nude female martyr is shown bound by garlands to a herm in the arena awaiting her fate. AS

Philip Hermogenes Calderon (1833–1898)

151 *St Elizabeth of Hungary's Great Act of Renunciation* 1891
Exh. RA 1891
Oil on canvas
153 × 213·4 (60¼ × 84)
Tate. Presented by the Trustees of the Chantrey Bequest 1891

✳

As Keeper of the Royal Academy Schools Calderon was an advocate of life-study, and during the 1880s he exhibited a number of mythological female figures which were criticised for being too 'modern' and 'French' in conception (he had trained in Paris under Picot). A precedent for this striking image of a naked woman posed in front of an altar was Mitchell's *Hypatia* of 1885 (no.148), from which time the ascetic female body became a popular pretext for scenes of Christian martyrs allowing a voyeuristic enjoyment of the unblemished female form while indulging feelings of pity and indignation.

St Elizabeth of Hungary (1207–31) was the extremely devout daughter of Andrew II of Hungary. On the death of her husband she was at first banished, but when subsequently invited to become regentess declined, opting to live a life of seclusion under the guidance of her confessor, Conrad of Marburg. Calderon's painting shows Elizabeth kneeling in the act of renouncing all worldly power and wealth in a small chapel overseen by Conrad while nuns and monks look on in prayer. In the 1891 exhibition catalogue Calderon cites a medieval Life of St Elizabeth but it is certain that he also had in mind a passage in Charles Kingsley's dramatic poem 'The Saint's Tragedy' of 1848, in which Elizabeth tears off her clothes and vows to go 'naked and barefoot through the world to follow | My naked Lord'. The extreme anti-Catholic bias of Kingsley's poem was read into Calderon's painting and provoked a spate of correspondence in *The Times* in which several writers, T.H. Huxley included, spoke out against Calderon's Conrad as a 'brute' (20 May). A number of outraged Catholics voiced their objections to the image, contending that Calderon had misinterpreted the medieval texts which both he and Kingsley had used as authorities. Writing in *The Times* the Jesuit R.F. Clarke particularly took objection to Calderon's rendering of the Latin 'nudus' into the English 'nude', the latter meaning more or less 'naked', the former having a wider, metaphorical implication: 'to suppose that St. Elizabeth voluntarily stripped herself naked to imitate [Christ's] involuntary and most pitiful nakedness [at the Crucifixion] is an idea utterly repulsive to Christian feeling, and would make her a madwoman, not a saint' (16 and 25 May). The Catholic Union of Great Britain even lobbied the Council of the Royal Academy to cancel the purchase of the work by the Chantrey Bequest on the ground that the image was likely to be misunderstood as evidence of a perverse Catholic ritual reinforcing anti-Catholic prejudice and halting the progress of denominational integration.

Beyond religious objections, it was also suspected that in showing the naked Elizabeth watched by monks and nuns Calderon was inviting a prurient gaze. The association between the figure of Elizabeth and 'exploited' women in modern society was picked up by sections of the media eager to capitalise upon the notoriety of the work. Both *Punch* and *Fun* published cartoons linking the composition with a recent case of alleged improper conduct on the part of two officers of the London County Council who demanded to inspect the body of the acrobat 'Zaeo' who, it had been claimed, was being compelled to continue her performances despite suffering from sores across her back. The uncertainty as to whether the officers were primarily philanthropists or voyeurs applied equally to Conrad (McEvansoneya 1996, p.268). Although the painting was considered embarrassing to both Catholics and 'purist' vigilantes, its opponents were unsuccessful in their efforts to change the minds of the Royal Academicians who administered the Chantrey Bequest. As the prime minister, Lord Salisbury, pointed out, the painting was destined for a secluded corner of the South Kensington Museum where it would be viewed mainly by art students, so there was little risk of it 'injuring public morality or offending the prejudices of religious minds' (Hansard 355, col.1522, quoted McEvansoneya, p.263). However, in 1897 the picture was rehung in the Chantrey galleries of the new National Gallery of British Art at Millbank, inciting yet further protest. AS

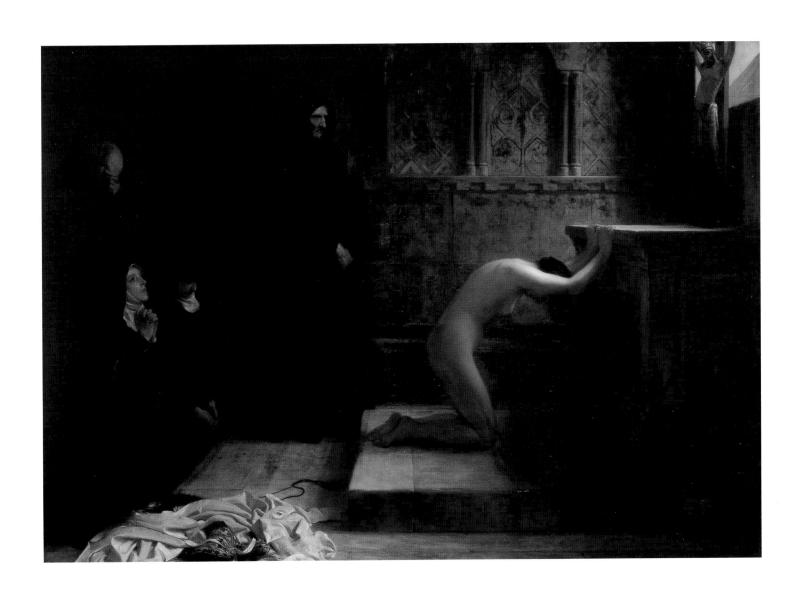

Ernest Normand (1857–1923)

152 *Bondage* c.1895
Exh. RA 1895
Oil on canvas
184×307 (72½×120¾)
Royal Institution of Cornwall, The Royal
Cornwall Museum, Truro

✿

Normand worked in the cosmopolitan manner characteristic of artists who had trained on the Continent. Educated in Germany, he worked in commerce before deciding to become a painter, entering the Royal Academy schools in 1880. In 1890 he and his wife, the painter Henrietta Rae, opted to continue their education at the Académie Julian in Paris, subsequently joining a colony of Impressionists at Grez. In Paris Normand worked in the ateliers of Lefèbvre and Benjamin-Constant from whom he developed a taste for drama and Orientalism. Benjamin-Constant had amassed a large collection of Islamic artefacts which he displayed in his Pigalle studio, and it was probably through his encouragement that Normand visited Morocco in 1891.

Returning to London, Normand and Rae set themselves the challenge of producing ambitious history paintings, and following their move from Kensington to Norwood in 1893, each produced a work on the theme of subjection conceived on the same enormous scale: Rae's *Psyche before the Throne of Venus* (1894), and Normand's *Bondage* which was exhibited in 1895. The slave subject had an established pedigree in Britain; starting with Powers' *The Greek Slave* and a series of figures produced by John Bell (nos.46, 13), the subject was later popularised through the painted extravaganzas of artists such as Edwin Long, whose *Babylonian Marriage Market* of 1875 influenced Normand's own *The Bitter Draught of Slavery*, exhibited at the Academy in 1885. The most notorious slave scenes were by Gérôme whose two paintings both entitled *À Vendre* (fig.35; shown at the Academy in 1871 and the French Gallery in 1873) drew on contemporary theories of racial and sexual difference put forward in ethnographic texts such as Darwin's influential *The Descent of Man* published in 1871.

Normand's view of ancient Egypt as sensual, material and slave-owning owes more to the Old Testament stories of Joseph and the Exodus than to archaeological evidence, which suggested that the harems of the Pharaohs existed for diplomatic and social reasons and that concubines were of Egyptian origin. Although *Bondage* is essentially a historical fantasy, it relies heavily on the discipline of Egyptology in conjuring up an image of Egypt around 1200 BC, and it is likely that Normand immersed himself both in reports of archaeological excavations, such as those carried out by Maspéro in the 1880s, and in historical texts such as Flinders Petrie's *History of Egypt* of 1894. He would also have had recourse to the numerous travel guides issued at a time when Egypt was a British protectorate conscious of its own national identity (Mustapha Kamel's Nationalist Party was founded in 1895).

The frame was designed specifically for the painting and, as N.H. Nail has argued, the references to Rameses II in the cartouches and winged sun disk with cobras are relevant to the subject since Rameses was widely regarded in the nineteenth century as the Pharaoh of oppression and the Exodus (1987, p.2). Symbols of royal power continue in the main scene with the statues of the lion and lion-headed goddess copied from sculptures in the British Museum, and the montage of temple, pylon and obelisk in the distance. The 'bondage' motif is reiterated in the foreground terrace by details such as the finial fabricated in the form of a bound Semitic captive on the side arm of the buyer's couch, and the doves with collared plumages suggestive of imprisoned love.

The scintillating light effects and skilful deployment of perspective assist in providing a convincing context for a drama of racial subjugation. The Pharaoh, surrounded by attendants and Nubian servants, consults his chief wife or concubine as to whether he should purchase the merchandise offered by the Semitic dealer who is shown presenting his prize exhibit, a magnificent Nubian standing proudly erect and naked except for her girdle, apparently a willing participant in the sale. The Nubians are represented as dark-skinned Caucasians, who in their nonchalant deportment contrast starkly with the two victims on the right – the young mother crouching with her pre-pubescent daughter who are white, fair-haired and completely naked. These forlorn, neglected figures are positioned to convey a northern European sense of shame, making them more suitable as domestic servants than for the harem. While the abjection of the white slaves might have been interpreted as a sign of a superior moral sensibility, their hapless demeanour would also suggest that they are susceptible to exploitation and degradation. Viewers would not have been blind to the contemporary ramifications of these contrasting images of indifference and despair, in that they correspond with contemporary sociological division of prostitutes into two types, the animalistic and the victimised. Such stereotypes proliferated in the wake of the scandalous revelations concerning white slavery, paedophilia and child prostitution made by W.T. Stead's infamous 'The Maiden Tribute of Modern Babylon' published in the *Pall Mall Gazette* in 1885. The outburst of moral fervour provoked by this sensational piece of journalism pressurised the government into passing the Criminal Law Amendment Act, raising the age of consent to 16. The relevance of *Bondage* at a time when the state was beginning to assume a more interventionist role in seeking to protect sexually vulnerable women and children may have made the picture seem inappropriate, even crass, in an 'art' context. Although it received little critical notice in 1895, the painting was bought by the diplomat and collector Christopher Henry Hawkins of Trewithin, Cornwall, for the considerable sum of £1,200, and was given by his widow to the Royal Institute of Cornwall in 1909 where it proved 'a highly attractive exhibit' (*Journal of the Royal Institute of Cornwall*, vol.18, 1910, p.44). AS

Fig.35
Jean-Léon Gérôme
À Vendre
Exh. RA 1871
Private Collection

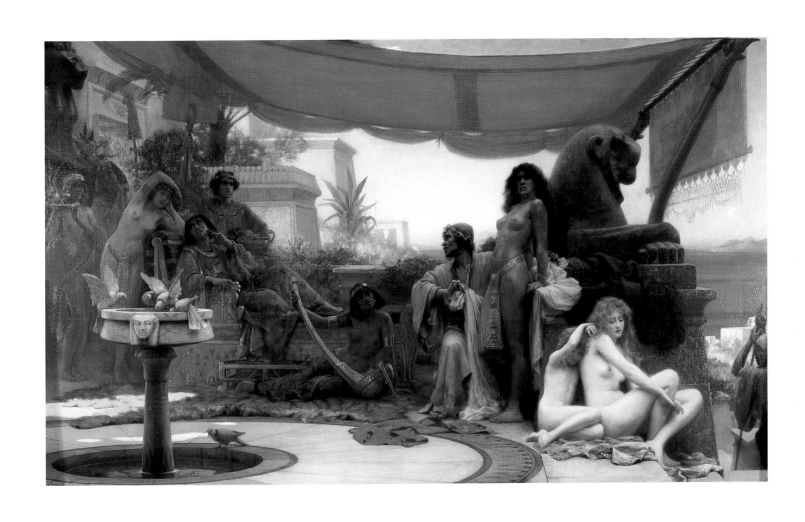

Frederic Leighton (1830–1896)

153 *An Athlete Wrestling with a Python* c.1874–7
Exh. RA 1877
Bronze
174·6 × 98·4 × 109·9 (68¾ × 38¾ × 43¼)
Tate. Presented by the Trustees of the Chantrey
Bequest 1877

❋

Leighton's first large-scale sculpture was exhibited with the title *Athlete Strangling a Python*, thus forestalling any equivocation over who would win the fight. The statue caused a sensation at the Royal Academy and was one of the first purchases made by the Chantrey Bequest for the national collection. It went on to win a Gold Medal at the Paris Exposition Universelle in 1878, and a full-scale marble replica was commissioned by Carl Jacobsen for the museum he established in Copenhagen in 1882. The impact of the bronze resided in the strength and tension of the design: a man stretched to the limits of physical endurance struggles to master an enormous python coiled around his left thigh, its gaping jaws held back by the force of his outstretched arm. In its naturalism and detail – the skin of the snake is minutely reproduced – the work signalled a radical departure from the smooth neo-classical tradition. As Edmund Gosse later remarked in the *Art Journal*: 'Here was something far more vital and nervous than the soft following of Flaxman dreamed of; a series of surfaces, varied and appropriate, all closely studied from nature' (1894, p.140). The aestheticised realism of the figure is indebted both to the example of Hellenistic sculpture, particularly the *Laocoön* in the combined sensation of power, pain and movement, and to that of Michelangelo in the spiralling dynamics of the form. Technically, the *Athlete* was influenced by contemporary French sculpture, especially in the way the skilful modelling of the musculature is reflected in the motile surface of the bronze. In fabricating the sculpture on such a large scale Leighton was assisted by his protégé Thomas Brock, the bronze itself being cast by Cox and Sons of Thames Ditton. A series of reduced bronze copies were later issued in two sizes by the founder Arthur Collie for the Leicester Galleries.

The *Athlete* became the icon of a new movement which Gosse christened the 'New Sculpture', and it inspired an emerging generation of sculptors to make their public début with male nude subjects (see no.154). The work also inaugurated the revival of the heroic male figure: as Michael Hatt has argued, it set the standard for a positive ideal of masculinity and was adopted by the physical culture movement of the 1890s as an emblem of health and disciplined action (1999, p.243). Both the turgid musculature and concentrated expression of the athlete convey his perseverance, will power and strength; and the glossy armoured surface of the body together with the man's projecting limbs seem to resist the spectator's gaze, acting as a bulwark against the projection of desire encouraged by figures shown in a more relaxed, passive state. At a time when athleticism was being promoted among young men as a means of instilling self-control, Leighton's *Athlete* was seen to set a 'moral' example in keeping degenerate forces at bay. AS

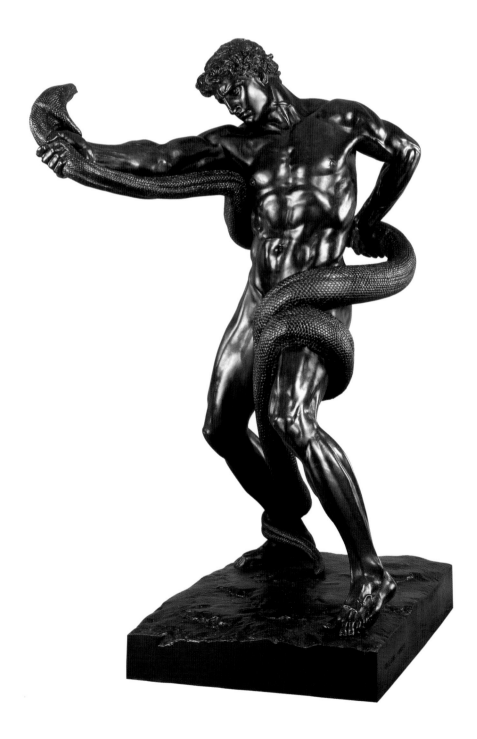

Hamo Thornycroft (1850–1925)

154 *Teucer* 1881
Exh. RA 1882
Bronze
240·7 × 151·1 × 66 (94¾ × 59½ × 26)
Tate. Presented by the Trustees of the Chantrey
Bequest 1882

✱

Teucer was exhibited first in plaster at the Royal
Academy in 1881, and the following year in
bronze when it was accorded a prime position
at the entrance to the Lecture Hall and was
purchased by the Chantrey Bequest for the
national collection.

Executed on a grand scale, this taut, alert
figure astounded audiences with its audacious
fusion of classicism and naturalism. As an
evocation of Homer's Heroic Age, the sculpture
was exhibited accompanied by lines from
Pope's translation of the *Iliad* (Book VIII,
359–64), which describe how Teucer, the
renowned archer of the Achaean (Greek) force,
made an attempt on Hector's life with a deadly
arrow shot from his incurved bow. The
narrative moment is realised through a slight
bend which runs downwards from Teucer's
head to his right foot, echoing the elastic
curvature of his bow, while the hero's extended
left arm, thrust almost parallel to the ground,
establishes a stabilising right angle
counteracting the tension of the pose. Despite
having been studied closely from a living
model, Thornycroft's favourite Orazio Cervi,
the vital realism of the figure is offset by its
erect rigidity adding to the overall tension of
the design.

In modelling the figure it is possible that
Thornycroft was seeking to emulate the spirit
of the so-called 'Severe' sculpture of the early
fifth century BC as a correlative to his heroic
masculine subject. The frontal disposition of
the trunk and legs, with arms and head in
profile, respects the conventions of late-Archaic
sculpture, as do the schematic configurations
of the chest and armoured kneecaps.
Thornycroft's skilful blend of linear alignments
with naturalistic detail to give a convincing
representation of the body in motion further
recalls sculptural prototypes such as the
Discobolus of Myron of *c*.450 BC – a reference
picked up by Edmund Gosse, who hoped
Thornycroft would go on to make his mark

as 'the Myron of our English gymnasium'
(*Magazine of Art*, 1881, p.331). With his firm
physique *Teucer* embodied the ethos of
Victorian sport as practised in public schools
and universities, and the pose was indeed
originally conceived as part of a series on
modern sports, although only one further
sculpture in the series was finished: *An Athlete
Putting the Stone* of 1880 (other 'manly' subjects
were developed as small sketches: 'Boxing',
'Cricket' and 'Golf').

Critically perceived as 'virile' and
'masculine', *Teucer* soon became an icon of
British athleticism and was popularised as an
illustration in Eugen Sandow's *Physical Culture*
magazine as an exemplar of physical and moral
endeavour, as a limited edition bronze statuette
issued in 1889, and as a trademark of the
Tate & Lyle Sugar Company. AS

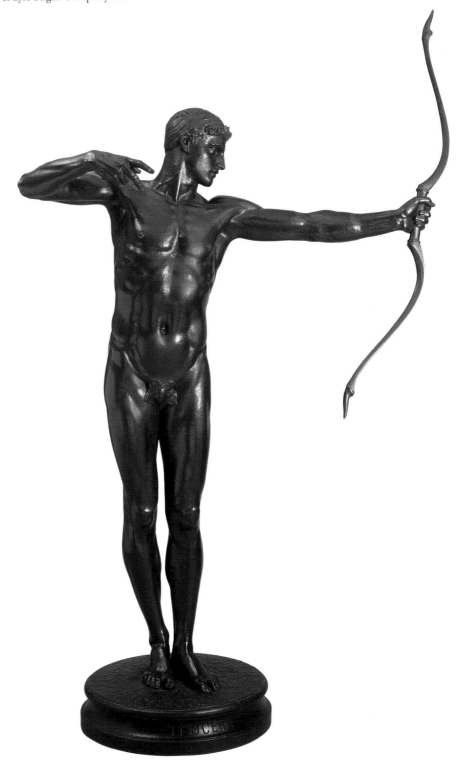

Robert Wiedeman (Pen) Barrett Browning (1849–1912)

155 *Dryope Fascinated by Apollo in the Form of a Serpent*, 1883
Exh. GG 1884
Bronze
196 × 63.5 × 61 (77⅛ × 25 × 24)
Dr Jonathan E. Minns
❀

The career of 'Pen' Browning was overshadowed by the reputation of his parents, the poets Robert and Elizabeth Browning. Despite having trained in Antwerp under Jean-Arnould Heyermans and then in Paris with J.P. Laurens and Rodin, Pen remained dependent on his father, who intervened in art-world politics on his behalf, and suggested many of the themes and titles of his son's works, including *Dryope* from Ovid's *Metamorphoses*, the story of a nymph entranced by Apollo in the form of a serpent. Pen had a lifelong fascination with snakes and in June 1883 purchased a 10-foot python from Senegal which he draped around his Italian model, Adelia Abbruzzesi, in order to develop an earlier idea of a solitary figure which he had cast as a statuette the previous year. The model survived the ordeal but according to one account only because Pen shot at the reptile when it began to tighten its grip around her body (Ward 1972, p.70). *Dryope* was cast in Paris at the Thiebault Foundry and then submitted for exhibition at the Royal Academy where due to the strong objection of the Treasurer J.C. Horsley (see no.53) it was rejected, despite the support of Leighton, a close friend of the Brownings. However, following a personal appeal by Robert Browning, the Grosvenor Gallery overlooked its rule of never accepting Academy refusals and accorded the sculpture place of honour in its 1884 exhibition. That same year *Dryope* was exhibited at the Académie des Beaux-Arts in Brussels and in 1885 received an honourable mention at the Paris Salon.

While the modelling of the figure reveals the influence of Rodin, the interaction of figure and serpent recalls Leighton's *An Athlete Wrestling with a Python* of 1877 (no.153), particularly the concentration of coils around the nymph's left leg. However, the ambiguity of *Dryope*'s attitude, her simultaneous repulsion and mesmeric fascination with the serpent, together with the way she turns away yet proffers a nipple to suckle the creature, strikes an antithetical note to Leighton's theme of manly resistance. The body of the *Athlete* hardens like the armoured carapace of the foe he struggles to conquer, but Dryope twists in sympathetic rhythm to her seducer. AS

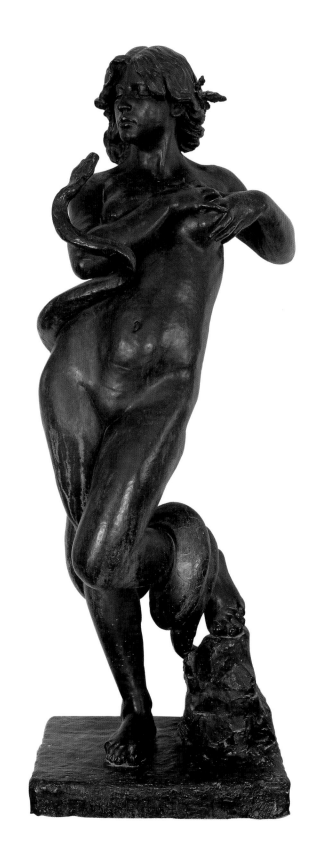

Frederick William Pomeroy (1856–1924)

156 *The Nymph of Loch Awe* 1897
Exh. RA 1897
Marble
26·7 × 64·1 × 22·9 (10$\frac{1}{2}$ × 25$\frac{1}{4}$ × 9)
Tate. Presented by the Trustees of the Chantrey
Bequest 1897

✱

Trained under Dalou and W.S. Frith at the
Lambeth School of Art, Pomeroy went on to
become a star pupil at the Royal Academy
Schools, winning both a Gold Medal and
travelling scholarship in 1885 which enabled
him to complete his education in Paris under
Antonin Mercié. Returning to England in the
late 1880s he collaborated with Leighton on
carving the marble version of *An Athlete
Wrestling with a Python* (no.153).

 The Nymph of Loch Awe derives from the
French motif of a dead or dying female lying
prostrate on the ground and may have been
directly influenced by Dennis Puech's *Nymph of
the Seine*, shown at the Salon in 1894. However,
Pomeroy arranges the limbs of his figure to
emphasise the weight and vulnerability of the
body in contrast to the sensuous appeal of the
typical French nude. This poignant subject was
based on an old legend explaining the origin of
Loch Awe in the Scottish Highlands: 'A Nymph
was set to watch a magic well to see that the
water did not rise above a certain height.
She fell asleep, and the water rose, and she
was drowned' (Cook 1898, p.280). Pomeroy's
achievement in producing such a subtle
simulacrum of a figure abandoned in the
heaviness of sleep persuaded the committee
of the Chantrey Bequest to purchase the work
for the new National Gallery of British Art
following its exhibition in 1897. Onslow Ford
was also struck by the work and strove to
capture a similar sensation of icy death in his
final work, *Snow Drift* of 1901. AS

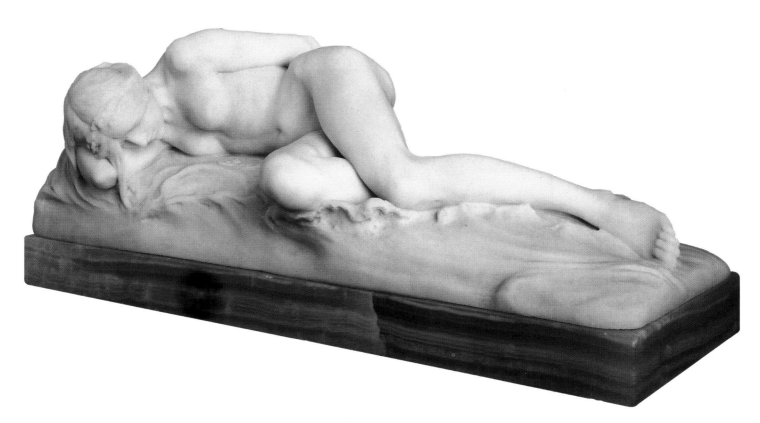

241

Edgar Bertram Mackennal (1863–1931)

157 *Circe* 1902–6
Bronze
63 × 24 × 27 (24³⁄₄ × 9¹⁄₂ × 10⁵⁄₈)
Birmingham Museums & Art Gallery
✱

The Australian-born Bertram Mackennal came to England in 1882 and briefly entered the Royal Academy Schools in 1883 before leaving for Rome and Paris where he was taught by Rodin. In 1894, after leading an international peripatetic existence which was reflected in the Continental style of his works, Mackennal settled in London where he established a reputation for producing elegant figures fashioned in both bronze and marble.

Circe was the mythological sorceress who dwelt on the island of Aeaea upon which Odysseus was cast with his crew. She tempted Odysseus' companions with a magic potion which turned them into swine, but with the help of Hermes Odysseus drank from Circe's cup without harm and persuaded her to restore his men to their former shape. In a symbolic interpretation of her command over men Mackennal presents Circe demonstrating the extent of her hypnotic powers: standing proudly upright with her arms outstretched and attended by entranced serpents she casts her victims into the vortex of orgiastic activity represented in the relief around the base. The sculpture was first conceived in Paris where it was executed on a large scale in plaster and coated with a bronze patination. It was exhibited at the Salon in 1893 where it received an honourable mention and was widely acclaimed for the firmness and sophistication of its design. However, when the same work was shown at the Royal Academy the following year, the Selection Committee felt that the frieze depicting the interweaving bodies of Odysseus' enslaved men (likely to have been influenced by Rodin's *Gates of Hell*, c.1887) was far too carnal for a London audience, and arranged with the artist for the base to be draped with red baize for the duration of the exhibition (*Magazine of Art*, 1895, p.390). This act of censorship attracted considerable press attention and as a result Mackennal received numerous requests for copies of the work. Between 1902 and 1906 he collaborated with the Gruet foundry in Paris in producing a bronze edition of *Circe* on a smaller scale, of which this figure is an example. The original plaster remained with the artist until 1901 when it was purchased by the collector Carl Pinschoff of Melbourne. AS

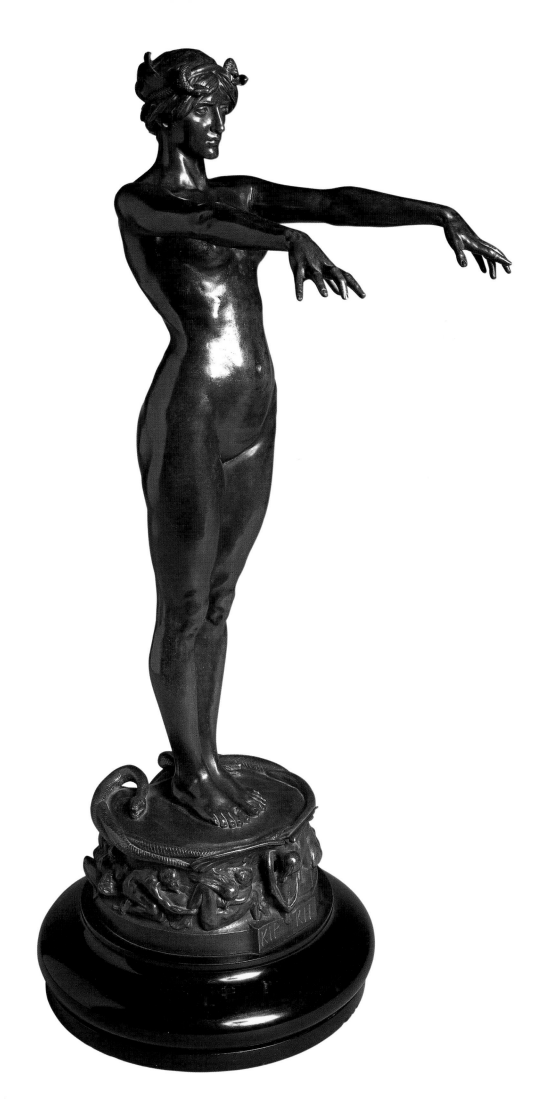

Edgar Bertram Mackennal

158 *Diana Wounded* 1908
Exh. RA 1908
Marble
147·3 × 81·9 × 62·2 (58 × 32^14 × 24^14)
Tate. Presented by the Trustees of the Chantrey
Bequest 1908
✳

Diana Wounded was first exhibited at the Royal
Academy in 1905 in the form of a bronze
statuette covered with a dark-brown patination.
This was followed by a larger plaster version
which was shown at the Academy in 1906, as
the basis for the marble exhibited in 1908 and
purchased by the Chantrey Bequest for the
national collection.

 Mackennal's graceful figure of the virgin
huntress bending around to staunch a wound
in her right thigh is in the tradition of the
bronze Hellenistic statuettes of Aphrodite
adjusting her sandal, but rendered in the
voluptuous manner of the French school,
and may also have been influenced by Arthur
George Walker's *The Thorn* of 1896, as well as
the figure of wounded Aphrodite in Poynter's
painting *A Visit to Aesculapius* of 1880. Indeed
were it not for the attribute of a crescent moon
adorning the goddess's forehead, the figure
could easily be mistaken for a fashionable
modern woman caught in the attitude of
adjusting a garter or stocking. AS

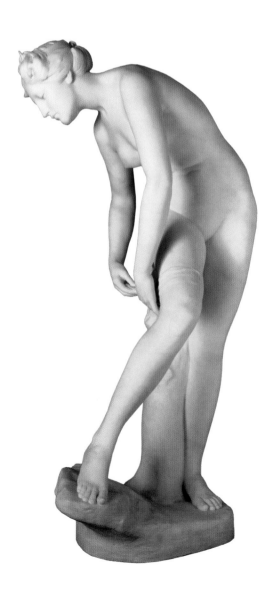

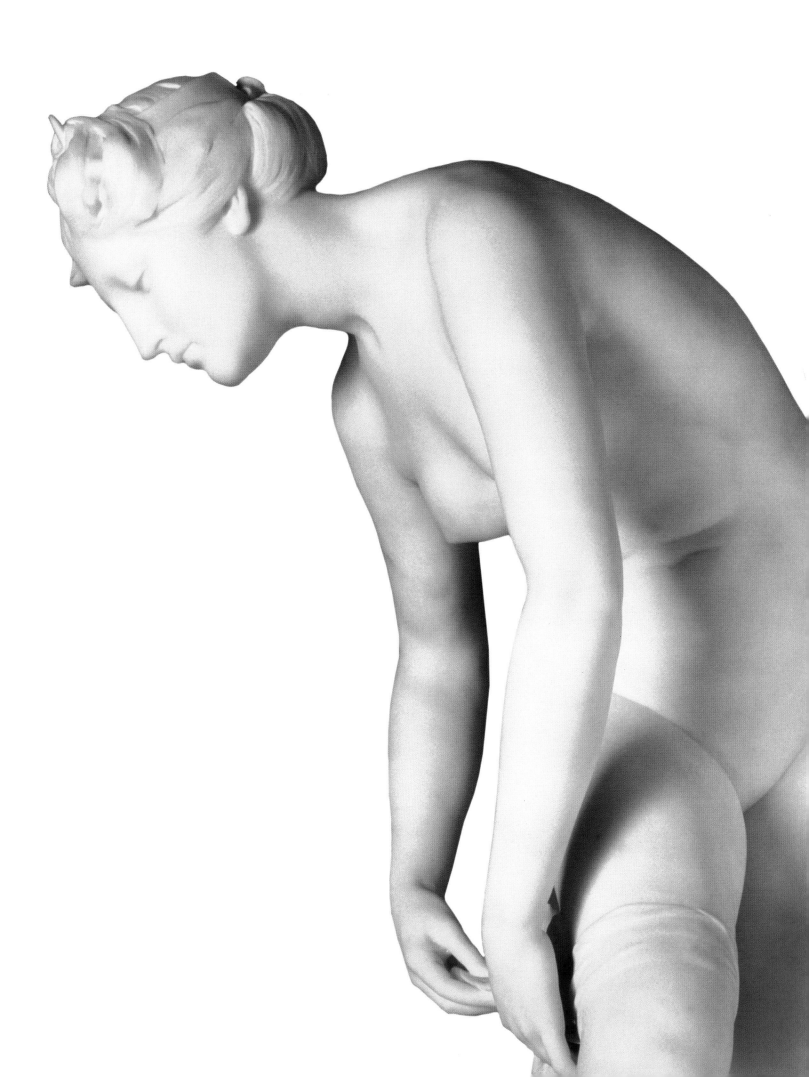

Edward Onslow Ford (1852–1901)

159 *The Singer* 1889

Exh. RA 1889

Bronze, coloured resin paste, semi-precious stones

90·2 × 21·6 × 43·2 (35$\frac{1}{2}$ × 8$\frac{1}{2}$ × 17)

Tate. Presented by Sir Henry Tate 1894

❀

Onslow Ford began his training as a painter in the early 1870s, working in Antwerp and then Munich where he studied under Michael Wagmüller who encouraged him to take up modelling in clay. Although Ford went on to establish a reputation as a sculptor he never abandoned his early interest in colour and pigmentation, dedicating the rest of his life to the creation of surfaces which astonished audiences in their variety and verisimilitude. During the mid-1880s he developed a close working relationship with Alfred Gilbert (see no.49) who occupied a neighbouring studio in London, and together they experimented with lost-wax processes to achieve an impression of colour in sculpture through surface qualities alone. It was around this time that Ford used the *cire-perdu* method to produce a series of bronze statuettes of nude girls posed in the self-conscious attitudes characteristic of adolescence, of which *The Singer* is a striking example, showing a harpist chanting as she nonchalantly strikes a chord on her instrument. The overall aim of synaesthesia is enhanced by the introduction of polychromatic devices: the turquoise and garnets inserted into the singer's circlet and the innovatory combination of resin and pigment to create the cloisonné-type panels around the base (Laurenson 1999, pp.37–8). As in Normand's *Bondage* (no.152), the introduction of archaeological motifs, such as the hieroglyphs and Egyptian figures on the base, adds to the sense of Orientalist otherness. Only the gauche expression of the girl disturbs the mood of reverie, introducing a contemporary note into this otherwise exotic composition. AS

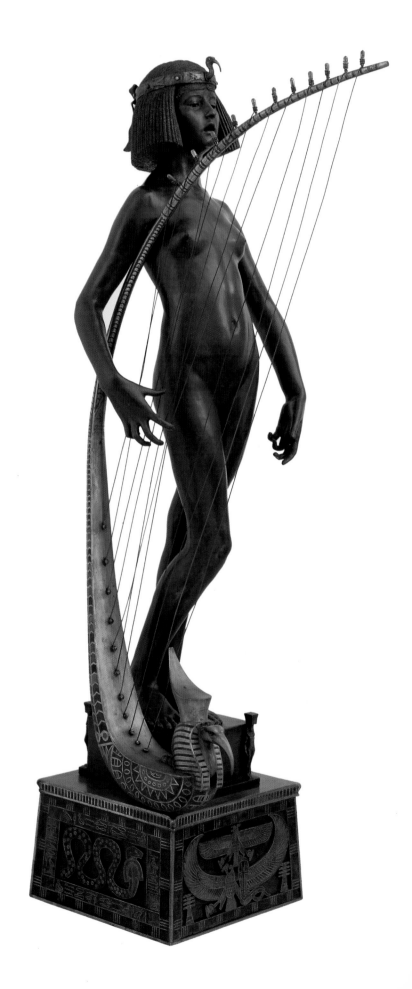

160 Edward Onslow Ford

Folly 1886
Exh. RA 1886
Bronze
88·7 × 41·5 × 33 (34⅞ × 16⅜ × 13)
Tate. Presented by the Trustees of the Chantrey
Bequest 1886

✣

Folly, the first of a series of allegorical female
nude bronze statuettes produced by Onslow
Ford, established his reputation as one of the
most innovative sculptors of the day. The Tate
version is one of only three casts known to have
been modelled by the artist and was bought by
the Chantrey Bequest following its exhibition at
the Academy in 1886. The novelty of the piece
resides in its disregard for classical iconography
and the conventions of ideal beauty. Any moral
reading suggested by the title is cancelled by
the figure of Folly herself who is presented as a
jejune adolescent with tousled hair, poised
precariously on a rock. Her fey gesticulations
and ungainly attitude add to the awareness
that considerable technical expertise has
been applied to the portrayal of what was
then referred to as a 'giddy' girl (see Gosse
1894, p.282).

Lost-wax methods are used here to enhance
the actuality of the figure at a careless moment,
the artist even going so far as to press strands of
animal hair into the wax to create the effect of a
tangled mop. Such attention to surface detail
led a number of critics to pronounce the work
unduly realistic, the term signalling a too literal
transposition of the mundane into the sculpted
object. Although the male nude bronzes
produced by Leighton, Gilbert and Thornycroft
just prior to *Folly* had also been considered
realistic, these works were evaluated mainly on
their technical merits, whereas Ford's figure,
being female, invited a moral response. Claude
Phillips for one cautioned: 'the highest truth is
not necessarily attained by a reproduction of
the accidental imperfections of individuals,
but rather by a selection which shall take all
that is expressive and essential, and cast aside
or simplify the rest' (*Academy*, 29 May
1886, p.385).

In foregrounding the particular female body
Onslow Ford was by no means unique, for a
number of painters and sculptors of the time
were criticised for elevating the peculiarities of
their models above classical standards of beauty
(see no.144). What made *Folly* appear so daring
was the curious interplay of exquisite
workmanship and surface realism, a quality that
was seen to invite physical engagement with the
figure as both a precious object and a real body.
In an important defence of *Folly* Marian
Hepworth Dixon (writing under the pseudonym
Marion), attributed the revolutionary modernity
of the work to the 'loving fidelity' of its
treatment, arguing that realism in sculpture did
not necessarily involve a loss of poetry but rather
opened up a new awareness of the sculpted body
itself (*Art Journal*, Sept. 1898, pp.294–5). This
view may help explain the irresistible appeal of
Folly, which was subsequently reduced to a
smaller scale by the founder Arthur Collie and
issued as an *objet d'art*. AS

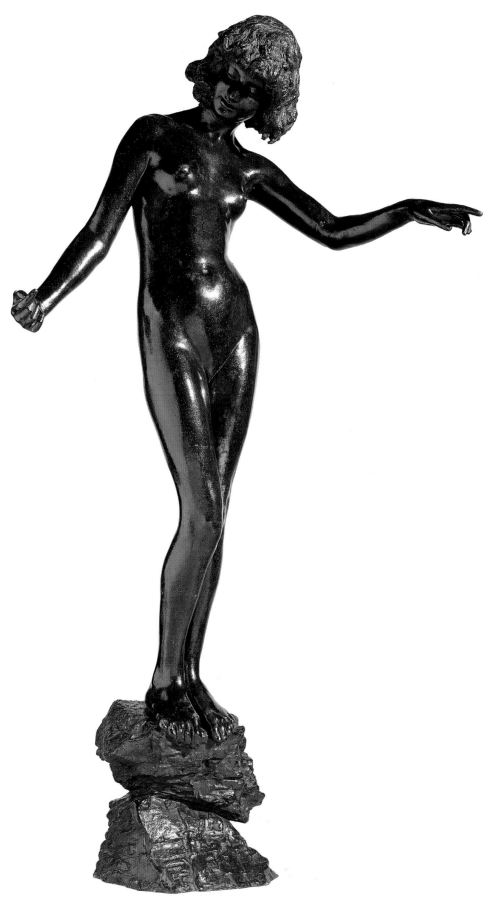

The Modern Nude

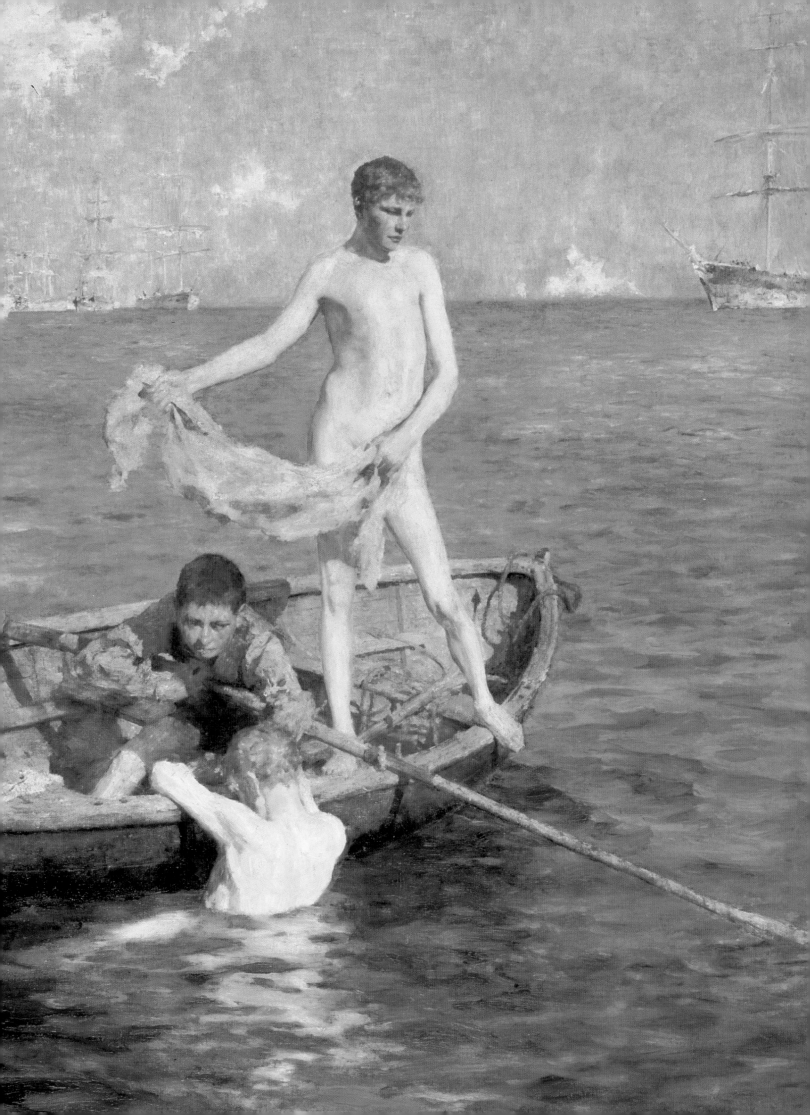

Boudoir nudes by a younger generation of painters such as Whistler, Sickert and Steer began to appear in the closing decades of the century, inspired by the French painters Degas, Renoir and Manet. They showed intimate moments of washing or undressing in bedrooms, hinting at the preparation for or possibility of sex, or scenes amid rumpled bedsheets that suggested the aftermath of erotic encounter. Such pictures took the nude away from any connection with classical myth, and instead located it firmly in the modern day, in a domestic environment, in a mixture of realism and naturalism. The bedroom setting was a justification of the model's nudity, but the contemporary, sometimes seedy interiors in which they were often shown were far from the elevated architecture of ancient Rome, and attracted great criticism. Many of these works were also painted in an avant-garde style, a British version of Impressionism, that was greeted with revulsion by conservative critics and Royal Academicians, who saw it as alien and actually immoral in itself, and, worst of all, French. William Orpen subverted such responses by adopting a painterly, Rembrandtesque style for *The English Nude* (no.166), but he never exhibited it, perhaps deterred by the inevitable critical reaction still possible in 1900 to the charged sensuality which pervades the picture. Gwen John seemed to draw a line under the boudoir genre with her *Nude Girl* (no.168), not only because this is a woman looking at a woman, but because the room itself has evaporated. Placed starkly against a plain wall, John's model appears emaciated and vulnerable, but her strong, direct gaze challenges the viewer.

The 1880s and 1890s saw the placing of the nude in a plein air environment. This emerged partly as a result of a turn towards rural-naturalist painting before the subject by cutting-edge British painters, inspired by developments in French art. Many of the most advanced pictures were shown at dissident exhibiting societies such as the New English Art Club, founded in 1886 as a direct challenge to the conservatism and influence of the Royal Academy. Steer's *A Summer's Evening* (no.182) and Harrison's *In Arcadia* (no.183) were both shown here, and as well as adopting a radical technique – Steer formulating a version of divisionism – they also treated the plein air nude on an epic scale usually reserved for classical subjects. This was calculated to provoke, and

Steer's painting was greeted with howls of critical disgust.

But the painted figure in the open air connected too with emerging ideas about the healthy body, and the benefits of fresh air, exercise and bathing, which were in themselves a response to reforming ideas and social policies concerned with public health. Nude male bathing was commonplace in the Victorian era, as many resort beaches were not open to both sexes. British naturism as a distinct doctrine was largely a twentieth-century phenomenon, but had its roots in the formation in 1891 of the Fellowship of the Naked Trust by expatriates in India; as a concept it was subsequently taken up by Fabian socialists and followers of Havelock Ellis. Many painters depicted boys or young men besporting themselves or engaged in athletic pursuits, and although sometimes deriving from a homoerotic sensibility, such representations fitted widespread admiration for the untainted innocence and healthy prowess of gilded youth.

The contrast between indoor and outdoor nudes is interesting, and connects to radically different sets of values. Often it is a distinction between the implications of sex, degeneracy and alienation of the interior, and the more positive connotations of the open air with physical health and comradeship, making connection with the health and efficiency and eugenics movements of the late nineteenth century. RU

Overleaf:
Henry Scott Tuke
August Blue c.1893–4
(no.179, detail)

William Stott (1857–1900)

161 *Wild Flower* 1881
Exh. Paris 1882
Oil on canvas
82 × 48·5 (32¼ × 19⅛)
Oldham Art Gallery & Museum, UK
✱

Stott painted *Wild Flower*, a studio composition based on an unknown child model, in Paris during the winter of 1880–1 and recorded the picture in a notebook as 'Jeune-fille-en blanc/"Fleur Sauvage"/Paris, exhibited Cercle des Arts Libéreaux, 1882'. The title *Wild Flower* may symbolise childish wilfulness, while the first part of this entry clearly alludes to Whistler's *The White Girl* of 1862: indeed, the lack of narrative in *Wild Flower*, together with the model's unbound auburn hair and inscrutable expression, not to mention the white background, rug and fallen petals, all suggest a conscious appropriation of Whistler's iconography. However, the theme of tainted innocence subtly implied in *The White Girl* is treated with much greater daring in Stott's image, with its startling juxtaposition of vulnerable exposed flesh against soft fur offset by brittle roses. Both the crease across the girl's stomach and her downcast exhausted demeanour create an intimation of violation made all the more disturbing by the model's childlike figure: the shadow along her left arm partially obscures her tiny waist and hips. Although it was customary for children and adolescents to pose as models (see nos.100–103), the absence of any allegorical or mythological message in this painting enhances the viewer's sense of tense psychological intensity; by contrast Stott's portrayals of naked boys are more informal and uninhibited (Brown 1999, p.26).

It was probably due to the sensitive undertones of the subject that *Wild Flower* was only exhibited once during Stott's lifetime. It was not shown at his solo exhibition at Durand-Ruel in Paris in 1889, nor was it among the paintings he sent to Les XX at Brussels in 1884 and 1889. In 1902 it appeared at a posthumous exhibition of Stott's work at the People's Palace in Glasgow and in the autumn of 1912 it was shown in Manchester. Since then it has only been exhibited once at Oldham in 1987, when it had to be removed due to vociferous complaints from a local official. AS

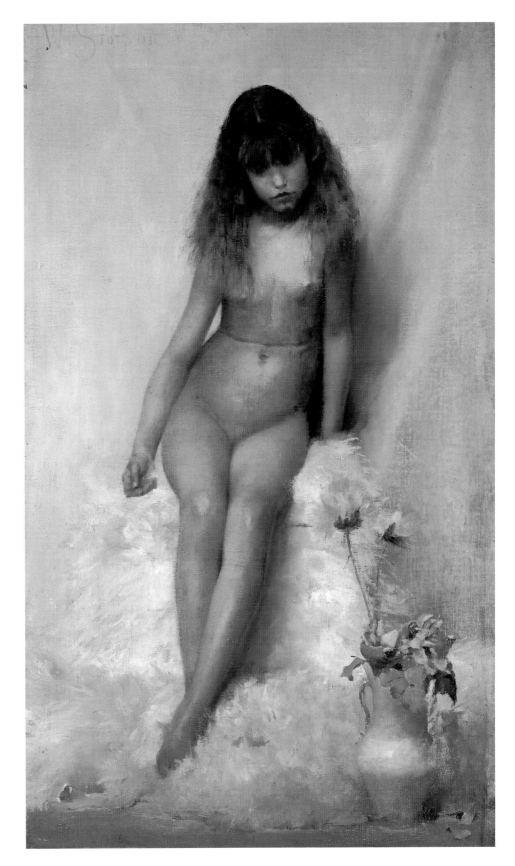

Théodore Roussel (1847–1926)

162 *The Reading Girl* 1886–7
Exh. NEAC 1887
Oil on canvas
152·4×161·3 (60×63½)
Tate. Presented by Mrs Walter Herriot in
memory of the artist 1927

✳

This was Roussel's principal contribution to the
1887 exhibition of the New English Art Club, the
first time he had shown there. A dissident group
of Impressionists, rural naturalists and aesthetic
painters, the NEAC sought to challenge the
conservative grip of the Royal Academy and
bring modern British art up to date. The 1887
show was the second the NEAC had staged; its
first the previous year had attracted some
favourable comments, but also flushed out
conservative reactions. In the *Magazine of Art*
George Clausen defended himself and his fellow
NEAC members, only to be denounced by the
pugnacious Academician William Powell Frith:
aestheticism was 'pernicious', Impressionism
and naturalism 'dangerous'. 'Born and bred in
France,' Frith thundered jingoistically, 'what is
called impressionism has tainted the art of this
country' (1887, pp.189–91). The large nude by
Roussel, while not Impressionist and actually
stylistically restrained, must have seemed
provocative in this context, and large-scale
nudes were prominent in the 1887 show in
which Alexander Harrison's *In Arcadia* (no.183)
was also included. Roussel was French, although
he had settled in England in the 1870s and
married an English woman. In the 1880s he was
one of Whistler's close circle, and *The Reading
Girl* has a Whistlerian restraint in its limited
colour and tone, and sense of aesthetic reverie,
while the draped kimono nods towards
Japonisme. But there are interesting echoes
too of Manet's *Olympia*, which had caused
such a scandal in France, as Roussel was aware.

Whistler met Roussel in 1885 and was
impressed by the scientific and theoretical
process he was developing with which to make
his pictures. Roussel dubbed this 'Positive
Chromatic Analysis', which he described as
'the means of discovering in any pigment of the
palette the prismatic rays it reflects ... so that ...
you can ... analyse in a moment any of these
pigments and with the proper allowance for
tonality extract from it one or more of its
chromatic components' (Rutter 1926, p.14).
Such scientific accuracy demanded reliance
on many subtly graded variations of pigment.
Roussel was technologically inventive, and his
friend the artist Mortimer Menpes recalled that
to facilitate his Positive Chromatic Analysis
he 'had designed a series of mathematical
instruments for matching the tones of nature ...
and worked out a scheme for mixing perfectly
pure pigment' (1904, p.20).

Lacking classical reference, still a dangerous
practice when painting the nude on such a
scale, Roussel's *The Reading Girl* excited some
strong criticism, no doubt exacerbated by
Roussel's nationality. The reactionary *Spectator*
demonstrated what fervent responses such
treatments of the nude could elicit. Reviewing
the NEAC show it commented:

There is one picture here of which we
feel inclined to speak in terms of severe
depreciation, if only because of its
wantonness in taking a beautiful subject
and making it all at once odious and ugly.
And this is M. Theodore Roussel's life-size
work of an entirely nude model sitting
reading the newspaper in a small folding
chair. Our imagination fails to conceive any
adequate reason for a picture of this sort. It
is realism of the worst kind, the artist's eye
seeing only the vulgar outside of his model,
and reproducing that callously and brutally.
No human being, we should imagine, could
take any pleasure in such a picture as this; it
is a degradation of Art. (16 April 1887, p.527)

Roussel's model was Harriet Selina Pettigrew
(1867–1953), known as Hetty. She was the
oldest of three sisters who were popular artist's
models (see nos.92, 170, 182). Hetty met
Roussel in 1884, and became his mistress and
bore him a child; but when Roussel's first
wife died he did not marry her, and he married
Arthur Melville's widow Ethel in 1914. After
this date Hetty stopped modelling for him.
She was engaged at one point to the successful
sculptor John Tweed (1869–1933), and Hetty
herself exhibited pieces of sculpture. RU

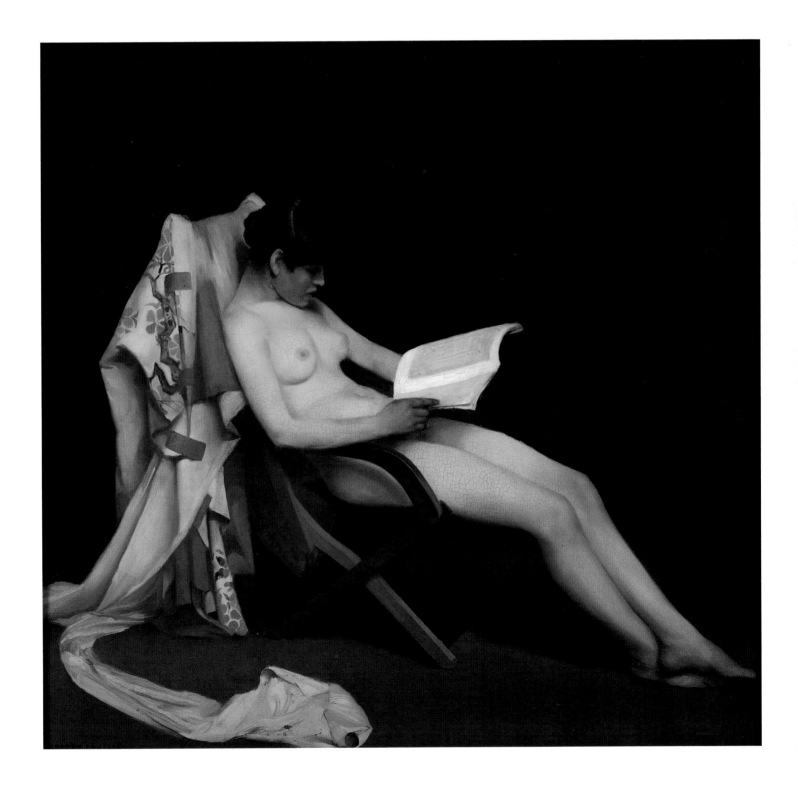

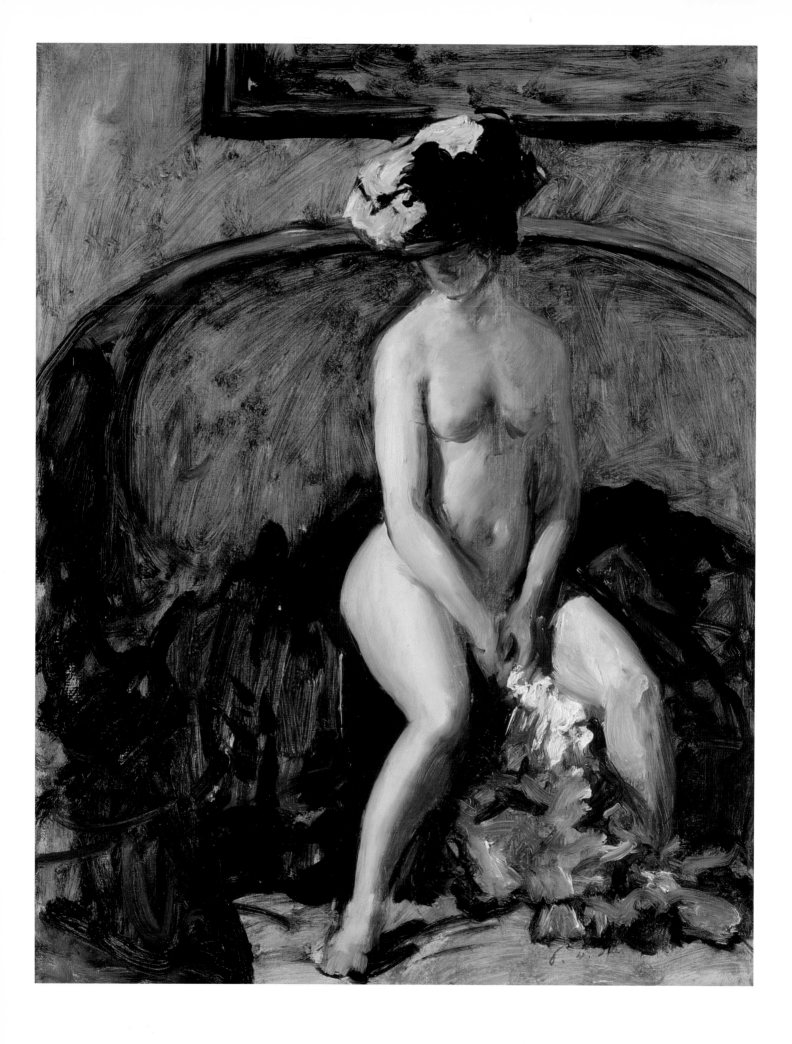

Philip Wilson Steer (1860–1942)

163 *Seated Nude: The Black Hat c.*1900
Oil on canvas
50·8×40·6 (20×16)
Tate. Presented by the Contemporary Art
Society 1941

✳

Steer experimented with the nude in a number of pictures around the turn of the century, ranging from the naturalism of pictures such as this to the baroque richness of T*he Toilet of Venus* (1898). Freely painted, the bedroom setting here increases the eroticism of the subject, and has interesting affinities and contrasts to William Orpen's drawing *A Nude Girl Seated on a Bed* (no.172) and his subsequent *The English Nude* (no.166). Although she has otherwise completely undressed, the model retains her hat, a feature which serves to emphasise her nakedness. The contrast between nudity and exotic headgear is found occasionally in Renaissance treatments of the male nude such as Donatello's *David*. Such was the negative response to *Seated Nude: The Black Hat* by Steer's intimates, that he never exhibited the picture and it remained in his studio until in 1941 it was bought by John Rothenstein for the Contemporary Art Society and presented to the Tate Gallery. Steer explained to Rothenstein: 'when it was painted, years ago, friends told me it was spoiled by the hat; they thought it was indecent that a nude should be wearing a hat so it's never been shown' (quoted Chamot, Farr and Butlin 1964, II, p.686). The model was a Miss Geary, who also posed for a standing nude in the same hat. RU

Walter Richard Sickert (1860–1942)

164 *La Hollandaise c.*1906
Oil on canvas
51·1×40·6 (20⅛×16)
Tate. Purchased 1983

✳

After his return from Dieppe in 1905 Sickert embarked on an intensive period of painting nudes in a variety of rooms and studios in Camden Town. Through these, and other pictures of figures in dusty London interiors, Sickert pursued his own distinct form of realism. He believed that the figure in 'the definite light and shade of ordinary rooms' was the only viable replacement to 'the bland monotony of the nude on a platform, with its diffused illumination of studio light' (quoted *W.R. Sickert* 1989–90, no.4). Responding to French realist and Impressionist art, Sickert also passionately believed in the poetic potential of scenes from ordinary life if treated correctly. Nevertheless, Sickert did not devote himself to mere prettiness and he could be brutal in his realism. The nude in *La Hollandaise* sprawls on a cheap iron bed and rumpled sheets, her foreshortened position emphasizing the solidity of her figure. Painted economically and fluidly, with a restricted palette, the model's face falls in shadow. But Sickert has curiously dashed in her facial features, with deliberately broad brushstrokes so that her identity, her individuality, is obliterated. It gives a harsh, brutal quality to the picture. Sickert's title may derive from *Gobseck* by Balzac, a writer he greatly admired, in which the prostitute Sara Gobseck is known as 'la belle Hollandaise'. If so, this might suggest the picture's model was a prostitute, or else Dutch. In common with so many of Sickert's pictures from this time a mirror adds recession to the scene, and he has positioned the bed near a window, so that light floods in from the left. In Sickert's article 'The Naked and the Nude' which he published in the *New Age* in 1910 he concluded that 'Perhaps the chief pleasure in the aspect of a nude is that it is in the nature of a gleam of light and warmth and life. And to appear thus, it should be set in surroundings of drapery or other contrasting surfaces' (*New Age*, 21 July 1910; Robins 2000). Sickert's article was formed around an argument for art students to be taught to draw more often from clothed models which would be more relevant to modern subjects. RU

Walter Richard Sickert

165 *Woman Washing her Hair* c.1906
Oil on canvas
45·7×38·1 (18×15)
Tate. Bequeathed by Lady Henry Cavendish-Bentinck 1940

✻

Sickert was in Paris in the autumn of 1906 preparing for his showing of ten pictures at the Salon d'Automne and his solo exhibition at the Galerie Bernheim-Jeunne. He took a room for some weeks at the Hôtel du Quai Voltaire, which overlooked the Seine, and he wrote to his friend William Rothenstein that he was 'doing a whole set of interiors in the hotel, mostly nudes' (unpublished letter; quoted *Sickert* 1993, p.184). Sickert had first stayed at the Quai Voltaire in 1883 with Oscar Wilde when he accompanied Whistler's portrait of his mother to the Salon; as Sickert would have known, it was in one of the hotel's bedrooms that Wilde had died in 1900, in exile in Paris. On this 1883 trip Sickert met Degas for the first time; the two formed a firm friendship of which Sickert was to be greatly proud and which was to be important for the direction his art was to take. Sickert's *Woman Washing her Hair* shows the continued influence on him of the French artist. In a voyeuristic moment of bathing intimacy typical of Degas, Sickert crops off the head in a composition which in showing a keyhole-like view is also reminiscent of Degas. However, the decorative effects of wallpaper and carpet confined by strong verticals and horizontals, and in addition the subject of ablution, was also probably influenced by Bonnard, whose work was visible that year at the Salon d'Automne.

Sickert used two models at the Quai Voltaire, Adeline and Blanche. It was the latter who posed for this picture, and Sickert wrote warmly to his friend Nan Hudson that she was 'most enchanting … the thinnest of the thin like a little eel, and exquisitely shaped, with red hair', who 'called the part she sat upon "ma figure de dimanche" and had endless other endearing sayings' (letter in Tate Archive; quoted *Sickert* 1993, p.184). RU

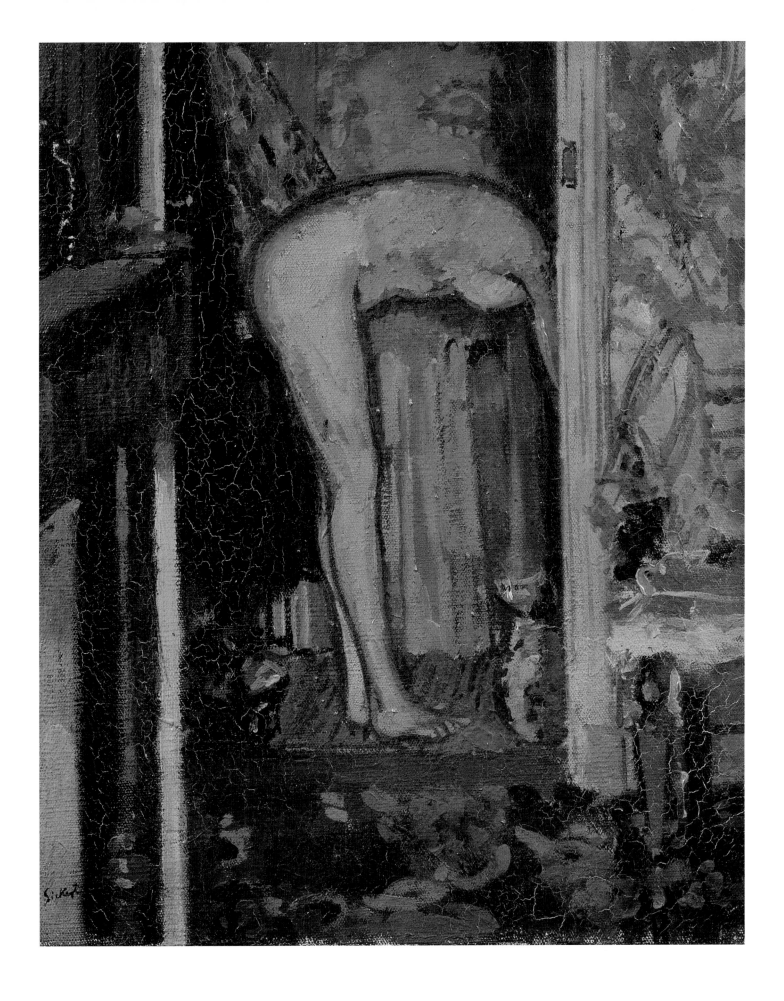

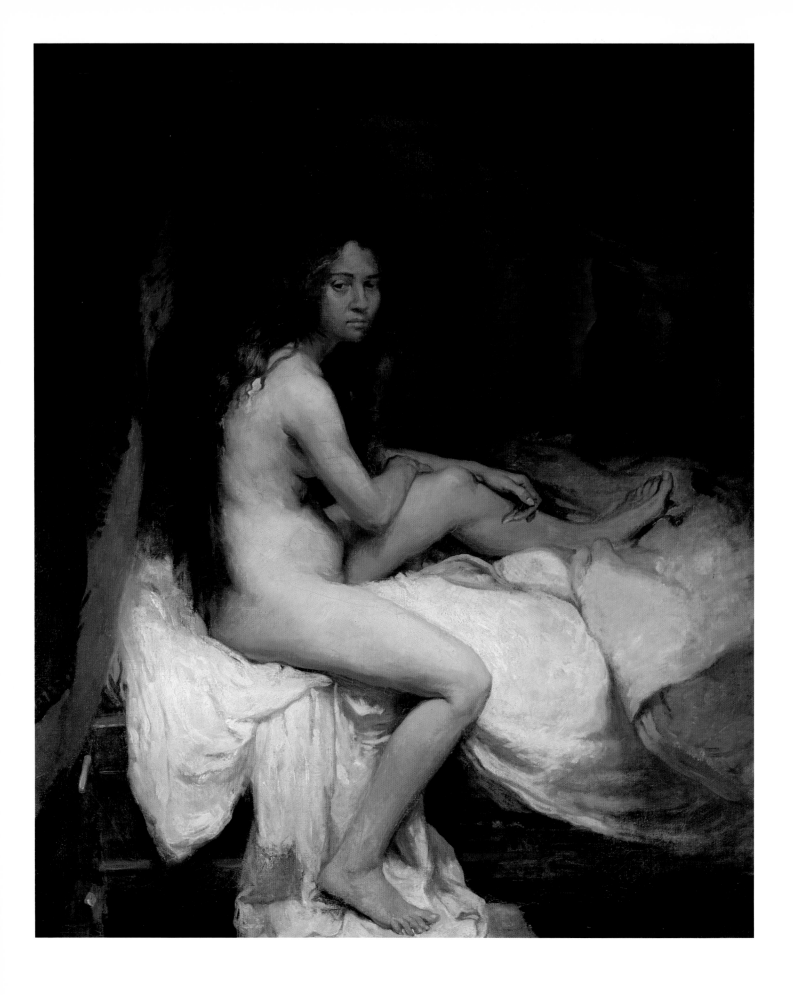

William Orpen (1878–1931)

166 *The English Nude* 1900
Oil on canvas laid down on board
91·8×71·9 (36$\frac{1}{8}$×28$\frac{1}{4}$)
Mildura Arts Centre Collection, Senator R.D.
Elliott Bequest, presented to the City of
Mildura, Australia, by Mrs Hilda Elliott, 1956
✳

This is one of a series of major paintings
Orpen made in 1899–1900 which seem self-
consciously to demonstrate his mastery over a
range of artistic categories: subject genre in the
complex *Play Scene from 'Hamlet'*, which won
him the 1899 Slade composition prize; the
virtuoso swagger portrait of his friend Augustus
John; the 'aesthetic' portrait arrangement with
knowing Old Master references of *The Mirror*
and *The English Nude*, in which his complete
understanding of the potential of the naked
form is clear. The picture was painted in
Orpen's basement-cellar room at 21 Fitzroy
Street, and possibly also worked on during a
trip to Cany in France. The room was dank and
dark, with an earth floor, and rats occasionally
gnawed the edges of Orpen's canvases. Into this
space was introduced a huge four-poster bed,
whose top must have nearly touched the ceiling.
The model for the picture was Emily Scobel.
She had wanted to be an architect, but when her
family ruled this out, she ran away from home
and earned a living as a model at the Slade.
Orpen and Emily became engaged around the
time this picture was made, but she broke it off,
according to her daughter because she found
him too ambitious. She was clearly a woman
of great charm and character. A contemporary
photograph shows her looking back over her
shoulder, hair down, and wearing a man's
corduroy or canvas suit and hat (reprod. Arnold
1981, p.77). She later married Orpen's Slade
contemporary Max West and had a large family.
Although he was concurrently continuing a
flirtation with Grace Knewstub, his friend
Albert Rutherston's sister-in-law, whom he
eventually married, Emily seems to have been
Orpen's first true love. Twenty years after, his
marriage in tatters, and traumatized by the First
World War, he remembered her with warmth
and poignancy. Whether their relationship
crossed the boundary into the sexual can only
be speculated upon. Emily accompanied him
to France, and again posed naked for him
outdoors. The warm intimacy of *The English
Nude*, and the sense of connection Emily's gaze
establishes point towards a strongly established
relationship and physical familiarity.

Orpen's nude was clearly influenced by
Rembrandt's pictures, both in its intimacy,
shadows and lighting effects and rich glazes.
In particular, Rembrandt's *Bathsheba* seems a
specific and close precedent, which Orpen
would have seen in the Louvre on the trip he
made to Paris specially to see Leonardo's *Mona
Lisa*. Orpen was enormously impressed too by
the large exhibition of paintings, drawings and
prints held at the Royal Academy in 1899, and
which stirred him to turn to etching himself.
A pencil and chalk study for *The English Nude*
is carefully outlined and cross-hatched in the
manner of a dry point (reprod. Arnold 1981,

p.85), suggesting that Orpen considered the
picture as a subject for a print.

Despite its Old Master precedents, Orpen's
treatment of his nude was advanced and risky.
While Sickert and Steer had shown boudoir
nudes at their toilette, neither had dared to
create a pure nude at this date, and to treat the
subject so sensuously. Amid rumpled
bedsheets suggesting sexual activity, Emily
has a languorous, tousled, sensual appearance.
Perhaps in view of possible criticism or because
of its very personal subject-matter, Orpen never
exhibited *The English Nude*, although it stayed
in his studio until his death. The bed seems to
serve as a symbol for life's rites of passage, the
setting for birth, honeymoon, conception and
death, as well as dreams. Orpen was to return
to the combination of rumpled bed and female
nude in *Nude Study* (no.167) and much later in
pictures such as *The Disappointing Letter* (1921)
and *Early Morning* (1922). Emily's distended
abdomen may merely indicate Orpen's
following of northern Renaissance treatments
of the nude by painters such as Lucas Cranach.
But if she is pregnant it may explain the sudden
collapse of the couple's relationship; Orpen
quoted from Van Eyck's *Arnolfini* portrait, a
picture about a marriage of convenience, in
The Mirror, another picture of 1900 for which
Emily posed.

The elusive title of *The English Nude* is most
likely a play on the contrast between Orpen's
self-conscious Irish identity and that of his
model, as well as lending it an elevated and
characteristically slightly ironic status. RU

William Orpen

167 *Nude Study* 1906
Exh. NEAC 1906
Oil on canvas
56.5 × 81·3 (22¼ × 32)
Leeds Museums and Galleries (City Art Gallery)
✻

Orpen's languid, smouldering nude was painted in Dublin, where he had returned to teach at the Metropolitan School of Art, leaving his young wife Grace in London. Richly coloured, but also restrained, the contrast between light and shade add to its sensuality, while also inviting comparison with the Old Masters Orpen revered. But Orpen's composition was highly original, and the expression of the model's face hints at a deeper, psychological state than vapid nineteenth-century 'dolce far niente' pictures of reclining girls. Instead, this was an overt attempt to portray the sexual, in a way that would still have been deeply provocative in Edwardian England. There is a sizzling post-coital sexuality about the exhausted set of the nude's body, the tousled bedding confirming the suggestion of recent erotic activity. Orpen took great trouble over the picture, and sent Grace a series of letters describing his difficulties, writing in one, when it was nearly complete, that it was 'the most trying job I've ever done, and I feel the result is not worth the "tryingness" – I feel real beaten. Father came in to see it this morning and it would have done you good to have seen his face – but the dear man was too nice to say anything about it' (quoted Arnold 1981, p.177). Although characteristically self-deprecating, Orpen must really have known how original his picture was, and the result was more than worth the effort, not least for the impact it had when first shown at the New English Art Club exhibition. Several critics were horrified; the *Speaker*, evidently unable to engage with the erotic subject of the picture instead attacked Orpen's painterly abilities, writing:

> The nude model lying on the couch in a very bright light is nothing more than female flesh, and possibly a little less, since female flesh showed in light and shadow has often beauties of greys and carnations, subtly interwoven, and this has none. There is no subtlety in Mr. Orpen's recumbent figure, either in its light or shade. In details it is even ugly; where the turned head touches the neck, the fold in the skin is represented by a hard gash. One feels that if the brightness of the light may justify this wound-like modelling, a light so bright is unjustified in art. (quoted Arnold 1981, p.176)

The true mark of Orpen's success can be measured by the picture's swift sale to the Leeds collector Sam Wilson, its inclusion in the 1907 Dublin International Exhibition, and in 1910 the commission by the Tokyo collector Marquis Maksukata to make a second, life-size version. Orpen referred to the *Nude Study* as *A Woman* in his studio book, and it was exhibited under this title and also as *Recumbent Figure*. The model was Flossie Burnett, whom Orpen had had specially sent out to Dublin from a professional modelling agency in Chelsea. At some stage before or during the making of the picture, Orpen and Flossie appear to have become lovers, something quite apparent in the tangible sense of connection in the painting between artist and model. Flossie also posed for *The Eastern Gown*, another overtly erotic work in which she stands before a mirror, her Arab gown held open to reveal her nakedness. She also appeared in less contrived circumstances seated on a sofa in the watercolour *A Model*, in which the *Nude Study* is seen hanging on the wall behind her. Orpen had subsequent mistresses, but also formed warm platonic friendships with other women. He was reputed to treat his models with kindness and respect. Connie, a model from the same agency as Flossie, who began working for him in 1913, recalled that he always paid her a retainer whether she posed or not, and gives a vivid snapshot of the trials of modeling: 'There was no meanness in him ... I modelled for them all at that time: John, William Rothenstein, his brother Albert ... There was meanness in all of them. John expected you to sleep with him every time. And he wasn't very polite about it. Others were mean over money. But not Orpen' (quoted Arnold 1981, p.180). RU

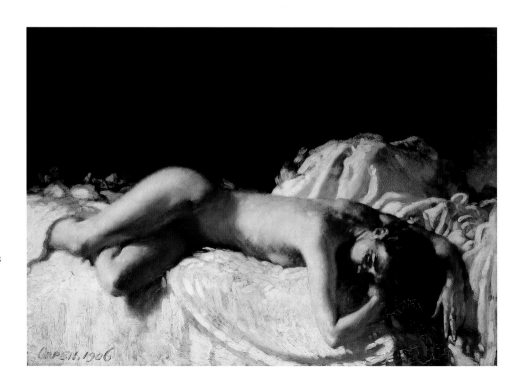

Gwen John (1876–1939)

168 *Nude Girl* 1909–1910
Oil on canvas
44·5 × 27·9 (17¹⁄₂ × 11)
Tate. Presented by the Contemporary Art
Society 1917

✿

During her lifetime Gwen John's career was
eclipsed by her flamboyant brother Augustus's
fame, although he himself always considered
her the better artist. In the decades following
her death appreciation of Gwen's gifts grew as
her work became visible in public collections,
until her own reputation in turn outshone
Augustus's. The calm, contemplative quality
of her pictures, and their rich interiority,
were finally fully recognized. After training at
the Slade, Gwen John attended Whistler's
Académie Carmen in Paris from 1898 to 1899.
In 1903 she settled in France permanently,
where she lived for the rest of her life. The
picture shown here is one of a pair of portraits
of the same model, made in Gwen John's rooms
in Paris. The other, *Girl with Bare Shoulders*
(1909–10), shows the model almost identically
posed, but clothed wearing an off-the-shoulder
dress. Both have a vital immediacy and
intensity in their approach to the figure. The
lack of foreground and plain, flat background –
both features derived from Whistler – focus
attention fully, almost uncomfortably on the
sitter; the intensity of her direct gaze heightens
the effect. The model was Fenella Lovell, whom
Gwen John knew in Paris and paid to sit for her.
The two did not get on, and the artist came to
loathe her, an emotion which perhaps found
its way into the pair of pictures. She wrote to
her friend Ursula Tyrwhitt about the clothed
picture in September 1909:

> I have not been able to paint much, only
> lately and I have done quite quickly the
> portrait of Fenella ... I think it will be good ...
> no one will want to buy her portrait do you
> think so? It was rather foolish of me to begin
> it but I meant to do others at the same time.
> I shall be glad when it is finished, it is a great
> strain doing Fenella. It is a pretty little face
> but she is dreadful.

In May 1910 she wrote again to Tyrwhitt
complaining bitterly about Fenella and
explaining 'I want to send two paintings [for
exhibition] ... because I may then sell them and
then I shall pay her what I owe her and never
see her again' (quoted *Tate Gallery* 1990, p.101).
In making this pair of portraits, one clothed,
one unclothed, John undoubtedly had in mind
the famous pair of Maja pictures by Goya, an
artist who in the early years of the new century
enjoyed renewed and widespread admiration.
John's nude derives further impact from the
somewhat emaciated, round-shouldered body
of the sitter. Distanced far from the heroic or
voluptuous nudes of the past, it instead seems
to suggest the vulnerability, weakness and
fragility of humanity. RU

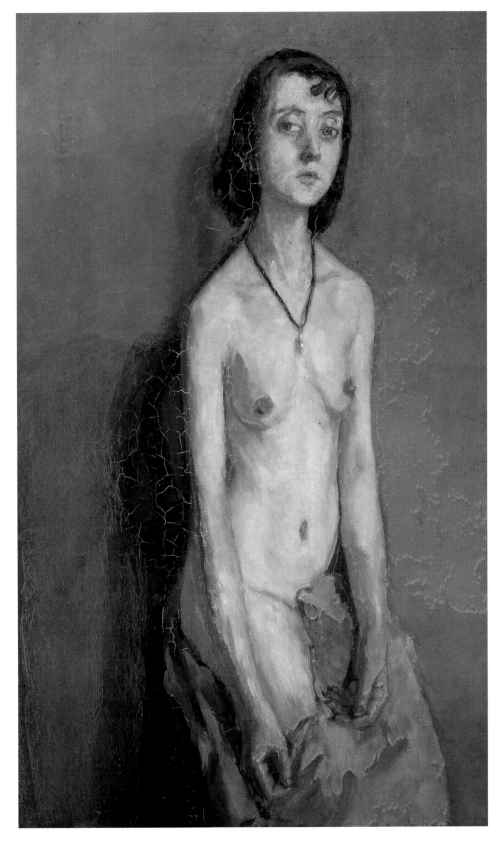

James Abbott McNeill Whistler (1834–1903)

169 *Little London Model* 1896
Transfer lithograph on paper
28·6 × 20·7 (11¼ × 8⅛)
The British Museum, London
❀

Whistler returned to lithography, a print technique towards which he had previously responded ambivalently, in 1887. He was encouraged by his printer Thomas Way, but he was also reacting to the new-found enthusiasm in artistic circles for the process. The boom for etchings was beginning to subside, and there was considerable public confusion between artists' intaglio prints and those manufactured mechanically and issued in art journals. The transfer lithograph, with its spontaneity and tonality, was vaunted as the perfect medium for the painter-printer. Whistler actually referred to his lithographs as 'drawings', as well as poetically dubbing them 'Songs on Stone', and gave them the evocative appearance of insights into the artist's private thoughts and responses. He said of his lithographs that they revealed 'the most personal and the very best proof of the qualities of the man who did them' (letter to Edward G. Kennedy, 14 March 1895, quoted Tedeschi 1998, II, p.266).

Many of Whistler's lithographs were devoted to the figure and specifically to the nude model. His preferred models were young girls in their teens, such as the spirited Pettigrew sisters, who were able to stand up to Whistler (see no.170). However, in *Little London Model* the girl is clearly somewhat younger, and apparently pre-pubescent.

Contemporary attitudes to children were very different to our own, and it was an age in which children worked and child prostitution was rife. The spatial dynamics of the scene – the girl standing isolated in the room – her arm crossed behind her back for comfort, and her evident embarrassment in posing, all make this an unsettling, troubling image. It is not overtly sexualised, or even particularly prurient, but it has a certain coldness of spirit, the uneasy young model firmly under the direction and control of the artist. It is a controlling portrayal of artistic power over his subject. The print was made while Whistler's wife was dying of cancer, and he abandoned lithography the following year in 1897, partly for personal reasons and partly because the market for artists' lithographs had begun to wane. RU

169

Théodore Roussel (1847–1926)

170 *Study from the Nude, Woman Asleep* 1890–4
Transfer lithograph on paper
16·7 × 23·5 (6⅝ × 9¼)
The British Museum, London
❀

When they first met Whistler had greatly admired Roussel's etchings, which were similar in subject and style to his own. They became strong friends, and it seems likely their shared interest in printmaking had led Whistler to pass on to Roussel his new-found enthusiasm from 1887 for transfer lithography. This is a process whereby a drawing is made on transfer paper, and then transferred onto a lithography stone, from which prints can be taken. It allows a soft, tonal print technique, as well as the immediate fluidity and spontaneity of the original drawing it reproduces. The immediacy the technique allowed gave the subsequent print the suggestion of being an intimate glimpse of the artist's creative vision, and frequently, too, a peep into studio life and licence. Like Whistler, Roussel kept editions of his prints small to heighten their rarity, desirability and value; only about twenty *Study from the Nude* prints were pulled, and few of them were signed in pencil as here. Roussel's model was again Hetty Pettigrew (see no.162). She also posed for Whistler, although he favoured her younger sister Rose. It is possible that Whistler and Roussel drew Hetty at the same time on this occasion, as there are strong similarities between *Study from the Nude* and Whistler's etching *Nude Model Reclining* (Kennedy 1974, no.343) and his pastel *The Arabian* (see Hausberg 1991, pp.208–10); the sofa is the same in each work. Roussel made another lithograph of Hetty reclining, but still awake (ibid., no.175). Hetty's sister Rose recalled that Hetty had 'soft straight hair, like a burnished chestnut, glorious skin and big hazel eyes'. Although the sisters liked Whistler, they thought 'he was clever and cynical, loving to say smart things, even if they hurt; my sister Hetty was a perfect match for him, he admired her, and was very amused by her cleverly cruel sayings, even when it was against himself' (quoted Laughton 1971, p.116). RU

Edgar Degas (1834–1917)

171 *Nude Woman Standing Drying Herself* c.1891–2
Lithograph on paper
37·4×26·6 (14¾×10½)
Trustees of the Cecil Higgins Art Gallery,
Bedford
✱

In the later part of his life Degas obsessively
made pictures of women bathing or at their
toilette. The subject was invasively intimate,
allowing the artist and the viewer access to very
private activities. The bathers' self-absorption
and the plausibility of their activity heighten
the voyeurism of this material. Women drying
themselves account for more of these nudes
than any other, and while it allowed Degas to
capture a naturally stretching, tensile pose, the
rubbing of towel against wet flesh is implicitly
erotic. Such works greatly influenced a group of
younger British artists, notably Walter Sickert,
who first met Degas in Paris in 1883. Sickert,
Steer and others went on to produce their own
'boudoir' nudes (nos.163, 165, 174). Degas's
prints were more visible in London than is often
assumed, available from French dealers with
London gallery branches there such as Durand-
Ruel. RU

170

171

William Orpen (1878–1931)

172 *A Nude Girl seated on a Bed* 1899
Pencil, pen and ink and brown wash on paper
26·7 × 21·4 (10½ × 8⅜)
The Trustees of the Barber Institute of Fine
Arts, The University of Birmingham
❀

As he neared the end of his time as a student at
the Slade School of Art, in the winter of 1899
Orpen moved into the basement of 21 Fitzroy
Street. Formerly a brothel, the house was now
leased to the colourful evangelical Augusta
Everett, a distant relation of Orpen's who had
briefly been a middle-aged student at the Slade.
Her son Herbert and niece Katherine, who lived
with her, also attended the Slade, and around
the turn of the century a number of the art
school's pupils lodged with her at different
times. Although Mrs Everett was staunchly
religious she was also unconventional and
bohemian. Orpen used his room to draw and
paint nudes, and it was here that his
relationship with Emily Scobel flowered (see
no.166). The great feature of Orpen's room was
a large, ancient four-poster bed. This was the
setting for *The English Nude* (no.166) and it
allowed Orpen to pose his model in a natural
but suggestive environment. The drawing
shown here is likely to have been an early
product of Orpen's occupation of the room.
He has set the model on the edge of the bed in
a relaxed pose. Her pile of clothes, just taken
off, add immediacy and a further note of
naturalness. But the heavy chain or necklace
around her neck, which Orpen has evidently
had her put on, emphasises her nakedness and
suggests the frisson of cold metal against warm
flesh. Orpen was clearly working through an
idea which was to culminate in *The English
Nude*. The model, as in that picture, appears to
be Emily Scobel, although with her hair pinned
up. RU

173

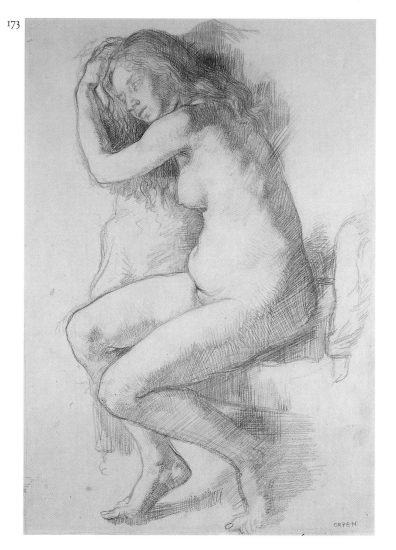

172

William Orpen

173 *Nude Woman* c.1900
Pencil and wash on paper
29·1×20·2 (111$_2$×8)
Trustees of the Cecil Higgins Art Gallery,
Bedford
✿

The Slade School of Art was famed for
the concentration of its teaching on the
importance and primacy of line and quality of
draughtsmanship. Students were encouraged
to examine Old Master drawings in the nearby
British Museum print room, and they also
made copies from the extensive collection
of photographs of such works the school
possessed. Orpen was one of the Slade's great
stars at the turn of the century, and only
Augustus John could match his outstanding
abilities as a draughtsman. The Old Masters
were objects of great admiration for the young
Orpen, and at this time he was particularly
influenced by Rembrandt, the large
retrospective of whose paintings, drawings
and prints he had greatly admired at the Royal
Academy in 1899. Chardin and Watteau were
further sources of inspiration, and these three
figures exerted an influence on him throughout
his career. Orpen's *Nude Woman* is seated on
his bed in 21 Fitzroy Street, and is apparently
a study related to his Rembrandtesque *The
English Nude* (no.166). However, the dense
network of shading and hatching, and the
building up of a lively planar surface through
chiaroscuro recall the drawings of
Michelangelo. The model for Orpen's
drawing was Emily Scobel. RU

Walter Richard Sickert (1860–1942)

174 *Sally* c.1911
Etching on paper
13·3×8·3 (51$_4$×31$_4$)
Trustees of the Cecil Higgins Art Gallery,
Bedford

175 **Walter Richard Sickert**

Sally c.1911
Pen and ink on composition paper
31·1×19·1 (121$_4$×71$_2$)
Trustees of the Cecil Higgins Art Gallery,
Bedford
✿

Sickert's *Sally* was clearly influenced by pictures
and prints by Degas, whom he greatly admired
and had befriended in France in the 1880s. In
1911 and 1912 Sickert made a large number of
figure drawings which were to provide the
mainstay of a group of his prints published by
the Carfax Gallery. In many ways *Sally*, with its
natural excuse for nakedness and subject of
cleanliness, was a return to Sickert's boudoir
nudes of the 1880s and 1890s, a retreat from
the uncompromising harshness or brutality of
pictures such as *La Hollandaise* (c.1906, no.164)
or *The Camden Town Murder* series (1908–9).
This may have been a commercial decision
informed by its intention to be used as a print
subject. As the inscription records, Sickert
made the drawing in Harrington Square in
Mornington Crescent, where he had moved in
1911 after his marriage to Christine Angus.
The model for the drawing was Marie Hayes,
who with her partner 'Hubby' worked as
servants and studio factotums. Together they
sat for Sickert in a number of pictures on the
theme of marital discord, including *Ennui*, *Jack
Ashore* (in which Marie is also nude) and *Off to
the Pub*. Their own relationship was troubled,
caused by Hubby's drunkenness and petty theft,
which eventually led Sickert regretfully to sack
him. The drawing has been carefully built up
with a network of hatching and dashing which
Sickert copied in the subsequent etching,
indicating that he conceived the pen and ink
study with the intention of issuing it as a print.
An initial, larger print was made in 1911, but the
published version was not issued until 1915,
going through four states in which Sickert
experimented with pulls in black, green and
red-brown inks (see Bromberg 2000, no.142).
Sickert's intensive bout of printmaking in 1915
led him to write to his friend Ethel Sands: 'the
restraints of etching have given me a new letch
for the brush' (letter in Tate Archive). RU

174

175

Frederick Walker (1840–1875)

176 *Bathers* 1867
Oil on canvas
91·4 × 210·8 (36 × 83)
Board of Trustees of the National Museums and
Galleries on Merseyside (Lady Lever Art Gallery,
Port Sunlight)

✱

Walker's *Bathers* marked a new departure for
him, as it was the first nude subject he had
exhibited. He was known for his canvases of
realist genre scenes which hinted at a narrative
or symbolic dimension. He intended *Bathers* as
a major statement. Although ostensibly a piece
of realism, showing a naturalistic scene of
youthful pleasure, it also refers to a classical
precedent, quoting Antique sculpture for the
figures, and in overall distribution recalling
Michelangelo's *Bathers*. The background was
painted in the open air, at a spot Walker found
on the Thames near Cookham, working on
the canvas over some considerable period.
The transport of a six-foot picture by train
from London and cross-country to the river
caused him regular logistical stress, as did the
inclement weather he frequently reports in his
letters. The figures were added in his London
studio, although he also brought one boy to
Cookham to model in situ. This ambitious,
compositionally complex work clearly taxed
Walker, and he sent it unfinished to the 1867
Royal Academy exhibition, where its
overworked surface was noted but accepted.
He continued working on it throughout 1868,
and made minor changes the following year
when it was bought from Agnew's by William
Graham. An avid patron of the nude, Graham
paid the large sum of £1,050. However, the
central seated boy with his legs apart, based
on the *Barbarini Faun* (fig.28, p.164), caused
embarrassment for Graham, whose evangelical
friends in London objected to it. Through his
friendship with Walker, and the arbitration of
the Revd Samuel Martin, minister to the
Congregational chapel in Buckingham Gate
where Graham worshipped, the artist was
persuaded to introduce a towel to cover the
boy's genitals (see Morris 1994, p.121). Critical
responses to the picture at its RA showing were
distinctly mixed. Although Walker's biographer,
his brother-in-law John George Marks, listed
many favourable comments (Marks 1896,
pp.102–3), others were less generous. The *Art
Journal* asked: 'Why in the name of all the arts,
it may be asked, should Frederick Walker have
painted *The Bathers*? There are some pictures
it were hard for even genius to justify. That no
ordinary talent presides over this repulsive
production few will deny ... opaque and
muddy ... The picture shows French influence'
(1867, p.143). However, Comyns Carr
defended the naturalistic manner in which it
treated the nude:

It is characteristic of Walker that he should
have seized one of the few opportunities of
modern life for dealing with nude designs ...
it seems to have been one of the fixed
principles of his art not to disturb or depart
from the realities of the world about him ...
to reach the nude without departing from
modern habit ... the union of reality and
refined beauty is successfully established.
(Carr 1879, pp.208–10)

This pseudo-realist aspect of the picture led
The Times to attack it along class lines: with
'no artistic or imaginative purpose' it was
only 'a study of vulgar little boys bathing on
the flat bank of say the River Lea not far from
Tottenham' (13 May 1867). The artist W.B.
Richmond praised it, and there are interesting
affinities with his *Bowlers* of 1870 (no.41).
Walker's picture is an important reconciliation
between classicism and realism, and an early
forerunner of the more naturalistically set *plein
air* nudes of the 1880s. RU

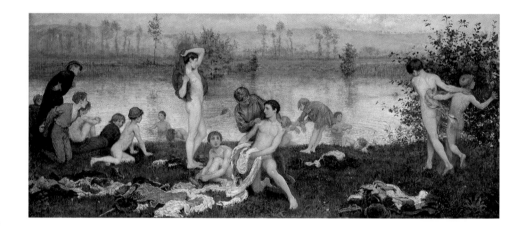

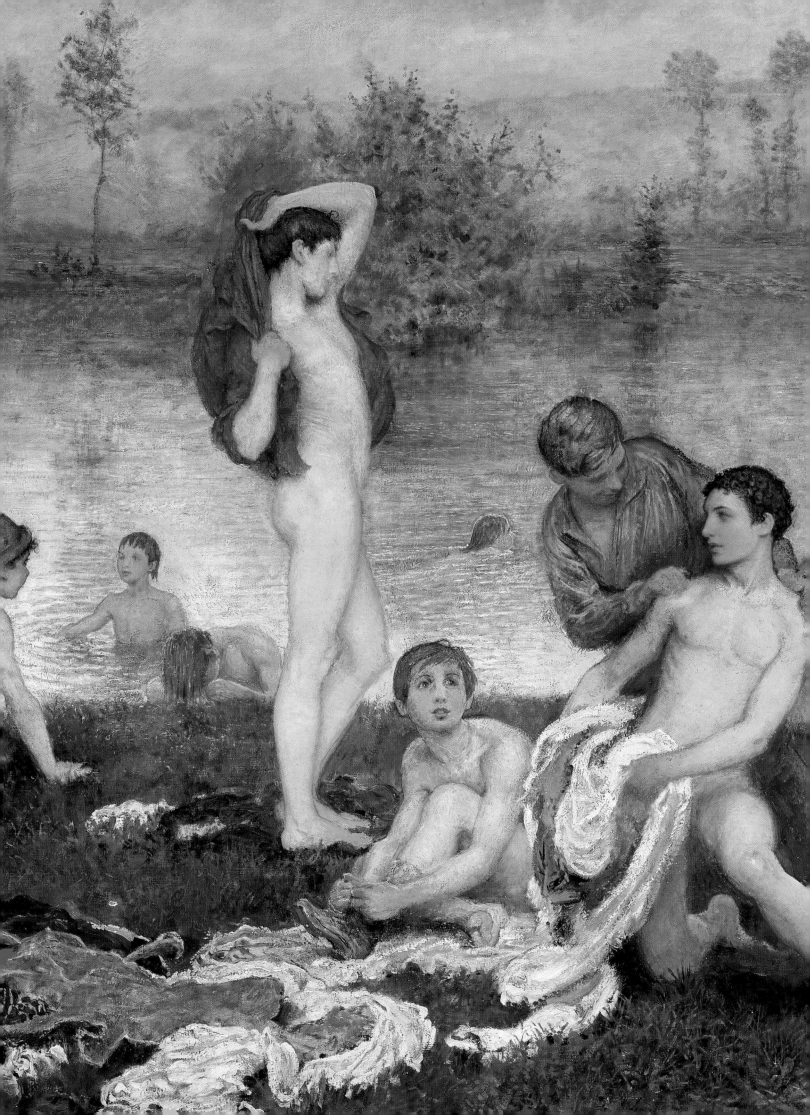

Henry Scott Tuke (1858–1929)

177 *Nude Italian Boy c.*1881
Oil on block end
21·6 × 17·4 (8½ × 6⅞)
The Tuke Collection, Royal Cornwall
Polytechnic Society

✳

In 1881 Tuke travelled to Italy to stay with the
painter Arthur Lemon in Florence. Lemon was
a staunch advocate of plein air painting, and
encouraged Tuke to paint in situ. In June they
travelled to the coast, to stay at the village of
Pietra Santa, between Leghorn and La Spezia.
Here Lemon introduced him to Charles Heath
Wilson, a friend and advocate of Sargent. Tuke
wrote cheerfully to his friend Thomas Gotch:
'We are going to paint nude boys on the shore
in a few days. We began yesterday by sketching
one in the sea, but the approach of females put
a stop to further operations. Both these men
[Lemon and Wilson] are great tonists so I hope
to learn lots' (6 June 1881; quoted Wainwright
and Dinn 1991, p.20). 'We have done several
nude boys on the beach,' he reported later,
'which is more useful than anything for me.
They sit till they are incapable of keeping still
any more, and are richly rewarded with 2d'
(quoted Sainsbury 1933, p.50). Tuke remained
for four weeks in Pietra Santa, discovering a
pattern of working combining sun, sea and
painting nudes outdoors which continued for
much of his subsequent career. His sister later
wrote of this Italian visit:

> He was perfectly happy ... He loved the
> outdoor life, with its combination of
> painting, bathing, boating and congenial
> companionship, and the people of the place
> charmed him, as he evidently charmed
> them. Some of the boys wrote to him
> afterwards, addressing him as 'Stimatissimo
> Signor Ebrico' and he composed Italian
> letters to them – Aristide, Oreste, Egido,
> Lorenzo, Canfino – all their names
> fascinated him. (Sainsbury 1933, p.52)

The carefree Mediterranean life amid simple
but charming local inhabitants Tuke described
was something which attracted many artists
and tourists from northern Europe. The
willingness of young boys to pose naked for
payment, and the tacit social tolerance or
encouragement of such exchanges, added to the
attraction of places such as Naples, Sicily and
Sardinia. The photographs of Plüschow and von
Gloeden are a record of these interests, and it is
interesting that Tuke's *Nude Italian Boy* is posed
in an attitude which might easily be found in
such photographs, raising the possibility that
he may have been aware of them. RU

Henry Scott Tuke

178 *Study for 'A Summer Morning'* 1886
Oil on panel
27·4×21·9 (10¾×8⅝)
The Tuke Collection, Royal Cornwall
Polytechnic Society

✱

Tuke had lived in Falmouth as a boy, and visited since, but in May 1885 he left London to settle there to paint, and remained there for the rest of his life. He was encouraged to settle in the area by the gathering at Newlyn of plein air painters such as Stanhope Forbes. But Tuke chose Falmouth, partly perhaps to distance himself from the Newlyn group, and also for practical purposes. He stated in 1895 that his principal artistic concern was 'to paint the nude in the open air; here there are quiet beaches, some of them hardly accessible by boat where one may paint from the life model undisturbed' (*Studio*, 1895, p.93). The busy, openly accessible beaches of Newlyn could never have offered this privacy, and Tuke seems to have always been concerned with the probity of his artistic practice, as his description of ceasing painting with the intrusion of 'females' in Italy confirms (see no.177). At first Tuke was worried about finding models, and brought with him from London a boy perhaps improbably named Walter Shilling, who modelled for him at the Slade. Stanhope Forbes reported that Tuke 'could get no models and has been painting this British youth in the style the British matron so strongly objects to' (letter dated 14 July 1885; quoted *Artists of the Newlyn School* 1979, p.132). By 1886 Tuke had found a new local model, Jack Rowling, a 16-year-old boy he described as a 'quay scamp'. It seems from the haircut and facial contours that he might be the model for *Study for 'A Summer Morning'*. It is an early example of Tuke's desire to render the play of sunlight and shadow on the body, and the colour and sparkling reflections of the sea. Modelling for Tuke could be hard, as he recalled later in an interview: 'When I first began painting nudes out of doors the model sat out till mid-November, and I used to watch him going pink and blue in patches' (*Windsor Magazine*, 1895, p.606). RU

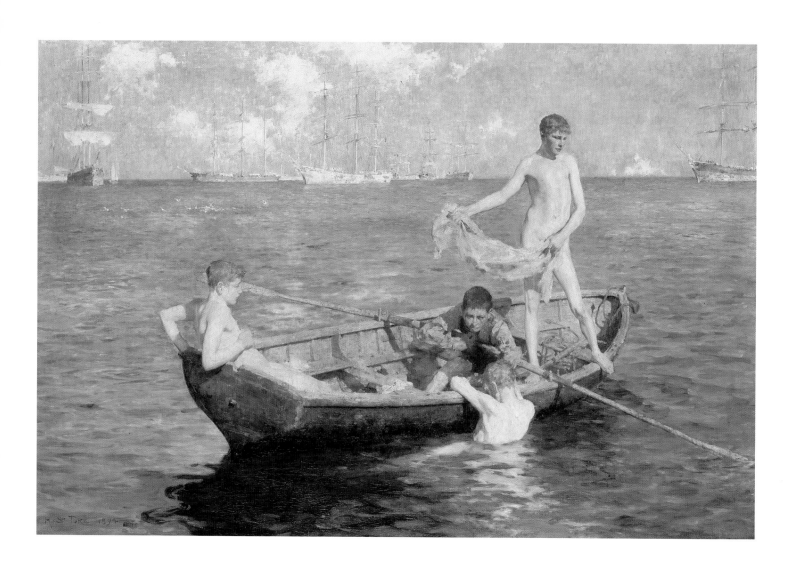

Henry Scott Tuke

179 *August Blue* 1893–4
Exh. RA 1894
Oil on canvas
121·9 × 182·9 (48 × 72)
Tate. Presented by the Trustees of the Chantrey
Bequest 1894
✳

Tuke's *August Blue* was much admired when
shown at the 1894 Royal Academy exhibition,
and it was acquired for the nation by the
Chantrey Trustees for £525. His dramatic
maritime scene *All Hands to the Pumps* had
been a Chantrey purchase in 1889, and to have
a second picture bought was a rare honour.
The perceived suitability of *August Blue* for the
national collection demonstrates how more
readily acceptable the nude had become by
this date, especially when athletic, masculine
bodies were presented in scenes of healthy
outdoor pleasure. Its lack of criticism can also
be accounted for by the lower degrees of nudity
and homoeroticism found in *August Blue* than
in many of Tuke's works. The background was
painted in situ in Falmouth Harbour, but it
seems likely the figures were posed on the
shore or in the studio. For all Tuke's
considerable maritime knowledge, it is likely
the boat would have capsized if the figure
standing in the bow had done so while it was in
water. It is easy to underestimate the radicalism
of Tuke's plein airiste, naturalist approach to
the nude, and his desire to capture the mood
evoked by sun, sea, sand and flesh. He was a
founder member of the New English Art Club
in 1886, and although associated by geography
with the more conservative Newlyn clique
centred around Stanhope Forbes, he was
greatly respected by the more avant-garde
Impressionist faction which included Sickert
and Steer. In reviews of his pictures, Sickert
praised their colouring, and Tuke has used
brilliant pigments to suggest the depth of the
sea's colour and brilliance of the sun. The title
of his picture, like the later *Ruby, Gold and
Malachite*, is Whistlerian in its suggestion of
sensory experience, and this was undoubtedly
deliberate. But 'August Blue' was also a quote
from a poem by Swinburne, 'The Sundew',
which appeared in *Poems and Ballads* (1866).
Ostensibly about the sundew, 'a little marsh-
plant, yellow green', the last two verses
indicate the poem is actually about the yearning
of lost love:

> O red-lipped mouth of marsh-flower,
> I have a secret halved with thee.
> The name that is love's name to me
> Thou knowest, and the face of her
> Who is my festival to see.
>
> The hard sun, as thy petals knew,
> Coloured the heavy moss-water:
> Thou wert not worth green midsummer
> Nor fit to live to August blue,
> O sundew, not remembering her.

In 1880 Tuke had apparently contemplated
proposing to Edith Santley, but was dissuaded
by the much older Samuel Butler, a
misogynistic bachelor (see Wainwright and
Dinn 1991, pp.15–16). Whether this experience
contributed to Tuke's immersion in a
masculine world can only be speculated upon,
but it perhaps informed his decision never to
marry. His pictures today appear transparently
homoerotic, but the celebration of gilded male
youth and athleticism was very much a
contemporary phenomenon. This exultation
of the youthful manly ideal was a trend which
culminated in the patriotic cult of masculine
beauty of Rupert Brooke and his circle. Another
mitigating factor for Tuke's nude bathers was
that this was an everyday scene. The practice of
male nude bathing continued well into the
twentieth century. Tuke's sexual orientation is
difficult to establish conclusively. But he knew
a number of homosexual men, and formed a
friendship with the much older John Addington
Symonds, who greatly admired his pictures.
A critic and writer, Symonds too worshipped
youthful beauty, and had formed passionate and
at times sado-masochistic relationships with
young men. His connection with Tuke points
at least to the painter's easy familiarity with this
sexual milieu. RU

William Stott (1857–1900)

180 *A Summer's Day* 1886
Exh. SBA 1886
Oil on canvas
132·9 × 189·3 (52³⁄₈ × 74¹⁄₂)
Manchester City Art Galleries

✱

Stott exhibited *A Summer's Day* in 1886 at the
Society of British Artists, which was dominated
by Whistler. With its broad sweeps of
unmodulated colour, aesthetic harmony and
distribution of the figures, it very much
embodied Whistler's advocacy of abstract
values. There is an ambiguous, Symbolist
sensibility to Stott's picture, prefiguring the
direction his art would take in the next decade.
The *Magazine of Art* (1886, p.111) believed it was
a riposte to Alexander Harrison's now untraced
Bord de Mer, shown to great effect at the Salon
the previous year and also showing a group of
nude boys on a beach. However, Stott's picture
has close affinities with Frank Meadow
Sutcliffe's famous and widely reproduced
photograph *The Water Rats* (no.184) of 1886.
Although showing boys in low water rather
than on a beach, two of Stott's figures seem to
imitate poses found in the photograph;
moreover, the glassy water of Sutcliffe's photo
finds an echo in the oil painting. Whatever the
connections between them, and it may only be
coincidence, both works are representative of
growing interest in the artistic potential of child
nudes, and trying to suggest the pleasures of an
open air, healthy existence. Stott's leftmost boy
appears to hold a pose adapted from Leighton's
statuette *Needless Alarms* (no.124), also,
curiously, exhibited in 1886.

Critical reactions to Stott's large canvas
were almost all negative. The *Athenaeum*,
intriguingly, may have confused it with seeing
Harrison's picture in Paris: 'A Summer Day …
we saw at the Salon with very mixed feelings.
Now that it is hung closer the eye its defects are
more visible, and attest the painter's audacity,
while it makes us regret more than ever his
willfulness in this triffling with his public'
(11 Dec. 1886). The *Magazine of Art* judged 'his
representation of the naked boys, grouped with
unnecessary contempt for harmony of line in a
vast expanse of sand … cannot be pronounced
successful' (1886, p.111). More vitriolically,
The Times reviewed the SBA exhibition saying
Stott had 'distinguished himself by sending the
largest, most expensive and the least beautiful
picture … there are three boys bathing.
Apparently they are constituted of something
different from flesh, and the anatomy of the
central boy passes understanding' (27 Nov.
1886, p.9). Undaunted, Stott returned to the
nude for his 1887 SBA contribution, *The Birth
of Venus* (no.144). RU

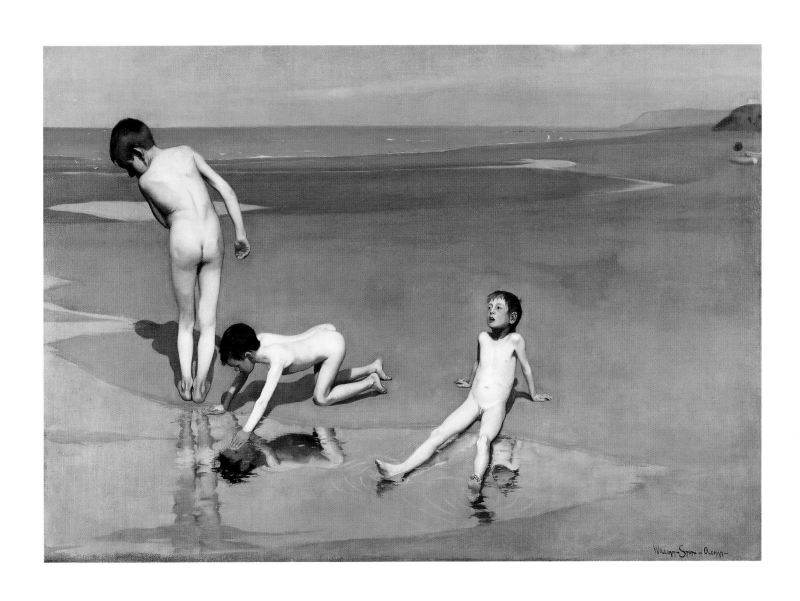

John Singer Sargent (1856–1925)

181 *A Nude Boy on a Beach* 1878
Oil on panel
26·8 × 35·1 (10$\frac{1}{2}$ × 13$\frac{7}{8}$)
Tate. Bequeathed by John Tillotson 1984

✻

After his success at the 1878 Paris Salon with his Brittany scene *Oyster Gatherers of Cancale*, Sargent spent the late summer in Italy, first briefly in Naples and then Capri. The island was a favourite haunt for artists, attracted by its coastline and turquoise sea, and its relaxed way of life. The beauty and innocence of its inhabitants was also an attraction, and Capri fisher girls were presented as romantic figures in popular melodramatic fiction. Some indication of why Capri attracted visitors and how they could view the local populace can be gained from the description in the *Art Amateur* of Sargent's favourite model Rosina Ferrara, 'the tawny-skinned, panther eyed, elf-like Rosina, wildest and lithest of all the savage creatures on the savage isle of Capri' (7 Aug. 1882, p.46).

Sargent made a number of studies of Rosina, but also made this oil sketch of a nude boy which he used as a study for *Boys on a Beach, Naples ('Innocence Abroad')*, a group of four nudes exhibited in 1879 at the National Academy of Design in New York. Thinly painted onto panel, so the wood grain shows through around the periphery, the sketch has the immediacy of an informal study while also suggesting through its shadows and bleached sand the brilliance of the Capri sunlight. The naturalism of the pose is reminiscent of photographs of nude boys by Baron von Gloeden, Plüschow and others, who were themselves drawn to the exoticism of places such as Sicily (see nos.107, 108), and it is tempting to imagine that Sargent's approach to his subject was informed by seeing such material. Certainly he was recorded as compiling an album of images of different ethnic types (see no.85). Such photographs as Gloeden's were often openly homoerotic, and Capri itself was notable for its numbers of homosexual visitors, drawn by the romantic tale of Hadrian and Antinous, and the sexual availability of local young men, for a price. RU

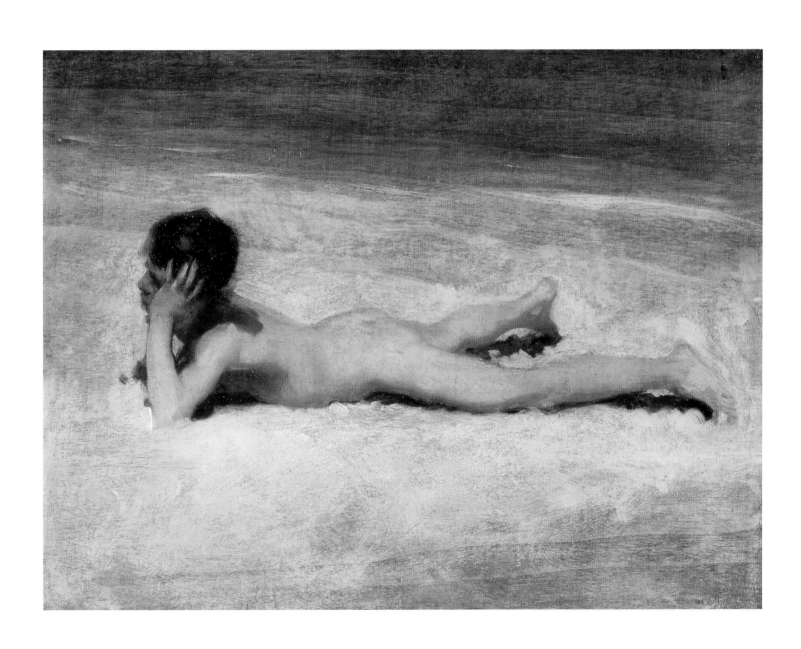

Philip Wilson Steer (1860–1942)

182 *A Summer's Evening* 1888
Exh. NEAC 1888
Oil on canvas
146×228·6 (57½×90)
Private Collection

Steer's large nude set-piece caused a furore when it was shown at the 1888 spring exhibition of the New English Art Club. Critics were accustomed to pouring scorn on nude subjects they had found there in previous shows, such as Roussel's *Reading Girl* (no.162) and Harrison's *In Arcadia* (no.183). But Steer's picture was considerably more avant-garde in its style and technique than anything that had been seen at the NEAC before. The dashes of broken colour form a continuously vibrating visual surface, a technique Steer derived from Monet. The lady critic who wrote under the nom de plume 'Penelope' had an almost physical revulsion to the picture:

> the utter unnaturalness and audacity of Mr. Steer's Summer Evening made me feel quite uncomfortable. Three nude girls with spotty coloured skins, who have been bathing in a deep blue sea, stand on a beach made of red, blue and yellow spots; the girls are in no respect even passable in appearance, the drawing imperfect, and the whole composition looked to me like a piece of aggressive affectation. [Unheaded cutting from an unidentified journal, quoted Laughton 1971, p.14]

Meanwhile the Portfolio, taking its lead from attacks on Impressionist tendencies in the national school which had been appearing in the *Magazine of Art* (see no.162), railed against the NEAC exhibition and highlighted Steer's picture for special scorn:

> It is a pity that so much affectation marks the work of the clever company of painters, more or less young, who exhibit ... under the title of the New English Art Club. It is also a pity that those among them who imitate recent phrases of French art should apparently fix on the weakest or crudest eccentricities as the point of their approach. We fail to see why the truth which underlies the system of painting primarily on a scheme of 'values' ... cannot be illustrated without a purposed selection of ugly or sordid models ... or a wayward choice of strange treatment to no purpose but strangeness ... (1888, p.104)

Steer's large canvas was evidently a riposte to Alexander Harrison's *In Arcadia* shown at the NEAC the previous year, and his title, composition and setting also indicate a response to Stott's *A Summer's Day* (no.180). Where Stott's picture is notable for a restrained, Whistlerian smoothness and subdued colouring of its beach, Steer's is an explosion of pointillist primary colours. Nevertheless, the positioning of Steer's models was perhaps influenced by Whistler's *Three Figures* project,

although Old Master representations of the Three Graces must also have been influential. When *A Summer's Evening* was shown at Les XX in Paris in 1899, contemporaries immediately drew comparisons with Seurat's *Les Poseurs* in the same exhibition, a pointillist composition of three nudes in his studio. It is very unlikely, however, that Steer saw Seurat's work, and instead they may have had a common inspiration in Harrison's *In Arcadia*, shown to great effect in the Salon of 1886. RU

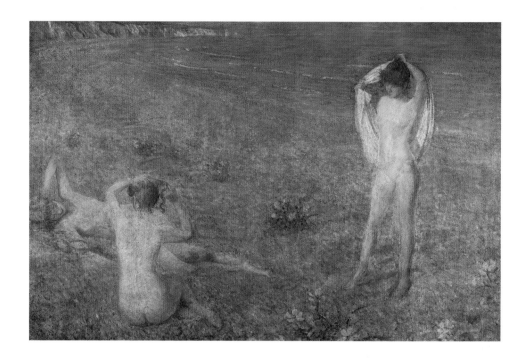

Thomas Alexander Harrison (1853–1930)

183 *In Arcadia* 1886
Exh. Salon 1886, NEAL 1887
Oil on canvas
197 × 290 (77½ × 114¼)
Musée d'Orsay, Paris

✤

Harrison was born in Philadelphia, and after training at the Pennsylvania Academy of Art in 1879 he travelled to Paris to continue his studies, like many American artists of his generation. Here he enrolled at the Académie Julian, and studied in Gérôme's atelier, where he met William Stott (see no.180), who had arrived in Paris the same year. The two painters followed parallel paths, both exhibiting at the Salon, to French critics' acclaim, and both painting large-scale plein air nude subjects. Contemporaries saw them as being in competition, and there seems to have been truth in this. Harrison's *In Arcadia* was shown at the 1886 Salon and received enormous critical praise, and its creator was hailed as the successor to Bastien Lepage. Painted at least partly out of doors in an orchard, *In Arcadia* presented a nude subject on an epic scale, and treated naturalistically rather than heroically. Bastien's pictures of peasant life were grounded in harsh reality. But Harrison took plein airiste painting in a different direction, to a voluptuous sensory experience, the dappled fall of sunlight and languid figures creating a languid vision of perfection. Its conception is reminiscent of Old Master pictures of the Golden Age, with nymphs and satyrs besporting themselves in an ideal landscape; but Harrison has created something dynamically different, entirely radical in its naturalistic approach, advanced technique and treatment of warm light and shade.

The New English Art Club painters centred around Sickert and Steer greatly admired it, and it was included in their second exhibition in London in 1887. Here critics saw it as symptomatic of impressionist tendencies at the NEAC, although the *Art Journal* praised it briefly, writing 'Mr A. Harrison's large canvas from the Salon ... is one of the most striking and important pictures owing to its size, powerful execution, and large nude figures' (1887, p.159). Harrison continued to live and work in France, and in 1889 he opened an art school in Paris which was popular with American art students.
RU

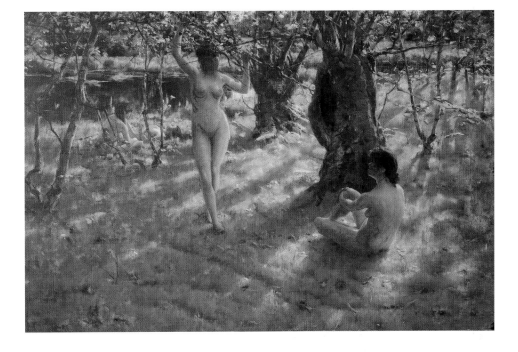

Frank Meadow Sutcliffe (1853–1941)

184 *The Water Rats* 1886
Carbon print
24.5 × 29 (9⅝ × 11½)
The Royal Photographic Society, Bath, UK
❋

Sutcliffe spent most of his life in or near Whitby. His father, Thomas Sutcliffe, was a landscape painter and watercolourist, who dismissed photography as 'the reflection of a gutta-percha world in a brass door-handle'. Sutcliffe recalled 'This made me ashamed of photography; have never got over it' (undated letter, quoted Hiley 1974, p.20). Whether or not he considered himself an artist, Peter Henry Emerson judged Sutcliffe's work a prime example of naturalistic photography; and, with Emerson, Sutcliffe was a founder-member of the Linked Ring.

Sutcliffe was always looking for an image that would sell well and garner critical praise. He came across a group of boys playing truant who had shed their clothes and jumped into Whitby harbour to evade apprehension. Sutcliffe stage-directed by adding the boat, coaxed the boys not to look at the camera, and paid each one a penny. Youths swimming nude in Whitby harbour were an everyday sight at the time, and considered rather a nuisance by those eager not to discourage the tourist trade.

The Water Rats was an instant and lasting hit. Though Sutcliffe later joked that the Whitby clergy had 'excommunicated [him] for exhibiting such an indecent print in his shop window to the corruption of the young of the other sex' (Sutcliffe to Harold Hood, 8 May 1930; repr. information from Michael J. Shaw, Sutcliffe Gallery, Whitby). The public demanded follow-ups, which led to Sutcliffe taking a formulaic series of boys in 'Adam's clothes' (Hiley 1974, p.71). These have been compared to Henry Scott Tuke's Cornish coast studies of naked youths, though they do not convey the same sense of celebratory sensuality.

There is an echo of an antique Arcadia in Sutcliffe's photographs. The frieze-like quality of the youthful figures arrayed across *The Water Rats* is not accidental but instinctual. As a boy, Sutcliffe slept in his father's studio alongside plaster casts from classical sculptures. This early familiarity with the most famous Venuses and Apollos stayed with Sutcliffe, and may be glimpsed in the graceful attitudes he caught as he watched and waited – and then asked 'Keep still just as you are a quarter of a minute' (*Photographic Journal*, June 1931, pp.255–6; quoted Hiley 1974, p.55). VD

Peter Henry Emerson (1856–1936)

185 *Water-Babies* (1887), plate 5 of *Idyls of the Norfolk Broads* (London: The Autotype Company, 1888)
Photogravure
15.9 × 12.2 (6¼ × 4¾)
The Royal Photographic Society, Bath, UK
❋

By the 1880s Norfolk was a tourist mecca, but for naturalist photographers and painters like Peter Henry Emerson and his collaborator Thomas Frederick Goodall, the Broads offered an ideal outdoor studio of untouched vistas peopled by unspoiled types. At this time Emerson was developing the theories that he published as *Naturalistic Photography for Students of the Art* in 1889 (and subsequently renounced in 1891). Subjectivity of sight and individuality of perception were central to his thesis of 'selective' or 'differential' focus. For Emerson subjectivity was all – in terms of optics (the human eye) and in terms of aesthetics (the artist's eye). In his opinion, 'the artist sees deeper, penetrates more into the beauty and mystery of nature than the commonplace man. The beauty is there in nature' (quoted Handy et al. 1994, p.18).

Emerson's texts clarify, reveal and amplify his intentions in ways that he could not achieve visually. In this instance the title refers to Charles Kingsley's *The Water Babies* (1863) and its central image of the cleansing and redemption of the dirty little chimney-sweep hero. Emerson's photograph shows 'village boys' (text to pl.5) turning and escaping from him. Their flight emphasises the photographer's psychological and social distance from his subjects, which Emerson spelled out in the accompanying text: 'Their pleasures are few and simple, but … one is often led to ponder as to who is the happier – the cultured man of the town, or the ignorant inhabitant of the village.' The motif of bathers surprised is an age-old pretext for the nude, but the camera's intrusion adds a whiff of voyeurism. There is a hint of the butterfly collector in Emerson's catching beauty au naturel. As he wrote, 'Many a day did we watch these young bathers … One day we determined to make a picture of them and as they waded forth … we secured them.' VD

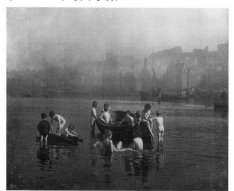

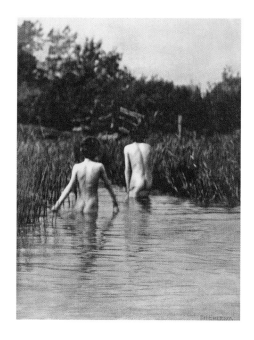

William Goscombe John (1860–1952)

186 *A Boy at Play* c.1895
Exh. RA 1896
Bronze
130·2×79·4×106 (511$_4$×311$_4$×413$_4$) on a Verdi di
Prato marble base 5·5×40·5×111 (21$_4$×16×433$_4$)
Tate. Presented by the Trustees of the Chantrey
Bequest 1896

❃

Goscombe John depicts a nude boy intently
engaged in a game of knuckles. In this, players
keep one foot planted behind a line on the
ground and try to touch an object with their
other foot without losing balance. The object is
moved progressively further away, making the
game harder and harder. Goscombe John shows
an actual knuckle being used in his portrayal.
A game requiring poise and skill, it allowed the
sculptor to depict an act of athletic prowess in
which the body is perfectly balanced but under
torsion in a naturalistic activity. The boy's
strong chest and straight limbs demonstrate his
healthiness in an age when the perfection of
body-type through exercise was increasingly
viewed as important. It was also a period when
awareness increased of trying to rid the nation
of the debilitating effects of malnourishment
and tuberculosis through education, exercise
and open-air activity, and social reform.
Goscombe John made a number of sculptures
of nude youths in this phase of his career,
probably part of the popularity for such imagery
at this time. The choice of pose for the figure
may have been influenced by other works.
In 1894, John Macallan Swan exhibited his
painting *Orpheus* at the Royal Academy (fig.36).
This shows Orpheus stepping over a leopard,
with his arms raised, and there are close
similarities between the two works. Another
source of inspiration must have come from
Muybridge's famous photographic-still series
of the body in motion.

The exhibition of Goscombe John's near
life-size figure appears to have been well
received, M.H. Spielmann recalling that
'carefully modelled and poised ... it was perhaps
rather as a realistic study than as a sculptural
conception that the statue was generally
regarded' (Spielmann 1901, p.130). A mark of
the piece's success was that it was chosen as
one of the sculptures for the British section at
both the 1900 Exposition Universelle in Paris
and the International Fine Arts Exhibition in
Rome in 1911. RU

Fig.36
John Macallan Swan
Orpheus 1896
Oil on canvas
Lady Lever Art Gallery,
Port Sunlight

Bibliography

Additional contemporary periodicals consulted:

Academy Architecture and Annual Architectural Review
Academy
Art Union, later (from 1849) *Art Journal*
Athenaeum
British Journal of Photography
Coventry Standard
Daily News
Illustrated London News
Literary Gazette
Magazine of Art
Punch
Pall Mall Budget
Photographic Journal
Saturday Review
Sculptor
Sculptors' Journal and Fine Art Magazine
Spectator
Studio
The Times
Vanity Fair
Windsor Magazine

All sources are published in London unless otherwise stated.

The Age of Rossetti, Burne-Jones and Watts: Symbolism in Britain 1860–1910, exh. cat., Tate Gallery, 1997.
Albert Moore and his Contemporaries, exh. cat., Laing Art Gallery, Newcastle upon Tyne 1972.
Altick, Richard D., *Painting from Books: Art and Literature in Britain, 1760–1900*, Columbus, Ohio, 1985.
Arnold, Bruce, *Orpen: Mirror to an Age*, 1981 (repr. 1982).
Artists of the Newlyn School (1880–1900), exh. cat., Newlyn Art Gallery, 1979.
Asleson, Robyn, *Albert Moore*, Oxford 2000.
Atterbury, Paul (ed.), *The Parian Phenomenon: A Survey of Victorian Parian Porcelain Statuary and Busts*, Shepton Beauchamp 1989.
Auerbach, Jeffrey A., *The Great Exhibition of 1851: A Nation on Display*, New Haven and London 1999.
Baldry, A.L., *Albert Moore: His Life and Works*, 1894.
Baldry, A.L., *Sir J.E. Millais: His Art and Influence*, 1899.
Barnes, J., *The Beginnings of the Cinema in England, 1894–1901*, 5 vols., Exeter 1998.
Barnes, Joanna (ed.), *Leighton and his Sculptural Legacy: British Sculpture 1875–1931*, 1996.
Barnes, Joanna, and Read, Benedict, *Pre-Raphaelite Sculpture: Nature and Imagination in British Sculpture, 1848–1914*, 1991.
Barnes, Richard, *John Bell: The Sculptor's Life and Works*, Kirstead, Norfolk 1999.
Barret-Ducrocq, Françoise, *Love in the Time of Victoria: Sexuality, Class and Gender in Nineteenth-Century London*, 1991.
Barrington, Emilia, *G.F. Watts: Reminiscences*, 1905.
Barrington, Emilia, *The Life, Letters and Work of Frederic Leighton*, 2 vols., 1906.
Bateman, Charles T., *G.F. Watts, R.A.*, 1901.
Beattie, Susan, *The New Sculpture*, New Haven and London 1983.
Beckett, R.B., *John Constable's Correspondence*, III, 1965.
Bell, John, 'Colour on Statues, and Paintings and Sculpture Arranged Together: A Lecture at the Society of Arts', *Journal of the Society of Arts*, 26 April 1861.
Bell, Malcolm, *Edward Burne-Jones, A Record and Review*, 1892.

and Other Galleries', trans. William Rothenstein, *Studio*, 1894.
Bignamini, Ilaria, and Postle, Martin, *The Artist's Model: Its Role in British Art from Lely to Etty*, Nottingham 1991.
Blühm, Andreas, *Pygmalion: Die Ikonographie eines Künstlermythos zwischen 1500 und 1900*, Frankfurt 1988.
Blühm, Andreas, *et al.*, *The Colour of Sculpture 1840–1910*, exh. cat., Van Gogh Museum, Amsterdam, Henry Moore Institute, Leeds 1996.
Blunt, Wilfred, *'England's Michelangelo': A Biography of George Frederic Watts*, 1975.
Bristow, Edward J., *Vice and Vigilance: Purity Movements in Britain Since 1700*, Dublin 1977.
Bromberg, Ruth, *Walter Sickert Prints: A Catalogue Raisonné*, New Haven and London 2000.
Brookfield, Charles, and Brookfield, Frances, *Mrs Brookfield and her Circle*, 1905.
Brooks, Peter, 'Storied Bodies, or Nana at Last Unveil'd', *Critical Enquiry*, vol.16, 1989, pp.1–32.
Brown, Richard, and Barry, Anthony, *A Victorian Film Enterprise: The History of the British Mutoscope and Biograph Company*, Trowbridge 1999.
Brown, Roger, 'William Stott of Oldham (1857–1900): An examination of the influences on his stylistic development and an account of his place in late nineteenth-century British Art', unpublished MA dissertation, Oxford Brookes University, 1999.
Bryson, John (ed.), *Dante Gabriel Rossetti and Jane Morris: Their Correspondence*, Oxford 1976.
Buchanan, Robert (signed Thomas Maitland), 'The Fleshly School of Poetry', *Contemporary Review*, Oct. 1871.
Burbidge, F. Bliss, *Old Coventry and Lady Godiva*, Birmingham 1952.
Burne-Jones, Georgiana, *Memorials of Burne-Jones*, 2 vols., 1904.
Calloway, Stephen, *Aubrey Beardsley*, 1998.
Cameron, Julia Margaret, 'Annals of My Glass House', in Mike Weaver, *Julia Margaret Cameron 1815–1879*, 1984.
Chamot, Mary, Farr, Denis, and Butlin, Martin, *Tate Gallery Catalogues: The Modern British Paintings, Drawings and Sculpture*, 2 vols., 1964.
Chapman, David L., *Sandow the Magnificent: Eugen Sandow and the Beginnings of Bodybuilding*, Urbana, Illinois, and Chicago 1994.
Chapman, David (introd.), *Adonis: The Male Physique Pin-up 1870–1940*, Swaffham 1997.
Chesneau, E., *The English School of Painting*, trans. L.N. Etherington, 1885.
Clark, Kenneth, *The Nude: A Study of Ideal Art*, 1980 (orig. pub. 1956).
Clarke, Ronald Aquilla, and Day, Patrick A.E., *Lady Godiva: Images of a Legend in Art and Society*, Coventry 1982.
Cline, C.K. (ed.), *The Owl and the Rossettis*, Pennsylvania 1978.
Cohen, Morton, with Green, Roger Lancelyn, *The Letters of Lewis Carroll*, London and New York 1979.
Cohen, Morton N., *Lewis Carroll, Photographer of Children: Four Nude Studies*, Philadelphia and New York 1979.
Cohen, Morton N., *Lewis Carroll: A Biography*, New York 1995.
Cohen, Morton N., *Reflections in a Looking Glass: A Centennial Celebration of Lewis Carroll, Photographer*, New York 1998.
Collier, The Hon. John, *A Manual of Oil Painting*, London, New York, Paris 1903 (orig. pub. 1886).
'A Consideration of the Art of Frederick Sandys',

Artist, special winter no., 1896.
Cook, E.T., *A Popular Handbook to the Tate Gallery: 'National Gallery of British Art'*, 1898.
Cooper, Emmanuel, 'Form Not Content: Physique Photography, Body Building and the Body Beautiful', *Fully Exposed: The Male Nude in Photography*, 2nd edn., New York 1995, ch.5.
Cooper, Emmanuel, '"On Aesthetic Grounds Alone": Turn-of-the-Century Nudes, Artistic and Erotic', *Fully Exposed: The Male Nude in Photography*, 2nd edn., New York 1995, ch.8.
Craig, Alec, *The Banned Books of England and Other Countries: A Study of the Conception of Literary Obscenity*, 1962, pp.117–22.
Dafforne, James, *Pictures by William Mulready*, 1872.
Dakers, Caroline, *The Holland Park Circle: Artists and Victorian Society*, New Haven and London 1999.
Darby, Elisabeth S., 'John Gibson, Queen Victoria and the Idea of Sculptural Polychromy', *Art History*, vol.4, no.1, March 1981.
Davies, Norman, *The Isles: A History*, 1999.
Delaney, J.G.P., *Charles Ricketts: A Biography*, Oxford 1990.
Dorment, Richard, *Alfred Gilbert*, New Haven and London 1985.
Dorment, Richard, *Alfred Gilbert: Sculptor and Goldsmith*, exh. cat., Royal Academy of Arts, London 1986.
Doughty, Oswald, and Wahl, J.R. (eds.), *The Letters of Dante Gabriel Rossetti*, vol.II, Oxford 1965–8.
Dowden, E.D., and Dowden, H. M. (eds.), *Letters of Edward Dowden and his Correspondents*, 1914.
Dyer, Richard, *White*, 1997.
Eastlake, Charles, *Contributions to the Literature of the Fine Arts*, 1848.
Eastlake, Elizabeth E., *The Life of John Gibson, RA, Sculptor*, 1870.
Ellmann, Richard, *Oscar Wilde*, 1987.
Emerson, Peter Henry, 'Water-Babies', *Idylls of the Norfolk Broads*, 1888.
Fairbrother, Trevor, *John Singer Sargent: The Sensualist*, New Haven and London 2000.
Fanin, Colonel, *The Royal Museum at Naples, Being Some Account of the Erotic Paintings, Bronzes and Statues Contained in that Famous 'Cabinet Secret'*, privately printed 1871.
Farr, Denis, *William Etty*, 1958.
Finch, Casey, '"Hooked and buttoned together": Victorian Underwear and Representations of the Female Body', *Victorian Studies*, Spring 1991.
Finch, Casey, 'Two of a Kind', *Artforum International*, vol.30, 1992, pp.91–4.
Forbes, Christopher, *The Royal Academy Revisited*, New York 1975.
Ford, Julia Ellsworth, *Simeon Solomon: An Appreciation*, New York 1908.
Foucault, Michel, *The History of Sexuality: An Introduction*, trans. Robert Hurley, 1978.
Gage, John, *Colour and Culture*, 1995.
Garb, Tamar, 'Modelling the Male Body: Physical Culture, Photography and the Classical Ideal', *Bodies of Modernity: Figure and Flesh in Fin-de-siècle France*, New York 1998, ch.2.
Gaunt, William, 'Nineteenth-Century Nudes', *Saturday Book*, vol.28, 1968, pp.237–40.
Gay, Peter, 'Victorian Sexuality: Old Texts and New Insights', *American Scholar*, vol.49, 1980, pp.372–8.
Gay, Peter, *The Bourgeois Experience: Victoria to Freud, I: Education of the Senses*, Oxford and New York 1984.
Gaze, Delia (ed.), *Dictionary of Women Artists*, 2 vols., 1997.

Getsy, David J., '"Hard realism": the thanatic corporeality of Edward Onslow Ford's *Shelley Memorial*', *Visual Culture in Britain*, vol.3, no.1, spring 2002.

Gilchrist, Alexander, *The Life of William Etty, R.A.*, 1978 (orig. pub. in 2 vols, 1855).

Girouard, Mark, *The Return to Camelot: Chivalry and the English Gentleman*, New Haven and London 1981.

Gordon, Catherine (ed.), *Evelyn de Morgan, Oil Paintings*, De Morgan Foundation, 1996.

Gorokhoff, Galina (ed.), *Love Locked Out: The Memoirs of Anna Lea Merritt*, Museum of Fine Arts, Boston 1982.

Gosse, Edmund, 'English Sculpture in 1880', *Cornhill Magazine*, vol.42, Aug. 1880.

Gosse, Edmund, 'The New Sculpture, 1879–1894', *Art Journal*, 1894.

Grigson, Geoffrey, 'The Nude and the Western Artist', in Jean Cassou and Geoffrey Grigson, *The Female Form in Painting*, 1953, pp.20–53.

Hamber, Anthony J., *'A Higher Branch of the Art': Photographing the Fine Arts in England 1839–80*, Amsterdam 1996.

Hamerton, P.G., *Man in Art*, 1892.

Handy, Ellen, *et al.*, *Pictorian Beauties, Naturalistic Vision*, Chrysler Museum, Norfolk, Virginia 1994.

Harker, Margaret, *Julia Margaret Cameron*, 1983.

Harrison, Brian, 'Underneath the Victorians', *Victorian Studies*, vol.10, 1966–7, pp.239–61.

Harrison, Fraser, *The Dark Angel: Aspects of Victorian Sexuality*, 1977.

Harrison, Jane, *The Myths of the Odyssey in Literature and Art*, 1882.

Harrison, Jane, 'The Myth of Odysseus and the Sirens', *Magazine of Art*, 1887.

Haskell, Francis, *Rediscoveries in Art: Some Aspects of Taste, Fashion and Collecting in Britain and France*, Oxford 1980.

Haskell, Francis, and Penny, Nicholas, *Taste and the Antique: The Lure of Classical Sculpture 1500–1900*, New Haven and London 1982.

Hatt, Michael, 'Physical Culture: The Male Nude and Sculpture in Late Victorian Britain' in Elizabeth Prettejohn (ed.), *After the Pre-Raphaelites: Art and Aestheticism in Victorian England*, Manchester 1999.

Hatton, Joseph, 'The Life and Work of Alfred Gilbert, R.A., M.V.O., L.L.D.', *Easter Art Annual*, 1903.

Hausberg, Margaret Dunwoody, *The Prints of Théodore Roussel: A Catalogue Raisonné*, New York 1991.

Haworth-Booth, Mark, 'Robert Crawshay', *British Journal of Photography*, 20 July 1994.

Haworth-Booth, Mark, *Photography: An Independent Art. Photographs from the Victoria and Albert Museum 1839–1996*, Princeton 1997.

Hawthorne, Nathaniel, *The Marble Faun: Or, The Romance of Monte Beni*, Ohio 1968 (*The Centenary Edition of the Works of Nathaniel Hawthorne*, IV).

Haydon, B.R., *Lectures on Painting and Design*, vols.I and II, 1844.

Heleniak, Kathryn Moore, *William Mulready*, New Haven and London 1980.

Hiley, Michael, *Frank Sutcliffe: Photographer of Whitby*, Boston 1974.

Hiley, Michael, *Victorian Working London: Portraits from Life*, 1979.

Hilton, Tim, *John Ruskin: The Early Years*, New Haven and London 1985.

Holroyd, Sir Charles, 'Alphonse Legros: Some Personal Reminiscences', *Burlington Magazine*, vol.20, 1912.

Houghton, Walter E., *The Victorian Frame of Mind, 1830–1870*, New Haven and London 1957.

Hunt, Lynn, 'Obscenity and the Origins of Modernity, 1500–1800', in Lynn Hunt (ed.), *The Invention of Pornography: Obscenity and the Origins of Modernity, 1500–1800*, New York 1993, pp.9–45.

Hunt, William Holman, *Pre-Raphaelitism and the Pre-Raphaelite Brotherhood*, vol.I, 1905.

Inglis, Alison, 'The Decorative Works of Sir Edward Poynter and Their Critical Reception', D.Phil, University of Melbourne, November 1999

Jackson, Russell, 'Shakespeare's Fairies in Victorian Criticism and Performance', *Victorian Fairy Painting*, exh. cat., Royal Academy of Arts, London 1997.

James, G.P.R., *The History of Chivalry*, 1843.

Jameson, Anna, 'John Gibson', *Art Journal*, vol.9, 1849.

Jameson, Anna, *A Hand-Book to the Courts of Modern Sculpture*, 1854.

Jones, Owen, *An Apology for the Colouring of the Greek Court*, 1854.

Jarves, James Jackson, 'The Nude in Modern Art and Society', *Art Journal*, March 1874.

Journal of the Royal Institute of Cornwall, 91st Annual Report, vol.18, part 1, 1910.

Kappeler, Susanne, *The Pornography of Representation*, Oxford 1986.

Kennedy, Edward G., *The Etched Work of Whistler*, New York 1974.

Kenyon, F.G. (ed.), *The Letters of Elizabeth Barrett Browning*, 1897.

Kilvert, Francis, *Kilvert's Diary 1870–1879: Selections from the Diary of the Rev. Francis Kilvert*, ed. William Plomer, 1973.

Kingsley, Charles, 'Nausicaa in London', Oct. 1873, repr. in *Sanitary and Social Essays*, 1889.

Koetzle, Michael, *1000 Nudes: Uwe Scheid Collection*, Cologne 1994.

Konody, P.G., and Dark, Sidney, *Sir William Orpen, Artist and Man*, 1932.

Kronhausen, Eberhard, and Kronhausen, Phyllis, *Pornography and the Law*, New York 1959.

Kronhausen, Eberhard, and Kronhausen, Phyllis, *Erotic Art: A Survey of Erotic Fact and Fancy in the Fine Arts*, London and New York 1971.

Lancaster, Joan, *Godiva of Coventry*, 1967.

Laughton, Bruce, *Philip Wilson Steer 1860–1942*, Oxford 1971.

Laurenson, Pip, 'The Singer 1889: Edward Onslow Ford', in Jackie Heuman (ed.), *Material Matters: The Conservation of Modern Sculpture*, 1999.

Lawrence, D.H., *Pornography and Obscenity*, 1929.

Leach, Karoline, *In the Shadow of the Dreamchild: A New Understanding of Lewis Carroll*, London and Chester Springs, Pennsylvania 1999.

Lebailly, Hugues, 'The Image of the Girl-Child's Body in Victorian Photography: C.L. Dodgson's Nude Studies Re-evaluated', manuscript.

Leighton, Frederic, *Addresses Delivered to the Students of the Royal Academy*, 1896.

Leighton, John (Luke Limner), *Madre Natura versus the Moloch of Fashion, a Social Essay*, 1870.

Lennie, Campbell, *Landseer: The Victorian Paragon*, 1976.

Lewis, Cecil (ed.), *Self-Portrait: Letters and Journals of Charles Ricketts*, 1938.

Liversidge, Michael, and Edwards, Catherine (eds.), *Imagining Rome: British Artists and Rome in the Nineteenth Century*, exh. cat. Bristol City Museum and Art Gallery 1996.

Lough, John, and Merson, Elizabeth, *John Graham Lough 1798–1876: A Northumbrian Sculptor*, Woodbridge, Suffolk 1987.

Lovoit, Louis, *J.J. Henner et son oeuvre*, Paris 1912.

Low, R., and Manvell, R., *The History of the British Film, 1896–1906*, 1976 (orig. pub. 1948).

Lowe, Alfred (ed.), *History and Antiquities of the City of Coventry*, unpub. compilation, Coventry City Library n.d.

Lucie-Smith, Edward, *Eroticism in Western Art*, 1972.

Lukitsh, Joanne, *Cameron: Her Work and Career*, Rochester, New York 1986.

Maas, Henry, Duncan, J.L. and Good, W.G. (eds.), *The Letters of Aubrey Beardsley*, 1970.

Maas, Jeremy, *Victorian Painters*, 1988 (orig. pub. 1969).

MacColl, D.S., *Life, Work and Setting of Philip Wilson Steer*, 1945.

McCalman, Iain, *Radical Underworld: Prophets, Revolutionaries and Pornographers in London 1795–1840*, Cambridge 1988.

McCauley, Elizabeth Anne, *Industrial Madness: Commercial Photography in Paris, 1848–1871*, New Haven and London 1994.

McEvansoneya, P., 'A Libel in Paint: Religious and Artistic Controversy around P.H. Calderon's "The Renunciation of St. Elizabeth of Hungary"', *Journal of Victorian Culture*, autumn 1996.

Mackinnon, Kenneth, *Uneasy Pleasures: The Male as Erotic Object*, 1997.

Macleod, Dianne, 'Rossetti's Two "Ligeias": Their Relationship to Visual Art, Music and Poetry', *Victorian Poetry*, vol.20, nos.3–4, 1984.

Macmillan, Hugh, *The Life-Work of George Frederick Watts, R.A.*, 1903.

Mainardi, Patricia, *Art and Politics of the Second Empire: The Universal Expositions of 1855 and 1867*, New Haven and London 1989.

Manning, Elfrida, *Marble and Bronze: The Art and Life of Hamo Thornycroft*, London and New Jersey 1982.

Marillier, H.C., *Dante Gabriel Rossetti: An Illustrated Memorial of his Art and Life*, 1889.

Marks, Edward, *The Life and Letters of Frederick Walker, ARA*, 1896.

Marryat, Frederick, *A Diary in America: With Remarks on its Institutions*, ed. Sydney Jackman, New York 1962 (orig. pub. 1839).

Marsh, Jan, *Dante Gabriel Rossetti: Painter and Poet*, 1999.

Mason, Michael, *The Making of Victorian Sexuality*, Oxford and New York 1994.

Matthews, T., *The Biography of John Gibson R.A., Sculptor, Rome*, 1911.

Mauclair, Camille, *The Great French Painters and the Evolution of French Painting from 1830 to the Present Day*, trans. P.G. Konody, 1903.

Menpes, Mortimer, *Whistler as I Knew Him*, 1904.

Mentone, Frederick H., *The Human Form in Art: With Reproductions of the Nude by Old Masters*, 1944.

Millais, J.G., *The Life and Letters of Sir John Everett Millais, President of the Royal Academy*, 2 vols., 1899.

Millar, Oliver, *The Victorian Pictures in the Collection of her Majesty the Queen*, 2 vols., Cambridge 1992.

Monkhouse, W. Cosmo, *The Works of John Henry Foley, R.A.*, 1875.

Morris, Edward, *Victorian and Edwardian Paintings in the Lady Lever Art Gallery*, 1994.

Morris, Edward, 'Thomas Stirling Lee (1857–1916)', *Sculpture Journal*, vol.1, 1997.

Mulready, William, manuscript notes, V&A library.

Muther, Richard, *The History of Modern Painting*, revised edn., 1907.

Nail, N.H., 'Bondage: Ernest Normand', unpub. manuscript, Jan. 1987, Truro, Cornwall.

Nead, Lynda, 'Representation, Sexuality and the Female Nude', *Art History*, June 1983, pp.227–336.

Nead, Lynda, *The Female Nude: Art, Obscenity and Sexuality*, 1992.

Nead, Lynda, *Victorian Babylon: People, Streets and Images in Nineteenth-Century London*, New Haven and London 2000.

Nellor, Lisa Marie, 'Honest Truth and Titian Beauty: Red Hair in Pre-Raphaelite Painting 1849–1880', MA thesis, Courtauld Institute of Art, University of London 1995.

Nicholson, Shirley, *A Victorian Household*, Stroud 1998.

Nochlin, Linda, *Women, Art and Power and Other Essays*, 1989.

Noël-Paton, M.H., and Campbell, J.P., *Noel-Paton 1821–1901*, Ramsay Head Press, 1990.

Ottley, William Young, *Engravings of the Most Noble The Marquis of Stafford's Collection of Pictures*, I, 1818.

Pater, Walter, *The Renaissance*, ed. Adam Phillips, Oxford 1986.

Pearl, Cyril, *The Girl with the Swansdown Seat: An Informal Report on Some Aspects of Mid-Victorian Morality*, 1980 (orig. pub. 1955).

Pearl, Cyril, *Tell Me, Pretty Maiden: The Victorian and Edwardian Nude*, 1977.

Pearsall, Ronald, *The Worm in the Bud: The World of Victorian Sexuality*, Harmondsworth 1971 (orig. pub. 1969).

Perry, Mark, *Wall Painting Conservation Record, The Poynter Fresco, St Stephen's Church, Dulwich, London*, The Perry Lithgow Partnership Conservators, Oxfordshire 1996.

Perry, W.C., *Greek and Roman Sculpture: A Popular Introduction to the History of Greek and Roman Sculpture*, 1882.

Peters, William, *The Statue Question. A Letter to the Chairman of the Crystal Palace Company dated 8th July 1854; and, An Appeal against the Practice of Studying from Nude Human Beings by British Artists and in Public Schools of Design*, 1854.

Phillips, Olga Somech, *Solomon J. Solomon: A Memoir of Peace and War*, 1933.

Playfair, Giles, *Six Studies in Hypocrisy*, 1969.

Pointon, Marcia, *Naked Authority: The Body in Western Art 1830–1908*, Cambridge 1990.

Pornography: The Longford Report, 1972.

Porter, Roy, and Hall, Lesley, *The Facts of Life: The Creation of Sexual Knowledge in Britain, 1650–1950*, New Haven and London 1995.

Potts, Alex, 'Male Phantasy and Modern Sculpture', *Oxford Art Journal*, vol.15, no.2, 1992.

Poynter, E.J., *Ten Lectures on Art*, 1879.

Price, B.D., *Tuke Reminiscences*, Falmouth 1983.

Pultz, John, *et al.*, *A Personal View: Photography in the Collection of Paul F. Walter*, New York 1985.

Rabin, Lucy, *Ford Madox Brown and the Pre-Raphaelite History Picture*, New York and London 1978.

Read, Benedict, *Victorian Sculpture*, New Haven and London 1982.

Redgrave, Richard, and Redgrave, Samuel, *A Century of Painters of the English School*, 1890.

Rejlander, O.G., 'On Photographic Composition; with a Description of "Two Ways of Life"', *Journal of the Photographic Society*, 21 April 1858.

Rembar, Charles, *The End of Obscenity: The Trials of Lady Chatterley, Tropic of Cancer and Fanny Hill*, New York 1986 (orig. pub. 1968).

Reverie, Myth, Sensuality: Sculpture in Britain, 1880–1910, exh. cat., Stoke-on-Trent City Museum and Art Gallery, 1992.

Reynolds, Joshua, *Discourses on Art*, 1981 (orig. pub. 1797), ed. R. Wark, New Haven and London 1981.

Reynolds, Simon, *The Vision of Simeon Solomon*, Slad 1985.

Reynolds, Simon, *William Blake Richmond: An Artist's Life 1842–1921*, Norwich 1995.

Roberts, Mary Ann, 'Edward Linley Sambourne (1844–1910)', *History of Photography*, vol.17, no.2, summer 1993.

Roberts, M.J.D., 'Making Victorian Morals? The Society for the Suppression of Vice and its Critics, 1802–1886', *Historical Studies*, vol.21, 1984, pp.157–73.

Roberts, M.J.D., 'Morals, Art and the Law: The Passing of the Obscene Publications Act, 1857', *Victorian Studies*, vol.28, 1984–5, pp.606–20.

Robins, Anna Gruetzner, *Walter Sickert: The Complete Writings*, Oxford 2000.

Roe, F. Gordon, *The Nude from Cranach to Etty and Beyond*, Leigh-on-Sea 1944.

Roget, J.L., *A History of the 'Old' Water-Colour Society*, 2 vols., 1891.

Rossetti, William Michael, *Fine Art, Chiefly Contemporary: Notices Re-printed with Revision*, London and Cambridge 1867.

Rossetti, William Michael, 'Notes on Rossetti and his Works', *Art Journal*, 1884.

Rossetti, William Michael, *D.G. Rossetti as a Designer and a Writer*, 1889.

Rothenstein, William, *Men and Memories, 1872–1900*, 1931.

Royal Academy Commission, 'Report of the Commissioners Appointed to Inquire into the Present Position of the Royal Academy in Relation to the Fine Arts, together with Minutes of Evidence', P.P. Session, 5 Feb.–28 July 1863, 15, vol.27.

Rugoff, Milton, *Prudery & Passion: Sexuality in Victorian America*, 1972.

Ruskin, John, *The Complete Works of John Ruskin*, ed. E.T. Cook and Alexander Wedderburn, 1903–12.

Rutter, Frank, *Theodore Roussel*, 1926.

Sainsbury, Maria Tuke, *Henry Scott Tuke R.A., R.W.S.: A Memoir*, 1933.

Saint-George, Caroline v., and Kempski, Mary, 'Examination and Treatment Report: William Blake Richmond "The Bowlers"', Hamilton Kerr Institute, University of Cambridge, 7 Aug. 1998, unpub.

Sambourne, Edward Linley, 'Diaries', Royal Borough of Kensington and Chelsea Library, London, unpub. mss.

Salaman, Malcolm C., 'Etty's Pictures in Lord Leverhulme's Collection', *Studio*, vol.85, 1923.

Scharf, George, *The Greek Court Erected in the Crystal Palace by Owen Jones*, 1854.

Shinn, Charles, and Shinn, Dorrie, *The Illustrated Guide to Victorian Parian China*, 1971.

Shone, Richard, *Walter Sickert*, Oxford 1988.

Sickert, exh. cat., Royal Academy, 1993.

W.R. Sickert: Drawings and Paintings 1890–1942, exh. cat., Tate Gallery Liverpool, 1989–90.

Sigsworth, Eric M., *In Search of Victorian Values: Aspects of Nineteenth-Century Thought and Society*, Manchester 1988.

Sizeranne, Robert de la, *English Contemporary Art*, 1898.

Smith, Alison, *The Victorian Nude: Sexuality, Morality and Art*, Manchester 1996.

Smith, F. Barry, 'Sexuality in Britain 1800–1900: Some Suggested Revisions', in Martha Vicinus (ed.), *The Widening Sphere: Changing Roles for Victorian Women*, Bloomington and London 1977, pp.182–98.

Spielmann, Marion H., *Millais and his Works*, Edinburgh and London 1898.

Spielmann, Marion H., *British Sculpture and Sculptors of Today*, 1901.

Sprawson, Charles, *Haunt of the Black Masseur: The Swimmer as Hero*, 1993.

Stead, Jennifer, *The Nude in Victorian Art*, City Art Gallery, Harrogate 1966.

Stephens, F.G., 'Thomas Woolner', *Art Journal*, 1894.

Storey, Gladys, *All Sorts of People*, 1929.

Surtees, Virginia, *The Paintings and Drawings of Dante Gabriel Rossetti 1828–1882: A Catalogue Raisonné*, 2 vols., Oxford 1971.

Surtees, Virginia (ed.), *The Diary of Ford Madox Brown*, New Haven and London 1981.

Swinburne, A.C., *Notes on Some Pictures of 1868*, 1868.

Swinburne, A.C., 'Simeon Solomon: Notes on his "Vision of Love" and Other Studies', *Dark Blue*, July 1871.

Symonds, John Addington, *The Letters of John Addington Symonds*, ed. Herbert M. Schueller and Robert L. Peters, 3 vols., Detroit 1967–9.

Symonds, John Addington, 'The Model', *Fortnightly Review*, 1887.

Tang, Isabel, *Pornography: The Secret History of Civilisation*, 1999.

Tate Gallery: An Illustrated Companion, 1990.

Taylor, Thomas, *Life of Benjamin Robert Haydon, Historical Painter, from his Autobiography and Journals*, III, 1853.

Tedeschi, Martha (ed.), *The Lithographs of James McNeill Whistler*, 2 vols., Chicago 1998.

Thomas, Donald, *A Long Time Burning: The History of Literary Censorship in England*, 1969.

Thorp, Margaret Farrand, 'A Lost Chapter in the History of 19th-Century Taste: The Nude and the Greek Slave', *Art in America*, vol.49, no.2, 1961.

'Tis', *Masters of Modern Art: Charles Shannon ARA*, 1920.

Toll, Simon, *Herbert James Draper: A Life Study*, 2001.

Trudgill, Eric, *Madonnas and Magdalens: The Origins and Attitudes of Victorian Sexual Attitudes*, New York 1976.

Tuke, Henry Scott, 'Diaries', Tuke Archives, Tate, unpub.

Visions of Love and Life: Pre-Raphaelite Art from the Birmingham Collection, England, exh. cat., Birmingham Museum and Art Gallery, 1995.

Waggoner, Diane, 'In Pursuit of Childhood: Lewis Carroll's Photography and the Victorian Visual Imagination', Yale University Ph.D. thesis, 2000.

Wainwright, David, and Dinn, Catherine, *Henry Scott Tuke 1858–1929: Under Canvas*, Carshalton 1991 (orig. pub. 1989).

Walvin, James, *Victorian Values*, Harmondsworth 1987.

Ward, Maisie, *The Tragi-Comedy of Pen Browning (1849–1912)*, London and New York 1972.

Warner, Marina, *Monuments and Maidens: The Allegory of the Female Form*, 1985.

Watts, M.S., *George Frederic Watts: The Annals of an Artist's Life*, 3 vols., 1912.

Watts, M.S., *Catalogue of Works by G.F. Watts*, Watts Gallery, Compton, Guildford.

Webb, Peter, *The Erotic Arts*, 1975.

Weekes, Henry, *Lectures on Art*, 1880.

Weeks, Jeffrey, *Sex, Politics and Society: The Regulation of Sexuality since 1800*, 1989 (orig. pub. 1981).

Westmacott, Richard, 'On Polychromy in Sculpture, or Colouring Statues', Journal of the Society of Arts, 4 March 1859.

Westmacott, Richard, *The Schools of Sculpture, Ancient and Modern*, Edinburgh 1864.

White, Adam, *Hamo Thornycroft and the Martyr General*, Leeds 1991.

Whitley, William T., *Art in England 1821–1837*, Cambridge 1930.

Wilcox, Timothy, 'Alphonse Legros (1837–1911): Aspects of his Life and Work', M.Phil. thesis, Courtauld Institute of Art, University of London 1981.

Wilcox, Timothy, *Alphonse Legros 1837–1911*, exh. cat., Musée des Beaux-Arts, Dijon 1987.

Williams, Linda, *Hard Core: Power, Pleasure, and the 'Frenzy of the Visible*, Berkeley and Los Angeles 1989.

Wolf, Sylvia, *et al.*, *Julia Margaret Cameron's Women*, Chicago, New Haven and London 1998.

Woody, Jack, *Taormina: Wilhelm von Gloeden*, Pasadena, California 1986.

Woolf, Virginia, and Fry, Roger, *Victorian Photographs of Famous Men and Women*, 1926.

Woolner, Amy, *Thomas Woolner RA: His Life in Letters*, New York 1917.

Yarrington, Alison, *The Commemoration of the Hero, 1800–1864: Monuments to the British Victors of the Napoleonic Wars*, New York and London 1988.

Younger, John G., 'Ten Unpublished Letters by John Addington Symonds at Duke University', *Victorian Newsletter*, vol.95, spring 1999.

Lenders and Credits

Index

Supporting Tate

Tate relies on a large number of supporters – individuals, foundations, companies and public sector sources – to enable it to deliver its programme of activities, both on and off its gallery sites. This support is essential in order to acquire works of art for the Collection, run education, outreach and exhibition programmes, care for the Collection in storage and enable art to be displayed, both digitally and physically, inside and outside Tate. Your donation will make a real difference and enable others to enjoy Tate and its Collections both now and in the future. There are a variety of ways in which you can help support Tate and also benefit as a UK or US taxpayer. Please contact us at:

The Development Office
Tate
Millbank, London SW1P 4RG
Tel 020 7887 8942
Fax 020 7887 8738

Tate American Fund
1285 Avenue of the Americas (35th fl)
New York, NY 10019
Tel 001 212 713 8497
Fax 001 212 713 8655

Donations
Donations, of whatever size, from individuals, companies and trusts are welcome, either to support particular areas of interest, or to contribute to general running costs.

Gifts of Shares
Since April 2000, we can accept gifts of quoted share and securities. These are not subject to capital gains tax. For higher rate taxpayers, a gift of shares saves income tax as well as capital gains tax. For further information please contact the Campaigns Section of the Development Office.

Tate Annual Fund
A donation to the Annual Fund at Tate benefits a variety of projects throughout the organisation, from the development of new conservation techniques to education programmes for people of all ages.

Gift Aid
Through Gift Aid, you can provide significant additional revenue to Tate. Gift Aid applies to gifts of any size, whether regular or one-off, since we can claim back the tax on your charitable donation. Higher rate taxpayers are also able to claim additional personal tax relief. Contact us for further information and a Gift-Aid Declaration.

Legacies and Bequests
Bequests to Tate may take the form of either a residual share of your estate, a specific cash sum or item of property such as a work of art. Tax advantages may be obtained by making a legacy in favour of Tate; in addition, if you own a work of art of national importance you may wish to leave it to us as a direct bequest or to the Government in lieu of tax. Please check with Tate when you draw up your will that we are able to accept your bequest.

Tate American Fund and Tate American Patrons
The American Fund for the Tate Gallery was formed in 1986 to facilitate gifts of works of art, donations and bequests to Tate from United States residents. United States taxpayers who wish to support Tate on an annual basis can join the American Patrons of the Tate Gallery and enjoy membership benefits and events in the United States and United Kingdom (single membership $1000 and double $1500). Both organisations receive full tax exempt status from the IRS. Please contact the Tate American Fund for further details.

Membership Programmes
Tate Members enjoy unlimited free admission throughout the year to all exhibitions at Tate Britain, Tate Liverpool, Tate Modern and Tate St Ives, as well as a number of other benefits such as exclusive use of our Members' Rooms and a free annual subscription to Tate: The Art Magazine.

Whilst enjoying the exclusive privileges of membership, you are also helping secure Tate's position at the very heart of British and modern art. Your support actively contributes to new purchases of important art, ensuring that the Tate's Collection continues to be relevant and comprehensive, as well as funding projects in London, Liverpool and St Ives that increase access and understanding for everyone.

Patrons
Tate Patrons are people who share a keen interest in art and are committed to giving significant financial support to the Tate on an annual basis, specifically to support acquisitions. There are four levels of Patron, including Associate Patron (£250) Patrons of New Art (£500), Patrons of New Art (£500), Patrons of British Art (£500) and Patrons Circle (£1000). Benefits include opportunities to sit on acquisition committees, special access to the Collection and entry with a family member to all Tate exhibitions.

Corporate Membership
Corporate Membership at Tate Liverpool and Tate Britain, and support for the Business Circle at Tate St Ives, offer companies opportunities for corporate entertaining and the chance for a wide variety of employee benefits. These include special private views, free admission to paying exhibitions, out-of-hours visits and tours, invitations to VIP events and talks at members' offices. Tate Britain is currently only available for entertaining by companies who are either corporate members or current sponsors.

Founding Corporate Partners
Companies are also able to join the special Founding Corporate Partners scheme which offers unique access to corporate entertaining and benefits at Tate Modern and Tate Britain in London, until the end of March 2003. Further details are available on request.

Corporate Investment
The Tate Gallery has developed a range of imaginative partnerships with the corporate sector, ranging from international interpretation and exhibition programmes to local outreach and staff development programmes. We are particularly known for high-profile business to business marketing initiatives and employee benefit packages. Please contact the Corporate Fundraising team for further details.

Charity Details
The Tate Gallery is an exempt charity; the Museums & Galleries Act 1992 added the Tate Gallery to the list of exempt charities defined in the 1960 Charities Act. The Friends of the Tate Gallery is a registered charity (number 313021). Tate Foundation is a registered charity (number 1085314).